Burke

S0-AWZ-708

个

SHAPINSKY'S KARMA,

· · · · · · · · · · ·

BOGGS'S BILLS,

· · · · · · · · · · · ·

AND OTHER TRUE-LIFE TALES

· · · · · · · · · · ·

by LAWRENCE WESCHLER

· · · · · · · · · · ·

NORTH POINT PRESS 1988 *San Francisco*

FOR JOANNA

Copyright © 1988 by Lawrence Weschler
Printed in the United States of America
Library of Congress Catalogue Card Number: 87-82581
ISBN: 0-86547-317-x

Grateful acknowledgment is extended to the publishers of
earlier versions of these essays: *The New Yorker* for "Shapinsky's
Karma," "Jensen's Shangri-la," "Slonimsky's Failure," and
"Boggs's Bills"; *Artforum* for the Postscript to "Jensen's
Shangri-la"; *Rolling Stone* for "Art's Father, Vladek's Son"; and
The L.A. Reader for "Lennie's Illusion."

CONTENTS

PREFACE

THE PIECES collected in this volume generally began betwixt and between. That is to say that over the years, especially after I joined the staff of the *New Yorker* in 1981, I developed a pattern of shuttling back and forth between heavy political themes and more lighthearted cultural ones. Or so, anyway, did I come to explain myself to myself. I used to imagine that these cultural forays cleared the palate, as it were, between courses of heartier political fare. They were recreations—occasions for re-creation. Thus, for example, I might parse the comic adventures of a frantic Indian schemer at the highest reaches of the contemporary art world between stints of reporting on martial law in Poland and torture in Brazil. I'd flee to these bright cultural venues as temporary respite from the darker political topics, which nevertheless continued to exercise a deep pull on my concerns.

But in rereading many of these cultural pieces in preparation for the current volume, I've come to see that such simple dichotomies won't do; they explain neither what I nor what my writing have been about. To begin with, these cultural pieces are themselves often quite political: the story of the hellbent Indian, for instance, opens out onto some fairly complex and subtle terrain involving the distribution of power in the art world. Beyond that, many

of the central themes in my political reporting made their first appearance in these lighter venues, or else were recapitulated and refined there.

Thus, for example, the theme of passion. I used to speak loosely of these as my "passion pieces" without even noticing that I'd earlier titled my book on Solidarity *The Passion of Poland*. In all my writing, I guess, I have been concerned with people and places that were just moseying down the street one day, minding their own business, when suddenly and almost spontaneously they caught fire, they became obsessed, they became intensely focused and intensely alive—ending up, by day's end, somewhere altogether different from where they'd imagined they were setting out that morning. Many of the finest theorists and activists in Solidarity used to describe that movement as an expression of "the subjectivity of the Polish nation," by which, they'd explain, they meant its capacity to act as the subject rather than the object of history. Such transformations are, at root, grammatical—an entity that was content to receive the action of its sentences now suddenly demands to itself initiate such actions—and are, of course, metastable. They are perpetually up for grabs and under siege (indeed, in the political realm, states of siege are launched precisely to upend them), but once they've occurred the field of play is forever changed.

Similarly, these passion pieces are punctuated with grace notes, and this mysterious working of grace is something I've likewise often considered in my political reporting: grace in its original sense as *gratis*, for free. One works and works and works at something, which then happens of its own accord: it would not have happened without all the prior work, true, but its happening cannot be said to have resulted from all that work, the way effects are said to result from a series of causes. There is all that work, which is preparation, preparation for receptivity, but then there is something else beyond that which is *gratis*, for free. August 1980 in Gdansk, Poland, would never have happened without the years and years of tenuous labor by a small band of seemingly marginal activists—no one denies this—but when that strike suddenly happened, it seemed to come out of nowhere, to happen all by itself. Everyone still talks about this (particularly the activists), talks about and wonders at the sudden overwhelming sense of rightness that descended on the place at that moment.

The descent of grace, like the upwelling of passion, occurs in the lives of individuals as well as in the lives of polities, and though such occurrences are

often fraught with significance, they can also be quite comical as well. There is something both marvelous and hilarious in watching the humdrum suddenly take flight. This is, in part, a collection of such launchings.

Most of these pieces first appeared in the *New Yorker*, in the old *New Yorker*, which is to say William Shawn's *New Yorker*. Mr. Shawn encouraged and supported and in a sense even inspired them: his generous concern for both the writer and his subject suffuses them. And I happily acknowledge that debt here.

On a more day-to-day basis, it was usually John Bennet who watched over the conception and gestation of these pieces and then oversaw their passage into print at the magazine. His uncanny sense of tone and his wry reserve saved me and the reader from many an infelicity: those that remain simply testify to my own stubbornness in the face of wiser counsel.

None of these pieces would have been possible without the openhearted cooperation of their subjects—Akumal Ramachander, Harold and Kate and David Shapinsky, Knud and Vivi Jensen, Art Spiegelman and Françoise Mouly, Nicolas Slonimsky and Electra Yourke, Leonard Durso, Stephen Boggs—and of course I once again warmly thank them here for their forbearance in letting me into their lives.

Into my own life, these last several years, has come my heart's true home, my bride Joanna, and this is Joanna's book.

Shapinsky's Karma,

Boggs's Bills,

and other true-life tales

SHAPINSKY'S KARMA

· · · · · · · · · · · · ·

I WAS UP late one night last fall, absorbed in Serge Guilbaut's provocative revisionist tract *How New York Stole the Idea of Modern Art*, when, at eleven-thirty, the phone rang. A stranger on the line introduced himself as Akumal Ramachander, from Bangalore, India. He was calling from Washington, D.C., he informed me in a spirited voice. He'd just been in Warsaw a few weeks earlier, where he'd had many fascinating experiences. He'd read a book I'd written on Poland, and could see that I'd given the situation there much thought. He was going to be in New York City later in the week, and would it be all right if we got together? It all sounded mildly diverting, so we set a rendezvous.

A few days later, on schedule, Ramachander appeared in my office—a youngish, fairly slight gentleman with short-cropped black hair and a round face. His conversation caromed all over the place (Gdansk, Reagan, Sri Lanka, Lech Walesa, Indira Gandhi, the Sikhs, Margaret Thatcher, Satyajit Ray, London); he told me that he was some sort of part-time correspondent for the local paper of one of those Indian towns almost no one in America has ever heard of. He'd taught English at an agricultural college but had generally been something of a drifter, he explained—that is, until recently, for

he'd just discovered his true calling. "My destiny!" he insisted. "We Indians believe in karma, in destiny, in discovering the true calling for our lives. It has nothing to do with making money, this 'making a living' you have here in America. No, it is the spirit calling, and we answer. Not in some silly mystical way but as if the purpose of life were revealed—sometimes, as in my case, all-of-a-suddenly, like that! And this is what has now happened."

And what calling, I asked him, had he suddenly uncovered?

"Shapinsky!"

And who, or what, was Shapinsky?

"Harold Shapinsky," he replied. "Abstract Expressionist painter, generation of de Kooning and Rothko, an undiscovered marvel, an absolute genius, completely unknown, utterly unappreciated. He lives here in New York City, with his wife, in a tiny one-bedroom apartment, where he continues to paint, as he has been doing for over forty years, *like an angel.*" Ramachander scribbled an address and a phone number on a scrap of paper, shoved it at me, and continued, "You *must* visit this Shapinsky fellow. He's a true find, a major discovery. It is my destiny to bring him to the attention of the world."

I was somewhat speechless.

Ramachander was not: "You will see—this is an extraordinary discovery. As I say, I don't care about money. What's money? I do it because of my destiny."

Well, at length Ramachander departed. (He was, he told me, headed for Europe a few days hence.) I tacked Shapinsky's address and phone number to my bulletin board but didn't get around to calling him right away, and then one thing led to another, and I pretty much forgot about the whole incident.

A few weeks later, at seven in the morning, the phone in my apartment rang me awake. "Hello, Mr. Weschler. Akumal here, In Utrecht, Holland. You won't believe the good news! I took slides of Shapinsky's work to the Stedelijk Museum in Amsterdam, and the curator there was amazed. He told me that I'd brought him the work of a great artist, that Shapinsky is a major find. I must tell you, I'm beginning to believe this is one of the great discoveries of the last five years. The curator was extremely supportive, and eager to see how things develop."

Myself, I wasn't really eager to believe any of it. I hung up and went back to sleep.

A few days later, the phone rang again—at ten in the morning this time.
"Akumal again here, Mr. Weschler! Only, in London today. More good news!
I visited the Tate this morning. Just walked in with no appointment, de-
manded to see the curator of modern art, refused to leave the waiting room
until he finally came out—to humor me, I suppose, this silly little Indian fel-
low, you know—but presently he was *blown away*. He bows to me and says,
'Mr. Ramachander, you are right. Shapinsky is a terrific discovery.' I'm be-
coming more and more convinced myself that he's the discovery of the de-
cade. Anyway, he gave me the name of a gallery—the Mayor Gallery. James
Mayor, one of the top dealers in London, Cork Street—Warhol, Lichten-
stein, Rauschenberg, first-rate. I went over there, and he, too, was flabber-
gasted. He's thinking about scheduling a show for the spring."

I still didn't know quite what to make of any of this; I assumed that it was
all a bit daft, some elaborate fantastication, and, anyway, I remained too busy
with other projects to take time to call and visit Shapinsky, if Shapinsky ac-
tually existed.

A few days later, the phone rang, again at seven in the morning, and, used
to the pattern by now, I managed to preempt my new friend with a "Hello,
Akumal."

"British television!" Ramachander exclaimed, utterly unimpressed by
my prescience. "I showed the slides to some people over at British Channel 4
and they loved them, and right on the spot they committed themselves to
doing a special, an hour-long documentary, to be ready in time for the show
at the Mayor Gallery. Did I tell you? A one-man show to open on May twenty-
first, Shapinsky's sixtieth birthday. They love the story, the idea of this un-
known genius Abstract Expressionist and of the little Indian fellow and his
destiny. They'll be flying me back to New York in several weeks with a camera
crew to re-create our meeting—Shapinsky and myself—and then the follow-
ing month they're going to fly Shapinsky and his wife and me to Bangalore,
in India, so I can show them around my digs. This meeting of East and West,
you see—that's the ticket. So maybe I'll see you in New York, yes?"

I set the phone back in its cradle, resolving to give the whole matter a bit
more thorough consideration once I'd reawakened at some more decent hour.
But just as I was nodding back off the phone rang again.

"The Ludwig Museum! I forgot to tell you. Just before Channel 4, I went

to Cologne and showed the slides to the excellent lady in charge of the Ludwig Museum there. She couldn't get over them. She can't wait to see the show at the Mayor Gallery. Everyone agrees.

"I'm beginning to see it clearly now: Shapinsky is one of the top finds of the century!"

Several weeks later (I'd anticipated the visitation with a notation in my desk diary), the phone rang at my office, and of course it was Akumal, this time in New York, in Shapinsky's apartment—I simply had to drop whatever I was doing immediately, he told me, and come see for myself.

So I did. The address on Seventieth Street, east of Second Avenue, turned out to be a Japanese restaurant. Off to one side was a dark entry passage behind a glass door. I pushed a doorbell and was buzzed in: a five-story walk-up; steep stairs and dim, narrow corridors. I could hear something of a commotion upstairs as I approached. Rounding the corner onto the fifth-floor landing, I was momentarily blinded by a panning klieg light: the tiny apartment was indeed overflowing with a bustling film crew. I craned my neck into the bustle. The foyer was almost entirely taken up by a single bed (the only bed in the apartment, I later discovered), which was covered with coats and equipment; the next room was an almost equally crammed kitchen; and just beyond that I could see into a tiny bedroom, which was serving as the studio. A very dignified and dapper-looking English gentleman had spread several paintings about the floor of the studio and was crouched down making a careful selection as the television crew peered over his shoulder. I managed to step in. In the far corner I spotted Akumal, who was beaming. Next to him stood a soft, slightly stooped, fairly rumpled, gray-bearded old man, wrapped in a moth-eaten wool sweater and puffing cherry-sweet tobacco smoke into the air from the bowl of a well-chewed pipe. "Ah!" Akumal exclaimed, suddenly catching sight of me. "Mr. Weschler! I want you to meet Harold Shapinsky."

Shapinsky looked up, mildly (understandably) dazed.

The dapper Englishman got up off his haunches, wiped his hands, gave one last approving glance at the paintings arrayed before him, and then looked over at Shapinsky, smiling. "Yes," he said. "I think that will do. That will do superbly."

"Cut!" shouted the film director. "Good. Very good." The kliegs went dark.

"James Mayor," Akumal said, introducing the distinguished-looking Englishman, whose identity I'd already surmised.

Shapinsky puffed on his pipe and nodded.

The cameraman asked if he could have Shapinsky and his wife stand by the window for a moment, and Mayor walked over beside me. "Most amazing story," he said. "I mean, an artist of this calibre living like this, dirt poor, completely unknown—*living in a virtual garret* five stories above a Japanese restaurant I've been to literally dozens of times. Quite good Japanese restaurant, by the way, that." Mayor is in his late thirties, trim, conventionally handsome, with a shock of black hair cresting to a peak over his forehead. "I must say, when Akumal brought me in those slides I was astonished," he continued. "I mean, this art business can get one pretty jaded after a while. One gets to feeling one's seen it all. You begin to despair of ever again encountering anything original, powerful, real. I haven't felt a buzz like this in a long time."

Akumal and the director of the film, Greg Lanning, joined us. Lanning explained that he'd now like to shoot a sequence of Mayor and Shapinsky talking together. Everything really was intolerably cramped. I asked Akumal if he'd like to join me for a little walk, and he agreed.

"Well," I told Akumal outside, "you've certainly gone and caught my attention. But do you think we might slow down and wind this tape back a bit? First of all, seriously, *who are you?*"

"Ah, yes." He laughed. "It's been just as I predicted, hasn't it? Wonderful destiny! Manifest destiny—isn't that one of your expressions here in America? Manifest *karma*, if you'll allow me. As I told you, I am a lowly professor of elementary English at the College of Agricultural Sciences in Bangalore. I am there every day from eight to three, teaching my classes of forty students grammar, spelling, sentence structure, conversational skills—only, I'm on leave just now, as you can see."

He was born in Bombay on the tenth of July, 1949, and his family presently moved to Calcutta. His father was a clerk in the army. His family was lower middle class, struggling to advance slightly higher, into the middle class proper. When his father and mother were married, they were so poor they couldn't afford a single night in the fanciest hotel in Bombay—they

couldn't even afford tea there—so they went over and just rode up and down in the lifts. "That was their sort of honeymoon celebration. When I was growing up, there were six of us in two rooms."

Walking and talking at a brisk clip, Akumal continued, "My parents are both polyglots—they speak five Indian languages each, I speak seven—and they would encourage my reading. Especially my mother: I remember coming upon her in my room one day; she was reading my copy of *Death of a Salesman* and she was weeping. I was very bookish. I almost went blind with all my reading. There was no electricity, and to save my eyes my father made a huge clamor and got electricity for the entire block. He was not able to complete his schooling himself, so he sacrificed enormously so that his children would be able to: he sent me to a fine school where I perfected my English. Eventually, I even managed to teach English for many years before ever going to England my first time, which was in 1980.

"I was especially in love with beauty. In India, even the poorest will adorn themselves with colorful saris or simple jewelry—you may be economically deprived, we say, but God has given you eyes in your head to see—and from a very early age I was entranced, mesmerized by the flowing movements of all those intense colors. One of my earliest memories in Calcutta was going to the fields not far from Fort William, along the banks of the Hooghly River. This was my art school. Because there, each summer, thousands—no, hundreds of thousands—of butterflies would gather, and I would run among them, chasing them, all those brilliant hues floating about. I never actually tried to catch any. It was just the swarming of all that color. And that was my initial association when I saw the slides of Shapinsky's paintings for the first time. They reminded me of the butterflies back in Calcutta, and the rhythms of classical Indian dance, too—another great passion of mine. I knew I must be in the presence of a profound art if it could inspire associations like that."

Akumal went on to relate that his family had moved to Bangalore when he was sixteen. He received his bachelor's degree in physics and chemistry *and* mathematics from the National College in Bangalore in 1968, shifted fields and campuses and attained a master's degree from Bangalore's Central College in 1971. In addition to teaching, he wrote poetry in Hindi and fiction in English. In 1973, an early draft of an antiwar play of his somehow got him an invitation to Weimar, East Germany—his first trip abroad—and there he was "bowled over by Brecht." I say "somehow": Akumal was actually very

specific—exhaustively so—about the circumstances, but my concentration had begun to buckle under the weight of his relentlessly detailed recapitulations. All of Akumal's accounts are exhaustive: it's not so much that he is incapable of compression as that he seems authentically dazzled by the particulate density of every aspect of his fate. Anyway, he returned to India and became something of a gadfly in Bangalore, one of the fastest-growing provincial cities in India, endlessly exhorting the editors of the local papers to expand their cultural coverage, especially of international film and literature. He haunted the British Council Library. He arranged for the first translation of Darwin's *Origin of Species* into Kannada, the local language. He acted as a literary agent on behalf of various local poets and essayists. He managed to finagle a special four-page supplement on the films of the Polish director Krzysztof Zanussi during a Bangalore film festival in 1979. Zanussi eventually saw the supplement, and had Akumal invited to the 1980 Gdansk film festival, at the height of the Solidarity period—the first of several trips Akumal took to Poland. Somewhere along the line, he met Lelah Dushkin, a sociology professor at Kansas State University, who managed to arrange an invitation for Akumal to come to Kansas to lecture on Indian politics and cinema, so that early in the fall of 1984 Akumal found himself in Chicago, fresh from Poland (where he had just attended another film festival), en route to Manhattan, Kansas.

This is where the story proper begins—a story that Akumal has now told hundreds of times, each time the same way, with the same formulaic cadences and ritualized digressions, except for the addition, at the end of each new telling, of the name and reaction of the person he told it to the immediately prior time. It's like one of those Borges fictions, in which to hear the story is to become part of it. And the story always begins with Akumal's fresh astonishment, his sheer amazement at the wondrous coincidence of it all. Because, as he points out, if he hadn't been on his way to Kansas he would never have been in Chicago, and if he hadn't been in Chicago he would never have accompanied his host, the distinguished Indian poet (and MacArthur Fellowship recipient) A. K. Ramanujan, to a retirement party for Maureen Patterson, the South Asia bibliographer at the University of Chicago library, and in that case he would never have had an impulse "to befriend one young man who was standing somewhat shyly in the corner"—an impulse that arose "because the man had an interesting, kind face"—and then he would never have met one

of Maureen Patterson's graduate assistants, who proved to be David, the twenty-four-year-old son of Harold and Kate Shapinsky. "It could all easily never have happened," Akumal invariably points out here. "It was all built on the most precarious of coincidences. But, then again, it had to happen, because it was my karma to discover Harold Shapinsky, and it was Shapinsky's karma to be discovered by me."

David Shapinsky was in Chicago doing graduate work in American diplomatic history, so their conversation initially revolved around international relations, alighting on the subject of Poland, and thence on to the subject of a young Polish artist whose work Akumal had taken to promoting since his most recent trip to Gdansk, and some of whose etchings he had back in his suitcase at Ramanujan's. (He had bought them in Poland to assist the poor artist, and was now reselling them as he went along to finance his trip; beyond that, he was virtually without funds.)

"David didn't mention anything about his father that night," Akumal explained to me as we completed perhaps our twelfth lap of the block the afternoon he recounted the whole story to me for the first time. "That took another coincidence—the next day, we just happened to run into each other at the University of Chicago library, and he asked me if I'd mind going with him for coffee. Presently, he told me about his father and invited me up to his room to look at some slides of his father's paintings and see if I might be willing to promote his father's work as well. He is a loving son, and he was pained by the oblivion into which his father had fallen. I was interested, but I really didn't know much about Abstract Expressionism—I mean, I of course had Alvarez's anthology of twentieth-century English poetry, which has a Pollock on the cover, and I'd read a piece in the *Economist* for June 1978, a review of a book about ancient Indian popular painting in which the writer suggested that these artists must have unconsciously anticipated Pollock. So I knew about Pollock, though I'd never heard of de Kooning. And I had no idea how I would react to this work of David's father. In David's room, though, looking at the slides, I got butterflies—the butterflies of my Calcutta youth!

"Over the next few days, I got very excited. I told David to call his parents and tell them to sit tight just a bit longer—that a crazy Indian from Bangalore was on his way to promote Harold's paintings. And I made David a two-part bet. I bet him that within a year I would secure a show for his father's paintings at a major world-class gallery—possibly not in America, possibly

in Europe. I wasn't sure about New York—they're funny in New York, you can never tell. And, secondly, we would force the *Encyclopædia Britannica* to revise its entry on Abstract Expressionism to establish the name Shapinsky in its rightful place among de Kooning, Pollock, Rothko, and the others. We bet a dinner at the fanciest restaurant we could think of, and then I was off to Kansas.

"From Kansas, I called a friend of mine in New Jersey, an Indian fellow named Sudhir Vaikkattil. An exceptional photographer, he was an earlier discovery of mine. I told him not to ask any questions but to call the Shapinskys right away, go over there, and take new slides of the work and of them. I'd be joining up with him in a few weeks. I told him not to worry, that somehow I'd find money to pay for the materials—although at that moment I was, frankly, penniless. I called Harold—this was our first conversation—and told him about Sudhir and the need for the new slides. And—this was fantastic—you know what he said? He said, 'Well, I hope he gets in touch with me.' This was a wonderful omen. In India, we have a proverb—'The thirsty man goes to the well, the well doesn't go to the thirsty man.' As I suspected, this confirmed that Shapinsky was a well, not a thirsty man. He is incredibly serene. He is *siddhipurush*—this is a Sanskrit expression meaning a wise man, self-actualized, unflappable, unfazed."

Akumal soon completed his lectures in Kansas and flew on, for some reason (he told me why; I just got lost somewhere in here), to Los Angeles and then to Washington, D.C. There, as elsewhere, he managed to find some Indian patrons. "I sing for them," Akumal explained to me matter-of-factly. "Oh, I didn't tell you? Yes, I am a great fan of Indian semiclassical music, and I can sing unaccompanied. Homesick Indians all over the world love to have me stay with them in their homes as long as I sing for my keep." He now launched his siege of the Smithsonian, armed with David's slides. There was a whole series of coincidences here as well, including a fellow named Asman ("This was a wonderful omen, because, you see, *asman* in Hindustani means the sky, and, of course, I was reaching for the sky, and also, in Bangalore, I am known as Chander, the Moon, so the Asman-Chander—you get the idea"), whom Akumal encountered somewhere along the way toward Dean Anderson, "the number two man at the Smithsonian." Anderson was impressed by the slides and dumbfounded that Shapinsky wasn't listed in any of the reference books on his extensive shelf. He promised to pass the slides on to the curators over at

the Hirshhorn and get back to Akumal with their response as quickly as possible. On one of the days in here, Akumal happened upon a copy of my book on Poland in a bookstore and noted, from the jacket copy, that I'd also occasionally written on art ("another wonderful omen"), which is why he called me later (very much later) that night. As he pointed out, admiring his own tactical acumen, he'd limited his conversation in that first phone call to the subject of Poland. This was partly, he now told me, because he'd spent much of the interim that afternoon calling New York galleries. "I must tell you I've made a major discovery," he'd told one receptionist after another, "an extraordinary Abstract Expressionist of the generation of Pollock, Rothko, and de Kooning, and I would like to make an appointment to come in and show you some slides." In a few cases, he managed to get past the flak-catchers, but it didn't much help. "Harold *who?*" was a common response. One prominent dealer, Ivan Karp, went as far as to assert, "He couldn't be very major if I've never heard of him." Akumal called thirty-two galleries and got not one appointment. A few days later, on October thirtieth, undaunted, he boarded a bus for Manhattan. He immediately called on the Shapinskys. They became fast friends, and later that very afternoon he showed up in my office, making his subtle (as it developed, almost too subtle) pitch.

The next day, Akumal called Anderson at the Smithsonian. "The people here are amazed," Akumal recalls Anderson's telling him. "They say either Shapinsky is an outstanding genius of twentieth-century art or he is a first-class derivative artist. They want more time." Akumal pointed out that all Western art was derivative of the East, if you wanted to get picky about things, and anyway art history was not a relay race. He asked whether Anderson would mind if he began showing the slides to art people in Europe. Anderson said of course not, and shortly thereafter Akumal boarded a flight to Amsterdam on the first leg of his prebooked, prepaid return to Bangalore.

We'd now accomplished a half-dozen more laps of the block, and we decided to peer in and see how the TV shoot was going. It was going like most such things—at a snail's pace—and Akumal would not be needed for a bit longer, so we decided to head out for a few more rounds.

"The next coincidence occurred on the plane," Akumal continued. "The KLM in-flight magazine happened to include an article about the Stedelijk Museum, mentioning a curator named Alexander van Gravenstein, so once I arrived in Holland I immediately took to calling him, and eventually obtained an appointment. When I arrived at his office, he invited me down to

the museum cafeteria, and I was momentarily alarmed, because I literally didn't have a cent in my pocket and, you know, there is this phrase 'going Dutch,' and, this being Amsterdam and everything, I figured I might be expected to pay for my own coffee. But he was very generous—another good omen—and he just picked up the tab. And after he looked at the slides, he said, 'You have brought me the work of a great artist. The work of the late forties and fifties is especially original.' He gave me the name of Xavier Fourcade, a dealer in New York City, but I decided not to tell him how I'd already called the thirty-two New York galleries, all to no avail."

Buoyed by that exchange, Akumal borrowed money from some Dutch friends and took the boat to England, arriving in London early in the morning and being met by an Indian friend who was studying at Cambridge. Over dinner, their conversation turned to the Booker Prize for fiction and the fact that it had recently been won by Anita Brookner, who happened to be a professor of art. "I took this as an omen," Akumal recounted. "And I excused myself momentarily from the table. I went over to the pay phone and looked up her number in the phone book. It was listed, *another* good omen. And since it wasn't too late—before ten, anyway—I placed the call. She answered herself, and I quickly explained my situation and she was very gracious, at the end suggesting that the man to get in touch with was her friend Alan Bowness, the director of the Tate." When Akumal returned to the dining table, his Cambridge friend was aghast that he'd actually called Miss Brookner but "once in a while you just have to be bold."

The next morning, Akumal presented himself at the reception desk at the Tate, insisting on seeing the director. No, he did not have an appointment, but he did have urgent business. Bowness, it turned out, was not in, but Akumal would not be budged. Finally, the receptionist managed to get Ronald Alley, the keeper of the modern art collection, to come down and attend to this immovable Indian. "I pulled out the slides, and as he looked through them he almost immediately said, 'You have made a major discovery.' I said yes. He suggested that what Shapinsky needed now was a first-class gallery, and asked if I'd like a referral. Of course, I said yes again. He went over to his phone and called James Mayor and told him he'd be sending over someone with some very interesting work. I thanked him, left the building, flagged a cab, and immediately proceeded to the Mayor Gallery."

Salman Rushdie, the best-selling author of *Midnight's Children* and *Shame*, who was to become another student and chronicler of this affair, has pointed

out, correctly, that this was the turning point in Akumal's Shapinsky quest. As Rushdie says, "Now, for the first time, Akumal had become that most *pukka* of persons, a man who has been properly introduced." (*Pukka* is Hindustani for "complete," "whole," "together.")

Mayor had hardly had time to put his phone back in its cradle when Akumal arrived at his door, pulling out his slides. And Mayor, too, was impressed. He asked for a couple of weeks to think it over, but a few days later, on December fourth, he told Akumal that he would like to schedule a Shapinsky retrospective for the spring. Akumal asked him to frame his request as a letter. Mayor did, and the next evening Akumal told the whole story to Salman Rushdie, whom he'd met a few years earlier when a lecture tour brought the writer to Bangalore.

Akumal now took a boat back to Holland, made his quick and highly successful side trip to the Ludwig Museum in Cologne, and then prepared to resume his flight back to Bangalore, again virtually out of funds. Dutch television had become interested in his story and wanted to scoop the world with news of the Shapinsky discovery. Unfortunately, the sole slot it had available was for a few days after Akumal's prepaid and nonchangeable flight back. Akumal called Rushdie to ask what he should do.

Rushdie offered some tentative advice, but the real import of this call in terms of the saga was that it served to remind Rushdie of the whole affair. This was important, because that evening it just happened—"another incredible coincidence"—that Rushdie was going to be dining with his friend Tariq Ali. Ali, who comes from an area of pre-Partition India that is now in Pakistan, had been one of the foremost student activists in Europe during the Vietnam War period; he'd been instrumental in establishing the Bertrand Russell–Jean-Paul Sartre war-crimes tribunal in Stockholm; and he'd gone on to become a prolific and highly regarded political writer. Ali had also recently been named one of the executive producers of a documentary-film company named Bandung Productions, which was loosely affiliated with Britain's new television network, Channel 4. One of Ali's colleagues from Channel 4 was at the dinner, and Rushdie naturally regaled the group with his improbable tale of Akumal and Shapinsky. As he did so, he warmed to his subject, finally insisting that Bandung and Channel 4 commit themselves on the spot to doing a documentary on Akumal's discovery—or else, he assured them, he'd go to the BBC with the tale the very next morning. He made one

proviso—that whoever took the project should take on Akumal's expenses for the interim as well. He was tired of seeing his friend ricocheting around the world so precariously close to bankruptcy. The dinner reconvened as an instant committee of the whole, they all agreed to Rushdie's proposal and his terms, and Akumal was called the next morning.

And now, a scant three months later, here we were, Akumal and I, negotiating loops around the real-life set of the resultant movie. We decided to go back upstairs, and this time Akumal's services were required. I spoke briefly with the Shapinskys, arranged for a meeting a few days later, when things would have quieted a bit, and took my leave.

Akumal telephoned me the next morning at my office to tell me that he and the film crew would be off to Chicago later that day to shoot a re-creation of the meeting with David ("We're going to reassemble the entire party," he said enthusiastically. "Miss Patterson is going to get to retire all over again"), but first he was going to the Museum of Modern Art to talk to William Rubin, the formidable director of the museum's Department of Painting and Sculpture.

"Do you have an appointment?" I asked.

"Of course not," Akumal shot back. "But, then, I haven't had appointments most other places, either. I'll drop by afterward to tell you how things went."

Twenty minutes later, someone stepped into my office to tell me that there was a Mr. Ramachander asking for me in the lobby. "Well," I said sympathetically as I guided Akumal back to my office a few moments later, "it must have been a short meeting."

"Ah," Akumal replied sheepishly. "It's Wednesday. I forgot. The museum is closed on Wednesdays. But"—he brightened—"I've made a wonderful new discovery." He reached into his satchel and pulled out a bag. "Croissants! Sort of like French flaky breakfast rolls. You can just go in and buy them at a place right around the corner. Very tasty. Here." He offered me one and then reached again into his satchel, this time pulling out a folder.

"I wanted to show you all the letters," he explained. He had apparently been collecting testimonials as he went along.

"Dear Mr. Akumal," the one from Ronald Alley began, under the Tate Gallery letterhead. "Thank you for showing me the slides of Harold Sha-

pinsky's paintings. I am sorry to say he was completely unknown to me, but he is clearly an Abstract Expressionist artist of real interest whose work deserves to be widely known. His pictures have great freshness and beautiful colour, and I think people are going to be very surprised that an artist of this quality could have slipped into total obscurity."

There was one from Dr. Partha Mitter, the eminent Asian Studies scholar from the University of Sussex: "I was deeply moved by [Shapinsky's] immensely joyous paintings which appeared to celebrate life and its manifold creations. They exude power and dynamism, and their range of primary colours and sinuous lines evokes striking impressions of organic forms."

It must have been by way of Mitter that Akumal was able to get to Norbert Lynton, the celebrated historian of twentieth-century art who is also a professor at Sussex. (Lynton's *The Story of Modern Art* was conceived of, and is currently used in classrooms throughout the world, as an adjunct volume to E. H. Gombrich's classic *The Story of Art*.) "I write to thank you for coming in and showing me your slides of the work of Shapinsky," Lynton's letter began. "Some days have passed since then: and though I had intended to write to you sooner the delay has not been without value, in that I find my recollection of many of Shapinsky's works crystal clear, a sure sign (I know from past experience) of artistic significance. He is certainly a painter of outstanding quality. . . . The slides suggest a rare quality of fresh and vivid (as opposed to mournfully soulful) Abstract Expressionism, a marvelous sense of colour, and also a rare feel for positioning marks and areas of colour on the canvas or paper. When you see Shapinsky, please . . . bring him respectful, admiring greetings from me."

There were several other letters in the file as well, and Akumal beamed as I read them. "It's all quite fantastic, isn't it?" he said. "So, don't you think you should come to the opening?"

I told him that I might try to make it to London for the opening, which was two months away. We left it at that.

Then he asked me if I would mind writing a letter, just to say that I, too, had now seen the slides, and that I might be coming to the opening.

I told him I'd try to remember to.

He said it was okay; he could wait—he had a few minutes before he had to go catch the airport bus.

So far, I really hadn't had a chance to talk with Shapinsky, or, for that matter, to get a good look at his work, but now that the traveling documentary show had hit the road and quiet had returned to East Seventieth Street I went over for a chat the next day. Actually, several such visits were necessary: Shapinsky turned out to be as reserved and measured and withdrawn as Akumal was voluble and extravagant and outgoing. He was always gentle and polite, but he was subdued; indeed, at times his restraint verged on the spooky. He answered questions in a flat, becalmed voice with simple sentences often consisting of just one or two words ("Yes, marvelous," "Truly gratifying"). Though his answers eventually got longer, they often seemed preset—not that he was being evasive or had adopted some sort of party line but, rather, that his life seemed to hold little curiosity for him, few fresh surprises, no new vantages. His accounts had none of the free-associative, scattershot unpredictability that characterized Akumal's. I could see what Akumal had meant when he spoke of Shapinsky's serenity, but it seemed clearly a serenity that had a cost—there seemed to be a certain exhaustion behind the equanimity.

I was struck on each new visit to the Shapinskys' by the extraordinary spareness of their circumstances. One day, there happened to be three dirty cups in the kitchen sink, and there were not enough clean ones to go around until Kate had washed one of them. Another time, I took along a couple of friends, and there were not enough chairs in the apartment for all of us to sit on until Shapinsky lifted an ancient stereo off a rickety stool, set the stereo on the floor, and brought the stool over to the table. At night, I learned, they pulled a rolled-up thin mattress out of the closet and spread it across the floor to sleep on. During my visits, Kate would occasionally sit with us in the kitchen, knitting (she was always more spry and animated than he); other times, she would repair to the little foyer, on the other side of the thin wall, and operate her sewing machine, using the single bed as a layout table, while tossing anecdotes and amplifications back into the kitchen.

Harold Shapinsky was born in Brooklyn in 1925, which is to say that, contrary to Akumal's telescoped version, he was a good fifteen years younger than most of the first-generation Abstract Expressionists. (For that matter, he was younger than many of the second-generation New York School painters as well.) His parents were first-generation Russian-Jewish immigrants, and his father worked as a designer in the garment industry. Harold was the third of

four boys. Music was highly prized in the family—one of his older brothers became a classical cellist, and the other played double bass—but the visual arts were encouraged hardly at all. Indeed, as Harold's precocious drawing talent started garnering notice it began to be actively discouraged. A musician, after all, could always gain employment somewhere, but what possible livelihood could there be for a painter?

Nevertheless, from an early age Shapinsky inhabited a highly visual universe. As a small boy, he was always attracted to the museums—especially the Brooklyn Museum, where he was particularly taken with ancient figurines, Egyptian friezes, and Coptic reliefs. But he also found visual stimulation in contexts other than the formally artistic. For example, he was fascinated by the patterns chalked out across the swatches of fabric his father brought home from his work in the garment industry—"the complex jumble of shapes," he recalls, "and especially the spaces in between." He also spent hours poring over weather maps in the newspaper, his imagination stirred by what he calls "the compression of distances and scale, the layering, the sense of pressures building and spilling into winds, the gracefully sweeping front lines, the three-dimensional density expressed through the simplest of abstract graphic means." He says that the fabric swatches and the maps influenced his later work.

When Shapinsky was in his early teens, his parents divorced, and his home life, which he seldom discusses directly, appears to have become quite strained and unhappy. His mother would find his paintings and throw them out; even more distressing, his stepfather—after she remarried—would find his paintings and paint right over them, in an act of not even thinly veiled jealousy. Shapinsky persevered. He became fascinated by modern European painting—especially Cézanne and Picasso—and he says that by the age of fifteen, in 1940, he had resolved to become a painter. By that time, he had been out of school a year—he had been forced to drop out of junior high to help support his family. He worked at a succession of jobs, and continued to draw and paint in the evenings. His early portraits were highly influenced by the neoclassical Picasso. In 1945, he received some sort of scholarship to the Art Students League, where he studied with Harry Sternberg and Cameron Booth. (I derive this fact from a photostat of a handwritten two-page "résumé," the only documentation the Shapinskys were able to muster when

James Mayor requested a curriculum vitae to be used in preparing the show.) That year, at twenty, Shapinsky moved to Manhattan—to an unheated three-room, five-flight walk-up on the lower East Side, for which he paid twelve dollars and fifty cents a month. (Forty years later, he and his wife share a space almost as small in a similar walk-up, although it's in a somewhat nicer neighborhood and costs a lot more.)

These were to be the high good times of Shapinsky's life—in many ways, its only good times, at least up until October of 1984. He got a job in a ceramics factory and gradually rose to become head of its decorating department. But that was just part-time. All the rest of his time, his energy, and whatever little money he was able to save were poured into his painting. "It was a wonderful period," he recalls. "There was a tremendous camaraderie among the artists. We were putting our all into painting, into the activity of painting itself. We'd get together at the old Waldorf Cafeteria at Sixth Avenue and Eighth Street, and we'd talk about the mission of painting. Nobody gave a thought to money, or to exhibiting, or even to selling the work. It was a pure scene."

The first-generation Abstract Expressionists were just making their breakthroughs—one-two-three, one after the other, like that! And Shapinsky watched as it was happening all about him. "I saw my first Gorky show at the Julien Levy Gallery in 1946, right around the time I was myself turning decidedly toward abstraction," he says. "Although I never met him, Gorky was a great encouragement: he had a beautiful touch—such a warm feeling to him. I met and became friends with Franz Kline around 1947. I saw my first Jackson Pollock show in 1948, at Betty Parsons. Although I saw de Kooning himself a good deal on the street and about town, I didn't see my first de Kooning painting till 1950 or so. But the point is, everybody was painting. We weren't Abstract Expressionists—that designation would only come later. We were just *painters*."

Shapinsky met Kate Peters at an all-night New Year's Eve party as 1947 became 1948. She was, she says, "a dancer and a shiksa." She was the renegade bohemian offshoot of an established New England family. Her father was an architect and had a bit of the artist in him. But her parents, too, had divorced. Her mother had remarried, and her stepfather was Hugh Lofting, the author

of the Doctor Dolittle stories, though he didn't seem to like children very much, or at any rate had little use for her. Her insistence on becoming a dancer received little support from her family, but she kept at it, studying with Doris Humphrey and José Limón, among others. Like many dancers, she hung around the artists. She *had* met Gorky, baby-sitting for his children not long before his suicide. "He'd walk me home afterward to the Sixteenth Street Y," she says. "He was angry at the world. He had a great big dog. His little girls called his paintings 'broken toys.'" At that party, Kate says, she was immediately attracted to Harold—"He was so thin and gaunt, he had a face like El Greco's Jesus Christ"—but she didn't think she had a chance, because of her New England background. She was wrong. ("She had marvelous form," Shapinsky recalls of his first impression.)

A few weeks later, he tracked her down: she was nude, modeling on a dais at the Art Students League. He borrowed a large drawing pad, scrawled in big letters MEET ME IN THE CAFETERIA, and held the pad up before her. The class broke into applause. And after class she did meet him in the cafeteria. They went off to a pizza joint ("No," she corrects him, "it was a health-food place"), and the dinner cost two dollars, cleaning him out completely. "It was worth it, worth every penny," he says now, smiling over at her fondly. Their courtship was gradual, proceeding by fits and starts, and, like many affairs among artists of the period, it took a long time to formalize. They weren't officially married until 1955, and David, their only child, didn't arrive until 1960.

Shapinsky continued to scramble, hoarding whatever time he could for his painting, though he never seemed to have enough. A great break came when he happened to hear, in the fall of 1948, that a school named Subjects of the Artist was being established on Eighth Street by the painters William Baziotes, David Hare, Mark Rothko, and Robert Motherwell. (They were subsequently joined by Barnett Newman.) After work one evening, he went over to see about the possibility of a scholarship—he certainly couldn't afford the tuition. Baziotes happened to be there, and they had a long talk before class. "Finally," Shapinsky recalls, "Bill said to me, 'Well, let's see what you can do.' So I ran downstairs, found a paint shop, bought some black and white enamel and a board, hauled the things back up, squatted on the floor, and set to work. A while later, Bill came over, and he liked it and said he thought I

had a good chance. A few minutes later, Motherwell came over and started watching. Something went wrong, though, and I became dissatisfied and began scraping the paint away, gouging it and starting over. Motherwell liked how I treated the painting as a process. So they offered me a tuition scholarship on the spot. It was worth thousands—or anyway, it was worth thousands *to me* at that time. I began hanging out there morning, noon, and night. There weren't very many students, actually—maybe about a dozen—and my work received a lot of attention, caused a lot of talk. David Smith liked it. Bradley Tomlin liked it. Sometimes I would draw with chalk directly on the wall—I liked its hardness, the challenge of opening up a space. One time, Mark Rothko, who was terribly nearsighted, was talking to the class, and he began to speak appreciatively about one of my wall drawings as an example. He reached up to get a better look and tried to pull it off the wall—only, it *was* the wall. It was very embarrassing. Baziotes meant the most to me as a teacher, although they all had an impact. He was warm and enthusiastic— the others were more intellectual—and he helped encourage me to continue dealing with issues in my painting that were just beginning to be formulated. That sense of painting as a process. There were Friday-night lectures—Jean Arp came and spoke, Adolph Gottlieb, others."

The school closed toward the end of the winter of 1949. Shapinsky dragged his stuff back to his cramped cold-water flat and continued working. He was pouring all his money into paint and brushes and boards. He was literally living on peanuts, consuming a packet a day. Finally, it all became too much. "I collapsed," Shapinsky recalls. "One day, I couldn't get out of bed in the morning. I couldn't move. It was terrible. If my brother hadn't come a few days later to see what had become of me, I don't know, I might have . . . Anyway, he came, he saw my condition and bundled me up and brought me back out to Long Island for the summer, where they pampered me, fattened me up, let me lie out on the beach, and I slowly recovered."

His brother, however, forgot to pay the rent on the cold-water flat—the twelve dollars and fifty cents a month. It may be that it didn't even occur to him. In the first of a series of terrible setbacks for Shapinsky, the landlord simply came up and cleared out the apartment, tossing several years' worth of work into the garbage. Although almost everything was lost, including all the large paintings, a few smaller pieces were salvaged at the last minute.

(Some of them would eventually be slated for inclusion in the Mayor show.) Shapinsky was devastated by the news.

Had Akumal been with us the afternoon that Shapinsky related this sad incident, he might (good student of karma that he is) have noted the date—the summer of 1949. Karma metes out mysterious compensations, uncanny reincarnations: somewhere on the other side of the globe, Akumal Ramachander was being born.

Shapinsky returned to the city around Christmastime of 1949 to take a job as extra help at the post office. Around New Year's, he learned that Motherwell had founded a school in his own studio, on Fourth Avenue, as a sort of follow-up to Subjects of the Artist, and Shapinsky began attending the sessions. He returned to full strength, poured himself into the work once again. At the end of the year, Motherwell selected one of Shapinsky's paintings for an invitational show at the Kootz Gallery.

Samuel Kootz had five artists in his stable and eight slots on his annual calendar, so he was always having to come up with creative ways to fill the extra spaces while not unduly favoring any one or three particular artists. That December of 1950, he invited the five artists themselves—Baziotes, Hare, Hans Hofmann, Gottlieb, and Motherwell—to select three artists each for a "Fifteen Unknowns" show. During one of my visits, Shapinsky foraged from deep within a kitchen drawer a flyer for the show. Most of the unknowns have returned to oblivion, but there are some surprises. Hofmann selected John Grillo. Gottlieb included Clement Greenberg, in his sometime role as a painter, and Helen Frankenthaler—a year before her first one-woman show, at Tibor de Nagy. The Kootz invitational received some good notices, and Shapinsky was among those singled out. In the *Times*, for example, Stuart Preston cited his "deft profiling of creamy shapes, waving like flames in a crossbreeze."

As second-generation Abstract Expressionists go, Shapinsky had staked his claim early. Indeed, in a sense he could have been conceived of as a transitional figure, too young for the first generation but so thoroughly identified with it in terms of ambitions and conceptions of the activity of painting as to be more of a precursor than a simple member of the second generation. But all this speculation soon proved moot. A few months before the opening of the Kootz show came the outbreak of hostilities in Korea, and Shapinsky was drafted. He got a night's leave to attend the opening but had to be back in bar-

racks the next morning. He wasn't sent abroad—in fact, he logged most of his hitch in Fort Dix, New Jersey—but he was effectively sequestered from the scene just as it was beginning to catch fire, or, rather, at the very moment that the torch was being passed from the first generation to the second. Thus, he missed the celebrated Ninth Street Exhibition, in 1951, in which several charter members of the Artists Club invited sixty-one artists to install one work each in an empty storefront in the Village. According to Irving Sandler, one of the period's premier chroniclers, in his book *The New York School*, the show included at least thirteen of the younger artists—Frankenthaler, Robert Goodnough, Grace Hartigan, Alfred Leslie, Joan Mitchell, and Milton Resnick among them. It is not inconceivable that Shapinsky would have been included had he been around. He might, at any rate, have been able to capitalize on his Kootz exposure, to insure that he would be part of the transition.

Instead, he was discharged, in the summer of 1952, into what he experienced as a radically altered environment. "The whole spirit had changed," he says, with something between a shudder and a sigh. "Money was beginning to flow in, and it was ruining everything. Politics was setting in. Everything was breaking apart. It was all becoming who you know, cliques, kowtowing, bootlicking. There was a mad scramble for galleries. It just got worse and worse." And Shapinsky began to fall inexorably away. "I couldn't stand all those cocktail parties," he recalls. He and Kate became more and more reclusive. "I tried to do my own work as quietly as possible, enjoy my family, my friends, visit the museums, study the Masters, return to my studio, paint." He'd show once in a long while—a single painting or two in an obscure exhibition at some out-of-the-way gallery. But these shows were marginal, peripheral, in a scene, on an island, where centrality was everything. He looked on, aghast, as the art scene was transmogrified. "Painting became a business," he says. "The painters became like factories. Their product was the new—something new for each season. Most of it nowadays is like newspaper headlines. That's what the galleries seem to want—it creates a big splash, but then it doesn't mean anything. The work can be quite competent technically, but it's dead. You don't feel the artist's hand. It's all superficial. It's launching bandwagons and chasing after them. Nobody is concerned about *feeling* anymore, about the journey."

One day, he finally took me into his little bedroom studio to show me some paintings. "Look," he said. "*Feeling is everything.*" One after another, he

pulled out works from 1946, 1958, 1963, 1982, 1970, 1948. . . . It was amazing: isolated, utterly alone, working for no one but himself, unconcerned about wider acceptance, not kowtowing to any gallery or potential moneyed patrons, Shapinsky had almost managed to make time stand still. The paintings *were* quite lovely. The ones he showed me (like all those slated for the Mayor Gallery show) were small, and many of them were on paper. Shapinsky explained that he would have loved to work on large canvases, but he could never afford the canvas or the paint; he never had the room to stretch any large canvases, or the space to store the resultant paintings. So he condensed his art, working in what the Abstract Expressionists would have considered a miniature format—eighteen by twenty-four inches. Remarkably, however, he seemed able to compress a great deal of energy into those limited spaces, so that there is occasionally an almost epic quality to the small images—or, rather, they start out lyric and seem to hover, to modulate toward the epic.

But the main thing about them was this sense of their being frozen in time. Perhaps, ironically, one of the functions of occasional gallery shows for an artist is to force him or her to focus and summarize and then to push forward to the next thing. Shapinsky never seemed to feel that pressure. In 1953, Robert Rauschenberg was erasing his de Kooning. Color-field painting, Pop Art, Op Art, Minimalism—they would all now come and go, and none of them would be in any way reflected in Shapinsky's stubborn, obliviously resolute passion. For almost forty years, Shapinsky would continue to do 1946–50 New York Abstract Expressionist painting. And Shapinsky's words, as he now spoke about his paintings, also seemed to come barreling out of some sort of time warp. "It's all a struggle with fluidity and spontaneity," he told me that day. "It's a journey—when you start, you don't know where it will take you, how it will all come out, how *you* will come out." *Now* he was becoming animated. "Sometimes I just start by throwing the brush at the blank surface. Then I try to respond to that mark. I enter into a dialogue with the surface. Then I try to deal with the surface tension. With enough tension, the piece comes alive, it begins to breathe, it swells, there's a fullness. I try to *puncture* the surface, to go deep inside, to build up the layers. I love to listen to music as I work—Mahler, for example, Bach, jazz—and, as they say, painting becomes a sort of visual music. It's abstract, but there's a sense of the

world in it. I love to take walks in the park, see the way the branches intersect and sway, the swooping of the birds. I love looking down on the city from rooftops—the clean verticals and horizontals, the movement of traffic. All that gets filtered in. But, above all, it's *feeling*—feeling that is then carefully composed and constructed and integrated. Feeling that breaks apart and then comes together again. It's feeling, and a human touch, an existential trace."

Time passed. Shapinsky became a father. He held various jobs. For a while, he was an antiquarian bookseller. He taught art to children, ran an arts workshop with his dancer wife. He became a neighborhood activist, organizing the Sixth Street Block Association in the East Village. He continued to paint. And his health broke again. A back injury from his army days gave him chronic problems. He contracted a severe, lingering case of pneumonia, was bedridden literally for years during the late sixties and early seventies. He suffered from hypoglycemia. For a period, he almost went blind: much of his work from the seventies is even more miniature than usual—intricate murals on sheafs of eight-and-a-half-by-eleven-inch paper. He trembled. It was thought that he might have multiple sclerosis. Perhaps it was partly a physical manifestation of his frustration and despair at having been left behind as the train pulled out of the station—that, and the perversity of somehow being condemned to continue living right there inside the station amid all the noise and bustle of the new trains as they came and left: to wait there, eternally cordoned off.

The family was poor. One evening, David Shapinsky recounted for me over the phone how for long stretches he and his parents had lived below the poverty line. "It wasn't the lack of material comforts," he said, "but, rather, the recurrent anxiety that come the end of the month there wouldn't be enough money to pay the rent and we might end up being thrown out on the street."

"I learned very early that sometimes you buy things just to make yourself feel better—and they don't," Kate told me one day. "Things you can buy usually don't matter." Kate began knitting sweaters and sewing patchwork-quilt vests and jackets, and selling her wares to Henri Bendel. What with one thing and another, they got by. And Shapinsky continued to paint. Time passed—everywhere but in his painting world, where it seemed to stay 1948. He'd become like one of those tribes secreted deep in the jungle by the headwaters of some lush, narrow New Guinean stream, a little cusp of the world

where the Stone Age still holds sway—and then, one day, over the godfor-saken, fog-enshrouded pass, in stumbled Akumal.

In the ensuing weeks, I showed a set of transparencies of the twenty-two paintings selected for the Mayor Gallery show to various dealers around New York. A consensus quickly formed among those dealers. There was no question but that Shapinsky could paint. "This is the work of a real painter," André Emmerich, of the André Emmerich Gallery, told me. "Technically, these are very proficient, smart paintings. This one here"—he picked out the transparency of *Poe*, a black-and-white piece from 1949–50—"is excellent." Other dealers singled out other paintings as "charming," "beautiful," or "strong." "Really a very fine painter," I heard over and over. But almost everyone followed up such observations with a string of misgivings. For one thing, the paintings were too small. "You simply couldn't work this small and be a true Abstract Expressionist," Emmerich declared. "The whole point about Abstract Expressionism was that sense of Action painting, and that required scale." I started to point out Shapinsky's explanation for the small size of his works—the problem of storage, for example—but Emmerich wasn't buying that. "Canvases roll up," he said. "I could probably store all of Morris Louis's lifework in this little room." (The room *was* little, but, in fairness, it was still larger than Shapinsky's entire apartment.)

The most frequent recurring misgiving, however, was some variation on the theme that Shapinsky's lifework was very close, uncannily close—indeed, uncomfortably close—to that of Willem de Kooning. "It's funny," Emmerich commented. "Future art historians might well have been excused if they'd accidentally attributed these works to de Kooning. That wouldn't have surprised me at all." Sidney Janis, of the Sidney Janis Gallery, agreed—the works seemed enormously derivative. Over and over, dealers would reach for their de Kooning catalogues and track the parallel years. "Look," one said. "See, here de Kooning is doing that sort of thing six months before Shapinsky—and he's doing it better." Shapinsky faced something of a double bind with these comparisons, because on those occasions—and there were several—when it appeared that Shapinsky had anticipated de Kooning (some of his paintings from 1947, for example, displayed the loose, lazy, languid curves of the very late de Kooning; and one Shapinsky, dated 1955–56, seemed to radically simplify the complexities of prior work, indulging in

wide swaths of luminous, uninterrupted color, a full year before de Kooning was doing the same thing), the dealers uniformly challenged the accuracy of Shapinsky's dating, suggesting that he had probably got it wrong, if only accidentally. Since Shapinsky was judged derivative as his work went into the analysis, all the work *had* to be derivative by definition, and certain dates therefore *had* to be mistaken, since de Kooning, the man whom Shapinsky was ipso facto deriving everything from, hadn't yet reached that point. Q.E.D.

Irving Blum and his partner, Joseph Helman, of the Blum Helman Gallery, were the most blunt in their evaluation of Shapinsky's significance. "It's just too dicey!" Blum exclaimed. "The early paintings are versions of de Kooning and the late paintings are versions of the early paintings. There were dozens of guys like this. He's just another one of those close-but-no-cigar cases."

"Look," Helman said, pulling the current copy of the magazine *Flash Art* from a nearby shelf and flipping through the pages quickly. "Look at all these neo-Expressionist surrealists operating today. Dozens of painters with virtually identical imagery. Look, look, here, this one, this other one—a whole page of them here. Now, if one of these guys goes on and develops, if he keeps pushing, if he breaks through, if he can demonstrate his power and strength over and over again, if he can keep it up—well, then you're talking about someone worth considering. But by itself—nothing. You can go back and look through some issues of *Art News* from the late forties and early fifties, and I'm sure you'd find the same sort of things—dozens of Shapinskys. De Kooning had a lot of clones—he was an enormously influential figure, an overpowering presence; he exerted a tremendous force field, warping all sorts of careers around him—but *he* moved on. He changed over the years across a sustained career of dazzling inventiveness. Just because somebody was painting like him at one particular point in time doesn't make him his equal, not by a long shot."

I pointed out that they had both agreed that some of the Shapinskys were good paintings. Didn't that count for anything?

"You can't separate the issue of being derivative from the issue of being good," Helman replied. "They're deft, they're flashy, but . . ."

What about the European museum people and art writers who had vouched for the work?

"They never understood Abstract Expressionism in the first place," Blum said.

Helman agreed. "Most of the Europeans missed it when it was happening, and now they're misreading it in retrospect."

Blum asked me how much Mayor was going to be charging, and I told him I'd heard between fifteen and thirty thousand a painting, average around twenty-five.

"Look," Blum said. "That's big stakes. And this could all just be a bubble, hype feeding on itself. It can be smashed flatter than a pancake in an instant— and it may well be. These paintings will not bear the weight." Blum paused for a moment, and then continued, "The scene today is enormously protected, enormously serious: too much money is at stake."

Outside the office, as I left, the gallery walls were graced by a gorgeous selection of recent paintings by the thirty-three-year-old Donald Sultan—so recent, in fact, that you could smell some of the panels as they dried. Blum Helman had sold the show out before it had even opened, at sixty thousand dollars a pop. The whole question of art and money has become terribly vexed this past decade—we are living through a period of cultural inflation—but it seemed to me that some of these dealers were being a bit harsh. Given that a painting's true value bears almost no relation to its financial worth, its financial worth may just be whatever the market will bear. It had yet to be seen what the market would bear in Shapinsky's case. Hype, at any rate, is always the other gallery's publicity. As far as Shapinsky goes, as he nears the end of his career—in many ways a noble career, which has produced certain paintings of merit, of beauty—I couldn't see what was so terribly offensive about his finally being rewarded.

The questions of Shapinsky's relationship to de Kooning and of his true historical place in the transition between the early generations of Abstract Expressionism in New York were interesting ones in their own right, however, completely independent of any implications they might have for the market in Shapinsky's paintings. They were difficult questions to research, however, partly because there was virtually no history of exhibitions or critical commentary on Shapinsky's case to refer to. And now many of the principal witnesses were dead or unavailable for comment. De Kooning, in particular, has for many years maintained a policy of refusing to be interviewed.

I did reach William Baziotes's widow, Ethel. It turned out that she had barely met Shapinsky while Baziotes was alive, but she well recalls her husband's talking about his young colleague during the years before his death, in 1963. "The teachers and fellow artists liked him enormously," she recalls. "They felt his gifts were evident, so much so that Franz Kline gave him several works—and there is no higher praise a painter can give a fellow artist than that. They thought of him as a younger brother. They trusted him. They knew he would not confuse the issues or choose the easy way. Bill felt that Shapinsky had a grave mind. It had known many hells, he used to say—he seemed to need to fight alone, to be terribly singular. His dark, painful youth, Bill felt, had conditioned him to move obliquely. Bill felt that Shapinsky would take a sober course at great cost but that he would stay the course. He used to say that once in a while he had come upon a student like that, and that had made it all worthwhile."

I then called Robert Motherwell, at his home in Connecticut. I summed up the recent developments and asked him if he remembered Shapinsky.

"Oh, yes," he said, but hesitantly, seeming to reach far back. "Extraordinary, the way things like that return on you. Yes, yes. Harold Shapinsky: big horn glasses, very pale, thin." He paused. "There was no question with him that the talent and the dedication were real. There were a lot of students moving through those schools, and many of them were just passing through, but Shapinsky was clearly the real McCoy. However, the main thing I remember about him was how terribly intense he was—a combination of extreme intensity and shyness. He'd tremble; he'd quiver with all that intensity. It was too bad, because whereas that sort of temperament might have worked ten years earlier—many of those first-generation people were loners, they were into profound psychological and existential self-exploration—that just wasn't the way things were developing after 1950. By then, people were becoming looser, more optimistic, more sunny, more social."

Our conversation turned to how Shapinsky had fallen away. I mentioned his having been drafted.

"That's odd," Motherwell said. "He must have been registered with some other draft board than the one in Greenwich Village. The draft board in the Village, if they heard you were an artist they assumed you must be some sort of Communist—or, at any rate, you were manifestly unreliable—and they had no use for the likes of you in their army, so it meant an almost automatic

deferment." (I subsequently asked Shapinsky about this, and it was true: he had been registered in Brooklyn, at his mother's address.) Motherwell agreed that Shapinsky's forced absence from the scene couldn't have helped his career. "But he would probably have been temperamentally unsuited in any case," he said. "He was so wound up. He couldn't have been one of the boys; it would have been like asking Kafka to be one of the boys. That second generation, they loved to party. I can't imagine Shapinsky enjoying a party or talking for hours at a time on the phone. I was married to one of them, Helen Frankenthaler, for twelve years, and I used to marvel at how much time she and her fellow artists spent on the phone. That first generation—there wasn't a single phone person. No, I take that back. Barnett Newman used to love talking on the phone. But Shapinsky just never could have been made to fit into the way things developed through the fifties."

I also visited with Irving Sandler, the chronicler of the history of the New York art scene since the war, at his apartment, in New York University faculty housing. "In my own work, I have a zillion loose threads," he said, smiling, as I laid out the basic contours of my Shapinsky subject. "Graduate students are going to be picking them up for years." Sandler had never heard of Shapinsky but seemed delighted at the prospect of widening his horizon. "What I love about the Shapinsky story as you've told it to me is that it manages to fulfill two of the most prevalent art-world fantasies of the time," he said. "One of them we all used to talk about was the fantasy of the late discovery at the very end of a career, after years and years of unsung labor. And the other one was the fantasy of the lonely secret master, slaving away somewhere completely apart: that here all of us were, expecting Master to emerge from our midst—we were, after all, the center—but in fact he was patiently working off in some barn or up in some garret, far away from it all." Sandler, however, was less than overwhelmed by the transparencies I now began to show him. "They're good paintings," he said. "Some of them are very good. But they're de Kooning. There were a lot of artists like this, but this one is almost the most de Kooning–like of any of them." Sandler then spoke for a little while about de Kooning's impact on the second generation. He read me a passage from a recent monograph he had written on Al Held, about the way de Kooning had labored heroically to create a new language, one that the second generation could now take for granted, could simply pick up and *start making sentences with*. Shapinsky fitted in there somewhere. Sandler continued to riffle

through the transparencies, marveling at the dates. "His uniqueness is that he's still doing it. The conviction carries all the way through: the later ones are as fresh as the early ones. *He still believes it.*"

Weeks were passing quickly now, and the London opening was less than a month away. I went over to the Shapinskys' apartment once again. (They had ended up not joining the film crew on its transit to Bangalore to film Akumal in situ.) I wanted to get a clearer focus on Shapinsky's own sense of his relationship to de Kooning.

Shapinsky was in his subdued mode again, puffing on his cherry-scented tobacco. It was difficult to narrow in on the issue—or, rather, Shapinsky's statements remained calmly consistent with his earlier claim that he had seen virtually no de Kooning work before 1950 or so. "I knew we were working in the same general terrain," he explained. "People kept telling me so. So I guess I bent over backward not to see his work. One time, he and Noguchi came by the Subjects of the Artist, and they were walking around looking at some of the students' work when they came upon one of my canvases—I happened to be on the other side of the room at the moment—and they spent a long time talking about it very intently with each other. That kind of thing didn't happen very often; it was sort of embarrassing. Later, de Kooning would call down to me from the window of his studio, inviting me up, but I intentionally made excuses, because I didn't want to be worried about the overlap."

He paused, and then said, "No, I really don't see de Kooning's having been that big an influence. Gorky, perhaps, a bit more. And several of the Europeans, definitely—Cézanne, Kandinsky, Miró. And above all Picasso. We were all of us drawing on the same sources, but Picasso was paramount. Everything you tried to do, Picasso had already done. It drove some people crazy, and they tried to reject Picasso. But I thought he was fantastic, and he was most important."

I decided to leave things at that and asked him and Kate if they were getting excited about the coming weeks.

"Oh, yes," Shapinsky said, with about as little excitement as I suspect it's possible for a human being to muster. "It is all very gratifying." He was silent for a moment. "The work will be seen."

"I can't get over it myself," Kate said, with more than enough animation for both of them. "I find myself on the phone talking to London—me, Lon-

don!—and I can't believe this is really happening. At first, it was really scary—the prospect of life's becoming a little easier came as quite a shock. I have a rich fantasy life. I wrote whole novels in my head about what was going on, entire scenarios of calamities playing themselves out. But it looks as if everything is going to be all right."

I asked them how they'd imagined that things might go in the days before Akumal.

"I always had the feeling that something like this would occur sooner or later," Shapinsky said. "That the work would someday be seen."

Kate said, "I used to cry at night. I'd cry and pray to my grandfather, who was a minister. It was so unfair, so terrible to live with this man who was creating so much beauty, and not have anyone know about it. The worst came about a year ago. I heard about an old artist who died; all his lifework was just tossed out onto the street, stray people passing by were picking at it. . . . That really got to me. I prayed all the harder. Akumal was like the answer to my prayers. Seriously, I think he's an angel." She said that Akumal had at first refused to accept any reward for all his labors but that she and Harold had insisted, during his most recent trip, and he'd finally agreed to accept a percentage of whatever they would be realizing from Harold's art from now on.

We made arrangements to meet in London. (This was going to be their first trip to Europe.) "Yes," Shapinsky said in his monotone. "It should be a big event."

"He's not like this all the time," Kate confided, smiling lovingly over at him. "Sometimes, lately, he just starts dancing. Sometimes he turns the radio to a disco station and suddenly he's *dancing*."

I had just arrived at my London hotel and was emptying the contents of my bags into the drawers and closets, and absentmindedly listening to a television program called "The Antiques Road Show." It was apparently part of a series of such programs, and it essentially played out endless permutations on the same basic formula. Doughty plebeian matrons of one sort or another would bring in examples of antique bric-a-brac, describe how they'd happened to come by them ("Oh, it were up in me attic, sir, just lying about for years"), and the supercilious experts, dressed to the nines in the most distinguished Bond Street finery, would then lavish their silken expertise upon the

proffered objects—a tea set, a china bowl, a pewter jug, a dresser, a pocket watch—in ostentatious displays of virtuoso discernment. At first, I thought it was a Monty Python skit, but it was all in dead earnest—these were real people. The show generally proceeded as a sort of morality play: those who came on too confidently were obviously destined for a fall. One woman stood before a large early-nineteenth-century English landscape painting and smugly predicted that it was a Constable, offering as proof positive a letter of evaluation she'd procured from a putative expert named Thomas Keating. The television expert, however, was not impressed: he evaluated not only the painting but the prior expert's letter as well. "Really, very typical late Keating letter, this. Because he goes on to conclude it to be 'possibly a sketch by Constable' and in fact he gives you every reason to believe that it is an extremely important painting. Now, you know, Tom Keating during his lifetime was a likable rogue—really, frightfully sad about the heart attack and all—but I can tell you without the shadow of a doubt that this painting has nothing to do with John Constable. Were it a Constable—three million pounds plus. But no, madam, it's not a Constable. It's not an F. W. Watts. It's not even a John Paul. Maybe it's a Paul." The most humble of all the petitioners—a squat farm woman who could barely mumble her own name, so awestruck did she seem in the presence of her tuxedoed expert—had somehow managed to cart in an antique chest of drawers the size of a prize bull. The expert was beside himself: "This is the most important piece of furniture we've had on the 'Road Show,' and doubtless the most valuable. It's a commode— that's the official term, French term. French shape, English built. To begin with, note the exquisite construction, and how it's been covered over with the most extraordinary collection of veneers. How ever did you come by it?" The woman's tongue remained hopelessly tied. "This is—please, madam, pray, sit down here, yes—this is a piece of national, no of *international* stature. It was made between 1770 and 1785 by one of three or four people, maybe even by Pierre Langlois himself before he went back to France in 1773. Should you choose to put this commode up for sale—naturally very carefully, with a great deal of expert advice—you ought easily to realize forty thousand pounds, and soon it should be worth twice that." The farm woman started to cry.

The phone rang. "Welcome! I've got wonderful news. The *Observer* Sunday magazine is going to be featuring a full-color spread on the discovery with an

article by Salman Rushdie. In addition, *Time Out* will be running a major story by Tariq Ali. And that's not all. Chatto & Windus, the top-class publishers, will be bringing out a big illustrated autobiography of Shapinsky."

"Hi, Akumal," I said. "I didn't know Shapinsky could write."

"No, no. *I'm* to write it."

"Well, sounds as if you've been keeping yourself busy and productive."

"Yes, everybody's talking about the discovery. I'd come over to visit with you right now, except that I'm afraid I must head over to the airport. I've got three friends coming in from India for the opening. It will be quite an international affair. There will also be six friends from Holland, three from West Germany, and one from America."

A couple of days later, on May twenty-first, Shapinsky's sixtieth birthday (and not even seven months since Akumal phoned me that first morning), I set out for Mayor's. Cork Street is a short nub of a thoroughfare, teeming with fashionable art establishments. Leslie Waddington seems to own most of them: four or five bear his name, and this May they were showing, among other artists, Alexander Calder, Sam Francis, David Hockney, Henry Moore, and Claes Oldenburg. John Kasmin runs another—the British outpost of Knoedler—right next door to Mayor's, and his current fare consisted of recent ceramic-and-steel wall constructions by Frank Stella. When I got to Mayor's, its large street window announced, in big white painted letters, HAROLD SHAPINSKY. Inside, Mayor and his partner, Andrew Murray, were making subtle adjustments to the lighting, and waiting for Akumal and the Shapinskys, who were going to drop by and give their final approval. The front two rooms contained the twenty-two Shapinsky paintings, framed and displayed to full advantage. Beyond the second room, a large, vaultlike space opened out and down (with a corkscrew stairway curling to the floor below), and that space was filled with Rauschenbergs, Lichtensteins, Twomblys, Rosenquists, and Warhols—remaining evidence of the preceding show, "A Tribute to Leo Castelli." Before long, Akumal and the Shapinskys arrived. This was the first time the Shapinskys had seen the show, and Kate was thrilled. Harold took it all in calmly, puffing contemplatively on his pipe, admiring the work. "Very good painting, that one," he ventured, in his flat monotone, before moving on to the next. "This one, too—fine painting. Nice sense of swell."

Akumal came over to me, flushed with freshly building excitement. "I brought you advance copies of the texts of Salman's and Tariq's articles," he said. "And here." He reached over and pulled a catalogue of the show out of a bulging box. "You'll want to have a look at this, too. And, oh!" He riffled quickly through his folder. "Look at this." He produced another letter from Ronald Alley, this one handwritten on Tate Gallery stationery. "Now that I have actually seen some originals of Harold Shapinsky's work I feel I must congratulate you again on your discovery," Alley had written Akumal some weeks earlier. "Colour slides can be very misleading, and I had expected to find lyrical work with glowing colours. Instead his pictures turn out to be much more thickly painted—definitely paintings rather than drawings—and, above all, much tougher and more dramatic. One senses a real drama and tension, even anguish, behind the works, which though small are very highly charged." As if in harmony with my reading, Shapinsky, on the other side of the room, was commenting, "Nice tension in this one here. Very gratifying."

David Shapinsky now entered the gallery, a surprisingly young man with delicate features, blondish hair, wire-rim glasses, and, yes, a very kind face. Kate greeted him warmly, and Harold came over as well. I could see that in this slightly offbeat, mildly daft family, David plays the role of the steady anchor, the responsible center, and had probably been doing so for some time.

Akumal, Kate, Harold, and David presently set out to find a suit for Harold for the opening; he didn't seem to own one. After they'd left, James Mayor and I found ourselves talking about Akumal and his mania for letters. "Did he have you write them, too?" Mayor asked me. "Most extraordinary; every time we have a conversation, he seems to want me to write it up as a letter—on the spot. I've got a title for your piece. You should call it 'The Man of Few Words and the Man of Many Letters.'"

I left the gallery, intending to return to my hotel where I could look through the various texts Akumal had gathered for me in preparation for the evening's opening. But first I dropped in on the Stella exhibition next door. Kasmin was sitting the desk himself. "So," he asked, "what exactly is going on over there? Who is this Shapinsky fellow?" I gave him the quick capsule version: Shapinsky, forty years, Akumal, no interest in New York, the Tate, and now a big show. "How remarkable," Kasmin interjected. "That's the sort of thing that usually just happens to the widow. I've got a title for you. You should call your piece 'The Man Who Became His Own Widow.'"

Back at the hotel, I flipped through the various texts Akumal had gathered, beginning with the catalogue—a handsome, thirty-two-page booklet in square format with an elegant plain gray cover, twenty-two illustrations, four of them in color, a preface by Ronald Alley, and an extended essay by Marta Jakimowicz-Shah, a Polish artist-friend of Akumal's who now lives in India. Alley's preface was laudatory in a careful, measured sort of way, concluding, "I am delighted that Shapinsky is at last beginning to get the recognition that he greatly deserves. Such a shame he has had to wait so long. As for Akumal, he amazes me more and more. Speaking for myself, it has usually been my experience when I try to help someone that the outcome is total disaster; but at least this time everything seems to have come out right." Well, not quite everything, I soon realized. Ms. Jakimowicz-Shah's catalogue essay, anyway, was—well, problematic: absolutely without any critical distance as it celebrated Shapinsky's virtually unparalleled importance.

Rushdie's and Ali's articles likewise tended to go a bit overboard in proclaiming Shapinsky's significance, but neither of them claimed any expertise in art. Both were mainly enthralled by the saga of the discovery itself. The circumstance of the discovery, the character of Shapinsky's art, his reticent nature—all seemed to act as a sort of Rorschach inkblot, with each of the various writers projecting his own rich themes of signification upon the material. For example, Tariq Ali, a formidable political pamphleteer, discerned a moral in the Marxist tradition: "It is almost a truism these days to suggest that Art is big business. Late capitalism has completed the transformation of works of art into commodities. Most art galleries in the West function as ruthless business enterprises." Shapinsky in this version came off as a sort of martyr to the vagaries of art capitalism who through Akumal's fluky intervention may yet receive some measure of justice at the last moment. "One can safely assert," Ali concludes, "that there are many Shapinskys in different parts of the world (including Britain), most of whom will never be 'discovered'! It is only when the priorities of the existing social order are irreversibly altered that they will ever stand a chance."

Salman Rushdie, for his part, found a different moral in the story. He had recently been involved in a fairly heated exchange with, among others, Conor Cruise O'Brien, growing out of an article Rushdie published in the British literary quarterly *Granta*. In that article, entitled "Outside the Whale," he'd attacked the current spate of Raj fictions—the television serializations of

"The Far Pavilions" and "The Jewel in the Crown," and the films of *Gandhi* and *A Passage to India*—describing them as "only the latest in a very long line of fake portraits inflicted by the West on the East." It was not surprising, therefore, that the aspect of the Akumal-Shapinsky story that seemed to appeal most to Salman Rushdie was the theme of The Tables Turned. "For centuries now," he wrote in the last paragraph of his *Observer* piece, "it has been the fate of the peoples of the East to be 'discovered' by the West, with dramatic and usually unpleasant consequences. The story of Akumal and Shapinsky is one small instance in which the East has been able to repay the compliment, and with a happy ending, too."

Ronald Alley, in his catalogue preface, glancingly hinted at another Rorschach reading. He recounted how, early in the saga, Akumal had been taking his slides around to show to people. "He even telephoned about thirty galleries in New York and asked if he could bring the slides round, but not one said yes," Alley wrote. "I suppose they thought that the chances of a visiting Indian finding an unknown Abstract Expressionist painter in New York who was any good at all were so remote as to be not worth thinking about." His next paragraph began, "When I saw the slides I was amazed," and from the silent interstice between those two sentences welled up the theme of The Smug, Closed, and Self-Satisfied New York Art Scene, with its subtheme of Europe Still Open and Curious. Ironically, this theme received its fullest exposition in Rushdie's piece, his rage at the smugness of the Empire notwithstanding. "There has been a certain amount of gleeful hand-rubbing going on, because the Shapinsky case reflects so badly on the New York art scene," he reported. "New York has been ruling the roost for so long that this piece of European revenge must taste sweet indeed."

The shopping expedition had been a success: Shapinsky was decked out in a smart new suit when I finally caught sight of him in the midst of the throng at the Mayor opening—a debonair gray flannel outfit with sleek, fresh creases tapering down to a pair of blue canvas deck shoes. The cherry aroma from his pipe wafted about the assembly throughout the evening, which Shapinsky spent quietly enduring the sometimes effusive adulation of his new admirers. In the face of this onslaught, his composure attained almost epic proportions. As for Kate, she was wearing one of her patchwork vests, a lovely medley of black and white rectangles with an occasional highlight of bright, bright

red. Toward the end of the evening, when the crowd had thinned, she pulled out a ball of wool and resumed her knitting. All the careful work that Mayor and Murray had put into modulating the lighting on the paintings went more or less unnoticed; in fact, this was one of those openings so crowded that the paintings themselves are virtually unseeable. In any case, this particular evening the lighting was drowned out by the roving television kliegs of the crew from Bandung Productions, capturing a few last shots for their documentary, which would be broadcast in a week.

"This is really more of a literary crowd than an art one," one of the guests told me. "But, then again, there really isn't much of an art scene here in London. The English like to look at words, not pictures."

"The whole thing is quite romantic in a shaggy-dog sort of way," I overheard one woman saying. "Aladdin's lamp and that sort of thing."

"But where has this fellow Shapinsky *been?*" her companion replied. "It all reminds me of those blind white fish swimming about deep in those underground caverns in Kentucky or wherever it is they do all that."

"Yes, look at him! He even *looks* like Rip Van Winkle, newly emerged from his sleep, his eyes still blinking in the glaring daylight."

"The Japanese soldier on that island outpost who's only just found out the war is over—say, what?"

At one point, I met Ronald Alley, who turned out to be a tall man in his late fifties, with a gentle, dignified bearing. "Originally," he recalled for me, "I went downstairs that morning simply to try and rescue my colleague from the siege of what she was describing to me as a very persistent Indian caller. I mean, you get people turning up like that from time to time, and I do try to go down and see them whenever I can, partly out of courtesy but partly in the hope that something like this might happen. It almost never does, but this"—he included the whole thronged room in his gesture—"sort of justifies the whole enterprise, doesn't it?"

For me, the opening provided an occasion to speak with several Indians who were able to offer me a much deeper understanding of Akumal's passion. (That passion appeared all the more remarkable to me when I learned, as I did in passing, that Akumal was suddenly deep in debt again, pending the eventual success of the show, because he had paid for part of the travel fares and lodging for several members of his Indian, Dutch, German, and American contingents.) Up to that evening, I'd seen Akumal's quest as by turns comic,

resourceful, vaguely frenzied, but always inspired. Through these new conversations, I began to get a sense of some of the darker imperatives underlying his intensity. One of his group from Bangalore, a beautiful woman draped in a luminous blue-and-green sari, noted that Akumal had always been like this, that it was sometimes exhausting to be with him for more than fifteen minutes at a stretch, but that to understand him "one has to realize how stultifying, for example, is his daily regimen at the school where he teaches, as is the case in most Indian academic settings." She continued, "You also must try to imagine how incredibly hard it is in India for someone from the lower middle class just to survive, let alone rise. I think Akumal derives a lot of his energy from this being betwixt and between."

A few moments later, Salman Rushdie amplified on this theme. "I think with Akumal there is a sort of desperation in part of his makeup," he said. "To describe him as a teacher of English at an agricultural college is gravely to diminish him—but that is his status in Bangalore. It is a terrible thing when someone's picture of himself does not coincide with the world's. You have to realize that the gulf between the classes is much greater in India, and for Akumal to have pulled himself up by his own bootstraps, as he has done, has all along required the continuous projection of the kind of frenetic energy he's now been demonstrating in this affair."

I asked Rushdie how Akumal had got access to him in the first place.

"Well, I was in Bangalore briefly during a lecture tour a few years ago," Rushdie said. "My hosts had escorted me to my hotel and had just left the room when there was an immediate knocking on the door. I figured that it was my hosts returning with one last bit of instruction, or something; when I opened the door, I was instead confronted by the hugest garland of flowers I'd ever seen, deep inside which, barely visible, stood Akumal. He barged into the room in this overwhelming, unstoppable frenzy of vast smiles and flashing eyes, proclaiming that he was my 'Number one fan in Bangalore,' and describing how he'd been pestering the editors of all the local papers for weeks, demanding that they include features and supplements on my coming visit, so that now, here, this was the result—whereupon he thrust a bunch of newspapers at me, all with big photographs and long stories. It was a unique and fairly winning sort of approach. I would then see him occasionally on his visits to Europe, although I must say I was a bit incredulous when he launched into this story about his discovery of an American painter. I mean, Akumal

sometimes strikes one as a bit of an operator. But it's impossible not to warm to his evident enthusiasm for life, his disarming openness, and his obviously genuine devotion to the arts. And he's pulled it off. Well, I hope that maybe this success will bring him a measure of peace."

A few minutes later, I was talking with Tariq Ali, an expansive and friendly man, with none of the archness of his occasionally polemical prose. "When Akumal first told Salman the story about Shapinsky, Salman says, he thought Akumal was making this artist up," Ali reported. "Well, when Salman subsequently told me about Akumal, I thought *he* was making *Akumal* up—I mean, I figured he'd gone a bit over the top. Akumal sounded so much like a character in one of his own fictions. But I eventually saw the slides and met the man. It was all true, and the story seemed a natural for Bandung."

We watched for a few minutes as Akumal buzzed about the room, bringing his contingents over to meet James Mayor or Ronald Alley or Salman Rushdie. "The thing about India," Ali continued, "is that this synthesis of almost two hundred years of British rule and native tradition means that there are a lot of people like Akumal—people with this very wide range of worldly, cosmopolitan interests who are condemned to live fairly narrow, constricted, provincial lives. I think part of his nervous energy comes from this being between classes, between cultures. It was a very moving experience going to Bangalore with the film crew to shoot that part of the documentary. People would come up to us and ask what we were doing. We'd tell the story, and they'd be quite dumbfounded. 'Are you serious?' they would ask. 'All this is happening because of our Akumal?' Or his students in the English class: 'Our Professor Ramachander has accomplished this?' I mean, Bangalore is a large and growing city, but in many ways it's like a Chekhovian small town, with Akumal as the village eccentric, the character from the local coffeehouse scene who suddenly makes good in the world. I mean, he's been doing this sort of thing all along in Bangalore, but everybody there is just amazed by the *scale* this time around."

Akumal had gone over to talk with Shapinsky. "A character from Naipaul meets a character from Bellow," Ali said.

On the evening the Shapinsky show was opening at the Mayor Gallery, a couple of miles away, at the Aldwych Theatre, Paul Eddington was starring in a revival of Tom Stoppard's metaphysical farce *Jumpers*. About halfway

through the first act, Eddington, playing the role of a second-rate philosophy professor, delivers himself of the following contention: "Of the five proofs of God's existence put forward by St. Thomas Aquinas, three depended on the simple idea that if an apparently endless line of dominoes is knocking itself over one by one then somewhere there is a domino which was *nudged*." It occurred to me on several occasions during the next few days, as I kept returning for visits to a teeming Mayor Gallery, that in the case of Akumal's discovery of Shapinsky *two* lines of dominoes had needed to be nudged. For this was a story of how the lifelines of two individuals—marginal, utterly peripheral figures in their own societies—had, most improbably, managed to intersect, and then of the entirely improbable chain reaction that their intersection had subsequently set off. Actually, *three* coincidental factors were playing themselves out in this story: Akumal, Shapinsky, and the specific, highly peculiar (one might use the word "marginal" here as well) situation of the art world itself in 1985. To shift metaphors, Akumal and Shapinsky were like two stray crystals dropped into a flask: it was only because of the special conditions obtaining inside the flask—the specific momentary chemical dynamics of the supersaturated medium—that these two crystals were able to conjoin and blossom in such a surprising way. I am convinced that had Akumal met Shapinsky in 1975, say, or even 1980, his quest would have got nowhere.

There are two major reasons for this. The first involves a sea change that has been occurring in the dominant aesthetic sensibility over the last decade. Fifteen years ago, Minimalism was at its height. The past decade has seen a resurgence of interest in both figurative and expressive imagery. This has proved true both retrospectively (witness the sudden rediscovery of the late Picasso at the Guggenheim in 1984, a phase of the Master's career that had been almost entirely dismissed until just a couple of years before; and the considerable popularity of the de Kooning retrospective that was up at the Whitney at about the same time) and with regard to the most up-to-date in gallery fashions as well (witness the proliferation of Neo-Expressionist imagery throughout the world over the past five years). It is hardly surprising that the time was ripe for a comprehensive reconsideration of the second generation of Abstract Expressionists, and, indeed, precisely that was beginning to happen: Completely unbeknownst to Akumal during that afternoon in September 1984, when he was first being exposed to Shapinksy's work via those primitive slides in David Shapinsky's apartment, a major traveling exhibi-

tion entitled "Action/Precision" and featuring work from the fifties by six of the second-generation luminaries—Norman Bluhm, Michael Goldberg, Grace Hartigan, Al Held, Alfred Leslie, and Joan Mitchell—was touring the country. (The exhibition was organized by the Newport Harbor Art Museum.) The show's unusually lovely catalogue features several excellent essays touching on this sea change in aesthetic sensibility—a change that, of course, has had a bearing on Shapinsky's reception as well. Robert Rosenblum, for example, recalls what it was like in the mid-fifties, as the tide began pulling out for interest in that sort of work: "For me and many of my contemporaries, Rauschenberg, Johns, Stella swiftly became the Holy Trinity that led us from the Old Testament to the New, liberating us from the burden of living under the oppressive yoke of the coarse and sweaty rhetoric of Action painting, whose supreme deity, de Kooning, suddenly loomed large for many younger spectators and artists as a conservative force, a tyrant of past authority who demanded the instant embalming of any youthful, liberated spirit . . . a suffocating father image." Paul Schimmel notes how "the rich and diverse paintings of [the six artists in this show] were relegated to obscurity because they embraced and expanded upon the revolutions of their predecessors rather than reacting against them." Rosenblum talks about how at the time he thought he could "write off most of the work by the six artists in this show as irritating anachronisms, the product of loyal but growingly irrelevant satellites." This "temporary blackout of visibility" for the second-generation Abstract Expressionists lasted almost thirty years. But suddenly they were back. "And now how do they look?" Rosenblum asks. "For one thing, they look surprisingly up-to-date, riding in unexpectedly as ancestral figures behind the latest neo-Expressionist wave from Germany, Italy, or our own shores, a wave that once more permits us to wallow and frolic in the primordial ooze of oil paint. Seen as a whole, these pictures have the tonic quality of sheer sensuous enjoyment. . . . For anyone who was getting chilled by the laboratory calibrations of so much Minimal and Conceptual art and by the puritanical ban on color and palpable textures, this is the perfect antidote, a drunkenly deep breath of visual oxygen."

Akumal was thus going to find himself hawking just the right sort of elixir for 1985: the atmosphere in which he would be moving stood a good chance of welcoming Shapinsky's sort of oxygen. But the previous decade had also seen a second transformation in the art world—one that would have an even

more dramatic impact on Akumal's and Shapinsky's fortunes. This had to do with the changing character of the art market. Prices across the board, as I suggested earlier, had shot completely out of sight.

The explanation for this is extremely simple: the market for art had exploded in size—the number of players (collectors) in the game had multiplied many times over. The explanation for *that* is more complex. For one thing, the baby-boom generation had come of age, gone to college in record numbers, and been exposed to the humanities and, in particular, the contemporary arts; and now many of its members were becoming professionals and earning substantial incomes, with the result that collecting seemed worthwhile to them both as an avocation and, increasingly, as an investment. Sidney Janis recently observed, "More money is being spent these days because more money is being made." Around the same time, corporations began to enter the art market, building up vast company collections as exercises both in good public relations and in shrewd investment. There was a tremendous increase in the number of museums and a tremendous upsurge in museum attendance. According to a recent article in the Los Angeles *Times*, West Germany will witness the launching of thirty new museums by 1990; another article in *Progressive Architecture* cites similar figures for the United States. Japan is involved in a parallel frenzy. Each of these new museum projects features dozens of empty walls, a board of trustees, and a carefully tended hive of supporting collectors. The infrastructure of art commerce—the network of galleries, art journals, and auction houses—has developed great sophistication, including extremely supple engines of publicity. Literally tens, and perhaps hundreds, of thousands of potential consumers are being funneled into the system. At recent contemporary-art auctions of the sort that just five years ago were being attended by only a few hundred collectors, well over a thousand people are jammed into auditoriums filled to standing-room-only capacity—and that's not even counting many of the highest bidders who choose to avoid the crush by phoning in their entries.

A friend of mine, the director of one of Europe's finest small museums, recently told me, "There's simply not enough work of superior quality anymore to go around—work, that is, by the *grands maîtres*—so the prices, of course, go way up, and prices for the next layer of artists, the *petits maîtres*, rise up in turn, to answer the demand. Paintings by artists I had barely even heard of until a few months before are going for fifty thousand dollars at auction."

This situation was recently encapsulated in a succinct formula by the Paris-based art critic Souren Melikian. In an article entitled "The Ten-Percent Law," which appeared in *Art & Auction*, he wrote, "Over the last twelve months a new law has been verified with increasing frequency in the Impressionist and Modern masters field. Artists regarded rightly or (not in-frequently) wrongly as second fiddles to famous artists are worth one-tenth of those from whom they supposedly took their cue." This assertion might at first appear to knock the wind out of any enthusiasms the *petits maîtres* could have been expected to arouse; but, on second glance, when one recognizes that individual works by *grands maîtres* are now selling for many millions of dollars, ten percent looms back up as a figure worth reckoning with, or for. Melikian cited several examples in his article. A work by Charles Angrand (1854–1910), a neo-Impressionist artist who "greatly admired van Gogh, who returned the compliment," recently sold for two hundred thousand dol-lars—one-tenth of what a van Gogh with a similar composition would fetch. This ratio also obtains between the works of Roger de La Fresnaye (1855–1925) and those of Braque, as it does between the works of Paul Sérusier (1863–1927) and those of Gauguin.

Lucy Havelock-Allan, the director of contemporary art at Sotheby's auc-tion house in New York, recently confirmed for me that a similar trend was beginning to be noticeable in the contemporary market—though not yet at quite the same percentage rate. She noted that artists like Esteban Vícente, Conrad Marca-Relli, and Joan Mitchell are all getting personal record prices for their works these days. "One reason people are looking at works by artists like these is that they can't afford de Kooning, especially the de Kooning of the late forties and the fifties, and they know they never will be able to," she explained. "Theodoros Stamos, for example, languished at around twenty thousand dollars for years, then last year a painting of his sold for forty thou-sand, and this year we saw a fine one go for over ninety thousand—this for a work that ten years ago would have been lucky to bring five thousand."

Almost in passing, Melikian includes the interesting observation that the ten-percent law "has nothing to do with beauty, as non-specialists would call it, or 'quality,' as the sophisticated professionals like to put it." He cites the example of a "stunning" 1892 landscape by Maurice Denis (1870–1943) that recently sold for $25,400, or roughly "one tenth of any Neo-Impressionist painting of similar size, even of third-rate quality, by Monet,

of which the great man committed more than a few." Melikian concluded, "In art-market thinking, there is no such thing as a masterpiece by a painter who is not currently dubbed a great master."

This last proviso would not have bothered James Mayor, if he read the article. With the price of de Koonings what it had come to be, he still had a lot of room to maneuver. I spoke earlier of the Rorschach responses that Shapinsky's story seemed to summon. To these must be added Mayor's own calculations. Mayor may well have been—indeed, no doubt he *was*—authentically taken with Shapinsky's work. But he must also have realized that if he could just get Shapinsky included in the lists of the *petits maîtres* working in de Kooning's wake, his prices would have a vast horizon. This was especially the case in Europe, for when Europeans began collecting American art in a serious fashion, in the sixties, they initially went after Warhol, Oldenburg, Stella, Rauschenberg, and Johns, and later, Pollock, but not so much after de Kooning, because, ironically, they saw him more as a transitional European figure, and *Americans* were what they wanted. By the time they realized their mistake, de Kooning's prices were out of reach for all but the wealthiest among them. Collectors with a speculative turn of mind would realize this, too: as long as the current bubble in *all* art prices lasted (and there was no particular reason to believe that it would burst anytime soon), and assuming Mayor was going to be successful in establishing Shapinsky's status as a second-generation Abstract Expressionist, Shapinsky's paintings at twenty thousand dollars each might prove a good investment. As Ronald Alley explained to me while we huddled together at the opening, "There's a tremendous interest in Abstract Expressionism now, and the prices of the famous names have gone straight through the ceiling. Here's a chap who's been producing work of enormous quality, and his prices are starting from scratch. I mean, it seems to me it's a dealer's dream, and a collector's dream."

I wasn't the least bit surprised, therefore, a few days later (I'd returned to New York in the meantime) to be awakened—at 8:00 A.M.—by a phone call from Akumal telling me, "Wonderful news! The show has already sold completely out." The review in the London *Times* by the redoubtable John Russell Taylor had been a rave. ("An extremely good and original abstract expressionist . . . his forms have an extraordinary interior energy . . . exquisitely subtle harmonies.") A few days afterward, however, the Shapinsky juggernaut had re-

ceived a bit of a jolt when the *Guardian* published a scathing review by its critic, Waldemar Januszczak, not so much on Shapinsky (whose paintings apparently left the critic fairly unmoved either way) as on Akumal and Tariq Ali and Salman Rushdie, and all their hype. All three of them immediately dispatched Letters to the Editor, and all three letters were published two days later, *along with a cartoon.* "It didn't really bother us," Akumal told me. "I was a little surprised, the fellow being of Polish stock and all, but even the Poles once in a while . . . And, anyway, it just doubled the ratings for the documentary on Channel 4 the next evening. The folks *there* were very pleased. And the BBC have invited the *Guardian* critic and Tariq to square off in a live televised debate next Sunday, and that should be interesting." The screening of the documentary had gone extremely well, and now Akumal was being stopped on the street, at bus stops, and so forth—especially by fellow Indians who were eager to congratulate him on his discovery.

I called up the gallery to see how things were going there. Andrew Murray answered the phone in the gallery's basement storeroom. "James and I are holed up down here, I'm afraid," he said. "It's the only place where there's any room. It's like a railway station up there—all chockablock. The limousines are queued up around the corner!"

Mayor picked up another extension. "There's a waiting list for Shapinsky! The last several purchases went to big world-class collectors, your household names. I've never seen anything like it. The press is all over Shapinsky. We had Greek television in here yesterday morning, Canadian national radio in the afternoon, the Jerusalem *Post,* two of the biggest German art periodicals. This morning, Shapinsky was being interviewed by a pair of Chinese reporters. Not Hong Kong—Peking!"

I asked them how Shapinsky was holding up under all this. "He's starting to talk," Murray reported. "It's bizarre—he's turned positively loquacious."

Mayor confirmed this improbable finding: "He seems to think he's back in the Waldorf Cafeteria or something."

The following week, I got another call from Akumal. "You'll never guess what happened to me." I didn't even try. "I met a man from California who'd read about the controversy in the *Guardian* and went to see the show. He'd just been over to the gallery and the paintings had bowled him over, and now he wants me to fly to Hollywood to meet a producer friend of his, so we can talk about the possibility of making a movie." Akumal seemed even more excited, however, by the fact that two of India's leading weekly magazines were

going to be doing major stories on the discovery. "And I have another important bit of news," he added. "Norbert Lynton was in the gallery again yesterday, and he inscribed a copy of his book, *The Story of Modern Art*. Listen to the inscription. I have it right here: 'All good wishes to Akumal, who is doing his best to force us all to rewrite our art histories.' So, you see, I think it's a good omen. I may yet win the second half of my bet with David." It occurred to me that whether or not Akumal succeeded in forcing Shapinsky into the *Encyclopædia Britannica*, he himself stood a good chance of transmigrating one of these days straight into the *Oxford English Dictionary*: "Akumal: *n*. A genie, a fairy godfather, a doer of good deeds, esp. with regard to artists who regard him as a sort of patron saint, *e.g.*, 'Marcel had been slaving away at his easel for years, all to no avail; he was beginning to wonder if he'd ever meet his *Akumal*.'"

"You know what the moral of the story is?" Akumal asked me. All the others had given me theirs. I wondered what Akumal's would be. "That sometimes the good can win," he said.

"Yeats, the poet I admire much more than Eliot—he wrote a poem called 'The Second Coming,' and two lines of that poem go, 'The best lack all conviction, while the worst are full of passionate intensity.' There is pure motive and there is impure motive. I see it as my mission to give the best some passionate intensity. And, you see, this is a story that celebrates the unity of the human race. Think about it: there are Dutchmen, Americans, Englishmen, Poles, Germans, Indians, Pakistanis—all united by a karma to bring a little good into this world. Don't you think it's wonderful? No matter what happens now, Harold will have a few years to paint in peace. He'll be having a big show at a gallery in Cologne—did I tell you? Fifteen paintings at increased prices, later this year—it's all arranged. But it doesn't matter anymore if not a single other one of his paintings sells, because now Harold and Kate will have a little comfort. They're even talking about moving here to England."

Akumal was silent for a moment, seeming to bask in the light of his good works. "With me, you see," he concluded, finally, "it was always *pure motive*."

POSTSCRIPT (1988)

Shortly after the events described in these pages, Akumal returned to India, to Bangalore, to his parents' home, where he subsided into a sixteen-hour-a-day sleeping depression. I can picture him there, the talk of his neighbor-

hood, children huddled in the shade outside the house gossiping about the guy inside who sleeps all day long and about the rumors of his earlier worldly adventures.

He slept for weeks on end, and then he roused himself, and a few months later my phone was ringing at 7:00 A.M. and it was of course Akumal, who had just arrived back in town—in fact, he was still at the airport.

"Gee, Akumal," I said groggily. "You must be suffering from jet lag."

"No," Akumal replied, laughing. "Are you kidding? Me? The *jet* has lag. I never get lag."

We arranged to meet a few days later at my office, and there he regaled me with a new saga, one that was barely more probable than the first. It turned out he'd made another discovery. He'd received dozens of calls and letters following the Shapinsky opening, he explained, young artists likewise eager to have themselves revealed to a thirsting world, but most of them he'd let slide. "This thing of discovering people is quite taxing," he explained. One inquiry, however, had for some reason held his attention (for several reasons, actually, all of which he rehearsed at length for me and none of which I can any longer remember). This was the plea of another son on behalf of his painter-father—in this case, a father who'd been dead for some years. Patrick Carr invited Akumal out to his mother's place to have a look at the paintings of his late father, David Carr.

Now, David Carr *had* been known in the British art world, but principally as a collector and an enthusiast—his own production (faux-naïf renditions of Irish peasants and fishmongers and more complex, neocubist studies of factory workers and their machines) had been virtually private. Akumal was thunderstruck ("completely floored") by these paintings, and he immediately set to work. By the time he returned to New York, he'd already managed to arrange for a major retrospective at the Mayor Gallery; the publication by the well-regarded firm of Quartet Books of a full-color, hardbound, coffee-table volume, with an introduction by Ronald Alley; and, of course, a full-length television documentary (this time with BBC-2 rather than Channel 4). All of these events have since come off flawlessly, and Carr's revival seems well assured.

The Shapinskys, for their part, did indeed prosper following the success of Harold's London show. They transposed themselves to England for about half a year but eventually returned to New York City, abandoning their East Side

garret for somewhat more commodious circumstances in the Chelsea district. Somewhat nonplussed by his sudden success, Shapinsky himself seemed to retreat for a time into the fabrication of dozens and presently hundreds of miniature paper-and-tinfoil sculptures—this mad progeny came to occupy virtually all the shelves and then all the floor space as well in his new apartment. After a while, though, Shapinsky returned to his painting, which he now seemed to tackle with renewed vigor and zest.

Akumal and James Mayor, however, were still having trouble cracking the New York City gallery scene. Most dealers remained dubious (the eerie stasis of Shapinsky's style, its proximity to de Kooning's, etc.), and not a few of them continued to resent the London provenance of this whole Shapinsky renaissance (or, rather, naissance).

Following his triumph with Carr, Akumal therefore decided that it was time to give his Shapinsky discovery another push. Here I get a little foggy as to the exact chronology (and chutzpahlogy), but somehow Akumal managed to befriend Kathy Ford, the wife of automobile tycoon Henry Ford II, and to enlist her support in the cause. At one point he was even talking about the possibility of having a Shapinsky show in the living room of her own Palm Beach, Florida, mansion—so that they could display Shapinsky's marvelous canvases directly to the potential buyers in that elite community, bypassing the hopelessly hidebound New York art scene altogether. As things actually developed, Shapinsky had a one-man show at Bruce Helander's Palm Beach gallery, which is how it came to pass that on a January 1987 evening, Akumal and Harold Shapinsky found themselves being celebrated at the gala opening of their new show by over eight hundred of the upper crustiest of *le tout Palm Beach*, including the Fords, Peter and Sandy Brant (owners of the White Birch Polo Farms and publisher of *Art in America*, respectively), and Hector and Susan Barrantes (the well-known Argentine polo player and his wife, the mother of Sarah Ferguson, the recently endowed Duchess of York). Another vision well worth conjuring.

By the time of the Helander show, Shapinsky canvases were fetching as much as $34,000 each—and once again the show proved a financial success (it had been half sold out before it even opened, partly on the strength of Mrs. Ford's contacts). The reviews were mixed to good, but the most remarkable of all was a rave by Kenworth Moffett, the former curator of contemporary art at the Boston Museum of Fine Arts, who now publishes a newsletter of his

own, entitled *Moffett's Artletter* ($150 for ten issues, artists half price). In discussing Shapinsky with his subscribers, Moffet went *way* out on a limb. He characterized the objection of most New York dealers, the similarity between Shapinsky's and de Kooning's work, as "beside the main point, which is that Shapinsky is better than de Kooning. I think if a show were hung with alternating pairs of the best pictures of Shapinsky and de Kooning, Shapinsky would win every time. He is simply a much more talented artist. His pictures have more movement and intensity. They have better color and drawing. They have more life." And then, further on: "Maybe Shapinsky's presence will help people finally see de Kooning's work for what it is. In any event, Shapinsky, despite his modesty, has been unusually good from the start and has been consistently good for forty years. He has known how to sustain his intensity. If de Kooning first invented the style, Shapinsky is the one who filled it up with feeling."

Mr. and Mrs. Murry Robinson, who purchased a Shapinsky from Helander, proceeded to donate it to the National Gallery of Art in Washington, D.C. On one of his subsequent visits to New York, Akumal handed me a copy of the letter with which the National Gallery's director, the redoubtable J. Carter Brown, accepted the gift:

> I am happy to report that at today's meeting, the Board of Trustees of the National Gallery of Art accepted with pleasure your gift of *Untitled*, 1948, by Harold Shapinsky.
>
> The story of the discovery of Shapinsky is fascinating and having now seen *Untitled*, I must say that the discovery is long overdue. In fact, this work will make an important addition to our twentieth-century holdings. The art of the Abstract Expressionists is a crucial strength of our collection, and Shapinsky's splendid painting will fit in exceedingly well.
>
> Thank you very much for your generous gift to the National Gallery. It is always a particular pleasure for us when collectors become involved with the Gallery, and I hope that in the coming months members of our curatorial staff can visit you either in Providence or in Palm Beach to view your collection and to discuss present and future projects.

To a skeptic this letter might reveal J. Carter Brown to be not only an erudite connoisseur but also a suave diplomat.

Helander now contacted his New York colleague Nathan Shippee, who

runs a gallery in the prestigious Fuller Building at the corner of Madison and Fifty-seventh. Shippee, like many who read my piece when it first ran in the *New Yorker* in December 1985, had imagined the whole story to be an elaborate fiction. He was now pleased to discover otherwise, and after seeing some slides and canvases, he scheduled a New York opening for Shapinsky at his gallery in the fall of 1988. Ironically (although Akumal would never begrudge the concept, he'd insist it had simply been fate, karma, all along), the opening will occur three stories directly below the room into which André Emmerich had earlier insisted to me that he'd have been able to fit Morris Louis's entire life production.

Having righted and relaunched the Shapinsky juggernaut, Akumal set himself to other tasks. One day, a few months later, he barged in on me at my office, bearing a medium-smallish white cube carton that came flying out of his arms as he entered the room, smashing against my filing cabinet and then rolling onto the floor. "Oh dear," he said, picking up the box, which he then proceeded to drop—indeed, almost to spike—all over again. After a few more elaborate stumbles and fumbles, Akumal triumphantly opened his little package: a package that turned out to contain in its hollow—otherwise utterly unprotected—a single, entirely undamaged, not even pockmarked, egg. I surmised that the egg must be hard-boiled. But Akumal proceeded to take a nearby coffee mug, crack the egg, and pour out its liquid (though completely scrambled) contents. "My newest discovery!" Akumal announced enthusiastically.

It turned out that Patrick Carr, the painter's son, was some sort of inventor in his own right, and this particular product of his laboratory, a virtually weightless ingeniously molded polystyrene-like packing box that could be mass-produced and sold in flats "so easy to assemble that any grandmother could do it," or so Akumal insisted, was going to "revolutionize the packaging industry." This was going to be Akumal's new project—this, and the career of that Polish graphic designer—Stasys Eidrigevicius—whose work Akumal had already been flogging when first we'd met. In fact, he was heading back to Warsaw to bring himself up to date on Eidrigevicius.

The next time he was back in New York, Akumal brought me up to date. He'd managed to secure a one-man show for Eidrigevicius in the very heart of New York's Soho, something I had never for a minute doubted he would. I asked him how things were going with the box. "Superbly!" Akumal ex-

ulted. As karma would have it, his friend Shippee, before turning to art deal-
ing, had been in the packaging business himself and retained all sorts of con-
tacts. "So we've now been able to show the box to the president of one of the
top companies in the country, and he was completely high on it, totally sold
out!"

If the box takes off, I commented to Akumal, he'd be able to retire. "Are
you kidding?" he said. "I'll be even more busy."

I've decided that "akumal" would never work as a noun. It is going to have
to be a verb.

ART'S FATHER,
VLADEK'S SON

.

A GOOD WAY to study the many possible furrowings of the human brow is by telling a succession of friends and strangers, as I've taken to doing lately, that the best book you've read in a long time is a comic-strip history of the Holocaust. Brows positively curdle, foreheads arch, faces blanch and stiffen as if to say, "If this is one of your jokes, it's not very funny." Only it's not one of my jokes—it's the truth. The book is *Maus* (published by Pantheon), and its author—the perpetrator of my perplex—is Art Spiegelman.

Actually, the fans of *Maus* have been following its development for some time in installment form. Each new episode has been tucked inside successive issues of *RAW*, the semiannual journal of avant-garde cartooning (THE GRAPHIX MAGAZINE OF ABSTRACT DEPRESSIONISM, as its cover once proclaimed) that Spiegelman and his wife, Françoise Mouly, have been editing and publishing out of their Soho loft, in New York City, since 1980. Jules Feiffer has described *Maus* as "a remarkable work, awesome in its conception and execution," and David Levine has characterized its effect on the reader as "on a par with Kafka" and its mastery of tone as "reminiscent of Balzac."

"A comic-strip history of the Holocaust" isn't quite right: such a characterization is begging for trouble—or for misunderstanding, anyway. This is

no Classics Illustrated/Cliffs Notes digest of the despicable schemings of
Hitler and Himmler and their whole nefarious crew. Hitler and Himmler
hardly appear at all. Rather, *Maus* is at once a novel, a documentary, a mem-
oir, an intimate retelling of the Holocaust story as it was experienced by a sin-
gle family—Spiegelman's own. Or rather, as it was experienced by Spiegel-
man's father, Vladek, who recounts the story to his son, Art, who was born in
1948, after the war was over, after everything was over, including the possi-
bility of any sort of normal upbringing. The conditions of survivorship skew
everything: Vladek's first son, a brother Art never knew, was an early victim
of the Final Solution; Vladek and his wife, Art's mother Anja, somehow sur-
vived their separate fates in concentration camps, emerging hollowed out and
cratered; years later, Anja would take her own life, just as Art was leaving the
nest. Art's relationship with his father is a continual torment, a mutual pur-
gatory of disappointment, guilt, and recrimination. This relationship is as
much the focus of Art's story as is his father's reminiscence. The elegant back
jacket of the Pantheon edition features a map of World War II Poland and,
inset, a street map of the Rego Park, Queens, neighborhood where that war
continued into the present in the mangled graspings and grapplings of father
and son. *Maus* is subtitled *A Survivor's Tale*, but the question of *which* survivor
is left to hover.

Maus is all this—and then again, it's just an animal story. For Spiegelman
has recast his tale in the eerily familiar visual language of the traditional
comic book—animals in human clothing and in a distinctly human environ-
ment—thereby playing off all our childhood associations and expectations.
Art, Vladek, Anja, Art's stepmother Mala, and all the other Jews are mice.
The Germans are cats, the Poles pigs, the Americans dogs. Spiegelman's
draftsmanship is clean and direct, his characterizations are charming and dis-
arming—the imagery leads us on, invitingly, reassuringly, until suddenly
the horrible story has us gripped and pinioned. Midway through, we hardly
notice how strange it is that we're having such strong reactions to these ani-
mal doings.

And then, midway through, it all stops: the volume is truncated in mid-
tale. Vladek and Anja's desperate progress from prosperity into the ghetto
and beyond, from one hiding hovel to the next, ends abruptly with their ar-
rival at Mauschwitz. To learn what happened to them there, how on earth
they survived—and whether or not this father and his son ever do achieve a
measure of reconciliation—we are invited to await a second volume.

The man greeting me at the entrance to the fourth-floor walk-up apartment in Soho looked far younger than his almost forty years. He also looked considerably more clean-cut and less threatening than the intense, long-haired, mustachioed, scrungy, Zappaesque character he had contrived as his own stand-in in some of the existentialist underground comic strips he'd produced during the seventies.

The apartment, too, was more spacious than I was expecting, and it was bustling. In fact, the Spiegelmans occupy the entire floor, which they've divided in two: the front half consists of the staging area for *RAW*, while the back half provides them with living quarters. After seeing me in, Spiegelman excused himself to go confer with Françoise, a strikingly lovely French woman with high cheekbones and a luxuriant overflow of wavy brown hair. The next issue of *RAW* was about to go to press, and Françoise was on her way out to consult with the printers. The production values of *RAW* are exceptionally high—"neurotically precious" is how R. Crumb, the legendary underground-comics master and an occasional contributor to the magazine, once described them to me.

Spiegelman and Mouly launched *RAW* with the twin intentions of raising the status of cartoon graphics to an art form and introducing an American audience to the sort of high-level comic-strip art that has thrived for many years in Europe and Japan. Mouly, as the publisher, is famous for the painstaking attention she lavishes on all technical aspects of the production process.

The two of them had a certain amount to discuss before she left, and they stood together for a few moments huddled over the proof sheets, chain-smoking filtered Camels. Meanwhile, several assistants sat hunched over flatbed tables, monkeying with galleys. The room was surrounded on all sides by bookshelves, which were sagging under the weight of the most extensive library of comic books and anthologies anyone could ever have imagined. After a while, Mouly took off, and Spiegelman invited me into the back half of his loft, the living quarters.

"The whole next issue is ready," Spiegelman confessed anxiously. "Everything's now waiting on me, because I still have to finish the next installment of *Maus*. And it's taking forever." He escorted me to the far back of the loft, to his Maushole, as he calls it, where a worktable was covered with a neat clutter. Notebooks bulging with transcripts and preliminary sketches were piled to one side; dozens of little packets of papers were scattered about on the other—each bundle representing the successive workings and reworkings of

a single panel. "Comics offer a very concentrated and efficient medium for telling a story," he said. "And in this case it's like trying to tell an epic novel in telegraph form. In a way, it's a lot more challenging than trying to simply tell a story. In a prose story, I could just write, 'Then they dragged my father through the gate and into the camp.' But here I have to live those words, to assimilate them, to turn them into finished business—so that I end up *seeing* them and am then able to convey that vision. Were there tufts of grass, ruts in the path, puddles in the ruts? How tall were the buildings, how many windows, any bars, any lights in the windows, any people? What time of day was it? What was the horizon like? Every panel requires that I interrogate my material like that over and over again. And it's terribly time-consuming.

"It's strange," he continues. "The parts of my father's story which I've finished drawing are clear to me. The parts I haven't gotten to yet are still a blur—even though I know the story, know the words. I've got everything blocked out in abstract, except the ending. In Part Two, the question of my father's veracity starts coming into play. Not so much whether he was telling the truth, but rather, just what had he actually lived through—what did he understand of what he experienced, what did he tell of what he understood, what did I understand of what he told, and what do I tell? The layers begin to multiply, like pane upon pane of glass.

"I still don't know how I'm going to end it," he said, pointing over at the notebooks. "I don't *see* most of it yet. I'm only just beginning to see Mauschwitz."

I asked him why he'd decided to publish the book version of *Maus* in its current truncated form.

"Funny you should ask," he replied. He suggested we go up on the roof, where he'd installed a rudimentary sun deck. We sat on some garden furniture and surveyed the Soho skyline, the tar-roof line. He lit up a Camel, took a deep drag, and resumed: "I'd never really had any intention of publishing the book version in two parts. But then, about a year ago, I read in an interview with Steven Spielberg that he was producing an animated feature film entitled *An American Tail*, involving a family of Jewish mice living in Russia a hundred years ago named the Mousekawitzes, who were being persecuted by Katsacks, and how eventually they fled to America for shelter. He was planning to have it out in time for the Statue of Liberty centennial celebrations.

"I was appalled, shattered," Spiegelman continued with a shudder. "For about a month I went into a frenzy. I'd spent my life on this, and now here, along was coming this Goliath, the most powerful man in Hollywood, just casually trampling everything underfoot. I dashed off a letter, which was returned, unopened. I went sleepless for nights on end, and then, when I finally did sleep, I began confusing our names in my dreams: Spiegelberg, Spielman. . . . I contacted lawyers. I mean, the similarities were so obvious, right down to the title—their *American Tale* simply being a more blatant, pandering-to-the-mob version of my *Survivor's Tale* subtitle. Their lawyers argued that the idea of anthropomorphizing mice wasn't unique to either of us, and they, of course, cited Mickey Mouse and other Disney creations. But no one was denying that—indeed, I'd self-consciously been playing off Disney all the while. If you wanted to get technical about it, the idea of anthropomorphizing animals goes all the way back to Aesop. No, what I was saying was that the specific use of mice to sympathetically portray Jews combined with the concept of cats as anti-Semitic oppressors in a story that compares life in the Old World of Europe with life in America *was* unique—and it was called *Maus: A Survivor's Tale.*

"I didn't want any money from them—I just wanted them to cease and desist. What made me so angry was that when *Maus* was eventually going to be completed, people were naturally going to see my version as a slightly psychotic recasting of Spielberg's idea instead of the way it was—Spielberg's being an utter domestication and trivialization of *Maus*. And then there was a further infuriating irony: theirs supposedly took place in 1886, and what with the Statue of Liberty tie-in, they were going to be swathing the story in all this mindless, fashionable, self-congratulatory patriotic fervor—whereas, if you were being true to the initial metaphor, in depicting the way things actually were in 1940, you would have had to strand my mice people off the coast of Cuba, *drowning*, because it is precisely the case that at that point, the time of their greatest need, mice people were being denied entry into the U.S."

Spiegelman started to calm down. His cigarette had gone out; he lit up another. "Well, anyway, it's over for the time being. My lawyers told me that while I had a very strong moral case, my legal one wasn't so hot. It'd be hard to prove anything one way or the other, certainly not enough to justify a prior injunction against release of the movie, which is the only thing I really

wanted. Some of my friends couldn't understand why I was getting so worked up. One editor told me 'Look, all the guy stole was your concept, and frankly, it's a terrible concept.' " (The redoubtable R. Crumb was likewise bemused by Spiegelman's desperate churnings. "He's such an egomaniac," Crumb told me, laughing. "I mean, who the hell cares? I've seen some of the previews for Spielberg's film. Those mice are cute." R. Crumb has the most devastatingly prurient way of pronouncing the word *cute*.)

Spiegelman may have been calming down, but he was still obsessing: "I mean, if Samuel Beckett had stolen the idea, I'd be depressed, but I'd be *impressed* as well. But Steven Spielberg! Oy! I just read where they've now licensed off the *doll rights* for the Mousekawitzes to Sears, and McDonald's is going to get the beverage-cup rights!"

So, Spiegelman continued, he decided that if he couldn't stop Spielberg, he might nevertheless beat him to the turnstiles, immediately publishing as much of the story as he'd already completed (he explained how all along he'd seen the arrival at Mauschwitz as the narrative's halfway point) and thereby at least establishing primacy. Pantheon was happy to go along, and Spielberg's production company obliged by running into difficulties and having to delay the film's release until around Thanksgiving. As Spiegelman observed, "It was actually a great idea. You see, in Europe there's a real tradition, in serious cartooning as well as in high literature, of multivolume projects—just think of that supreme mouse writer, Proust, and all the volumes he was able to generate from that initial whiff of Camembert!"

When Art Spiegelman was about ten years old, in 1958 in Rego Park, Queens, he fell one day while roller-skating with some friends, who then skated on without him. Whimpering, he walked home to his father, who was out in the yard doing some carpentry repairs. Vladek inquired why his Artie was crying, and when Art told him about the fall and his friends, Vladek stopped his sawing, looked down at his son and said gruffly, "Friends? Your *friends*? If you lock them together in a room with no food for a week, then you could see what it is, friends!"

Spiegelman places this incident as the first episode in the book version of *Maus*, and it serves as a sort of overture, an intimation of one of the book's principal themes. For, at one level, Artie was an all-American boy, roller-skating, out goofing with his gang. Back home, though, life was haunted, darkly freighted and overcharged with parental concern.

Actually, Artie had been born in Stockholm in 1948, three years after his parents' miraculous reunion at the end of their separate camp fates. Two years after Artie's birth, the family was finally permitted to immigrate to America. Back in the old country, in Poland between the wars, Vladek had been a wealthy man, or rather Anja's father had been a wealthy man, and Vladek had married into that wealth. Art seems to leave intentionally ambiguous (although here, as elsewhere in *Maus*, the ambiguity is of an almost crystalline precision) whether or not he thinks Vladek initially married Anja for her money and her station. At any rate, Vladek managed important aspects of her family's textile business and attained substantial financial security for himself, his wife, and their beloved baby son, Richieu—until the war, that is, when both the wealth and the beloved son were snatched away. In America, in New York, Vladek worked in the garment trade and later in the diamond district, but he never recaptured the security of his earlier life. Though the Spiegelmans were basically middle-class, they lived below their means. Raising his first son, Vladek had been a young father with a buoyant sense of his future. Raising his second son—his second "only child"—he was an old man, fretting over his insecure present when he wasn't fixated on his desolate past. Art's parents *were* old. There were really two generations separating them from this American boy; on top of that, they were old-world; and on top of that, they'd aged well beyond their years owing to their experiences during the war. As Artie grew into young adulthood in America of the sixties, he would be facing generation gaps compounded one upon another.

And yet, for all that, Art remembers his childhood as remarkably normal. "I really didn't encounter serious problems," he recalled that afternoon on his sun deck, "until I went away to college and was able to match my experiences against those of others. I mean, for instance, the fact that my parents used to wake up in the middle of the night screaming didn't seem especially strange to me. I suppose I thought everybody's parents did. Or the fact that in the Spiegelman household, the regular birthday gift for my mother, year in and year out, was some sort of wide bracelet, so that she could cover over the number tattooed on her forearm. Sometimes when neighbor kids would come over and ask her what that stuff on her arm was, she'd say it was a telephone number she was trying not to forget.

"No," he continued, "I was a pretty normal kid, except that I was reading a lot too much Kafka for a fourteen-year-old. I knew I'd grow up to be neurotic, the way today I know I'll soon be losing my hair." He brushed back a

thinning, brown wisp, further revealing his precipitously receding hairline. "It didn't, it doesn't bother me."

"By fourteen, too, I knew I'd be a cartoonist: I was obsessed with comics. I spent hours copying from comic books, especially the satirical ones, like *Mad* magazine, which was a terrific influence."

I asked Spiegelman whether any of that bothered his parents. "They encouraged me up to a point," he replied, "up to the point where it became clear that I was serious. A kind of panic set in as I turned fifteen and was still doing it. They were terribly upset because clearly there was no way one could make a living at cartooning, and my father especially was, perhaps understandably, obsessed about money. They wanted me to become a dentist. For them, dentist was halfway to doctor, I guess. And we'd have these long talks. They'd point out how if I became a dentist, I could always do the drawing on the side, whereas if I became a cartoonist, I couldn't very well pull people's teeth during my off hours. Their logic was impeccable, just irrelevant. I was hooked."

Young Spiegelman knew he wanted to be a cartoonist, but he wasn't sure what kind, so he tried everything. When he was twelve, he approached the editors of the Long Island *Post*, a local paper, seeking employment as a staff cartoonist. The *Post* ran a story about the incident, headlined, BUDDING ARTIST WANTS ATTENTION. When he was fifteen, he was in fact appointed staff cartoonist of the *Post*, an unpaid position. Meanwhile he commuted by subway to the mid-Manhattan campus of the High School of Art and Design, where he edited the school paper, hung out after (and sometimes during) school at the nearby offices of *Mad* magazine, and, inspired, began turning out his own cartoon digests, one called *Wild*, and another *Blasé*, which "was printed with a process even cheaper than mimeo." He contributed to a Cuban exile paper, and served a stint up in Harlem, disguised to the world as a hip black cartoonist ("Artie X").

In 1966, Art left home for Harper College, the experimental subcampus of the State University of New York at Binghamton, and there things began to come seriously unmoored. The underlying conflicts with his parents roiled to the surface now that he was no longer in their immediate presence. Furthermore, "Binghamton was one of the early capitals of psychedelics," he says, "and the drug culture definitely accelerated my decomposition beyond any containable point." His intensity became increasingly manic. He was living off campus, in a forest cabin. "And I made a strange discovery," he re-

calls. "I was just kind of holding court, people were coming out to visit, and I found that if I just said whatever came into my mind, the atmosphere would get incredibly charged—and if I kept it up, within half an hour, either my guests would run out, screaming, or else we'd approach this druglike high. It was like a primordial sensitivity session. And this was going on for days on end. I wasn't eating, I was laughing a lot, I was beginning to suffer from acute sleep deprivation. I was starting to experience these rampant delusions of grandeur. I was sure I was onto something, and sure enough, I was—a psychotic breakdown."

Eventually, they came to take him away (he informed the school shrink that the top of his head looked like a penis); he was dispatched by ambulance to a local mental ward (exaltedly he wailed in tune with the siren); they sedated him (it took three full-bore shots) and threw him into a padded cell. ("Waking up, my first thought was that I was God alone and that what I really needed to do now was invent me some people. . . . Later, I began screaming for a nurse, and when this guy came in, I said, no, I wanted a *nurse*. He said he was a nurse—I'd never heard of such a thing as a male nurse—and I said, 'Gee, how do you people reproduce here on this planet?' ") Gradually, they reeled him back in—or he reeled himself back in; they didn't seem to be of much help. One attendant, a conscientious objector doing alternative service, befriended him and advised him on how to get out. ("He told me to drink less water—they seemed to think I thought my brain was overheating or something—to play Ping-Pong, *lots* of Ping-Pong, and to blame it all on LSD, which was a category they could understand; all of which I did, and within a month I was released.")

He was released on two conditions: first, that he start seeing a psychotherapist on the outside, and second, that he go back to living with his parents. "Living at home was exactly the wrong prescription," Spiegelman said, "since it was home that was driving me crazy. I said this quite emphatically to the shrink one day, and he asked me, 'So why don't you move out?' I told him about the condition. And he said, 'You really think they're going to throw you back in if you don't follow their conditions?' I said, 'Gee, thanks,' and immediately left both home and psychotherapy.

"The wonderful thing about the whole episode, though, is that it cut off all expectations. I'd been locked in a life-and-death struggle with my parents. Anything short of the nut house would have left things insoluble. But

now I could venture out on my own terms. Over the years, I have developed a terrific confidence in my own subconscious."

Art was out of the house, but the tormented Spiegelman family drama did not subside, and a few months after his release, his mother committed suicide.

Spiegelman becomes quiet and measured when he talks about this period. "The way she did it, I was the one who was supposed to discover the body, only I was late coming by, as usual, so that by the time I arrived there was already this whole scene. . . . Was my commitment to the mental ward the cause of her suicide? No. Was there a relation? Sure. After the war, she'd invested her whole life in me. I was more like a confidant to her than a son. She couldn't handle the separation. I didn't want to hurt her, to hurt them. But I had to break free."

He's silent for a moment, then resumes: "But talk about repression. For a while I had no feelings whatsoever. People would ask me, and I'd just say that she was a suicide, period. Nothing. I moved out to California, submerged myself in the underground-comics scene, which was thriving out there, imagined myself unscathed. And then one day, four years later, it all suddenly came flooding back, all the memories resurging. I threw myself into seclusion for a month, and in the end I emerged with *Prisoner of the Hell Planet*."

That four-page strip, which first appeared in San Francisco as part of the *Short Order Comix* series in 1972, was an astonishment — one of the most lacerating breakthroughs yet in an extraordinarily active scene. The strip opens with a drawn hand holding an actual photograph portraying a swimsuit-clad middle-aged woman and her smiling T-shirted boy; the photo is captioned "Trojan Lake, N.Y., 1958" (the same year of the roller-skating incident with which *Maus* opens). In the next frame, the mustachioed narrator peers out, framed by a fierce spotlight and decked out in prison (or is it concentration-camp?) garb. "In 1968, my mother killed herself," the narrator declares simply. "She left no note."

There follow four pages of vertiginous, expressionist draftsmanship and writing—part Caligari, part Munch. The story of the suicide is recounted, and the strip concludes with the narrator locked away in a vast prison vault: "Well, Mom, if you're listening, congratulations! You've committed the perfect crime. . . . You put me here, shorted my circuits, cut my nerve endings, and crossed my wires. . . . You murdered me, Mommy, and you left

me here to take the rap." A voice bubble intrudes from out of frame: "Pipe down, Mac, some of us are trying to sleep."

A few months before *Hell Planet*, Spiegelman had composed an early version of *Maus*, a three-page rendition that he included as his contribution to an underground anthology called *Funny Aminals*. In that first version, the relationship between father and son is quieter, almost pastoral. The cozy Father Mouse is telling his little boy Mickey a bedtime story. It's an adorable, cuddly scene (there's a Mickey Mouse lamp on the bedside table)—only the story is ghastly. Several of the incidents that were to be amplified years later in the book-length version appear here in concentrated form. But by the strip's end—as Daddy and Mommy in the bedtime story are being herded into Mauschwitz—Daddy explains that that's all he can tell for now, he can tell no more, and Mickey has, in any case, already nodded off to sleep.

It's strange: Spiegelman's 1972 take on his parents—a warm, empathetic father and cruelly manipulative mother—was to undergo a complete reversal by the time he returned to these themes in the book version of *Maus*. As if to underscore this transformation, he contrived to include the entire *Hell Planet* strip within the body of the new *Maus*'s text, drawing on a true episode in which his father accidentally comes upon a copy of *Hell Planet* his son never intended for him to see.

The 1972 *Maus* and *Hell Planet* strips were representative of one channel in the distinctly bifurcated artistic program that Spiegelman was pursuing now that he'd launched his underground cartooning career. On the one hand, he was trying to push the comic-strip medium as far as he could in terms of wrenchingly confessional content. Simultaneously, although usually separately, he was testing the limits of the comic strip's formal requirements. In high deconstructionist style, he was questioning such things as how people read a strip; how many of the usual expectations one might subtract from a strip before it began to resemble an inchoate jumble of images on the page; whether that mattered. By 1977, he managed to unite examples of both his tendencies in a single anthology of his work, which he titled, with considerable punning cleverness, *Breakdowns* (besides its obvious confessional connotation, the word *breakdown* refers to the preliminary sketches that precede and block out a finished comic strip).

"*Breakdowns* came out as I was turning thirty," Spiegelman recalls, lighting up another cigarette, "and with some of the strips there, it was really like

I'd taken things, particularly the formal questions, pretty much to the limit. So I was faced with a dilemma, 'Now what?' And after all my experiments, it was as if I finally said, 'All right, I give up, comics are there to tell a *story*.' But what story? Drawing really comes hard to me. I sweat these things out—one or two panels a day, a page maybe a week. And I was damned if I was going to put in all that work for a few chuckles. I hesitated for a while, but finally I decided that I had to go back and confront the thing that in a way I'd known all along I'd eventually have to face—this presence that had been hanging over my family's life, Auschwitz and what it had done to us."

With the first installment of that second version of *Maus*, which appeared in the December 1980 issue of *RAW*, Mickey, the little pajama-clad mouse boy of the initial version, had grown up. He was now a chain-smoking, somewhat alienated, somewhat disheveled, urban cartoonist mouse named Art. His father, too, had aged, become more stooped and crotchety, and their relationship had become far more complicated. "I went out to see my father in Rego Park," says Art, the narrator mouse, introducing his tale. "I hadn't seen him in a long time—we weren't that close."

"After I'd left home to go to college," Art, the real-life cartoonist, recalls, lighting up another cigarette, "my father and I could hardly get together without fighting, a situation that only worsened after Anja's suicide. Vladek remarried, this time to a kind woman named Mala, another camp survivor who'd been a childhood friend of Anja's back in her old town of Sosnowiec, but it was a sorry mismatch, and that relationship too seemed to devolve into endless kvetching and bickering. It was a classic case of victims victimizing each other—and I couldn't stand being around. And yet now, if I was going to tell the story, I knew I'd have to start visiting my father again, to get him to tell me his tale one more time. I'd heard everything countless times before, but it had all been background noise, part of the ambient blur; precisely because I'd been subjected to all of it so often before, I could barely recall any of it. So now I asked him if he'd allow me to tape-record his stories, and he was willing. So I began heading back out to Rego Park.

"From the book," Spiegelman continues after a pause, "a reader might get the impression that the conversations depicted in the narrative were just one small part, a facet of my relationship with my father. In fact, however, they

were my relationship with my father. I was doing them *to have a relationship with my father*. Outside of them, we were still continually at loggerheads."

The Vladek portrayed in the present-tense sequences of *Maus* is petty, cheap, maddeningly manipulative, self-pitying, witheringly abusive to his second wife, neurotic as hell. But when he settles in and starts retelling his life story, you realize that, yes, precisely, he is a survivor of hell, a mangled and warped survivor. The present Vladek imbues his former self with life, but that former Vladek illuminates the present one as well. Spiegelman develops this theme overtly but then, too, in the subtlest details. At one point, for example, Vladek is recounting how when he was a Polish soldier in a Nazi POW camp, early on in the war, he and some fellow soldiers were billeted into a filthy stable, which they were ordered to render "spotlessly clean within an hour," a manifestly impossible task, the failure at which cost them their day's soup ration, "you lousy bastards." Suddenly Vladek interrupts his story and the scene shifts to the present, with Artie seated on the floor before his father, taking it all in. "But look, Artie, what you do!" Vladek cries. "Huh?" asks the absorbed Artie. "You're dropping on the carpet. You want it should be like a stable *here?*" Artie apologizes and hurries to pick up the cigarette ashes. "Clean it, yes?" Vladek will not relent. "Otherwise I have to do it. Mala could let it sit like this for a week and never touch it." And so forth: kvetch, kvetch, kvetch. And then, just as suddenly, we're back in Poland: "So, we lived and worked a few weeks in the stable . . ."

While many of the ways Vladek grates on his son amount to minor foibles and misdemeanors, he is capable of more substantial outrages as well. Perhaps the most mortifying (and unforgivable) of these atrocities emerges only gradually as the story unfolds—the fact that Vladek didn't just misplace the life history that Anja had written out years earlier to be given someday to their son, a folio Artie even remembers having seen somewhere around when he was growing up . . . that, actually, he destroyed it. "Murderer!" cries a flabbergasted Artie when Vladek finally confesses the callous immolation at the climax of Book I. "Murderer," he mutters, walking away. Curtain falls.

"The fact that he'd destroyed that autobiographical journal of hers," Spiegelman says, "meant that the story forcibly became increasingly *his* story, which at first seemed like a terrible, almost fatal, problem. The absence of my mother left me with—well, not with an antihero, but at any rate not a pure

hero. But in retrospect that now seems to me one of the strengths of *Maus*. If only admirable people were shown to have survived, then the implicit moral would have been that only admirable people deserved to survive, as opposed to the fact that people deserved to survive as people. Anyway, I'm left with the story I've got, my shoehorn with which to squeeze myself back into history.

"I've tried to achieve an evenness of tone, a certain objectivity," Spiegelman continues, "because that made the story work better. But it also proved helpful—*is* proving helpful—in my coming to terms with my father. Rereading it, I marvel at how my father comes across, finally, as a sympathetic character—people keep telling me what a sympathetic portrait I've drawn. As I was actually drawing it, let me tell you, I was raging, boiling over with anger. But there must have been a deeper sympathy for him which I wasn't even aware of as I was doing it, an understanding I was getting in contact with. It's as if all his damn cantankerousness finally melted away."

I asked Spiegelman about the mouse metaphor, the very notion of telling the story in this animal-fabulist mode. It seems to me one of the most effective things about the book. There have been hundreds of Holocaust memoirs—horribly, we've become inured to the horror. People being gassed in showers and shoveled into ovens—it's a story we've already heard. But mice? The Mickey Mice of our childhood reveries? Having the story thus retold, with animals as the principals, freshly recaptures its terrible immediacy, its palpable urgency.

I asked Spiegelman how he'd hit upon the idea. "It goes back to that *Funny Aminals* comic anthology I told you about before," he explained. "Along with several of the other underground-comics people out in California, I had been invited to contribute a strip to this anthology of warped, revisionist animal comics. Initially, I was trying to do some sort of Grand Guignol horror strip, but it wasn't working. Then I remembered something an avant-garde–filmmaker friend, Ken Jacobs, had pointed out back at Binghamton, how in the early animated cartoons, blacks and mice were often represented similarly. Early animated cartoon mice had 'darkie' rhythms and body language, and vice versa. So for a while I thought about doing an animal strip about the black experience in America—for about forty minutes. Because what did I know about the black experience in America? And then suddenly the idea of Jews as mice just hit me full force, full-blown. Almost as soon as it hit me, I began to recognize the obvious historical antecedents—how Nazis had spo-

ken of Jews as 'vermin,' for example, and plotted their 'extermination.' And before that back to Kafka, whose story 'Josephine the Singer, or the Mouse Folk' was one of my favorites from back when I was a teenager and has always struck me as a dark parable and prophecy about the situation of the Jews and Jewishness.

"Having hit upon the metaphor, though, I wanted to subvert it, too," continued Spiegelman, the veteran deconstructionist, lighting up again. "I wanted it to become problematic, to have it confound and implicate the reader. I include all sorts of paradoxes in the text—for instance, the way in which Artie, the mouse cartoonist, draws the story of his mother's suicide, and in his strip (my own *Hell Planet* strip), all the characters are *human*. Or the moment when the mother and father are shown hiding in a cramped cellar and the mother shrieks with terror because there are 'Rats!' All those moments are meant to rupture the metaphor, to render its absurdity conspicuous, to force a kind of free fall. I always savored that sort of confusion when I was a child reading comic books: how, for instance, Donald would go over to Grandma Duck's for Thanksgiving and they'd be having turkey for dinner!

"But it's funny," Spiegelman continued. "A lot of those subtleties just pass people by. In fact, I remember how I was over at my father's one evening soon after I'd published the three-page version of *Maus*. As usual, he had several of his card-playing buddies over—all fellow camp survivors—and at one point he passed the strip around. They all read it, and then they immediately set to trading anecdotes: 'Ah, yes, I remember that, only with me it happened like this,' and so forth. Not one of them seemed the least bit fazed by the mouse metaphor—not one of them even seemed to have noticed it! A few days later, I happened to be making a presentation of some of my work at this magazine. I was sitting out in the art editor's waiting room with a couple other cartoonists, old fellows, and I pulled out *Maus* and showed it to them. They looked it over for a while and began conferring: 'Kid's a good mouse man,' one of them said. 'Yeah, not bad on cats, either,' said the other. Utterly oblivious to the Holocaust subject matter."

I asked Spiegelman what his father had thought of the newer installments of *Maus*, as they began appearing in *RAW*. "He never really saw them," Art replied, snuffing out his cigarette. "Early in 1981 he and Mala moved down to Florida, and within a few months of that he was already beginning to lose it. He was past seventy-five years old, and he was pretty much incoherent

throughout the last year before his death. We had to put him in an old-age home. He died on August 18, 1982."

Art paused for a moment, then continued: "I was less affected by his death than I thought I'd be, perhaps because he'd been a long time going, maybe because there was no room for that relationship to change. I went to his funeral, almost like a reporter trying to see how his story was going to end up. But my feelings were more inchoate than anything that would make a good anecdote.

"I'd already finished all my taping sessions with him before he'd begun to go senile, and I had the story pretty well blocked out, chapter by chapter, except for the ending. As I say, I still don't know how I'm going to end it. The last time I saw him, he was sitting there propped up in the nursing home. He may or may not have recognized me. The nurses were trying to stroke any last vestiges of memory in him. They were showing him these "Romper Room" flashcards, you know, 'Dog,' 'Cat,' 'Dog,' 'Cat' . . . 'Cat.'"

Spiegelman's voice trailed off. It seemed he might have come upon his ending after all.

POSTSCRIPT (1988)

As things turned out, Spiegelman need not have worried about Spielberg's film. The film opened to middling reviews and middling success—no one, at any rate, was confusing it with *Maus*, which, for its part, was greeted with overwhelming critical acclaim and proved an unexpected best-seller. During its first year and a half, Spiegelman's book sold almost one hundred thousand copies in the United States, and arrangements were under way for no less than twelve foreign editions (including German, French, Hebrew, Finnish, and Japanese translations). Meanwhile, Spiegelman continued to eke out the subsequent chapters, slowly, laboriously. . . . And a new character made a brief appearance in the eighth chapter, in a momentary flash-forward to the present: a baby girl mouse named Nadja, Vladek's sudden granddaughter.

JENSEN'S SHANGRI-LA

.

FROM ITS name—the Louisiana Museum—I was half ex-
pecting some bayou vista. The view from the window of the director's office,
however, was of a broad green lawn girdled by a profusion of tall, dense trees;
a smattering of modern sculpture; a dip about two hundred yards off, where
the plateau gave way to bluff; then sea strait—a band of blue—and, off in the
distance, about seven miles across the calm water, Sweden.

The Louisiana Museum, that is, in Humlebaek, Denmark.

"There, all right," said Knud Jensen, the museum's founder and director,
as he speared a memo from his desk, folded it neatly, threw it away, then
reached back into the wastebasket, retrieved the folded page, and left it on top
of a pile of similarly reprieved documents. "Okay, let's see. Is that every-
thing? I think so. Well, there's always something, but I think . . . No,
wait." Looking up at me, he smiled at his own mild confusion. "People accuse
me of being a perfectionist, but I'm not. On the contrary, I know what per-
fection should be, so I realize each evening how far short I've once again fallen.
By now, I'm miles and miles behind!"

Speaking about Jensen with museum people and artists in the United
States and Europe, as I was preparing for my visit, I'd heard him described,

variously, as an elf, a pixie, Ariel, a leprechaun, "the kindest man in the museum world," and King Puck. Danes are almost always described this way; people tend to have Hans Christian Andersen on the brain when it comes to Danes. Or Victor Borge. But it was true: the short, brisk, white-haired man who came circling round from behind his desk to greet me seemed wholly unconnected to any Viking ancestors. "Ah, yes," he said, chuckling, when I offered the observation. "We Danes do have a hard time squaring our current lives with our supposedly fierce Viking heritage. Our history classes at school are somewhat demoralizing: we start out very big and important, the scourge of the world, and then it's just one defeat and dismemberment after another."

He started to guide me out of the office, stopped, excused himself, went back to his desk, riffled through several piles of papers, passed a hand over a bookshelf, sighed, gave up on whatever the project had been, and returned to the door, muttering something about tomorrow. Jensen, I came to realize during the ensuing week, perpetually projects an aura of benign befuddlement—he seems to be moving in a cloud of good-natured confusion—but he is *not* confused. He may be thinking about a lot of things at once; he may even enjoy the pose of innocuous disorientation; but he's a masterly organizer. From that diffuse cloud dart startlingly succinct aphorisms and hard-edged decisions. He may not be a Viking, but during the past twenty-five years he has amassed one of the loveliest and best-loved treasure hordes of modern art in Europe.

"Well," he said as we left his office and descended the single flight of stairs into what had once been the vestibule of a Victorian-era manor house and now constitutes the entry hall at Louisiana. "Where do you want me to start?" I suggested that the museum's name might be a good place.

"Ah, yes," Jensen agreed. "People do have trouble with that. Actually, we had nothing to do with naming it Louisiana. The name came with the estate. This house was built by the estate's founder, one Alexander Brun, during the eighteen-fifties. He was a comfortable landed gentryman, with a strange fixation: over the years, he wed a succession of three wives, each of whom was named Louise. Somewhere in there he founded the estate, and named it after one or all of them."

As Jensen was speaking, we'd walked around to a porch, which opened out onto the lawn I'd observed from his office window. The trees were even more magnificent from ground level: a blue-green cedar, a flowering magnolia, a

tall, distinguished pine, a wide, low cotoneaster, a gorgeous ginkgo, and—
perhaps most awesome—a tremendous blood beech, breathing like some
deep-burgundy giant in the springtime breeze. "The grove is very much Mr.
Brun's legacy," Jensen explained. "He was the president of some sort of Dan-
ish beekeepers' and fruit-tree-growers' association, so he planted all sorts of
exotic and remarkable trees during his time here. Owing to one of the per-
petuation clauses in the deed to this property, Louisiana is, I think I can safely
say, the only museum in the world where presentation of an entrance ticket
entitles the bearer to the cutting of his or her choice."

From the vantage of the porch one could see another special feature of Lou-
isiana: an unparalleled sense of the human provenance of art. People milled
in the late-afternoon sun, sat on picnic blankets, slept on the lawn, or cuddled
in the shade, more like neighbors than visitors. There was a great sense of re-
laxation, of familiarity—none of the stiff propriety, the soreness at the back
of the knee and the base of the spine that I usually associate with museum-
going. As we sat for a few moments on the porch steps, Jensen said, "I have
noticed that you can classify the world's museums by their metaphorical im-
ages of themselves. Some—the Tate, the Museum of Modern Art—seem
like arsenals, tremendously imposing and exhaustive in their thoroughness.
Others seem like cemeteries, an endless array of tombstones; some museums
are almost self-consciously mausoleums, devoted to the eternal flame of an in-
dividual artist—a Rodin, for instance, or a Vasarely. I've always thought of
the Guggenheim as a temple and the Centre Pompidou, in Paris, as a forum,
in the ancient sense, or else a circus fair. At Louisiana, we've tried to create a
refuge, a sanctuary, a sort of Shangri-la." I suggested the image of a deer park.
"No, no." Jensen objected. "Or at any rate, in the deer parks I know of, ani-
mals are penned in—they've become docile and domesticated. We've tried to
preserve the wild and slightly dangerous element in art."

Although there are dozens of sculptures scattered through the grounds of
Louisiana, only three bronzes are visible on the part of the wide lawn seen
from the main porch. In the foreground rests a small, sensuously smooth and
lyrical abstract concretion by Jean Arp. In the middle distance, slightly
larger than life-size, stands a squat figurative maiden by Henri Laurens. And
at the edge of the bluff, magnificently framed against the dapple of sea and
sky, looms one of Henry Moore's huge abstract reclining figures. From the
porch, thanks to the play of the perspective, the three bronzes seem the same

size, occupy the same amount of visual field. The tiny Arp, at any rate, holds its own and establishes a confluence of form and presence with the massive Moore—a dialogue seemingly mediated by the quiet, gentle Laurens. Their placement evokes a myriad of triangulations—the interrelationship, for instance, of pieces that are abstract, figurative, and abstractly figurative. "It's strange—this whole wide lawn, and all it can take is three pieces," Jensen observed. "I've noticed that when you create a human enclosure, a walled-in square or rectangle, you can put in five, seven, ten pieces of sculpture. It's as if the pieces were slightly tamed by the cage. But against a natural backdrop you can seldom have more than three, no matter how large the space. You know the work of Konrad Lorenz, the great ethologist—his writings on animal behavior and territoriality. That is why the sculptures at Louisiana are spaced as they are: Lorenz has shown that all living things stake out their natural territory, require their breathing space. Sculptures, like all great art, are, of course, living things. I once tried to move another piece onto the lawn here, but the others got very angry; they withheld their lustre as if in resentment. Anyway, three is the ideal number. We have three Moores, three Calders, three Ernsts, three Arps, three Kienholzes. In fairy tales, as we all know, one is lonesome, two is sterile, but three—ah, three is fertile, the number of possibility. Thesis, antithesis, synthesis. Flaubert once wrote that it takes three particular details, when describing any fresh new scene, to establish its substantial reality in the reader's mind, to give it a sense of lived-in three-dimensionality. Freud, too, has many things to say about three."

We got up from the porch and took a little walk along the edge of the lawn and then into the encircling grove. The corridors of the museum, as they span out northward from the manor house, are virtually invisible, completely absorbed into the surrounding nature. Occasionally, one catches glimpses of visitors walking through low glass passages from one exhibition hall to the next. Outdoors, there's a fresh surprise every few feet. "The children call those the 'Muppet Show,'" Jensen said as we happened upon a view of three whimsical Max Ernst beasts—a turtle, a bird, and some other sort of thing. "And here's an army of little stone creatures by my Danish friend Henry Heerup." They looked as if they were marching in from the sea—petrified Viking dwarfs.

"I've always had a love of journeys," Jensen said, thrusting his way through a jungle of ferns toward a sudden clearing—the terrace of a cafeteria,

upon which were straddled three medium-sized Calder stabiles. "I am fasci-
nated by the sense of around-the-bend—the expectation, the anticipation of
a voyage. That's always been a key element in our planning at Louisiana—lots
of around-the-bend." The Calders, two black flanking one bright red, re-
vealed an unexpected maritime aspect: they were cast like proud sails against
the sea. Some children chased a blue-yellow-and-white mobile that circled
gently, high atop the red metal mast of the center stabile. We ambled back
toward the lawn and emerged near the Laurens. Small children love the Lau-
rens; they relate, perhaps, to her short, stubby legs, her low waist, the soft
tumble of her half-enveloping blanket. They try to shinny up the knee to
grab an arm. Or else they sit beside her, nuzzling her sun-warmed calves.
She's like a very nice baby-sitter, and picnicking parents leave their kids to
her. The Moore, meanwhile, attracts a slightly older crowd. Eight-year-olds
understand Moore; they recognize a giant lap, and they climb aboard to
perch. As we walked by, I noticed one boy curled inside a hollow, intently
reading Tolkien, not the least bit distracted by a frisky band of seven-year-
olds burrowing follow-the-leader through the holes and over the promonto-
ries at the other end of the platform. Jensen looked on, beaming, well-
established smile lines spreading out from his eyes, his white hair blown back
by the breeze. "I suppose I should worry a little bit about the wear and tear,"
he remarked. "But even Moore says it's good there's at least one place where
the children can provide a natural polish."

"Knud, at age sixty-five, retains the wonder and exuberance he must have had
when he was five or six," says one of his associates at the museum. "Nothing
is ever routine. About everything, there is an almost childlike enthusiasm.
He wears all the rest of us clean out."

Knud Jensen was born in 1916, in Copenhagen. His mother, Christiane,
was thirty-seven at the time, and there were already two daughters, aged ten
and twelve. His father, Jens Peter Jensen, was forty-six and had long since
given up hoping for a son, to whom he could leave his cheese-exporting busi-
ness. "It was like being an only child, only more so," Jensen recalls. "People
sometimes describe me as impatient, overeager, headstrong. I think this has
something to do with how spoiled I was. I had not one but three doting moth-
ers; my sisters—who, by the way, were both out of the house by the time I was
ten—used to compete with each other at indulging me."

Jensen regales his companions with memories of Copenhagen during the twenties—his sisters' flapper friends, his own long discussions with the family chauffeur, the summers in the family villa, about fifteen miles north of Copenhagen, and not far from where Louisiana stands. He attended public schools, "along with children of all classes," and almost from the start he reveled in literature. During his adolescence, his favorite authors were Poe and Rabelais; earlier, he'd steeped himself in the faerie world of his countryman Hans Christian Andersen. His father, an autodidact who'd had to suspend his own schooling at age fifteen, when *his* father died, had built up an extraordinary library of valuable and cherished old books. "It was not a collection gathered by the meter but, rather, the library of a life," Jensen recalls, lapsing into bittersweet nostalgia as he leafs through a catalogue he once had prepared—first editions of Andersen, Kierkegaard, Poe, Rabelais, and Goethe, among others. "Many years after my father died, once I'd started the museum, I decided to sell the library. Sitting through that auction was a tremendously masochistic experience, because I loved the books. But it was no doubt better that they nourish other people's collections. And the proceeds helped cover some of our construction costs. The books became bricks—meters and meters of bricks."

Jensen had begun showing a head for business by the time he entered college, and between 1936 and 1938 his father sent him abroad to Germany, France, Belgium, England, and Switzerland, partly to deepen his comprehension of the languages he would be needing once he'd joined the family firm. Languages came easily, but while he was learning them he developed an increasingly consuming passion for literature and, soon, the visual arts. At the University of Lausanne, he composed a senior thesis entitled *Les Influences des Arts Primitifs sur l'Art Moderne*. In the introduction to the essay, he quoted a sentence from Gide: "*L'influence ne crée rien, elle éveille—la puissance d'une influence vient de ce qu'elle n'a fait que de me révéler quelque partie de moi encore inconnue à moi-même.*" (Influence creates nothing: it awakens. The power of an influence comes from the fact that it has only revealed to me some part of myself that was still unknown to me.) The choice of quotation was doubly autobiographical, in that it described both Jensen's situation at the time and the aspirations he came to embrace as his vocation. Jensen returned to Denmark early in 1939 and informed his father that he would not be going into the family business after all but, instead, wished to pursue some sort of career in the

humanities. "My father was disappointed, a little doubtful, but generally supportive," Jensen recalls. "The funny thing was that after about three months I began to miss the excitement and tangibility of commerce. And I went back to him and asked to return to the firm."

Soon thereafter, Hitler invaded Norway and Denmark. From the outset, the Danes acquitted themselves with remarkable valor and honor, rescuing, for example, most of their Jewish population. (The small harbor town of Humlebaek, facing neutral Sweden at a narrow point along the Øresund strait, was one of the principal launching points for midnight smuggling operations.) Jensen plays down his own contributions to the Resistance; as the only son of an old and ailing father, he says, he had to be careful. Others tell stories of how the Jensens gave Resistance fighters innocuous work in their company's warehouses, allowing the buildings to be used as hideouts. When Jensen *père* died, in 1944, Jensen *fils* was only twenty-seven; nevertheless, he took over the business. Hans Erik Wallin, a former advertising executive who is a longtime friend of Knud's and is now his colleague at Louisiana, recalls meeting him on the street soon afterward: "Knud was quite agitated. Several of the other cheese exporters, the veterans, considered him something of an upstart and were trying to maneuver him out of the cheese-exporters' association. But Knud insisted he wasn't going to allow that to happen—'If you do something, you do it right,' he said—and within a few years he had become, like his father before him, president of the association."

"I very much enjoyed the business," Jensen told me one evening as I sipped coffee with him and his wife, Vivi, around the kitchen table, following a delicious dinner at their home, about a mile from Louisiana. "I loved the morning drives out to the country, the conversations with the farmers, the stimulation of commerce. During the first few years after the war, Denmark, which had emerged relatively undamaged, was very much the farm for all of Europe, so the work was important and the business good. But I was really living a sort of double life." Jensen had all the while maintained his literary interests. He spent most of his free hours in the company of Copenhagen's bohemian community, such as it was—writers and painters and poets who whiled evening into night scanning Rilke and Baudelaire, Eliot, Auden, and Isherwood. "I loved being with writers, even though I was no writer myself," Jensen recalls. "I was the one they sent for beer." The parties would drift from tavern to tavern and eventually back to Jensen's modest, three-room downtown

apartment. "At a certain point, I would have to retire to the bedroom, leaving them to their disputations. The next morning, when I got up for work at six-thirty, I'd find them sprawled all about the apartment, draped in curtains they'd taken down for blankets."

"Yes," Mrs. Jensen puts in, smiling, as she pours fresh coffee. "I was one of those underneath the curtains." Jensen had first seen Vivi Arndal during the war, sitting at a restaurant table with two friends, while he was on a date with another woman. Vivi must have been a stunner; she still is. Vaulting over the intervening difficulties—her escorts, his companion—he called out to her, lobbed a few one-liners. Nothing quite took. "Several months later, however," Jensen recalls, "I was on the top deck of a ferry, and next to me was standing a woman all bundled in a hood. I used the old 'Don't I know you from somewhere?' approach, but once I'd got her down to the ferry bar and she'd lowered her hood, I had to gasp, 'Gosh, I do! I do know you!' This was Vivi."

The first months after the liberation, in May 1945, were a heady period. Jensen would procure gasoline on the black market and spirit Vivi off to the country. Vivi, a schoolteacher with a special interest in psychology (she subsequently compiled Rorschach inkblot interpretations from many of the greatest artists of our time, though she guards this collection with absolute discretion), quickly became part of his bohemian circle, and slept in his curtains. In 1946, Jensen traveled to the United States on business for several months, leaving her behind. He established contact with Kraft and Swift and other American corporations, which had by then begun to expand their European operations.

Returning to Denmark, Jensen went straight to a travel agent, bought two tickets to the Faroe Islands (the home, about three hundred miles off Iceland, of Vivi's maternal relatives), and then called on Vivi to propose marriage. Everything blew up in his face. Vivi laughs about it today. "I didn't like his attitude," she says. "He bought the honeymoon tickets before he'd even proposed. He was too sure of himself." The fact is that while Jensen was away Vivi had fallen in love with another member of the circle, a painter. A few months after she rejected Jensen's offer, she married the painter; presently, Jensen also married someone else. Both marriages lasted less than three years, but it took almost a decade for Jensen and Vivi to get it right. Jensen has yet to visit the Faroe Islands, although he talks about them with a passion he ordinarily reserves for the work of Henry Moore.

His business, meanwhile, was undergoing a phenomenal expansion. Within a few years, he had guided it through a fivefold increase in sales and personnel. And the other side of his double life was blossoming simultaneously. In 1945, he and a friend, Ole Wivel, founded a small publishing house, specializing in contemporary literature. Three years later, Jensen helped to finance the launching of *Heretica*, which became one of the most important Danish literary magazines. Then, in 1952, he acquired the controlling interest in Gyldendal, Denmark's oldest and most distinguished publishing house—it was founded in 1770—which had been on the verge of falling into the hands of foreign speculators. "Jensen is the ideal owner to work for," one of Gyldendal's senior editors told me one day, when I stopped in at the Copenhagen headquarters of the firm. "There's no expectation that the company will make money. We are not criticized if we do things that fail, as long as they have quality. For that matter, Jensen hardly ever interferes with the running of the house at all. The thing with the supermarkets last week was quite the exception."

A few days later, I asked Jensen about the supermarkets. "Our salespeople were trying to persuade us to start marketing our books on racks in supermarkets, which is something that is beginning to be popular here," he explained. "All the figures support the idea, but I had to veto it. It was a question of morale. I felt that it would hurt the feelings of the book dealers, and we shouldn't hurt their feelings, because they support us and work very hard."

By the early fifties, Knud Jensen was well established in Copenhagen as a business and civic leader. He would not, however, have merited a place on anybody's list of major European art collectors—or even, for that matter, of significant Danish collectors. To his three-room apartment he brought a taste for uncluttered walls; he owned a single Picasso drawing and one Munch print. He lacked, in his words, "the collector's mania, the need to possess." But with his acquisition of Gyldendal and the completion, later the same year, of a large cheese factory and warehouse, he suddenly found himself with a lot of empty walls. "It was like a dam bursting," he recalls. "I suddenly began acquiring all kinds of things for all those new empty spaces." Not satisfied with his own new walls, he soon forged an association of forty Copenhagen companies to carry out an ambitious program called Art in the

Workplace. The companies began pooling resources, buying artworks from
young Danish artists, and circulating the pieces in traveling shows. "This
program wasn't for the offices of management," Jensen explains. "We figured
that managers could fend for themselves. Rather, these shows visited work-
ers' canteens and rest areas. The art ran the gamut from traditional to modern
Danish style. Some of it was quite difficult, and sometimes the workers com-
plained. I remember one fellow who stared at a painting a long time and then
got up and walked away, muttering in disgust, 'At least, it should have a gold
frame or something around it.' We didn't condescend and we didn't bend,
and there was some resistance. But the moment a show had moved on and the
walls were again empty, the workers would demand, almost in unison,
'Where's *our* art?'"

Through *Heretica*, Gyldendal, and Art in the Workplace, Jensen was be-
ginning to build a reputation as something of a cultural power in Copen-
hagen. One afternoon, a journalist invited him to appear on a radio interview
show to discuss the situation of the Danish Royal Museum of Fine Arts. The
museum's longtime director—a man who loved Matisse and loathed Picasso,
and, for that matter, anything more adventuresome than Fauvism—had re-
cently resigned, and the future direction of the museum had become a matter
for public debate. "I hadn't particularly thought about the Royal Museum in
some time," Jensen recalls. "I guess I just took it for granted. But prior to the
interview I went over to take a look. And I was dumbfounded. It was a true
horror, very much the nineteenth-century bourgeoisie's exaggerated view of
its own importance, manifested in the transcendent value of the art it prized.
It was a real art temple—huge, fat columns, a broad, forbidding marble
staircase, rows and rows of plaster busts, dark alcoves. During the interview,
I therefore started criticizing the museum, saying that it was a relic and had
nothing to do with the art of our time. 'So what do you propose?' the jour-
nalist demanded. Well—just improvising—I suggested that they ought to
move out into the museum's large park, get a good architect, build a low pa-
vilion, with not-too-high ceilings and good lighting, and move all the mod-
ern stuff out there. The main thing was to make it inviting, so that all the
people who walked through the park—the young mothers, the maids with
their perambulators, the old pensioners—would have an oasis in the park.
Well, parks are sacred in Copenhagen. Even though the city has dozens of

parks, and some of them are ugly, and some have too-tall trees and too-shady groves—idyllic but also unsafe—they don't let you touch a single tree. People told me I was crazy: 'How can you violate the green areas of our town?' It was nuts. But I got fascinated by the idea. I thought, Damn it, maybe I could do it myself."

At first, Jensen merely played with the notion, in moments of idle speculation, but increasingly it began to play with him. He was becoming possessed. He began thinking about where such a museum could be placed. There were already twenty museums in downtown Copenhagen—historical, geological, military, civic, and so forth. Jensen noticed that people seldom visited those museums during the workweek, and that on weekends they did everything possible to get out of town altogether. Private cars were becoming more popular, and Danes loved to take single-day excursions, to places like "Hamlet's castle," in Helsingør. Jensen began to think of his dream museum as the terminus of such an excursion. He had in the meantime moved out of town and up the coast about twenty miles. A single man once again, following the dissolution of his first marriage, he was now living in a comfortable house on the outskirts of Humlebaek, a quiet town not far from the summer haunts of his childhood. And he began poking about. At one point, for instance, he visited the novelist Isak Dinesen (he was her publisher), who lived nearby on a small, wooded estate, and tried to interest her with visions of a museum of modern art. "Oh, is there a modern art?" she asked, and he dropped the subject.

"One afternoon in 1955," Jensen recalls, "my dog and I were taking a stroll about a mile up the coast, when we came upon an old, deserted estate . . . a poetical, enchanted wilderness." Jensen and his dog had ventured into Louisiana.

"In some ways, it was even more beautiful than it is today," Jensen told me one afternoon as we walked through the grounds. "The tennis lawn had become a jungle. There were broken-down hothouses, splintered stables. The walls around the rose garden—over there, where we now have the cafeteria— were crumbling, and the garden itself had become a thicket. It was a tremendous, wonderful mess, and I knew I had to have it." Easier said than done. Louisiana, which was in probate, had already been spoken for, by the town of Humlebaek itself. "And they had already drawn up elaborate plans for the es-

tate," Jensen says. "They had in mind three principal uses—as a senior citizens' home, a graveyard, and a sewerage plant: a macabre combination that I somehow couldn't envision."

During the next several months, Jensen worked feverishly to transplant the three proposed projects to other sites. The pensioners' home was fairly easy, the sewerage plant a bit trickier, and the graveyard positively fiendish. "I had so many teas and cakes with the pastor of the neighboring church and his committee, trying to persuade them to expand their little graveyard in some other direction, that at last I was almost a candidate for the cemetery myself." But by year's end the encumbrances were cleared away, and he was able to buy Louisiana, for approximately thirty-five thousand dollars. At that point, Jensen was overextended. His money was tied up in the cheese business and the publishing house; the purchase of the estate had been something of a stretch. So he cleaned out the main building, installed a number of Danish paintings, some Greek and pre-Columbian bric-a-brac, a few chairs and benches, and hid the key under the doormat—and for a while the Louisiana existed as a word-of-mouth museum. If you happened to hear about it, you were welcome to go out there and let yourself in. There were occasional concerts—evenings of Carl Nielsen chamber music and the like. But Jensen had no real vision of what he wanted to do with Louisiana, and that was just as well, since he didn't have the funds, anyway.

Then, one day in 1956, some American executives from the Kraft Foods Company came to town with a proposal, which was very much like an ultimatum. For almost a decade, Jensen had been selling about 25 percent of his cheese to Kraft. According to Jensen, the executives now offered to buy him out completely; they tendered a good price and suggested to him that if he failed to accept they would not only withdraw their quarter of his business but also could make it difficult for him to find buyers for any of the rest of his cheese. Jensen considered the offer for about two seconds and then accepted. Within a few weeks, his holdings were reduced to approximately a million dollars in cash; controlling interest in a publishing house; title to a dilapidated nineteenth-century estate; and full ownership of a company that produced powdered milk—the one element of his dairy business for which Kraft had no use. He pooled a part of his holdings in a nonprofit Louisiana Foundation; from that point forward, all interest and all profits would go to the museum. "People sometimes imagine Knud to be a phenomenally wealthy

patron," one of his friends observed recently. "They figure he'd have to be in a class with the Rockefellers or Norton Simon to pull off the kind of thing Louisiana has become. Well, he's not. He probably could have been, if he'd taken that money in 1956 and begun speculating with it—he's got a good business head. But he didn't. Instead he poured it into the foundation. And now, although he lives a comfortable life, he in no way commands the kind of fortune that his accomplishments would lead you to expect."

"That milk-powder company!" Jensen exclaimed one day. "It turned out to be a gold mine. I had a feeling it might, which is why I kept it, but I had no idea. For years, Louisiana was kept afloat on a sea—or, rather, dunes—of powdered milk. Our manager there proved an extremely gifted leader. Basically, he was running an exporting business. But recently the farmers began to get tired of dealing through a middleman. 'Why should we be subsidizing an art museum?' they wondered. And they had a valid point. I'm surprised they didn't make it earlier. So, anyway, last year we sold it to them, and now Louisiana runs largely on whatever interest we can extract from the proceeds of that sale."

"I'm not sure whether the Kraft deal had come through yet," Vilhelm Wohlert, a thin, somewhat tense, and yet genial architect of sixty or so told me one afternoon, in his Copenhagen office. "I just remember the phone call, and then Knud arriving in his chauffeur-driven Mercedes. He jumped out of the car, wonderfully enthusiastic, transferred to my little *deux-chevaux*, and proceeded to talk all through the drive out. In the rearview mirror I could see his chauffeur in the Mercedes trailing us the whole way. When we arrived at the estate, Knud showed me around the grounds—it was really a jungle—and I suggested that it might be a good idea to bring Jørgen along on the project."

"*Ja,*" said Jørgen Bo, Wohlert's plump, jolly, and extremely expansive colleague. "And I remember your first call. 'Listen, Jørgen,' you said. 'Don't get excited. This is going to be a small, humble job. We're just going to re-model a few stables.'"

Soon thereafter, Jensen's ambitions began to soar. He spent many hours with the young architects, talking about museums and congeniality. At one point, he invited the two of them to spend a few weeks with him on an architectural excursion through Italy and Switzerland. Upon their return, he put them up in Louisiana's manor house and had them live there for a month.

Every few days, he'd come out and join them for a tramp through the under-
brush. "I remember a line from a Danish hymn I used to recite as we forged
our way through that wilderness," Jensen said one day. " '*Oh, vidundertro du
slår over dybet din gyngende bor*'—'O miracle faith, you throw over the abyss
your shaky bridge.' After the Kraft sale, when I had some funds to spend, our
shaky bridge began to seem a bit more stable. It was now possible to think in
terms of some sort of expansion of the manor house. I generally left it up to
the two of them to come up with a plan. I had only three conditions. First, the
old house had to be preserved as the entrance. No matter how elaborate the
museum might become in later years, I knew I'd always want the visitors to
arrive through that modest, nonthreatening nineteenth-century entrance
hall, to feel as if they were perhaps just coming to visit a stodgy, comfortable,
slightly eccentric country uncle. Second, I wanted one room—where the
Giacomettis are now—to open out onto that view, about two hundred meters
to the north of the manor, overlooking our lush inland lake. Third, about an-
other hundred meters farther on, in the rose garden—on the bluff overlook-
ing the strait and, in the distance, Sweden—I wanted to have the cafeteria
and its terrace. The problem was that we didn't have enough money to go all
the way down with buildings. We were going to have to have long glass cor-
ridors connecting the various exhibition spaces, and I was afraid that these
might get boring. 'No,' I remember them assuring me, 'the corridors will es-
tablish the character of the whole place.' There was one other principle I tried
to emphasize, and that was that there always be a way out. Have you noticed
how in museums that feel like labyrinths part of your mind is always stuck on
hypothesizing a means of escape? This can be very distracting, and a terribly
fatiguing claustrophobia can set in. At Louisiana, I felt that escape should al-
ways be just a few walls away. Also, the views of the woods and the lawn seep-
ing in all the time allowed for that perpetual play of art and nature which has
become one of our hallmarks. One specific side benefit that has in the mean-
time resulted has to do with the more adventuresome avant-garde work we
subsequently came to show—things we never imagined we'd be exhibiting
when we began. I don't like to overpower the visitors, and some of the recent
art can get quite fierce. Thus, it's good that we're always offering an out, some
safe place to turn the eyes, like a familiar tree, a stretch of lawn, children play-
ing outside—some safe haven from the wild beasts. The point is that you
don't want to leave people alone with the beasts."

Once Wohlert and Bo had drawn up their initial plan, the three men spent a weekend charting the whole project with string stretched across the land. Jensen offered some revisions (ironically, one of his main changes was to add a few extra zigzags along one stretch of glass corridor in order to save a tree, a particularly glorious nine-trunked beech), but he generally deferred to his architects. "I left the last word to them," Jensen explains. "I realized that just as I have my ethics they have theirs. Anyway, there were seldom disagreements."

Disagreements weren't the problem, according to Wohlert and Bo. It was just that the goals of the project kept ballooning as they went along. "For long periods, our principal function seemed to consist of informing Jensen about the *physical* limitations on his inspiration," Bo recalls. "Human limitations—problems of finance, zoning laws, relations with neighbors, and so forth—he could invariably surmount. We occasionally had to deliver the bad news on things like gravity." The final plan reflected Wohlert's then recent exposure to the California style (he had been studying in Berkeley for several years), filtered through a Danish love of natural materials. The walls were white-painted brick, the floors red tile, and the ceilings natural pine. The external woodwork was teak with beams of laminated pine. In general, the dimensions derived from the masonry; that is, the various dimensions of rooms and corridors tended to echo the proportions of the individual bricks in their walls. The buildings were long and low-slung, and they tended to recede into the natural profusion that surrounded them. As the years passed, there were to be several additions, but the architecture's understated transparency—its quiet, clean, self-effacing purity—persisted. And recently, when Jensen began planning a vast new south wing, it was Wohlert and Bo who received his call.

"I remember one Sunday morning about two months before the opening," Jensen remarked one day. "As usual, the workers, who had spent the whole week mixing cement and planing wood, were there again—this time for picnics with their families. I was walking along one of the glass corridors when I got this sudden feeling: Damn it, this thing is going to work."

Louisiana wasn't the only thing that was beginning to work for Jensen. While the estate was being converted, he had resumed his courtship of Vivi Arndal, herself now divorced and bringing up a young daughter, Sanne, and

this time when he offered marriage she accepted. She and Sanne soon joined Jensen at the Humlebaek home—which Wohlert and Bo were commissioned to enlarge. She must have had some sense of what she was letting herself in for, but over dinner at the house, where they still live, she denies it. "If it weren't for Vivi, I'd have been dead a long time ago," Jensen confides to me when she is out of the room. "I'd have spent forty-eight hours a day over at Louisiana. But she insists I come home occasionally for dinner. She's adamant on the subject of weekends. She drags me away for summer vacations, and I begin to enjoy them the minute I get out of Louisiana's magnetic field. We're even talking about my taking a year-long sabbatical next year—maybe going to the Faroe Islands." (That will be the day, Mrs. Jensen telegraphs with her eyes as she returns: He says that *every* year.)

Once the buildings at Louisiana were completed, in 1957, the question became how to stock them. During the next few years, Jensen's ambitions were fairly modest and somewhat provincial. He focused on contemporary Danish artists and designers. At the time, Danish arts seemed to be coursing along two tracks—the elegant, sleek, constructivist modernism that Americans associate with classic Danish design, on the one hand, and, on the other, the rambunctious, explosive, self-consciously primitivist expressionism of the artists who came to be known as the COBRA group. (The acronym derives from Copenhagen-Brussels-Amsterdam, the cities with which the group's members are associated.) Neither school was receiving much exposure in conservative, staid Denmark prior to the opening of Louisiana, and Jensen, in the early days, felt that his museum could help. He was, in any case, hesitant about competing with the big boys in the field of international contemporary art; he didn't feel he knew his stuff, and anyway the prices were probably too high.

It was a hesitancy that evaporated in 1959, and Jensen credits Arnold Bode with bringing about his change of attitude. Bode had been a promising young painter in Weimar Germany in the twenties—one of the type whose work was denounced as decadent by Hitler and his cronies. He had lain low, managing to be a Good Soldier Schweik throughout the Second World War. At the end of the war, he emerged in Kassel as a professor of art. During the next decade, Bode became obsessed by the idea that Germany, once the seedbed of modernism, had simply missed fifteen years of that movement's most significant flowering. By 1954, he was able to secure the summer use of

three castles in the environs of Kassel as the staging area for an exhibition he called "Documenta." Its subtitle was "The Classics: An Update." Jensen missed it, but in 1959 he ventured south for its sequel, "Documenta II." "You cannot imagine how naïve I was," Jensen said one evening as he recalled those days over schnapps at his home. "I arrived in Kassel like a country hick, like someone who comes in on the four-o'clock train. Up to that point, I had been completely preoccupied with Danish art. Now, for the first time, I saw Pollock, de Kooning, Bacon, Dubuffet. I caught up with the postwar work of Moore, Calder, Arp. . . . The abundance overwhelmed me. I said, 'Gosh, I have lived in vain.'"

Jensen paused and remained silent for several seconds. "Ach," he finally said, sighing and shaking his head. "I was so stupid. You know, all those things—finding the estate, Kraft stepping in, building the museum—it sounds as if it were all good luck and good intuition. But I made some terrible misjudgments in those years. In 1954, in Stockholm, I'd seen a terrific Cézanne-to-Picasso show. Instead of being inspired, I was cowed. I imagined there was no way I could compete internationally, so when Louisiana started I confined myself within parochial horizons. And yet I could have started international collecting right from the start. In 1956, a Max Ernst sold for the equivalent of a good Danish painting, a Léger went for maybe twice that, a Picasso three times. By 1960, though, prices had begun to jump right out of my range; in many cases it was too late. When I think of all the things I could have done and didn't, I could tear out all my hairs and run around screaming." Jensen bounded out of his chair at the sheer thought of it, his hands tugging at fistfuls of white hair, his feet pounding a dance of retrospective frustration—and then, just as suddenly, he stopped, lowered his hands, sighed again, and chuckled quietly. "Ah, well," he concluded, "I suppose all collectors face this sorrow. And, you know, there's a danger of inverted hubris in all this: 'By my incredible intelligence and sensitivity, I should have been able to achieve more.' It's our vanity, finally, that condemns us."

Returning to his chair and smoothing back his ruffled mane, Jensen resumed his tale. "At any rate, standing there in Kassel, I knew I had to make a fresh start," he said. "It couldn't be too sudden—I didn't want to hurt the feelings of my Danish artists—but it was going to have to be complete. That very first day, I rushed up to Bode's office and pleaded with his secretary to let me see him. Finally, she got up, walked over to his door, leaned in, and said,

'Professor Bode, there's a man out here just as crazy as you are. Do you want to see him?' I stormed into his office and cried, 'Let me do something immediately! Otherwise, I explode!' And he was very generous. Over the next few days, we chose a hundred and fifty of the best works in 'Documenta II' for showing at Louisiana later that fall. It was the beginning of a great friendship."

Besides Bode, Jensen cites two other museum men as early mentors. Willem Sandberg was the influential, hugely inventive director of Amsterdam's Stedelijk Museum. "He was a visionary practitioner," Jensen explains. "An eighteenth-century Voltairian who was still very much in the present. An encyclopedic humanist with roots in Freud and the Bauhaus, and at the same time with a deep sense of the emotional and the mystical. The first time I visited the Stedelijk—this, again, was *after* the Louisiana had opened—Sandberg had organized a big comparative exhibition of modern and primitive art. It was my old Lausanne University theme. But Sandberg was launching something like fifty shows a year; there were often two or three openings on the same day. He was the Alfred Barr of Europe—very much a father figure to all of us. It's strange—I am as old now as he was then, but I could never imagine myself his equal." Jensen's other mentor was Pontus Hulten, the young and brashly innovative director of Stockholm's Moderna Museet, who went on to become the founding director of the Centre Pompidou in Paris, and who was then in Los Angeles preparing for the 1985 opening of the Museum of Contemporary Art, of which he would be director. In 1958, Hulten, then a young art historian, had been tapped by the Swedish government to organize a gallery for modern works after a wealthy benefactress willed a vast sum—anything!—to get "those horrible modern things" out of the National Museum. Starting with this small nest egg of exiles, Hulten, through contacts with enthusiastic young artists, quickly developed a thriving art center in the otherwise implausible north. "Sandberg was particularly good with the classics of the modern movement, and Pontus with the cutting edge, the newest trends," Jensen recalls. "They were both extremely helpful in allowing me to borrow their shows. In 1960, we had a show called 'The Moderna Museet Visits Louisiana,' which drew from Pontus's permanent collection, and we followed that in 1961 with a similar survey of Sandberg's Stedelijk holdings."

By 1961, Jensen had turned the corner in his development of Louisiana into an international institution. There was a regular traffic in contemporary

shows among Amsterdam, Stockholm, and Humlebaek, and Jensen, whom museum people had started out by dismissing as "Cheese Jensen," had now graduated to being known as "one of those three wild men of the north." The transition was not universally applauded by Jensen's neighbors and country-men. In the summer of 1961, Louisiana played host to Hulten's razzle-dazzle extravaganza "Movement in Art," which included works by Marcel Du-champ, Richard Stankeiwicz, and Alexander Calder. As an adjunct to the show's opening, Jensen invited Jean Tinguely, the notorious and celebrated Swiss kinetic assemblagist, to come up and fashion one of his self-destroying sculptural contraptions on the manor lawn. "Tinguely arrived," Jensen re-called, "and he immediately informed me he'd need two thousand francs for fireworks. This made me a bit nervous, since only a year earlier his 'Homage to New York' had almost succeeded in burning down the Museum of Modern Art. I suggested that maybe we should have the fireworks master from Tivoli come and supervise, but Tinguely assured me that no, there would be no problem—the rockets, which would be controlled by an electrical impulse at his command, would be aimed at the ground, not at the sky. He was calling the piece 'Sketch for the End of the World,' so I was wary, but I went along. Finally, the night of the opening, the sprawling junk sculpture was in place. It actually consisted of three separate structures between twelve and fifteen feet high, made out of baling wire, wheel sprockets, bicycle chains, a per-ambulator, a rocking horse, a sewing machine—*everything*—and near the top was a cage with a pigeon inside. This was 'the peace dove,' and it was supposed to be released just before all the excitement. Well, Tinguely was famous as a big *farceur*, so there was a large, festive crowd, somewhere between one and two thousand people, including all sorts of press and dignitaries. Soon after twilight, Tinguely started the whole thing up from his switchboard behind a tree. The wheels began whirring, the engine chugging, metal clanging, the rocking horse rocking, a foghorn tooting, smoke and noise, and then, sud-denly, there was a big *Bang*! and the rockets started shooting out. It turns out that they went neither into the ground nor into the sky but, rather, straight at the audience. The laughter went from carefree to somewhat nervous to downright terrified and hysterical. The press photographers became war cor-respondents. Rockets went spraying into the old house. One sputtered straight at the prime minister's chest. I was running around mobilizing doc-tors, attending to people's small wounds, assuring everyone that Louisiana would pay for the burned clothes, and so forth. Nobody was seriously hurt,

but when I looked back at the steaming debris on the lawn I realized the cage had failed to open. The photographers were swarming around the ruins, snapping pictures. Later that evening, back at the party at my house, the phone kept ringing, with newspeople demanding to know, 'What's all this we hear about murdered birds?' "

By now, Jensen was rocking back and forth, savoring the memory with delight. "Well, naturally," he continued, "the next morning there were banner headlines: MACABRE OPENING OF SHOW: ANIMAL SACRIFICED AT LOUISIANA. People called our equivalent of the SPCA, they called the police, and by midmorning the police were calling on me—I remember how they looked to me through my vague hangover—and demanding 'the corpus delicti.' Well, I told them I had no idea where it was, but our maid then informed me that it was in the kitchen. Tinguely, it turns out, had brought it home the night before and given it to her, saying, 'Here, take this. Knud can have it fried or boiled in the morning.' It became a huge scandal. The police brought in a veterinary professor from the university to conduct an autopsy—I remember one sentence from his report: 'This bird was killed while alive.' How else could it have been killed? There was a trial, although by then Tinguely had already left; in absentia he was meted out a fifty-dollar symbolic fine. But you should have seen all the discussion this led to—the editorials pro and con. Things weren't helped any when Nam Jun Paik, the Korean-born avant-garde artist, did a performance the following weekend in which he took a bath in an oil drum, destroyed a piano, threw eggs at the walls, and went around with a scissors cutting off the critics' ties. The next morning, we opened our papers to the banner, YET MORE INSANITY AT THE LOUISIANA! Ah, yes," Jensen said, calming himself. "Those were the days of our heroic youth."

Jensen's mood turned suddenly serious. "It was all so hypocritical," he said. "Thousand of pigeons are killed each year to beautify our parks and no one complains. People who wouldn't mind if human beings were being intentionally tortured were scandalized at the thought of an animal's being accidentally killed. I gradually realized that much more was at stake—that a lot of this was angry resentment against modern art. So around this time I decided to organize a series of seminars entitled 'What Is Modernism?' "

By the mid-sixties, Jensen had begun collecting in earnest: to his excellent holdings in such modern northern European and Scandinavian masters as

Pierre Alechinsky, Asger Jorn, Henry Heerup, Karel Appel, Robert Jacobsen, Carl-Henning Pedersen, and Richard Mortensen, he was now adding works by Yves Klein, Victor Vasarely, Arman, César Baldaccini, Lucio Fontana, Naum Gabo, Josef Albers, Max Bill, Jean Dubuffet, Antonio Tàpies, Morris Louis, Sam Francis, Ellsworth Kelly, Kenneth Noland, Jim Dine, Roy Lichtenstein, Frank Stella, and Andy Warhol. He was dogged all the while, however, by the worry that the art he was collecting—some of the finest pieces from the forefront of contemporary artistic practice—was fundamentally misunderstood by a large fraction of its potential audience. "I remember a passage in a book by one of your American writers—I think it was Kurt Vonnegut," Jensen remarked one day. "A character suggests that modern art is a conspiracy between rich people and artists to make ordinary people feel stupid. And I've often been concerned about this kind of misperception. There was a gap, especially in the fifties and sixties, between what artists were doing and what many people were prepared to appreciate. This gap led to frustration, which, in turn, produced anger or insecurity—neither of which was a terribly good mood from which to open oneself to new experience."

During the early sixties, Jensen wrote extensively on what he called "the developing crisis of leisure time." In those heady days, there was a general expectation, especially in Scandinavia, that the forty-hour workweek would soon dwindle further, that automation would free workers from mind-dulling drudgery, that society was on the verge of extending a basic level of material sufficiency and security to all its members. "It seemed as if we were at the dawn of a new age, the era of leisure," Jensen told me. "People were beginning to have a lot of free time, and corporations were moving quickly to colonize that leisure through the various structures of popular culture, such as television, spectator sports, vacation packages—all the standardized ways in which people could be turned into consumers of fun. At that time, I wrote a book called *Slaraffenland Eller Utopia*—*Lotusland or Utopia*—and those appeared to be the options. It seemed vital that some alternative to the mass standardization of human possibility be provided—that material sufficiency not lead to spiritual anemia. This is where art seemed so important, and especially the work of contemporary artists who were wrestling directly with the challenge of individual, as opposed to standardized, expression."

Jensen paused, smiled, and then continued. "I think people in positions like mine—people who try to mediate between art and society—need a lot of

self-irony, modesty, and ambivalence. Also, a certain skepticism as to whether art can make anything happen, and just how much a person can get out of art. I mean, there are a lot of truly happy people who have virtually no exposure to art, and, conversely, some fairly evil specimens who are tremendously sophisticated in artistic matters. Still, having said that, I think art can be a vital tool in one's life. You don't have to conceive of art in Olympian terms to see how it helps people to learn to think for themselves, to sharpen their own perceptual capacities and heighten their sense of self, while at the same time allowing an immediate sense of other people's unique, subjective experience. Art thus has an important role to play in staving off the standardization of society. But it can achieve that promise only if we find some way of overcoming that initial frustration—the anger and insecurity—that tends to alienate many potential viewers from modern works." This became Jensen's consuming passion at Louisiana—to create a milieu in which art and people could meet and mingle. His attitude was neither missionary nor pedagogical. He preferred a sort of relaxed persuasiveness—a mild offer tendered quietly and almost tangentially. Although part of the problem was unquestionably the strangeness of a lot of contemporary art, Jensen increasingly came to feel that a major cause of the frustration arose from the very institution of the museum. "You have to realize that museums are a relatively recent aberration in the history of art," he pointed out. "This segregation of art from the world of everyday life has impoverished both. It used to be that a religious person, for example, would enter a cathedral, just as he did every Sunday, and the light might be streaming through the window in a particular fashion or falling upon a statue of the Virgin in a new way—the hue from the window intensifying the deep blue color of the Virgin's garment—or there might be snow on the shoulder of one of the Prophets outside, and our friend would say, '*Tiens*. Look at that. I never noticed that before.' Art existed in town squares, in the marketplace, in theaters, and in homes—you came upon it in the middle of your day, at the corner of your eye. Now Rembrandt's *Night Watch* is enshrined behind thick glass in a dark, cold room in a large, cold museum. They make you stand there, almost pulling you by the hair: 'Look, damn it, you idiot, this is the greatest work of art in the world, appreciate it!' The trouble with many museums is that they impose this kind of demand for aesthetic worship."

For Jensen, at Louisiana, the challenge became the search for a way to re-

turn art—"difficult" modern art, especially—to the everyday lifeworld of its potential viewers. As the years passed, he added a movie theater, a concert hall, a stage for experimental drama. He offered Louisiana as a site for conferences, symposia, and political rallies. There were poets' days and antinuclear expositions. The idea behind all the sideshows was that people might meet the art on their way to something else. In addition, Jensen and his associates soon started interspersing their calendar of modern shows with significant archeological and anthropological exhibitions. For some reason, people who couldn't care less about Malevich or Surrealism swarmed to look at gold from Peru, funeral masks from Egypt, and stone zodiacs from Mesopotamia.

"It's quite extraordinary—there's an apparently insatiable appetite for the antique and the exotic," Hans Erik Wallin, the former advertising man who now supervises, among other things, Louisiana's archeological spectaculars, remarked to me. (Of the four principal administrators who currently guide Louisiana, not one has any academic credentials in art history or arts administration. To the uncomfortable bewilderment of many traditional museum people, Louisiana seems to swim along just fine under the guidance of a former cheese exporter, a former Ford dealer, a retired advertising executive, and a professional painter—"the boys," as Jensen fondly refers to the museum's leadership.) "Our two biggest shows ever, in terms of attendance, were exhibits of Pompeii in the year 79 A.D. and, just recently, the Chinese bronzes and artifacts from the burial site of the First Emperor of Qin—the one who had himself buried with an army of life-size terra-cotta warriors and horses. A museum man once said, 'For success, you need gold or, if not gold, corpses.' Well, there must be something to what he said, because with those two shows people just couldn't get enough."

The Chinese exhibition proved particularly challenging. Wallin not only had to make several junkets to Peking but was required to entertain a delegation of Chinese officials at Louisiana. "They were, to say the least, bewildered by many of the things they saw here," he recalled. "At one point, as we rounded a bend, I was struck dumb with horror: there before us loomed our large Andy Warhol portrait of a blue Mao with red lipstick. There was a tense moment of silence—I could feel the prospects for a show slipping right through my fingers—and then the leader of the delegation, arching his eyebrows, muttered something to the effect that the late chairman himself had said: 'Let a hundred flowers blossom.' " Wallin concluded, "These archeolog-

ical shows are very effective. People come for the jewels and coffins, but they end up passing the modern stuff on their way to the pastries."

"Of every thousand persons who come for the archeological extravaganzas," Jensen later agreed, "nine hundred and ninety-nine may pass right by the modern things, but the curiosity of one may be piqued, and maybe the next week he comes to look again. That is our greatest satisfaction. Of course, I don't want to leave an impression that we coerce people here under false pretenses. As you know from my somewhat naïve thesis in Lausanne many years ago, I have always felt how deeply we are indebted to these faraway cultures and how important they have been in the development of our whole modern sensitivity. Alfred Barr's Museum of Modern Art made exhibitions of African and Pacific art and so did Willem Sandberg's Stedelijk, and, as for Louisiana, we would never assemble a show that was not in some way related to the art of this century. During the past twenty-four years, we have had about a dozen shows of this kind, always trying to emphasize the connection *between*, for example, the pre-Columbians and Moore, the Egyptians and Giacometti, Pacific art and the COBRA artists, and so forth. The only exception may have been the Pompeii exhibition, but even that show implied a kind of self-identification emanating an atmosphere of catastrophe—a civilization extinguished in two days and later forgotten—which makes us understand the Pompeians. And even there the 'calcis'—the casts of dying human beings—have inspired artists like Giacometti, César, Richier, and others, which is why we showed works of these artists at the end of that exhibition."

One of Jensen's favorite exhibitions in this context was also one of the earliest—a presentation, in 1963, of the Mexican government's vast European traveling exhibition. "The exhibition was so big we had to show it in two stages," Jensen recalls. "It arrived at the Humlebaek station in a special train—six or seven cars filled with two thousand pieces, ranging from huge, several-ton Olmec heads and little red clay pre-Columbian pots and figurines to works by such modern masters as José Orozco and David Siqueiros. The nine hundred pre-Columbian pieces in particular were tremendously fragile. I remember the last day, as we wrapped the show ever so carefully under the anxious gaze of four officials from the Mexican Cultural Ministry—it was like holding your breath for a whole day, totally nerve-racking. Finally, we delivered the last case to the train—not a single item had even been scratched—and I turned to the four Mexicans and said, 'Come with me.' We got into my

car, drove to Copenhagen, parked outside Tivoli, marched in, and proceeded to a little booth where for a couple of kroner—the equivalent of a quarter—you can throw three hard balls at several piles of ceramic plates. I put down a wad of bills, and for the next hour or so we went berserk—reduced the place to a shambles. There wasn't a saucer left whole. It was tremendously gratifying."

Tivoli is generally considered the top children's amusement park in Denmark. There are times, however, especially during the summer, when Louisiana has much the same atmosphere. Again, it's part of Jensen's attempt to make his museum a milieu for living as well as viewing. "Sometimes it seems that children are the world's greatest oppressed minority," Jensen commented one afternoon as we stood at his office window watching a group of kids scaling the Moore. "Children are usually bored at museums, and I feel pity for them: they're nice and polite to us and say they like it. But I don't think you can expect kids to really enjoy art at a museum until they're in their early teens; it's a taste that comes late, so that finding some way to involve them when they're younger can be a challenge. Some museums respond by setting aside a room for finger painting and clay modeling. But that's merely the kind of thing they get at school. Here at Louisiana we've tried to enlist artists in the invention of high-calibre practical and aesthetic objects and environments that are capable of exciting and involving the children. Unfortunately, because of some trouble we've been having with the neighbors, we've had to temporarily close off our largest children's area, but let me show it to you anyway."

As we left Jensen's office and descended to the vestibule, we could see a long line of people in the courtyard waiting to get into the museum. It was the last weekend of a phenomenally successful Picasso retrospective. (Indeed, by the end of the weekend the Picasso show proved to have been the most highly attended exhibition in Louisiana's history, surpassing both Pompeii and the Chinese bronzes. Charter buses streamed in from as far away as Helsinki and Oslo. During the two months of the show, its entry receipts exceeded the museum's budgeted expectations for the entire year. The bookshop dispensed over three hundred and sixty thousand postcards, the cafeteria almost a ton and a half of shrimp.) We moved quickly through the throng, past the exhibition halls, and along the connecting glass corridors. From inside its buildings, Louisiana feels something like a watercourse, a series of lazy pools con-

nected by cascading streams and narrows, debouching, finally, at the
cafeteria's terrace, onto a view of the strait. Just past the Giacometti room and
before the cafeteria, we veered out of the main stream. Jensen unlocked a side
door, and we were quickly pushing through the underbrush on the far side of
the museum. As we emerged into a clearing, we came upon four trespassing
teenagers. Jensen shooed them away, and they scampered off into the forest.
"I don't blame them," Jensen said, laughing. "If I were their age, I'd be down
here, too."

In 1978, Jensen had decided to expand his usual practice of inviting one
artist each summer to work with the children of Humlebaek on a group in-
stallation. Instead, he made the children's projects the center of the Louisi-
ana's entire summer program. Dozens of artists and theatrical groups were in-
vited to contribute pieces around the theme "Children Are a People." (The
phrase is a line from a Swedish song, which concludes, "They live in another
country.") Most of the action took place near the lushly overgrown, shallow
lake to the north of and just below the Giacometti room. A platform was
erected on the far side of the lake, and a Huckleberry Finn–type raft made
continual crossings to it, powered by a taut rope anchored to both shores and
pulled by the children themselves. On the raft's side were strapped life pre-
servers bearing the legend "Who Needs the Atlantic?" On the terrace above,
where the three Max Ernst "Muppet Show" pieces dawdled, with their silly
grins, one artist contrived a makeshift funicular: a pair of children would
climb aboard a narrow seat, get strapped in, and then fly about two hundred
meters swooshingly across the lake and down to the platform at the other side.
One artist bought an old schooner, sliced it in half across the middle, and
mounted the two ends deck to deck, prow and stern to the sky, along the
shore, where they became a striking clubhouse. There was a thrillingly steep,
bumpy slide, and all kinds of tree houses and hammocks. One artist con-
trived a soft, red, womblike room, and another made a shallow straw bowl
with an enormous wooden spoon; small children seemed to love to climb into
the hollow of the spoon and sit. Suspended above the ground there were nar-
row platforms on which children could stretch out and flap large goose wings
hinged to the structures. In another corner of the woods lay a moss-covered
Volkswagen Beetle.

The show's success was tremendous, but so was the opposition it aroused
from the neighboring church. Jensen walked me around the now silent lake,

parted some branches, and showed me the site of the difficulty. On the other side of a chain-link fence dividing the museum's grounds from those of the church lies a section of the church's graveyard. "They were very upset, because they claimed the noise of our children having all this fun was, in their words, 'disturbing the sleep of the dead,'" Jensen explained. "There was a big polemic. One man even filed a petition with the ministry of church affairs to have his wife unearthed and her casket moved so 'she could get some peace.' I don't know. If I'd been in her position, I tend to think I would have enjoyed the company. But it presented us with a big problem, and we didn't know quite what to do. My friend the artist Pierre Alechinsky heard about the controversy and cabled me, 'Don't give in unless you hear from the dead themselves, preferably in writing.' Well, we didn't hear from the dead, but I decided that for the present, anyway, for the sake of peace among the living, it was probably better to close off the area." As we walked back toward the museum, however, climbing alongside the tumbling slide, Jensen paused, a gleam in his eye, and said, "Don't you think it would be great to invite Niki de Saint-Phalle and Jean Tinguely up here to make a huge serpent with this slide as its open mouth? The serpent's body could coil around underneath the Giacometti room, and the children, digested, could come out eventually over there on the other side. I'm going to have to ask them."

If Jensen's previous record with artists is any indication, Tinguely and Saint-Phalle will very likely be delighted to cooperate. Archeological shows and children's summers may explain some of Louisiana's popularity among its public, but it takes the contagious enthusiasm that Jensen brings to his relationships with artists to account for the remarkable quality of his museum's holdings in modern art. Jensen is not nearly as wealthy as many museum patrons in the United States and in Europe, yet his collection ranks among the most distinctive and distinguished in Europe. "He came to my studio several months ago with the intention of buying one painting," the noted Israeli artist Menashe Kadishman told me recently. "But he was so lively, so interested, so delightfully involved, that being with him was like being near a fire of enthusiasm. He is a man of love. He radiates passion about art. I got so caught up that I found myself lowering prices, giving him other pieces outright. He ended up leaving with four works!"

Pierre Alechinsky, the Belgian-born master, who has donated an extraor-

dinary canvas entitled *Le Doute* to Louisiana, describes Jensen as *"un conservateur de foudre,"* a lightninglike curator. Morris Louis's widow, Marcella Brenner, was instrumental in seeing to it that Jensen was able to secure three—the magic three—large paintings by her late husband. Henry Moore and Alexander Calder, Naum Gabo and Sam Francis—the list seems endless—have all responded to Jensen's charm. He has countless stories of his relationships with artists. Perhaps the story of his friendship with Giacometti can suggest their tenor. "In 1965, the year before his death, Giacometti was having a retrospective at the Tate Gallery, in London," Jensen told me. "I wrote to him out of nowhere and asked him whether he would allow the show to travel to Louisiana—several letters, actually, but no reply. Finally, on the eve of the Tate show's opening, I flew down to London to see him. I found him in the galleries, applying finishing touches to some of the sculptures; in fact, he was daubing some of the bronzes with little flecks of colored paint. I went up to him and introduced myself. 'Ah, yes,' he said. 'You are the Dane. Absolutely out of the question.' He looked at my face and I must have looked crestfallen, because he said, 'Oh dear, let's go to the cafeteria and at least have some tea.' Well, this tea lasted three hours. We began telling very black-humored stories—especially about cannibalism. For some reason, Giacometti was fascinated by cannibalism. He felt that Holy Communion was a cannibalistic rite. I told a story I'd recently read about a fine Berlin burgher who killed his wife and then canned her mortal remains, which he took to eating at his leisure. After a few weeks, he was arrested, tried, convicted, and sent to prison, but they never located the body. In prison, he complained to the guard about the food and asked him, wouldn't he please go to his house and bring back some of the cans he had stored in the cupboard there? We were all laughing and having a very good time. All of a sudden, Alberto tapped me on the shoulder and said, 'Of course you shall have the show. No problem.'

"Later that year, I invited him to come up and see our installation of the show. He didn't travel much and he had a fear of flying. He once took a five-day boat trip to spend five days in New York City and then took five days sailing back. He had intended to place three figures in the Chase Manhattan Plaza, but when he saw the scale of Manhattan he felt he couldn't compete. We've since acquired those three pieces—the standing woman, the walking man, and the large head—and they're in our special Giacometti room, with the lake as a backdrop. I like to think he'd be pleased. Anyway, he came up by

train. We, of course, invited him to stay in the converted boathouse down by the shore where we always put up our visiting artists. But he declined. He preferred to stay in a hotel in the harbor district of Copenhagen, where he could stay up late and trade stories with the sailors. When he came out to Louisiana, we were very proud. The show consisted of over one hundred and seventy-five pieces—it was quite remarkable. We'd taken a great deal of care in installing them, and we were eager to get his response. Well, he went up to the first piece and stared at it fixedly for some moments, then shook his head and muttered, '*Ah, c'est terrible, c'est moche.*' He went on to the next one—same thing. Every few pieces, he'd grumble, '*Affreux, c'est bête.*' It was quite shocking to see how depressed and disgusted he was by everything he'd ever done. I remember thinking, Why does he become so masochistic? But it continued from one room to the next—terrible curses, and not a word about the installation or anything. Eventually, we came back round to the beginning, and it was as if he went through a catharsis. Suddenly, he smiled and brightened. He launched out again, going from room to room, praising the installation and the lighting, commenting on the fine choice of groupings and the beauty of the site. It was an unbelievable transformation.

"A few months later, I had occasion to visit him in his tiny workshop in Montparnasse. He lived the life of a bohemian, yet he was tremendously disciplined. It was said that he kept his money in a little box under his bed. In the evening, he took me on a walk and told me stories. Eventually, we ended up at La Coupole, the huge restaurant, which must have been one of his favorites—the waiters called him Monsieur Alberto. At another table were seated Sartre and Beauvoir; I didn't try to engage them in any conversation— I didn't want to bother them, although I am their publisher here in Denmark. Alberto, meanwhile, continued to hold me spellbound with his stories. He told me about one time when Stravinsky called and asked whether it would be all right if he dropped by for a visit. Giacometti had said, 'Of course,' although he'd never really had any relations with the man and couldn't imagine what he wanted. Presently, there was a knock on the door, and it was Stravinsky's chauffeur, saying that the Maestro was outside, waiting for him in his limousine. Giacometti emerged from his studio and was expansively greeted by Stravinsky, all this being captured for posterity on film by two busy cameramen. Apparently, they were making a documentary about Stravinsky, and he thought it would be impressive to be seen with Giacometti.

"Later that evening—it must have been getting on to two or three, and the tired waiters were nodding sleepily but indulgently in the corner—Alberto told me about a time some years earlier when he'd been commissioned to draw a portrait of Matisse as a study for a commemorative medallion. Matisse was old and virtually paralyzed, but very patient and supportive. At one point, he asked to see the drawings. Giacometti, handing them over, sighed and said, 'It's very difficult to draw.' 'Yes,' Alberto said Matisse replied. 'Yes, it's the most difficult of all.' Two of the finest draftsmen of our century talking to each other like that! Imagine!

"Alberto was tremendously generous. Later during that trip, I mentioned that it was a great dream of ours to be able someday to buy a particular group of his figures, but that we didn't have the money. 'How much do you have?' he asked. I told him. 'Oh, that's enough,' he said." Jensen paused for a moment, then added, "And within two months he was dead. That was the last time I saw him. He died early. He was not at all a man who had finished telling the world what he thought of it."

One day, I asked Hans Erik Wallin, Jensen's associate, what he thought Louisiana would be like in twenty years.

"Oh," he assured me, "Knud will still be running it, and no doubt as he's running it today—with more energy than any of the rest of us. He's like Titian, who ran his studio until he was almost ninety. If it hadn't been for the plague, he'd still be with us, and, knowing how Knud relates to artists, he'd probably be right here."

"I don't care about my obituary," Jensen said one afternoon. "I'm just interested in having a good time while I'm here. Everything I've done, I've done for fun, for my own satisfaction. Anyway, you can't enjoy good notices when you're in your urn." After a moment's consideration, he went on, "Besides, I couldn't help myself. Peter Brook, the great stage director, once said something to the effect that 'there is no deep, inevitable need for theater on the part of society. If theater completely disappeared, it would take weeks for most people to notice. No, theater exists because there are a number of individual people who could not survive without making theater.' I think it's the same with museums and museum people."

My visit was coming to a close, and Jensen was in uncharacteristically low spirits. He'd spent the morning in a meeting with the board of the Louisiana

Foundation. During the last several years, Louisiana has finally been receiving support from the Danish state and from greater Copenhagen, as well as from some important groups, including the New Carlsberg Foundation, the philanthropic trust that owns the beer company, and the Augustinus Foundation, which distributes grants on behalf of the family of Peter Augustinus, a Danish philanthropist. This meeting of the board had been called to consider plans for 1982, a year that would see the opening, in September, of the huge new south wing as a site for perpetual display of Louisiana's permanent collection—a wing that was entirely financed by the Augustinus Foundation. "Oh," Jensen remarked, with a sigh, "sometimes it takes herculean strength to maintain the optimism of my board. The next year will be crucially important. The opening of the new wing will be a major test; the eyes of the museum world will be upon us. We're just a small museum in a small country in an increasingly competitive art world. In the last ten years at least a dozen new contemporary museums have opened up in the United States, a similar number in Japan and West Germany—and that's not even counting the big boys—all of us competing for the same limited pool of masterworks. It's very difficult, but you've got to take risks; we especially have to make a stretch right now—to risk a major gesture. The board is being very careful, which is good—I am reminded of a Danish proverb, 'Ideas need wings, but they must have feet to walk on.'—but it is also somewhat exhausting. You see, I am also reminded of a story about our Danish Prince Christian Frederik. In 1814, after Denmark had ended up on the wrong side in one of the Napoleonic Wars and had gone bankrupt, Christian Frederik's advisers came to him with a proposal to close the Royal Academy of Fine Arts as an austerity measure. He refused to do so. 'Poor and miserable we certainly are,' he declared. 'Now, let's get silly, too, so that we can just be done altogether with this business of being a state.' And that academy is there to this day." After a moment's reflection, Jensen continued, "Actually, now that I think of it, my board isn't at all like the prince's advisers. I mean, look, here in this time of economic crisis, we are going ahead with a building program that will double our size, and the board has been extremely cooperative. Sometimes I just get anxious."

In the hall a few minutes later, I passed Børge Hansen, the former Ford dealer who has been Louisiana's business manager since the early seventies. ("I told Knud I didn't know a thing about art. 'I'll stick to the figures and leave the art to you,' I said, and that's how it's been. I go around tending to all

the practical matters Knud leaves in his wake.") I asked Hansen about the meeting. "Oh, it went fine," he assured me. "Knud's a little frustrated, but he's always frustrated after these meetings. Face it: Knud is always going to be at least two steps ahead of the rest of us."

"I have a veritable portfolio of snapshots of Knud taken from behind as he's racing off somewhere," said Sanne Bertram, Jensen's stepdaughter, the next day as she drove me out to the airport. Miss Bertram is in her early thirties and the two are quite fond of each other. In addition to being an accomplished photographer, she is completing graduate studies in Spanish. "I remember one time in particular," she continued. "Knud and Vivi and I were on our way to see Alexander Calder, at his home in Saché, France. This was to be the culmination of two years of extremely delicate preparations—contacts, correspondence, courtship, tentative queries, and so forth. We'd flown to Paris, and everything was going to hinge on a series of very tight connections—taxi and train. We were desperately late, and the taxi had got caught in a traffic jam. Knud was pleading with the driver to please, please, hurry. The passenger compartment was stinking up with the smell of this large, smoked Danish salmon that Knud was bringing, along with a bottle of homemade schnapps, as a love offering. Finally, we reached the station just as the last train was scheduled to leave. I have this vivid, vivid memory of Knud racing up ahead, careering through the crowd, the salmon flopping under one arm, the schnapps splashing beneath the other, Vivi and I in hot pursuit. It was so tense, so nearly tragic, and yet simultaneously so hilarious. And the wonderful thing is how Knud realized this, too. How, once we'd made it onto the train—it was pulling out just as we boarded—and into our little compartment, he started laughing uproariously, as if to say, 'How silly! It doesn't matter. What do I care?' When, of course, he cared immensely."

POSTSCRIPT: WAKING UP TO HOW WE SLEEPWALK (1982)

One afternoon early last fall, Knud Jensen opened the gates of the Louisiana Museum to activists in the Danish and Scandinavian antinuclear movement. "I'm getting a certain amount of flak for this from people at other museums," Jensen told me in his office. Down below, the museum's wide lawn teemed with visitors in all kinds of attire, carrying banners and posters, gathering around booths, collecting literature, sampling pastries, and listening to a poetry reading. One group, near the edge of a small grove, huddled about a folk-

singer; others meandered through the museum's glass corridors, from one special exhibit to another. Everything was part of a calling out for peace—specifically, for nuclear disarmament. Thousands of visitors had converged from as far away as Oslo, Stockholm, and Hamburg for this day of vigilance and celebration.

"I keep being told," Jensen continued, "that it's not a good thing to mix museumship and politics like this. But I don't know. My coworkers here at Louisiana and I have gone to a tremendous effort to create this sanctuary for art, to see to its long-term preservation, so that it will be here for our children and grandchildren; I guess we consider it part of our curatorial responsibility to do whatever we can to make sure that they will be here to enjoy it."

As we walked among the Calders and the Arps, I noticed that some of the visitors carried black plastic bags filled with air, the necks tied with string. Several people had them, and there didn't seem to be any organizing principle as to who did and who didn't. If you asked what the bags signified, their carriers simply said they'd been given them at the entrance, and then moved on.

The air was beginning to cool, although the sun was still high in the sky when we heard the bells of the neighboring church ring six o'clock. We continued to stroll about, talking and listening. It must have been five after six before we began to notice: first one person and then another, and then dozens all over the grounds, stood frozen, stock-still. Children with their mothers, businessmen, teenagers, farmer types—isolated individuals all over the grounds stood deathly still, limp black bags hanging by their sides.

Only not so still after all. Looking away and then looking again, you'd see that they'd have moved, infinitesimally. They were all moving, in suspension, maybe a few feet each minute—but moving nonetheless, toward the bluff: Afternoon of the Living Dead. By six-fifteen, the "zombies" had coalesced into three vague groups; one proceeding out from the cafeteria terrace to the north, another down the gully that bisects the sculpture park, and the last setting out across the wide lawn to the south. All moved slowly toward and then down the face of the bluff. The rest of us looked on; some giggled nervously. Little kids ran up to the zombies and tried to distract them, to no effect. They simply crept on—not even grim exactly, just absent; emptily compelled. The rest of us jockeyed for position; some took photographs, while others seemed to become even more transfixed than the zombies and stood motionless, staring at their glacial advance.

By about six-forty-five, the three columns had begun to converge at the

foot of the bluff. Now they continued on out across the narrow lawn toward the sand and the sea strait, seeming utterly deliberate, utterly mindless. There were about two hundred of them. Their black bags hung limp. Any laughter from the onlookers had stopped. The silence was immediate; it wasn't that we didn't know or weren't thinking about what would happen next—time itself seemed to have congealed. Our anticipations had become as suspended as their gait. We watched.

The walkers kept advancing, inevitably; still, it was a shock when the first one entered the water. Or, rather, failed to stop at the water's edge. The wavelets slapped across the man's shoes—a few minutes later he was immersed to his knees. All the rest followed him in, mindless but determined; the sea received them. The water must have been cold, but they continued on. As the small waves rose and fell, wet clothes clung to limbs and torsos not yet entirely submerged. This death march became erotic. Cloth outlined sinew: thigh, groin, arm, breast, hair.

One child broke into tears as the water reached his waist. Unable to continue, humiliated, he bounded free of his trance and out of the water into the arms of his grandmother, who'd been watching from the shore—the strangest figure of hope I've ever seen. The others were in the sea up to their necks before they began to turn. The black bags bobbed alongside their heads; now, moving parallel to the shore, the zombies let them go. Downshore a bit, a low canoe dock jutted out from the beach, and the heads now drifted underneath it, beginning finally to arch back inland on the other side. Slowly, one by one, the sleepwalkers emerged from the water and filed—still trance-slow, dripping, shivering violently—through the doors of a large converted boathouse.

While they were still filing in, I entered the boathouse to talk with some of these walkers. Once inside, one by one they snapped to; friends offered them towels and cups of hot rum. It took over half an hour before the last made it through the doors and back to life. Kirsten Dehlholm, the leader of one of the columns, a woman in her mid-thirties with sharp features, punkishly styled, was drying her hair. "So," she asked, "what did you think of our trained snails?" We were presently joined by Per Flink Basse, a tall young man who'd headed the cafeteria group, and Else Fenger, a somewhat older woman who'd led the lawn contingent. The three of them, along with architect Charlotte Cecilie (who wasn't present on this occasion), have been work-

ing together since 1977, when they pooled their artistic resources (Dehlholm had previously been a sculptor, Basse a set designer, and Fenger a lithographer) in founding the Billedstofteater. "That translates roughly as 'picture theater,'" explained Basse, "or 'theater of the image.' We are basically a group of performance artists interested in a theater built out of spaces, rooms, occasions, images, rather than literary sources. We often try to involve others in our conceptions—we usually stage them in public spaces around Copenhagen. We almost always work in slow motion, usually exploring themes from everyday life—eating, sleeping, walking—slowing things down to help people notice them. In a way that's what we were doing here— trying to find an image, a way of helping people to *notice* what is going on."

I asked how the performance had come about. "We were contacted several months ago by the people here at Louisiana who were organizing this Peace Festival," recalled Fenger. "We came out to look at the site, since all of our performances arise from the occasion provided by the site. After we got our idea, we sent out about three hundred letters to people who had worked with us before or expressed interest after seeing our work—we've developed quite a network. We said we were planning a performance for the Peace Festival and that the one criterion was that they must not be afraid of water. As you can see, about two hundred people responded."

"We had two meetings at the beginning of the week," Dehlholm took up the story, "and then we performed our snail walk today. Most of us are strangers, but it's incredible the intimacy and fellow feeling this kind of thing brings out. Look at everyone." Throughout the large room people were hugging each other, laughing, stripping out of wet clothes and putting on dry ones. Any anxious feelings of propriety seemed to have given way.

I walked over and asked one young man, who was punching his head through a turtleneck sweater, why he'd joined the performance. "You know," he said, "a few months ago even, I was more or less ignoring this issue. But Haig and Reagan have really frightened us. When they said it is possible to win a limited nuclear war, we suddenly realized what they're talking about— they meant a war *limited to Europe*."

"It's funny," said a woman who'd been listening to us. "I had all kinds of associations during the walk besides nuclear war. For one thing I found myself thinking of the boat people in Vietnam. And then—it was so strange— I realized that this is one of the narrowest points between Denmark and Swe-

den, and that it was out of the little village harbors up and down this coast that the Danes smuggled their Jews across to neutral Sweden during the early days of the Nazi occupation."

"I don't consider myself particularly religious," another listener offered. "But I kept thinking of baptism—and death and resurrection." "For me," another woman said, "the whole thing became incredibly compelling—almost primal. It stopped being political and became biological. I felt the pull of the sea: I felt primordially alive, and then this feeling of feeling so alive came back on itself and became powerfully political. Because that after all is what we must fight now to save. Nuclear war is a threat, precisely, of primordial proportions."

A few minutes later I was standing out on the wood-plank porch of the boathouse, facing the water, talking with Jensen once again. "It's very difficult, you know," he said, "to find new images which can wake people up to the horrible reality of this nuclear-war danger; this is vital work which artists are especially qualified to take on, since their very livelihood is image-making. The whole world seems to be sleepwalking toward a holocaust. Maybe the image of such sleepwalking paradoxically can help to wake people up."

"Do you realize how long we were out there?" said Dehlholm as she joined us on the porch. "Almost two hours! It's incredible: it felt like maybe ten minutes. It was strange," she continued. "At first I felt incredibly alone, cut off, isolated. It was a scary kind of feeling. But then there came this very strong feeling of being with others, of togetherness, of communion. When two hundred people concentrate that strongly, it gives off an aura. Ordinarily you have a thousand ideas kicking around, and at first we were having our various associations, but as time went on, it became like an emptiness for us. Everything became suspended. It was like a meditational exercise.

"No," she said, and paused for a moment, searching for the right word. "No, it became like a prayer."

Twilight was descending. The strait was flat and silver, and on the water two hundred black balloons drifted out toward the gathering night. Dozens of ships, their lights gradually flickering on, coursed north and south through the narrow strait. It occurred to me that this very place—a crucial access for Soviet shipping out of the Baltic and into the North Sea—could well be one of the first targets for irradiation were a nuclear war ever to begin,

and that the folk laughing and partying in the hangar behind me could well be some of the war's first victims.

"Two paths lie before us," Jonathan Schell recently concluded in his remarkable essay, *The Fate of the Earth*. "One leads to death, the other to life. If we choose the first path . . . we in effect become the allies of death, and in everything we do our attachment to life will weaken: our vision, blinded to the abyss that has opened at our feet, will dim and grow confused; our will, discouraged by the thought of trying to build on such a precarious foundation anything that is meant to last, will slacken; and we will sink into stupefaction, as though we were gradually weaning ourselves from life in preparation for the end. On the other hand, if we reject our doom, and bend our efforts toward survival . . . then the anesthetic fog will lift: our vision, no longer straining not to see the obvious, will sharpen; our will, finding secure ground to build on, will be restored; and we will take full and clear possession of life again. One day—and it is hard to believe that it will not be soon—we will make our choice."

To say that artists and writers today have a particular responsibility with regard to this choice is to acknowledge that this particular crisis—the specter of obliteration—bleeds into all areas of human life, and most profoundly into those very areas that have always constituted the life source of culture and civilization. Being, time, vision, presence, co-presence, tradition, posterity—the fundamentals out of which art has always sprung—today all of these are in jeopardy. It's simple: artists are inexorably implicated in the current crisis of vision.

LENNIE'S ILLUSION

.

ONE NAME they'd thought of was "Better Than Suicide"
Books. That idea had surfaced around 4:00 A.M., once the three young writ-
ers were well into their second fifth of Jim Beam. They'd just committed
themselves to pooling their money and launching a literary bookstore on the
West Side of Los Angeles; so, rather than spend more time rehashing their
trepidations, which were considerable, they'd set to concocting names. "Lost
Illusions" was another possibility. Or "Books Books Books!" One of the
guys, who'd been reading Jung, had been taken with one of the voluble mas-
ter's truisms: "There are two kinds of people you can't change, intellectuals
and liars." "*Intellectuals and Liars!*" A half hour and another fifth later, Jung's
nomination won the vote.

That was three years ago. Soon thereafter the store opened near the corner
of Wilshire Boulevard and Eleventh Street in Santa Monica and quickly be-
came a literary refuge. It didn't exactly prosper—literary refuges seldom do.
But it mattered, and mattered profoundly, to a steadily growing clientele,
myself included. Money problems dogged the store from its inception.
Within six months, one partner had abandoned ship, and, within another

year, Leonard Durso was left alone, the last of the three, to steer the precarious venture into a suddenly looming recession.

It ended up being a pretty grim voyage, and, a couple of months back, Durso had to scuttle the store on the jagged reefs of California's bankruptcy laws.

Shortly after that, we were sitting in the ghost ruins of the store, Lennie and me. A month-long Going-Out-Of-Business sale had gutted the stock. The remaining miscellany had been boxed and remanded to the dispensation of the court. Lennie had never gone bankrupt before, and it felt strange. We sat there, downing Beam. Our talk returned to names, and I asked Lennie what he'd name the store today, were he to

" 'Idiot Idealism,' " he said, not even letting me complete the question. "Or no. 'The Albatross.' 'Lennie's Albatross.' "

"This was going to be a store run for and by writers," Lennie said. "That was the idea—the sort of place where people could come and browse and loiter and talk. We had a coffee machine initially, the whole first year. We only stopped because we were getting too many outpatients coming by and spilling coffee all over the books. I mean, they'd come by and get a cup to go. This one guy once, he takes his cup and asks for a lid! For a while we had a donation can, but it was pathetic: At the end of the day there'd be an empty coffeepot and one quarter. One time somebody even stole the donation—that was really heartbreaking."

Lennie's manner had always been wry laced with sorrow. Even now, when the pain was most palpable—the dark eyes somehow more liquid, the once trim beard a bit more shagged out—the open, vulnerable humor was still there. He downed another shot of bourbon.

Durso is thirty-three. He grew up on Long Island, went to school at Bowling Green in Ohio, as did his two partners. For a while he acted, then increasingly he took to writing—plays, poems, novels. He worked in bookstores, jousted with the Selective Service System for several years, and for many years thereafter worked for the Boy Scouts, of all things. Running a bookstore in California was some kind of cockeyed dream. Maybe he just picked the wrong years to try.

Still, for the three years of its existence, Intellectuals and Liars was, after

its fashion, a considerable success. It had one of the best poetry walls in the city and certainly some of the most convivial poetry talk. Most weekend evenings the long, narrow, ramshackle space would find itself entired by spirited readings and after-reading spirits. It was the sort of place writers could visit most any time and find some kindred souls, likewise procrastinating, parsing everything from Dostoyevski to Coover to the current baseball standings. Everyone sensed that the operation was marginal at best, but one tried not to think about that, because it provided such a rich context in a city so lacking in contexts.

There are a lot of reasons Intellectuals and Liars went under. Lennie would be the first to tell you that he did some things wrong. He probably overemphasized poetry. ("That poetry wall was sustained by the fiction—trouble is, I threw more money into the poetry.") He probably overindulged the esoteric. ("As we began, we made sure to stock up on all sorts of books you'd never find elsewhere. But many of those volumes are still here—I can't even unload them in a 40 percent sale. And they just soaked up funds I should have been using on the classics. I mean, when you run out of Tolstoy, that's tragedy. When you run out of Dan Curly, who the hell cares?") And from the start the store was underfinanced. ("Maybe we shouldn't have started in the first place when we failed to reach our initial capital goal. Maybe the whole thing was a mistake.") But two causes loom over all the others—the relentless conglomeration of the book trade and the onset of the current recession.

"You know," Lennie said, "I'd like to think that publishers at one time really cared about what they published and really cared about the survival of small bookstores. Because small bookstores had to be the backbone of their sales, serving the community, sustaining the backlist—not only selling the current best-selling volume of some author but also his earlier tries. But that's changed. And it's not the editors' fault. It's not the salespeople's fault. Most salespeople are terrific people who really care about books; some once owned stores, were book people—only a few could just as well be selling shoes."

Well, whose fault is it then?

"Management. Almost all the once-independent companies have been swallowed up by conglomerates where policy is set principally by accountants and the principal policy is expediency. I mean, look at it: CBS owns Holt Rinehart, Times Mirror owns NAL, some railroad almost just took over

Houghton Mifflin. And it goes the other way, too. Harcourt Brace owns Sea World! Only publisher who ever suffered a loss because their whale got sick. Some poor schmuck novelist got a sorry note—they couldn't publish his first novel because Snafu the Whale got diarrhea.

"So there's this division between the sales department and the credit department. Now, you'd think it would be to everybody's benefit that the store lives. But the credit people could care less. Just as it's easier to focus on big blockbusters—Harold Robbins, The Joy of Diet Sex, and so forth—so it's easier to deal through big chains.

"Why should publishers care about a little dippy store that maybe grosses $70,000 a year? B. Dalton nationwide probably does that in half an hour. And the publisher dealing with B. Dalton doesn't have to go to each store. He goes to Minneapolis, where one buyer buys for the whole country. That makes for a nice homogenous national culture, which is comfortable and is the best way to deal—*for them*. That's the way they give us cereal, so why should we get books any other way? But it's murder on small bookstores."

How so?

"Most companies for instance have a thirty-day policy. You have to pay for your order within thirty days or you're put on hold, they won't send you any more books. That's crazy. That means you have to turn over your entire inventory every thirty days. You can't do that if you're a small bookstore, especially if you stock backlist. Now, I know a lot of stores—the book comes in—if it doesn't sell in a month, they just ship it back. We used to keep such a book for at least six months. I gave it a chance. I thought that's what they wanted me to do, let people hear about it, give the book a life. As a writer, I tried to treat the book the way I'd have liked my book to be treated.

"But many of the credit departments have no conception that some of us out here might be trying to run a different kind of operation from B. Dalton's, and that credit policies that make sense for a mass-market mainline store don't make any sense for an intimate effort like this. Some of the credit managers, like the guys at Penguin and Norton, they were at least human beings. But others—Random House!—don't get me started on Random House!"

During the last eighteen months of the store, when somebody would come in and ask for a title, Lennie would ask them who the publisher was, and if it was Random House, he'd tell them to forget it.

"Yeah, they were always putting me on hold. I'd fallen behind in my payments and they weren't going to ship me any books till I caught up. But how was I supposed to catch up if they didn't ship me any more books? If you don't get a steady supply of new things, it gets harder to sell what you have—people don't look as hard."

I asked Lennie what it was like to deal with the credit department at Random House.

"You mean like the time near the end when Random House would not send me copies of one of their books for which I was having a reading—they wouldn't ship me the box unless I paid for all the copies up front—you mean that conversation?"

Yeah, okay, that one.

"It was very tense. I told them to shove it. I told them they were very suppressive people, they didn't give a damn about small bookstores, that this wasn't some kind of joke, this was my life."

What did they say?

"This guy was a robot talking. Ticker tape spewed out of his mouth: Yes, yes, no, I understand, yes, no, we can't do that, policy, balance due, no. You can't even get those people angry."

Even faced with such obstacles, the bookstore had managed to contrive a tentative progress into its second year. Last summer things were moderately healthy, business was slightly ahead of where it had been the year before. But starting with September, sales began to fall precipitously. I asked Lennie what the recession had meant to him.

"It meant I couldn't pay my bills anymore. And why not? Because the dollar isn't worth anything anymore. It meant that people who would normally have bought three books now only bought one. People who used to come in once a week now came in once a month, because they couldn't afford to come in more often. Or they didn't come in at all anymore because they felt guilty. They'd have liked to support the store but they couldn't because the bag of groceries cost twenty-five dollars and it only gave them two dinners, some paper products, and some soap.

"The last few months, sales were off 40 percent. Let's talk about March and April when I would sit in the store from ten in the morning until seven at night—six days a week—and some nights, counting out at the end, I'd only

have thirty-two dollars total in sales. One week we did under five hundred dollars. You know what that does to you?"

What does it do to you?

"It kills you. Little by little I was dying here. I mean, I'm only selling books I care about. I'm not selling crap. You have this store you care about and you're bringing in thirty dollars a day, five hundred dollars a week, two thousand dollars a month, which barely pays your fixed expenses, doesn't even pay the publishers anything, they're calling you and hounding you, when are you going to pay? You feel like shit."

Was there a final straw?

"Well, add to all that the fact that my expenses were simultaneously rising. I guess the last straw was when the building changed hands and the new landlord announced he was almost doubling the rent. I couldn't afford the new rent, but I couldn't afford to move, either. I guess I just realized that was it, it was over, I'd failed. I tried to negotiate with various credit departments, but one after another they turned me over to collection agencies, and at that point it becomes hopeless. So, with a great deal of sorrow, and even more a feeling of guilt, I had to declare bankruptcy."

During a period of weeks, whenever I'd spoken with Lennie about his impending bankruptcy, I'd been struck by these pervasive feelings of guilt. The failure I could understand, but the guilt eluded me. I asked him about it.

"It's just the American way, I guess, and the Italian way. I mean, it's not as if I've been hoarding all this money . . ."

How much had he taken from the store those three years?

"Funny you should ask," Lennie said, breaking into a wide grin. Reaching into his pocket, he pulled out his wallet, extracting and unfolding a crumpled index card onto which he'd scribbled a file of figures. "I keep this here just in case I ever start flirting with the idea of another store. Let's see. This is the money I took from this store—not including all the money I was putting into it at the same time, not counting the $14,000 that I poured into this thing initially and which I'll never see again. Okay. 1977—that was a good year, or actually half a year—$2,808. 1978—another good year, my first partner had split, for the whole twelve months, $2,605. Then 1979, the peak year, both partners have split, I'm all on my own—$1,938. And finally,

1980, up through April, when I decided to put this thing out of its misery, $545. A nice even bell curve. Three years: $7,897."

So why the guilt?

"I averaged $2,600 a year those three years and I feel guilty because the publishers won't get it. They're only going to get a percentage. I was trained as a child that you don't borrow something from somebody and not pay them back."

But what if the economic system is designed so as to make you fail?

"Sure, sure," Lennie interrupted. "But nobody told me to open this store, nobody told me to specialize in this stuff. I have to accept that responsibility.

"And I feel like maybe I should have done more. A million things go through your head—you didn't do enough. Granted I put in all those hours, lost all that money, the dentist and the doctor visits I never allowed myself, the personal life that was affected, the friendships ruined, the tension, the pressure. But that was my decision, so I feel like somehow I didn't do enough.

"I don't know," Lennie said. "I guess we're trained to think that if we want something bad enough, it succeeds. If you love somebody enough, you'll be able to live with them forever. Of course, at another level, we know that's a lot of crap—love can't keep a marriage together or a store going. Turns out there's more to life than caring. I don't know: Maybe it's a crime to want to do only what you want, what matters to you. Anyway, I feel guilty."

What had been striking to me for some time in all of this was how, except for a few isolated run-ins with robotoid credit managers, Lennie's guilt just would not translate into anger. Guilt is sometimes stoppered rage, and there was no dearth of occasion for rage in Lennie's tale. For starters, rage at a corporate system that could calmly deign the bankruptcy of X-thousand small businesses and the forced layoffs of X-hundred thousand factory workers as a legitimate means of "cooling off the economy." Instead of getting angry, Lennie seemed to pour it all back in on himself.

"How do you answer that?" Lennie countered, after a moment's quiet reflection. "All I know is that what I was doing here I cared about a tremendous amount and a lot of people cared about it and I feel guilty because I couldn't make it work. *I* didn't make it work. It doesn't matter whether anyone else could have made it work. I don't care about anyone else."

Lennie subsided again for a few moments. We refilled our cups, he went

back to nursing his. As he resumed, free-associating, it began to seem a little clearer that the guilt wasn't entirely self-induced.

"Nothing's worse than talking to somebody over the phone and you tell them you sent a check and they call you a liar. And you did—you *did* send the check. You just want to die. It gets so you don't want to answer the phone anymore. You don't want to open the mail. 'Cause it's the same old shit—more bills, more threats, more demands. Nothing can make you want to do that."

"You put yourself through all this abuse," he continued, "and all you're trying to do is sell poetry and quality fiction. A nice drama section. You're just trying to sell some nice stuff, and these assholes jump all over you like you're some criminal, as if you just murdered some family, you wiped out the seven Dimicos, they're all gone, there are no Dimicos left because you killed them all in your shameful wickedness. And all you were trying to do was sell Kingsley Amis."

But it works, I pointed out. "You do feel guilty."

"Yeah, well, I do. In the long run it doesn't matter whether I succeeded at this—this is a piddle in the universe—but no one told me to do it. No one said, 'Leonard, go open a literary bookstore in West L.A. because they need one.' I did it of my own free will.

"It was a matter of drawing the line: 'This is how I as a person am defining me, here are my definitions.' And you lay them down. And you stand by them. That's all I did here. And I couldn't stand by them."

And that, finally, is what the guilt is all about.

"It doesn't matter whether it was my fault. It doesn't matter if the economy is collapsing. The point is, the lines were laid and I couldn't keep 'em there. This store, which was my line, my statement, is over. It's finished. The guilt is that it's no longer here—that I, with all my background, my smarts, my charm, my talk, my bluff, couldn't keep it going. Basically I just bluffed for three years. It's like I stayed in the bar for three years getting beat up. Stupid. Just to prove some point. And I don't even know what the point was anymore. And now I've been thrown out. And I'm not going back in."

Lennie smiled, always one to find sustenance in an apt metaphor.

So, I asked him—so, what are you going to do now, guilty person?

"I'm going to lay low for a long time," he laughed. "I'm going to disappear. I'm not going to be seen. I'm leaving my ex-partner's number as the forwarding address. I'm going to move back to New York, get a job, make real

money, feel what it's like to go to movies on a regular basis, to live a normal life and not feel like a fugitive or an indentured servant. Not space out in the middle of a conversation because the Kramerbooks bill just passed through my mind. I'm going to try to get back to what I'm supposed to be doing, get back to my writing."

Notwithstanding the mire of the past year, Lennie is first and foremost a writer. In fact, he's an exceptional novelist. Once of his manuscripts, *Rizzo and Mike*, which has been kicking around New York publishers for some time now—just a little too intimate to have any chance at blockbusting—may be the finest thing I've read on what it's like to try and sustain a relationship to-day—the need for commitment, the fear of commitment (Mike's short for Michelle). I mention this because Lennie opens the novel with an epigram that could just as well serve as epitaph for his bookstore. It's from the "Match-book Poem" by Paul Blackburn, and it reads:

> BUT WHY do you always go to the wall?
> Why does he go to the wall?
>
> You go to the wall
> because that's where
> the door is
>
> maybe.

Postscript (1988)

Lennie did move back to New York City, where he soon got a job managing a discount shoe store. "If I was going to have to sell books as if they were shoes," he'd sometimes quip wistfully, "I'd rather be selling shoes." After that he managed a television set rental outlet. He wrote a novel that at one point he was going to call *Retail*. Some years later, he got a job running the student store and teaching English and Speech at a prep school out on Long Island, which is where he is today. He has assured me that, no, he's not going to stock this book in his student store and that, furthermore, if any of his students so much as hears about it, he's going to kill me.

SLONIMSKY'S FAILURE

.

I.

NICOLAS SLONIMSKY is continually driving his daughter crazy, and it's not just because he named her Electra, although that certainly didn't help. To hear Slonimsky tell it, he chose the name because it means "amber" in Greek, or because it contains "good hard letters" like *E* and *T* and *R* missing from his own name, or for some such reason. "But can you imagine what it was like growing up as a kid in Boston with a name like that?" his daughter asked me recently, seeming palpably to shudder at the memory of the experience, though it's over forty years past. "That name was a blight, a plague—it was like lugging around an extra leg, or having another eye sprouting out of the middle of my forehead. You know how terrifically cutting kids can be, and naturally they're going to grab on to something like that." But it's *not* that. Nor is it because of some of the other—well, peculiar aspects of her upbringing. For instance, the way her father insisted on conversing with her almost exclusively in Latin during the first five years of her life. This is one aspect of the enterprise that Slonimsky himself—a spry, animated, and exuberant ninety-two-year-old who is considered to be one of the

foremost musical lexicographers in the world—seems particularly to savor to this day. "Yes, we'd have long conversations," he told me when I was visiting him a few months ago at his home in West Lost Angeles. "I'd imparted to her a vocabulary of several hundred words, and they were part of the lingua franca of our household: *auris*, *oculi*, *fenestra*, *nummi*. Visitors were always tremendously impressed by her precocity. Over time, she became somewhat ambivalent about it, I suppose. Once, she picked up a feather and held it out to me. I dutifully told her '*Pluma*,' and she countered, 'No, Daddy, the way Mommy would say it!' And then, one afternoon, she came home and angrily announced, 'Daddy, it's not true! *None* of the other daddies speak Latin to their kids at home.' After that, she'd simply stare at me blankly whenever I tried to revive our Latin conversations."

Electra is not charmed by the tale. "It was basically a trained-seal act," she says, dismissing her apparent precocity. "I mean, what does it take to teach a child what is basically the wrong word for something? In fact, if anything, it was a mild case of intellectual child abuse." Electra is likewise uncharmed by her father's delight in recounting his experiments to determine innate predisposition toward either consonance or dissonance in music. "I was curious whether people automatically start out by favoring consonant musical experience or whether it might be possible to pattern an infant toward a preference for dissonant experience through some sort of behavioral conditioning," Slonimsky recalls. "So, for a while, whenever I was home alone with her and she'd awaken crying for her bottle I'd immediately rush over to the piano and launch into some lovely Chopin nocturne, utterly ignoring her urgent entreaties, and continue to play like that for about a minute. Then I'd pause for a moment, pound out ten seconds of the densest Schönberg, at which point I'd immediately hand her her bottle." The experiment appears to have worked, though perhaps not as Slonimsky intended: Electra reports that today, notwithstanding her remarkable genetic inheritance from her father, she finds herself entirely unmusical. But none of that is what drives her crazy about her father; indeed, she reports that while she was growing up she generally found her eccentric dad vastly amusing and great fun to be around.

No, what exasperates her is her father's seeming inability to make anything of his career; his endless tendency to squander his immense talents; his ongoing failure to focus. That and his total lack of self-discipline. It's a surprising indictment, especially since on the surface her father appears a man of

overwhelming accomplishment: his résumé, if he were any longer bothering to keep one, would include sterling achievements as a piano accompanist to several world-renowned singers during the twenties, as secretary and "piano pounder" to the conductor Serge Koussevitzky (first in Paris and then in Boston), as a professor of Slavic languages at Harvard University, as a composer of considerable distinction, and as a path-breaking conductor who introduced major compositions in the canon of avant-garde music—all this before, quite late in his career, he launched into his new vocation as musical lexicographer. The charge of indiscipline seems especially untenable. In the past couple of years alone, Nicolas Slonimsky has managed to bring out three new books: the seventh edition of *Baker's Biographical Dictionary of Musicians*; a Supplement to his authoritative *Music Since 1900* (a day-by-day "descriptive chronology" of musical birth dates, death dates, premier dates, and all sorts of musical arcana) and his translation of a major Russian biography of Alexander Scriabin.

Most surprising of all, however, Electra's is an evaluation that Slonimsky himself shares, endorses, and even amplifies. "You see, I *am* a failure," he says bluntly. "It's true. My life has been an enormous disappointment." He reaches for a huge sheaf of typed pages stacked on a nearby table. "Here," he says, plopping the pile in my lap. "I've even acknowledged as much in the title of my forthcoming autobiography." "Failed Wunderkind," the manuscript's title page announces portentously, in boldface, and, beneath that, in a lighter typeface, the subtitle "A Rueful Autopsy." The cloud of seriousness has fled the room, and Slonimsky is beaming. "Autopsy, yes? That's precisely correct usage. Not the dissection of a body, of course. Rather, from the Greek: that's auto, 'self,' and ops, 'eye'—hence, self-observation. You can look it up. The publishers are dubious, but I told them they could look it up, too." (I subsequently did; the publishers may have a point.)*

With Slonimsky, it's hard to tell: he's cheerful and expansive almost all the time, and perhaps that facade indeed merely masks interior desolation; on the other hand, his sense of the tragic undergirdings of his life, whenever he does allow himself to show it, almost immediately melts away to reveal an antic humor, grounded in a yet wider perspective. In any case, whether happy or sad, content or disillusioned, he is continually and freshly open to the won-

*The publishers, at any rate, retitled the book for publication. A failure even at failure, Slonimsky had to make do with their dictate: *Perfect Pitch* (Oxford University Press, 1988).

drous structure of language itself—be it musical or verbal—and through the grace of this linguistic fascination he is at all times momentarily on the verge of transport.

"When I was six years old," Slonimsky's autobiographical manuscript begins, "my mother told me I was a genius." Paragraph break. "This revelation came as no surprise to me." Slonimsky's putative genius had an air of inevitability. Indeed, he reports a few paragraphs down, "So precocious was I that even before I was born and before my gender was determined, I was named Newtonchik, a diminutive Newton."

As we sat talking in his living room, Slonimsky commented, "My family, you see, had been a hotbed of geniuses for generations. All my ancestors were intellectuals." As he spoke, I recalled the opening sentence in Slonimsky's *Baker's* entry on himself: "Possessed by inordinate ambition, aggravated by the endemic intellectuality of his family on both maternal and paternal branches (novelists, revolutionary poets, literary critics, university professors, translators, chess masters, economists, mathematicians, inventors of useless artificial languages, Hebrew scholars, speculative philosophers), he became determined to excel beyond all common decency in all these doctrines; as an adolescent, he wrote down his future autobiography accordingly, setting down his death date as 1967, but survived."

"In short," he now summarized, "my family were model specimens of that extraordinarily peculiar and uniquely pointless species, the Russian intelligentsia."

Los Angeles seems a long way from St. Petersburg, where Slonimsky was born, and 1986 a long way from 1894, the year of his birth. And yet he seems at ease here, and he certainly doesn't look—or behave—like a man of his years. "The other afternoon, I went to the movies, as I often do," he told me at one point, "and the cashier refused to give me a senior-citizen discount unless I produced some valid identification. I was so flattered I gladly paid full fare."

I asked him about his health in general. "Listen, I don't have *time* to be sick," he replied. "I could use a good nervous breakdown, or even a cold, but I can't work one in with all my deadlines. Actually, though, I seem to be in good shape. A while back, during a physical, my doctor wanted to test my hearing, so he put some earphones on my head, sat himself down behind some

complicated-looking machinery, adjusted his dials, and then played two tones, asking me which of the two sounded higher. 'Well,' I told him, 'the first one was 3,520 cycles per second and the second was 3,680 cycles per second. Is that what you mean?' He rechecked his dials and then looked over at me, dumbfounded. But, I mean, that was just sheer exhibitionism of the worst kind—an ongoing problem with me. Anyway, the point is, though I may not be endurable, I *am* durable."

Slonimsky lives alone—as he has since his wife's death, in 1964, when he first moved to Los Angeles—but over the years he has enjoyed the companionship of a succession of devoted secretaries and oblivious cats. The secretaries are invariably beautiful young women, the more innocent of culture the better, as far as he's concerned—although the current pair, Laura Kuhn and Dina Klemm, arrived on the scene extremely well read and musically sophisticated. In the past, Slonimsky has particularly savored his role as mentor, guiding the cultural tutelage of these wards, whom he and everyone else (including the young women themselves) refer to as his "odalisques." Month by month, year by year, Slonimsky and his odalisques have compiled their files and piled their galleys while the cats have lounged indolently about. "First," as one of the odalisques recalls, "there came Mango and Papaya. They were then succeeded by Dorian Gray, a gray cat who was supposed to age and grow old in place of Nicolas—*and did!* And now his latest cat, a fluffy black-and-white, is named Grody-to-the-Max."

WARNING: HOUSE GUARDED BY ATTACK CAT, announces a scroll tacked to the white front door of Slonimsky's house, a light-green bungalow, which is one of a series of such bungalows in a quiet residential-tract neighborhood about a half mile from the Santa Monica Freeway. But the door is usually ajar, and the only thing Grody appears to be guarding is his own languor. The front door opens into a living room with beige walls and a beige carpet, on which a wooden rocking chair is pulled up close to a rectangular glass-topped wrought-iron worktable in the middle of the room. Over to the side is a fairly beat-up upright piano, and on top of the piano, occasionally (not always), is a blown-up photograph of a human skull. "That is the cranium of one J. S. Bach," Slonimsky will inform you, if you can't restrain yourself from asking (though he's also perfectly content to hold his peace and watch you eyeing the photograph nervously). "Don't even ask me how I managed to dig it up—we haven't got the time." The walls all around Slonimsky's worktable are fes-

tooned with a gallery of ghoulish nonsense—bizarre tabloid headlines, M. C. Escher conundrums, a reproduction of an 1853 painting by William Holman Hunt entitled *The Awakening Conscience*, which depicts a male pianist reaching seductively toward a young, demurely clothed female student. ("When I was growing up," Slonimsky volunteers, "that image represented the height, the very pinnacle, of depravity.") Beyond the piano is a plain, not terribly well inhabited kitchen; through another door is the file room, with the odalisques' desks and typewriters; off down a corridor is Slonimsky's austere bedroom, with a narrow single bed facing a framed copy of Richard Avedon's famous photograph of a naked Nastassja Kinski, reclining seductively, draped by a huge snake. One of Slonimsky's odalisques got it for him, to replace a poster he used to have there of a heavily bearded old man, recumbent and seemingly asleep: Brahms on his deathbed.

Slonimsky is clean-shaven—a short man of odd shape. He has written of "the unfortunate lack of Grecian golden mean" between the parts of his body. He has the legs, shoulders, and arms of a slight man, and then, as he says, "where other people have abdominal cavities, I have an abominable convexity." His belly balloons—the buttons on his shirts (usually plaid flannel) strain to contain their unexpected bounty (any shirt that fits him at the shoulders will at best barely suffice to encompass his midriff). But then everything tapers precipitously from the waist down: I'm sure he hasn't seen his belt in years, not even in the mirror. I have read rave reviews of concerts in the twenties and thirties in which he was said to resemble a "young gentleman out of Pushkin's Byronic pages" or, in another context, "Napoleon at Marengo." Today, he resembles a skinny tenor trussed up with vast pillows for a stint as Falstaff. Walking, he pads along like a fat man, gingerly, carefully; talking, his arms and hands dart all over; seated, listening, he crosses his arms and rests them atop his belly as if on a bar counter.

His face is smooth, virtually without wrinkles, like a turtle's; it rests on a neck that is jowly, like a turtle's, too. He has a turtly beak nose, which swerves abruptly, halfway down, to his left, like a freeway on-ramp. It wasn't always thus: when he was a youth, his nose was beaky and *straight*, but in 1916, in Revel, the capital of Estonia, while serving as rehearsal pianist with a provincial opera company and walking across a darkened backstage area, he fell through an open trapdoor and landed on his back, entirely unscathed except for a chair he'd grabbed falling, whose leg now stabbed smack into the middle

of his face. No blood, but a crooked nose forever after. His wide, smooth fore-
head is crowned with a thatch of gray hair, parted virtually down the middle
and shagged to either side. Down below, the forehead ends in two incon-
gruously black circumflex eyebrows, which are seldom still. Nowadays, his
eyes are milky blue, with large, cloudy pupils. People who knew him years
ago have described his eyes as beacon-black, and perhaps they were darker
then. They still seem to shine—indeed, they pierce.

His eyes pierce, but it's his voice that captures and holds. It is high and yet
throaty, accented and yet clear and assured, somewhere between Dr. Ruth
("Good Sex") Westheimer and Clara ("Where's the Beef?") Peller. It is a voice
that invites study—and, in fact, it has *been* studied, by one Charles Amirk-
hanian. Amirkhanian, the music director at KPFA, the Pacifica radio station
in Berkeley, is also a poet and composer. He is one of the leading American
proponents of text-sound composition; that is, the manipulation of taped
word and phrase fragments into musical form through repetition, accelera-
tion, deceleration, cross-tracking, and so forth—a battery of advanced tech-
niques that result, in Amirkhanian's case, in a sort of restless minimalism.
On several occasions, he has used taped interviews of Slonimsky as raw ma-
terial for his compositional forays. Being a percussionist as well, Amirkhan-
ian likes to think of words as percussive objects, and he finds Slonimsky's
words particularly easy to think of in that way. "He's always speaking with a
lot of energy, from the gut," Amirkhanian told me one afternoon when I
asked him to describe Slonimsky's voice. "He's always aspirating, enunciat-
ing, trying to make himself clear. He can't manage an American accent for
the life of him—consonants are always intruding at the beginning and end of
words. I called one of the pieces in which I used his voice 'Heavy Aspirations.'
But the contour of his voice is remarkable: he punches the words out, as dis-
tinct entities, in extraordinarily complex rhythms—rhythms that I think are
related to his musical rhythms, his conducting and piano rhythms. And then
there are those odd things—for instance, the way that when he's thinking, or
gathering his words, instead of a typical flat 'uuunnnhhh,' his voice goes
through amazing extended timbral changes, like what you get with a Tibetan
monk. It's a high voice but with profound authority. The high energy of the
voice relates to the high energy, the boundless energy, of his life. He centers
on a story and becomes full of himself, but in an attractive way: he's giving
himself over to the listener through his voice."

As Slonimsky and I sat talking in his living room, he was still giving himself over to stories of his family background, in St. Petersburg and before. "Our family was, if anything, *plus Russe que les Russes* in our passion to be seen as members of the intelligentsia, because in fact we were just passing," he said. "You see, we were Jewish—a fact which my mother, especially, regarded with horrendous shame and tried to keep hidden from us children for years. Indeed, in our family there were two great taboos. The first was sexuality. One time, a doctor friend of my parents was visiting and asked my mother how she was handling the topic of human sexuality with her three teenage sons. 'Sir,' she interrupted him severely, 'this is a *literary* family.' And, indeed, there was no instruction on the topic whatsoever, except for the persistent admonition that kissing would lead inexorably and inevitably to syphilis, a prospect before which I lived in continual terror, not so much for fear of the physical consequences, which, I assure you, my mother had rehearsed for us in morbid detail ad nauseam, as out of the dead certainty that were I ever to contract the disease she would immediately broadcast my dread condition to everyone within miles.

"The other taboo, as I say, was Jewishness. We had all been baptized in the Russian Orthodox Church. I mean, we weren't believers or anything; we were confirmed agnostics. I for one have always found transubstantiation difficult to swallow, figuratively speaking—not that I later felt any special reverence for the Jewish God Jehovah, either: for one thing, his punishments always seemed wildly out of proportion to the offense in question.

"Our baptisms were only part of a massive effort, especially on my mother's part, to render us as Russian as possible. For instance, she named my oldest brother Alexander, after the czar who had been assassinated just two months before his birth, and I was named Nicolas, after the czarevitch at the time, who became the last czar, Nicholas II. My mother used to account for our obviously Jewish physiognomies by reference to our 'noble Roman heritage'—whatever that meant. I was so protected from the horrible fact of our Jewishness that I used to imagine Jews were some ancient tribe, like the Sumerians or the Babylonians, and, in fact, one day, the story goes, I asked the poet Nicholas Minsky, who was married to my cousin (and after that to my aunt), whether any Jews were still alive. 'I wish I could see a real Jew,' I'm supposed to have said, to which he is said to have replied, 'Go look in the mirror.' Apparently, the hint didn't take, because it wasn't until I was fifteen that the

traumatic revelation struck me with full force. I was looking my father's name up in the Russian encyclopedia, and the entry opened with 'Son of the preceding.' The preceding turned out to be one Chaim Selig Slonimsky, who was described as an eminent Hebrew scholar and scientist. So it was true after all."

Nicolas's father's *grandfather* Abraham Jacob Stern was one of the first eminent geniuses on the Polish branch of Nicolas's bountiful family tree. He was born in 1760 (just three generations separate Nicolas from the heart of the eighteenth century) and was renowned as the inventor of a sophisticated calculating machine—an early precursor of the computer or an awesome elaboration of the abacus, depending on how one chooses to look at it. "This device achieved such fame," Slonimsky told me, "that my great-grandfather was summoned to bring his machine for an audience before Czar Alexander I, Savior of the Russians, Victor over Napoleon, who was known to dabble in the sciences. He complied, and after he'd demonstrated the intricacies of the machine the czar challenged him and the machine to an arithmetic contest. The czar had previously instructed the court chamberlain to prepare a sequence of arithmetic computations—addition, subtraction, multiplication, division—and now the man read them out. My great-grandfather set to work at his machine; the czar dipped his quill into a nearby inkwell and was just completing his first calculation when already my great-grandfather announced the final result. The czar looked over at him, then at the chamberlain, who nodded confirmation as to the correctness of the announced result, and then pronounced solemnly, 'The machine is good, but the Jew is bad.' "

Stern's daughter Sarah presently married Chaim Selig Slonimsky, who was born in Bialystok in 1810. Chaim Selig had pursued rabbinical and Talmudic studies alongside some remarkably precocious—and remarkably secular—scientific investigations right up through his nineteenth year, when, marrying Sarah Stern, he moved in with his new father-in-law. In subsequent years, he perfected Stern's calculating machine, adding the capacity for extracting square roots. In 1862, he founded *Ha-Zephirah* (Daybreak), one of the first Hebrew-language periodicals, which continued publishing, in the spirit of the modern Jewish Enlightenment, until 1931. Chaim Selig Slonimsky has a prominent entry in the *Jewish Encylopædia*, where he is credited with having popularized all manner of contemporary sciences for Polish and Russian Jews of the period. Nicolas had stories for me about this grandfather as well: "My mother used to say to me, 'He was a genius, but an impractical one. Don't fol-

low in his footsteps.' For instance, she'd tell me how one day, while puzzling over the question of instant communication from a theological point of view, he'd invented a prototype for an advanced form of telegraphy. But the act of invention appears to have satisfied him; he felt no need to publicize or patent his invention. 'There, Sarah,' he said to his wife, folding the sheet of paper and placing it high above a cupboard. 'Let's see how long it takes *them* to figure it out.' And several years later, when word of the new invention was published, he reached for his sheet of paper, examined it, clucked contentedly, and announced, 'Well, they got it right.' Or, anyway, so my mother claimed. The amazing thing is that in more recent years the Soviets have taken to publicizing an identical claim on his behalf." Chaim Selig Slonimsky died in 1904, at the age of ninety-four. "So," his grandson concludes, "that means that I must still have a few years to go myself."

Chaim and Sarah Slonimsky had three sons, of whom two lived out their lives in Warsaw and the third—Leonid, Nicolas's father—eventually went to live in St. Petersburg. Leonid's brothers, Stanislaw and Josef, were themselves fairly remarkable. Stanislaw was a much-beloved doctor, and *his* son, Nicolas's first cousin, was Antoni Slonimski, one of the foremost poets and satirists in modern Polish literature. Antoni was continually in trouble with the Communist authorities in postwar Poland. (The Communist Party chairman Wladyslaw Gomulka had at one time been a personal friend of his. But one day Gomulka questioned him about his relations with acquaintances in the former wartime London government-in-exile, and Slonimski replied, "Friend Gomulka, I cannot stand physical pain, so please don't waste your time calling in your Star Chamber boys—just list my crimes and I'll sign the confession," whereupon the friendship came to an abrupt end.) "Something I learned just recently," Slonimsky told me, "is that Antoni's personal secretary in the years just before his death, in 1976, was Adam Michnik, this young fellow who went on to become such a leader in Solidarity. So nowadays when I'm being hounded by my publishers because of my perennial tardiness I plead with them, 'Yes, I admit it, I'm late, I admit to everything, but my cousin was like a godfather to Solidarity. Surely that must count for something!'"

Josef, the other brother who stayed in Warsaw, was "a linguist with a passionate obsession for completeness," his nephew recalls. "He knew every single European language fluently and passed his time composing phrase books

for use by citizens of one country on their travels inside another one, covering just about every circumstance in every conceivable permutation. My personal favorite was the Norwegian-Yiddish booklet. Years later, Wanda Landowska, the Polish harpsichordist—now, *she* was some baby—told me a story about how one young man had approached my Uncle Josef inquiring whether he could enroll with him for six weeks of intensive Spanish lessons in preparation for an upcoming assignment in Brazil; my uncle complied with the request, the student progressed quite nicely, and on the last day, after the student left the apartment on his way to the train station, Uncle Josef turned to his wife and said, 'Boy, is that young man going to be surprised when he finds out it's *Portuguese* they speak in Brazil.' But, anyway, he is the one who devised that utterly forgotten, utterly forgettable language which he called Universal Romanic, which even lost out to Esperanto, the invention of a similarly obsessed contemporary of his in Warsaw, in that particular sweepstakes for futility."

The third brother, Leonid, moved to St. Petersburg, where he married Faina Vengerova, Nicolas's mother. Toward this bearded, fairly withdrawn and remote but kindly father of his, Nicolas still harbors feelings of devotion and admiration, especially for his many scholarly publications, which, as a young boy, Nicolas imagined constituted the very pinnacle of worldly achievement. Leonid Slonimsky was the foreign-affairs editor of the liberal St. Petersburg journal *Messenger of Europe*. He was also the author, in 1890, of *The Economic Doctrine of Karl Marx*, one of the first books on Marx ever published in Russia. "Tolstoy read the book and seems to have made extensive notes in the margins of his copy," Slonimsky says. "Lenin read it, too, and because of this my cousin Antoni years later told me—only half-facetiously, I'm afraid—that he held my side of the family responsible for the whole Bolshevik business. Lenin himself, however, had some pretty nasty things to say about my father. In a pamphlet published in 1894 in the Russian underground, he dismissed my father as 'an ordinary liberal, utterly incapable of understanding contemporary bourgeois society' and argued, for good measure, that my father's soft spot for the idea of peasant ownership of small plots of land simply revealed his 'reactionary utopianism.' I don't know: with us he was always a mild, fairly befuddled man, with his head in the clouds, and his status entirely overshadowed by the huge, overbearing presence of my mother."

Faina's family heritage, when her son was finally able to ferret it out, years later, turned out to stretch all the way back to the Maharal of Prague (1525–1609), the great rabbi who was said to have fashioned the legendary Jewish robot known as the Golem. One of her second cousins was the renowned chess master Semyon Alapin. Faina's mother, Pauline Epstein, married a rich Jewish banker, Afanasy Vengerov, had four children, and lived to a ripe old age, at which time she published a book entitled *Memoirs of a Grandmother*, which became something of a Victorian best-seller. "In that book," Nicolas told me, "she included a scathing denunciation of her children who'd lost their faith, allowing themselves to become baptized, and then of the third generation, who, she said, 'feared neither God nor the Devil.'" Nicolas paused and gulped melodramatically, his eyes widening. "That's us," he then continued, in almost reverentially hushed tones, "my generation, the ones who feared neither God nor the Devil—that's really something."

Faina's brother Semyon was renowned in Russia as a professor of Russian literature, a tireless editor of Pushkin, and the compiler of a celebrated critical-biographical *cartothèque* of Russian writers. Her younger sister Isabelle Vengerova was a superbly gifted pianist, who contributed a great deal to Slonimsky's early development and, years later, after moving to America and attaining a professorship at the Curtis Institute, in Philadelphia, contributed even more to the careers of Samuel Barber, Lukas Foss, Gary Graffman, and Leonard Bernstein (who called her his Beloved Tyranna).

Slonimsky's mother became one of the first women medical students in Russia, studying chemistry under the composer-scientist Alexander Borodin. But, to hear Nicolas tell it, she gradually abandoned that career so as better to be able to rechannel all of that inherited, imperative energy into wreaking domineering havoc on the lives of her children. The first of these, Alexander, born in 1881, became another noted Pushkin scholar; then came Julia, in 1884, also a future writer; there followed a decade-long hiatus—or rather, a series of perilous miscarriages—before Nicolas himself arrived, in April 1894. "My mother continually assured me—indeed, she never for a moment allowed me to forget—that she'd lain in bed for a full year so as to effect my safe delivery," Nicolas recalls. "The extra three months were my mother's poetic license, for dramatic effect, but she never tired of reciting all the sacrifices she'd made on my behalf and denigrating the sad, pathetic recompense she'd gotten in return."

"Clearly, she was some kind of monster," surmises Slonimsky's own daughter, Electra, who never really knew her. Slonimsky himself generally displays more equanimity—or, at least, resignation—when he is describing her; that is to say, when he describes her as a monster, he means it physically. "She was *huge*," he says. "Often, when we were kids, she'd call for us to come over to the bottom of the stairwell so as to help push her up the stairs."

After Nicolas, Faina gave birth to two more sons—Vladimir, in 1895, Nicolas's closest kindred spirit, who was to die of tuberculosis just after his twentieth birthday; and Michael, in 1897, who became a prolific and well-admired Soviet novelist. "And all of them," Slonimsky now said with a sigh, after completing the inventory of his predecessors and the members of his own generation, "they're all now gone. I'm the last of the Mohicans."

The first of Michael Slonimsky's many books—he produced more than a dozen before his death, in 1972—was titled *Lavrovy*. Published in Russia in 1926, it was a model of Socialist Realist fiction, detailing the travails of a spoiled young bourgeois as he tried to adapt himself to the rigors of the Revolution. According to Gleb Struve's summary of the novel (in *Geschichte der Sowjet Literatur*, this passage translated by Robert Stevenson), to the hero "are opposed, on the one hand, the other members of his family—his vulgar domineering mother; his meek, henpecked father; his vain futile brother—and on the other, Fonna Kleshnyov, a true Bolshevik."

"Yes," Nicolas said, after I read him that plot summary one day. "The vain and futile brother, that's me. A not altogether inaccurate portrait." He paused for a moment, then smiled broadly. "What's interesting there is that as the years have passed I've ended up having to write about Michael's son, Sergei, who has become a leading Soviet avant-garde composer whose work is every bit as far-out as the most outrageous stuff we've been able to produce here in the West."

After another pause, Slonimsky resumed. "My nephew Sergei is interesting for another reason. He illustrates a curious pattern in our family line. For, you see, in our family it appears that the musical gene is transmitted across a series of chess knight's moves. Aunt Isabelle was musical, her sister Faina, my mother, was not, but I was. My own daughter isn't, my brother Michael wasn't, but his son, my nephew Sergei, turned out to be. This may in part explain in some mysterious way the course my life has taken. For, you see, with

that background, in that hothouse atmosphere of the St. Petersburg intelligentsia, and especially under the pressure cooker of my mother's expectations, I was going to have to be a genius at something. And perhaps this knight's gene dictated that it be in music."

Indeed, there was no special musical emphasis in Nicolas's immediate household. "We were a middle-class, bourgeois family, typical of the late nineteenth century," he continued. "So naturally we had a piano, just as part of the furniture. But this piano quickly became my favorite household beast. You see, I possessed perfect pitch, and from an extremely early age I used to dazzle any and all comers by simply reeling off the name of any note—indeed, any combination of notes—that would be played for me. It all started out with this aspect of simply showing off."

When Slonimsky is in his darker moods—that is, when he is playing the theme of his self-estimation in a minor key—he sometimes asserts that it all ended there as well, that throughout his remarkable career he has simply been locked into a compulsive pattern of infantile exhibitionism. (Electra has been known to venture similar thoughts about him.) Without doubt, he still relishes astounding. One time, for example, while he was briefly in another room, I meandered over to the piano and mindlessly klimpered out a fairly complex and utterly inchoate sequence of nonsense chords—about ten seconds' worth. He came back in, I returned to my chair, and he went over to the piano and reproduced my sequence exactly, concluding with an elegant harmonizing flourish. "Sometimes," he said, his eyes twinkling, "it's best not to leave things unresolved like that, don't you think? Now, where were we?"

We were at his musical youth. "Ah, yes," he continued. "From a very early age, I was completely fascinated by sounds. I was as receptive to sounds as I was to objects, to toys, to the letters of the Russian alphabet. I would sit by, rapt, as my Aunt Isabelle gave piano lessons to my mother and my older brother and sister, none of whom were particularly musical. I'd approach the keyboard afterward and poke out elementary versions of the melodies they'd been rehearsing. She gave me my first official lesson on November 6, 1900, by the old Russian calendar. I remember the calendar itself, the look of the numbers, the configuration of black dates and red holidays. Numbers and arithmetical patterns were quickly coming to fascinate me as well. I was six years old, and my aunt was only twenty-three."

He continued his lessons with his Aunt Isabelle for several years, and his mother became increasingly invested in his precocity. Years later, he wrote of

his first day at grade school, "My mother addressed the class, cautioning my schoolmates against coming into close physical contact with me or indulging in rough games which might be harmful to my delicate pianistic fingers. This speech led to the expected results, but I was not badly maimed." By the time he reached age fourteen, his aunt determined to enroll him in the St. Petersburg Conservatory. He was paraded into the rehearsal room to audition before the conservatory's imposing director, Alexander Glazunov, who was at that time one of the reigning titans of Russian music. Glazunov was especially taken with the boy's virtuoso exhibition of perfect pitch, and at the end of the examination he announced that he was admitting him. At a subsequent exam, Glazunov recorded the top mark of five in his gradebook, with the parenthetical notation "Talent." "My mother immediately took to whispering the glory of this 'five (Talent)' to every visitor to our home, until it got to the point where the phrase itself began physically to repel me."

In school, Nicolas excelled in mathematics; he memorized vast swaths of Latin and recited them in exhibitionist extravaganzas. At the same time, he was attaining considerable pianistic heights: "I was able to get my 'Minute Waltz' down to forty-three seconds." But now—and this was the beginning of the major crisis of his youth, one of the defining crises of his life—he started to encounter kids as gifted as he, some even more so. "The truth was I didn't like practicing, I wasn't very good at it, and as I began to reach high levels I came to realize I simply didn't have the requisite technique. I could master expression—my aunt, on her deathbed, said that no one could play Schumann as expressively as I could. I had very good *touché*, as they call it—a sense of which notes should be brought to the fore, which ones left in shadow, how to shape the piece, bring out the internal contrasts, how to express the structure of the work. But I didn't have the technique. And, as I say, I couldn't help noticing, with a jealousy that verged on panic, that other boys did have it. With growing horror, I watched as boys my age rose past me to prominence. One, in particular, I remember to this day: Pepito Arriola. I ask you—how could one ever forget a name like that? A young Spanish child, still in knee socks, *on tour*, for heaven's sake—he was tan and chubby in a healthy, Mediterranean sort of way, I was skinny and pale in a neurotic, Russian sort of way. He dared to perform a recital of works I considered my own special province—Schumann, the Romantics—and he even got his name in the paper the next day! I'd never had my name in the paper."

Meaning itself began to desert Nicolas's existence. If he was not a prodigy,

what identity could he claim? "Suicide was very much in vogue in St. Petersburg in the years before the war," Nicolas told me another afternoon, as we discussed this period of his life. "It had a certain aura. Russian romantic literature was strewn with convenient role models. And, as a stale nineteen-year-old wunderkind, I was in a fairly hopeless way. In addition, this business about sex and syphilis, all the terror associated with temptation, was becoming intense. Two of my classmates in fairly quick succession in fact succeeded in killing themselves, a circumstance that held me spellbound and which I took as some sort of omen or dictate. I conscientiously prepared, therefore, to hang myself in the bathroom, and, indeed, did so—only the hook in the ceiling gave way under my weight, and I collapsed ingloriously onto the floor, a wet, crumpled heap. So much for my pseudo-suicide, my fraudulent pendency. I guess I was just trying to call attention to myself."

Nicolas's parents proceeded to do what any members of the St. Petersburg bourgeois intelligentsia would have done if they had been faced with a like calamity: they bundled their son up and sent him straight to a sanatorium on the banks of the Rhine, where he could be cared for by specialists and cured by the fresh, clean air. I asked Nicolas about the results of the regimen of the ensuing months, and he answered, "Well, by age twenty I realized that I was not a genius, that it was no longer important whether I was a genius, and that what was important was to kiss girls."

One afternoon a few days later, I was talking about Slonimsky with Ana Daniel, a young writer and photographer who acted as one of his secretaries for seven years during the seventies, and at one point she commented, "When he realized that he wasn't a genius, he realized he wasn't the center of the world, and that led to a certain mock despair—in fact, a tremendous amount of mock despair—but I think it also came as a relief."

Slonimsky returned to Russia in the spring of 1914 and resumed his studies at St. Petersburg University, where he was concentrating on physics, astronomy, and mathematics, having abandoned hope of a pianistic career, although he was continuing to take private lessons in composition with Vasily Kalafati, who had been Stravinsky's first teacher. Within months, the First World War began.

In early 1916, Slonimsky was drafted. "When the czar had to recruit a soldier the likes of me," he said one evening, as our conversation turned to this phase of his life, "it was a plain indication—plain to me, anyway—that he

was in serious trouble." Slonimsky was assigned to the music section of the Preobrazhensky regiment, which had been founded as Peter the Great's own. In the summer of 1916, the Preobrazhensky orchestra was sent to the placid delta of the Don River, where Slonimsky helped safeguard the empire's southern flank by, among other things, serving as soloist in the orchestra's rendition of the first movement of Rachmaninoff's Second Piano Concerto. He and the regiment were called back to Petrograd—as St. Petersburg had been recast, to rid the capital's name of its Germanic connotations—toward the end of 1916, just in time to appear as featured players in the initial Russian Revolution in February the following year. To hear Slonimsky tell it, less than world-historical forces were at work. "Actually, all the trouble started because of a crazy rule about the electric trams," he insists. "Soldiers, because of their service in the war, were being allowed to ride free, but because of the way they tended to hog all the available space, preventing civilians from even getting on the trams, the number of soldiers permitted on board a tram was limited to six at a time. If a seventh soldier boarded, all seven were subject to immediate arrest, notwithstanding the manifest innocence of the first six. This led to increasing clashes between soldiers and military police, and one day in February some regular army troops were called in to back up the military police, but they refused to act against their buddies. So then, in an effort to stanch the deteriorating situation, the most loyal imperial regiment, my own Preobrazhensky, was called in to quell the mutiny—only, we refused, too. And within hours came word that the czar had abdicated. We'd had no idea! All over a silly, unenforceable regulation."

Slonimsky was swept up in the revolutionary fervor. In his autobiography, he quotes a passage from the diary of a bohemian contemporary: "Nicolas Slonimsky, a student, came to see us, full of the joy of the revolution. He even forgot all about his egocentrism." Things in Russia radicalized fairly quickly during 1917, and the parliamentary revolution that had brought the moderate Aleksandr Kerensky to the fore was soon superseded by the October Revolution of the Bolsheviks. "That second revolution actually took place during a night and early morning when I happened to be on a train returning from Moscow to Petrograd," Slonimsky recalls. "And the first indication I had that anything had happened was that the town of Petrograd seemed unusually quiet as I disembarked from the train. A few minutes later, on the tram, I was reading a newspaper which a few weeks earlier would have been thought quite radical but had overnight been transmogrified into a forum for

reaction. A sailor seated next to me demanded, 'How can you read a rag like that, which supports that Jew Kerensky? Me, I endorse that true Russian, Trotsky!' Of course, Trotsky was the Jew—he was born Bronstein—and Kerensky was a pure Russian from the Volga region, but I decided that this might not be the appropriate moment to debunk this particular young man's misconceptions. He was carrying a bayonet."

Although Slonimsky was basically sympathetic to the initial goals of the Revolution, he was, like his father—perhaps like most members of the St. Petersburg intelligentsia—at best only vaguely political. He witnessed some remarkable things—he was present, for example, at the rally where Trotsky actually called for the formation of the Red Army and began taking volunteers—but he barely recognized their political import. Or, at least, in his autobiography and in his conversational recollections, he seldom frames matters in political terms. (He and John Reed, for example, seem to have inhabited two different revolutions.) Rather—but perhaps this is what it is actually like to have lived through such seminal events—Slonimsky's recollections quickly descend into a chaotic, almost anarchic swirl of shortages, pestilence, mobilizations, sieges, marauding armies, insuperable bureaucratic complications, and devastating famines. Slonimsky stayed on in Petrograd through the winter and spring of 1918. (Indeed, he was engaged for a brief period as a piano teacher to the children of the Grand Duke Michael, the brother of the deposed czar—a job for which he was regularly picked up in a splendid troika.) But in the summer and early fall of 1918 the situation in Petrograd deteriorated dramatically: with famine spreading, Slonimsky recalls, the city of his birth was turning into "a city of death." Hunger hallucinations were becoming commonplace, along with things that ought to have been hallucinations but weren't: one afternoon, gazing down a street, Slonimsky saw people pouring out of their houses, carving knives held at the ready in every upraised right arm, converging on an overworked horse that had just collapsed in the street. In mid-autumn of 1918, Slonimsky resolved to leave Petrograd.

Having been granted a three-month passport to organize concerts in the Ukraine, Slonimsky set out for Kiev. It was the beginning of a harrowing journey: the civil war was by then in full fever, and the landscape was overrun with shifting armies. "The terrible thing," Slonimsky recalls, "was that you never had any idea who was manning each new barricade, so you never had any idea which password to use, which documents to show, which loyalty to

claim. And things weren't much better once you got to Kiev, because that
city, too, seemed to be overrun by some new army every second week. In fact,
between 1918 and 1920 Kiev changed hands seventeen times! So you went to
bed in a city flying the white flag, or the green, and woke up in one flying the
red, or that of some Ukrainian nationalist army or some other free-lance out-
fit. One morning, we woke up and the town had been overrun by *Martians*—
or people who might as well have been Martians for all we understood of their
language, which certainly wasn't Russian or any Ukrainian dialect. These
guys turned out to be elements of the Polish Army who'd simply boarded an
empty train and ridden it a couple hundred miles east, since nobody seemed
to be around on that particular day to stop them. But they had no particular
reason to be there, either, and I guess they got bored, because a few days later
they were gone, having taken the same train back."

During his time in Kiev, Slonimsky resided in the city's only skyscraper—
a six-story building, owned by an industrialist friend of his family's, that was
also serving as refuge for a remarkable collection of cultural figures, includ-
ing the widow and children of the composer Scriabin, and the great religious
philosopher Lev Shestov and his family. By late 1919, however, Slonimsky
had launched out once again, heading south on a journey that proved even
more harrowing. Eventually, he made it to the Crimea, to Chekhov's Yalta,
which was in its final days of White Army rule. There, among other things,
he saw the famous beach promenade transformed into an improvised gal-
lows, with the bodies of young men and women strung up from telegraph
poles and swinging in the breeze, signs reading RED draped across their
chests.

At length, he managed to book passage aboard a small boat flying the
Turkish flag and bound for British-occupied Constantinople, where he de-
barked, famished and virtually penniless, in late March 1920. As luck would
have it, musicians were in great demand in the bars and restaurants and thea-
ters and silent-movie houses of the Turkish capital. There, during the next
year, and then briefly in Bulgaria as well, Slonimsky gradually recouped both
his physical and his financial health; and, finally, in April of 1921, he set out
for Paris, the great magnet for Russian émigrés.

The evening Slonimsky described this terrifying period of his life for me,
I asked him whether he had ever got nostalgic for life before the Revolution,
for the life he might have led if it had never happened.

"On the contrary," he said vehemently. "I was *saved* by the Revolution.

Without the Revolution, I would have become obsessed with my vanity. I would have reverted to brooding over my supposed genius, I would have become subsumed into the pointless life of the St. Petersburg intelligentsia. The Revolution—and especially the civil war that followed it—reduced everything to its lowest common denominator: survival. It forced me, among other things, to go out and earn a living—me, from my family, in which any commercial undertaking had always been deemed a disgrace. It forced me out into the world."

Still, I asked him, hadn't all the horrors he'd experienced and witnessed somehow scarred him?

"History never drives anyone mad," Slonimsky replied. "History made *me* sane. I was unbalanced. These sorts of upheavals quickly deprive you of vanity, of egotism, of self-centeredness, *because nobody's interested*. If you simply have to save your physical self, your mental and psychological disturbances tend to vanish."

As it turned out, Slonimsky stayed in Paris less than two years, but they were eventful years. He was quickly caught up in the vigorous Franco-Russian cultural scene, with its concerts and recitals and parties. In his autobiographical manuscript, he reports one of his "most striking memories" of a party from that period:

> Among those present was a very tall, middle-aged woman with a rather small head which looked like an extension of a long slender neck, continued in an elongated torso, with the whole upper body reposing rather incongruously on a disproportionately large pelvis and fat legs. I asked the hostess who the woman was. "Why, she is Mademoiselle Eiffel" was the reply, "the daughter of the builder of the Eiffel Tower."

During this period, Slonimsky procured a great deal of work as piano accompanist for opera singers giving solo recitals—he could sight-read virtually anything. Occasionally, these concerts produced their share of problems: critics would praise the accompanist more than the featured soloist. But he continued to be in considerable demand. He also served a stint as a pianist with the Diaghilev ballet company.

His most important breakthrough in Paris, however, came when he was approached by Serge Koussevitzky, who asked whether he'd be willing to try

out for a position as a rehearsal pianist. "I'd never heard of such a thing," Slonimsky explained, "but it appeared that Koussevitzky—who was independently wealthy by way of his wife and could therefore afford to do so—preferred to rehearse for his full-orchestra rehearsals by going over the score alone with a pianist. I'd play a piano arrangement of the orchestra score, and he'd be off to the side, keeping the beat and delivering elaborate cues to the phantom orchestra which—in his mind, anyway—he'd managed to crowd into the room with us. We'd rehearse thus over and over, until he felt ready to face the actual full orchestra."

Koussevitzky invited Slonimsky to join him for the summer of 1922 in Biarritz and help him prepare for an autumn performance of Stravinsky's *Le Sacre du Printemps*. "This proved my first experience at tackling a truly modern work," Slonimsky recalled. "The discords, the rhythmic fluctuations were all incredibly exciting to me. But, to my dismay, I began to realize that they were beyond Koussevitzky's grasp: in particular, he seemed unable to cope with the sudden metrical changes. For instance, where the score went from 3/16 to 2/8, he kept slowing down the sixteenth notes or else accelerating the eighths, dissolving everything into formless, neutral triplets. Or, at the very beginning of the most difficult section, the 'Danse Sacrale,' there's a sixteenth-note rest followed by a full-orchestra chord on an eighth note. Conductors often have trouble with this. Stravinsky himself, when he conducted *Le Sacre*, usually solved the problem by burping on the tacit downbeat. But Koussevitzky just couldn't get it. Then, one day, I noticed that the situation could be remedied, after a fashion, by rebarring the piece so that, for instance, a succession of bars of 3/16, 2/8, 1/16, and 4/8 could be integrated into a single bar of 4/4. This created certain problems with regard to the downbeat, but they could be compensated for. I sketched out some of these possible revisions for Koussevitzky, but he'd have none of it. 'We can't change Stravinsky's rhythms,' he insisted. Several weeks later, however, back in Paris, rehearsals with the full orchestra were going badly, and at one point he came up to me and said, 'Show me that arrangement you made.' I eagerly explained the idea to him, pointing out examples in the score, but his eyes quickly glazed over. 'I don't understand a thing you say,' he declared. 'Just go over there and put in your bar lines in blue pencil.' Which I did, and the solution worked. Every performance thereafter, in Paris and subsequently in Boston, Koussevitzky worked from scores rebarred according to my arrangement.

"The story has a coda," Slonimsky now said, getting up for a moment, heading down the hall, and returning with a large scrapbook. "Back in April 1984, on the occasion of my ninetieth birthday, there was a party, and various people sent notes, and—Let's see, where is it? Ah, yes, this one here." He handed me a sheet of elegant, heavy beige paper, on which was inscribed the following handwritten message: "Dear Nicolas: Every time I conduct *Le Sacre*, as I did most recently two weeks ago (and always from Koussy's own score, with your rebarring), I admire and revere and honor you as I did the very first time. Bless you, and more power to you.—Lenny B."

In addition to serving as Koussevitzky's surrogate orchestra, Slonimsky increasingly took on responsibilities as his secretary. Between brief touring forays as an accompanist, he'd return to Paris and help order the Maestro's affairs. For example, he handled the negotiations when Koussevitzky commissioned Ravel to produce a full-orchestra version of Mussorgsky's *Pictures at an Exhibition*. And things would no doubt have continued along such lines had not Slonimsky, one day early in the fall of 1923, received a telegram from America.

Vladimir Rosing, one of the countless musicians with whom Slonimsky had toured Europe as an accompanist, was a somewhat eccentric, ostentatiously mannerist Russian tenor (and, incidentally, a great favorite of Ezra Pound's). Some months after their tour together, Rosing happened to be crossing the Atlantic aboard a luxury liner on which George Eastman, the millionaire inventor of the Kodak camera and lavish cultural philanthropist, was a passenger. After being introduced to Eastman, Rosing suggested, on the spur of the moment, that perhaps he ought to include an opera subdivision in the Eastman School of Music, which he'd recently founded in Rochester, New York; and, on the spur of the moment, Eastman agreed, appointing Rosing to head it. As a consequence, one morning in October 1923, Slonimsky found himself getting off a train in Rochester, to which he'd been summoned to take up the position of coach and rehearsal pianist with Rosing's newly formed American Opera Company. He was almost thirty years old, and he spoke almost no English.

"Well, actually, that first week, he was capable of three phrases," Paul Horgan recently recalled. " 'Yes,' 'thank you,' and 'please.' " Horgan himself later attained considerable fame as a novelist and man of letters, but in 1923

he was working as a scenic designer with Rosing's opera company, collecting the experiences he would presently distill and transform into his first novel, *The Fault of Angels*—in which he included, among other characters, a charmingly bemused Russian émigré opera coach named Colya Savinsky (Colya being the Russian diminutive for Nicolas). Horgan is now professor emeritus at Wesleyan University, where I'd tracked him down and found him filled with fond memories of those years. "When Colya first arrived, he was pale, small, trim, with black eyes and a fascinating intelligence, always in perfect control while always affecting a mild bewilderment," Horgan told me. "He dressed in black at all times, like a clerk. But, as I say, that first week he had only these three phrases, by which he was somehow able to convey to me his wish that I should help him learn English. I gave him a copy of *The Pickwick Papers* and instructed him just to start reading it and under no circumstances to have recourse to a dictionary. And that is what he did: he read it avidly while rehearsing the opera company, and in a couple of weeks he was speaking fine Dickensian English."

I asked Horgan what he meant when he said that Slonimsky read *while* rehearsing the company.

"Just that," Horgan replied. "Colya would sit there at the piano playing out a piano score flawlessly, from memory, with impudent efficiency. He'd even memorized all the cues, so that he'd be interacting with the stage directors and the singers. And as he played he'd be reading *The Pickwick Papers*, which he had perched on the piano easel before him, and he'd be turning the pages in the middle of his playing, entirely absorbed."

"Yes," Slonimsky said some time later when I mentioned Horgan's recollection to him. "I'd memorized the piano score for virtually every opera in the standard repertoire back in my conservatory days, as a hobby. And my work as an accompanist in Paris had, of course, refreshed my memory. So I'd use the time to read. I read Anatole France's *Les Dieux Ont Soif*, I remember, during the rehearsals for *Carmen*. But I was mainly reading English. I was having a terrible time with phonetic pronunciation. O-u-g-h, for example, bothered me frightfully. You know—'through,' 'though,' 'bough,' that sort of thing. Or vowels—I couldn't *hear* the difference, let alone reproduce it. And the t-h diphthong. On the boat over, a book I consulted had suggested that one achieved the t-h sound by sticking one's tongue between one's teeth. What kind of crazy language was this, I remember wondering, that forced you to

stick your tongue out every time you used the definite article? And, of course, the idioms were impossible. Friends would ask me how my day had gone, and when I'd say, 'I worked hardly,' they'd all crack up. It wasn't until the company was doing *H.M.S. Pinafore*—remember that passage 'I never use the big, big, D. What, never? . . . Well, hardly ever'—that I suddenly saw the light on *hardly*. Actually, I learned a great deal of my English from Gilbert and Sullivan, although, as you can imagine, this produced some strange results in the coffee shop."

"The fact is we all became so charmed with Nicolai's mispronunciations that we took them up ourselves, and this certainly didn't make things any easier for him," another of Slonimsky's friends of the period, the harpist Lucile Johnson Rosenbloom, told me. "For instance, he would tell people about his Awunt Isabelle, and they'd correct him, and he'd say no, 'awunt' must be right, because that was how Paul and Lucile both pronounced it." Nicolas had suggested that I phone Mrs. Rosenbloom, recalling that he and Horgan and their colleague Rouben Mamoulian (he had been recruited by Rosing as a stage director for the company but soon moved on to greater fame in Hollywood) had formed a fan club around the beautiful harpist in the Rochester Philharmonic Orchestra—"the Venus de Milo with arms," they'd called her. "It was a wonderful time," she told me. "Nicolai had somehow managed to rent an apartment in a little white wooden house, which he left perpetually unlocked, and our group would repair there almost every night, late, following all our various engagements. George Eastman was sparing nothing in those days, and he'd gathered an extraordinary group of people together there in Rochester: the conductors Albert Coates and Eugene Goossens, and, later, the composer Otto Luening. So we'd all collect at Nicolai's and discuss how very stupid everybody in the world was except us—we were being playful, it was never malicious. And the thing was that Nicolai had discovered a novelty store, so that in Nicolai's house if you reached for a candy it was invariably made of soap; if you reached for a glass of water it turned out to be a dribble glass and you got soaked; if you tried to light a cigarette the match would explode, sending colorful sparks in all directions. He had the whole place booby-trapped with his enthusiasms. That was Nicolai's discovery of America, and we were all getting to experience it through him. That, and his discovery of English. For he seemed to be constantly memorizing new words—lists of them at a time, the longer and more abstruse the better—and then

working them into his conversation as quickly as possible. 'Parcevenda-geous'—I can still remember that—I think was his own invention, meaning second- or third-rate. Or 'accubate,' which was to eat while lying down. Or 'pediculous,' from the Latin word for louse, as he'd inform us, meaning lousy. He and Paul and Rouben had formed this Society of Unrecognized Geniuses, but they had to disband it a few years later, because they'd all become too famous."

I asked Mrs. Rosenbloom whether Nicolas dwelt at all on the horrendous events associated with his flight from Russia, which, after all, had occurred just three or four years earlier.

"Not at all," she replied. "Not once, ever. He didn't seem the least bit traumatized. Or, rather, he seemed entirely caught up in the intensity and vitality and energy of this new land." Mrs. Rosenbloom paused for a moment, then sighed. "Oh," she said. "I do thank you for calling. I've got into a wonderful mood just thinking about all this."

I had asked Horgan a similar question about Slonimsky's sense of his dark past, and he had agreed. "He displayed no sense whatever of the tragedy of the history which had preceded his arrival," he replied. "No, our connections were all larkish and prankish. It was a bohemian world of great conviviality. Colya would sit there in his house at his piano and entertain us for hours with his wonderful diversions. 'Le Petit Cochon Qui Se Dégonfle,' I remember, was one piano piece he'd written which was much called for at parties. And then, of course, there were the Advertising Songs."

"Another one of my fascinations in those early days," Slonimsky recalled for me one afternoon, getting up from his table and moving over to the piano, "was the *Saturday Evening Post*, and particularly the unique poetry of its gaudy advertisements. I couldn't get over their language: cynicism set in only much later, I suppose—these early offerings were utterly unabashed. There was one, for example, in which a bearded Germanic doctor was pointing his finger at a beautiful, forlorn female sufferer"—Nicolas now suddenly struck the keyboard, producing a deep, ominous descending underflourish. "And the banner headline above the picture read"—now Nicolas launched into song, unleashing his "unbeautiful tenor voice" (as he sometimes calls it)— "AND THEN . . . THE DOCTOR TOLD HER . . ." He momentarily interrupted his song, though not the suspenseful rumbly basso piano accompa-

niment, "Who knew, who knew what terrible fate lay in store for this poor creature? You read on, mortified, only to discover. . . ." He now reverted to his singing self-accompaniment:

> For some time she had not been herself,
> She was ruuuun dowwwn, laaaanguid, tiiiired
> each day before her work began. . . .
> One day she called her doctor,
> He advised her to eat bran muffins
> Made . . . according . . . to Pillsbury's recipe
> Pillsbury's marvelous, natural laxative!

At this point, the music suddenly broke free, becoming playfully uncongested:

> He knew the underlying cause of her trouble
> It was a case of faulty e-li-mi-nation . . .

And so forth.

One after another Nicolas now crooned a whole series of advertising songs, his fingers dancing across the keyboard, his head arched toward the ceiling in the manner of a coyote in rapture. "Mother," he urged plaintively at the climax of a song based on a truly bizarre ad for Castoria, "relieve your constipated child!" A few minutes later, he was imploring, "No more shiny nose," in a rendition of an ad for Vauv nose powder ("something to keep your nose from getting shiny, something to relieve you of this oiliness of skin"), which seemed to derive its melodic inspiration from a chorus of Volga boatmen. On a more sprightly note, moments later, he was inviting me to "make this a day for Plurodent." ("It brings to you new beauty, new emotion; it means to you new safety, new delight. . . . Film on your teeth ferments and forms an acid, this vicious film that clings to teeth.")

"Plurodent?" I asked when he'd concluded.

"Yes," he said, thoroughly invigorated. "Of course, it was Pepsodent, but, strangely, the Pepsodent people refused to grant me permission to use their name; I tried to sell my song to them, but instead they threatened to sue me. So a few years later, when I got set to publish the songs, Pepsodent became Plurodent. The nose-powder company had in the meantime gone out of business, so no problem. Strangest of all, the Castoria people gave me unqualified permission to use their name."

Slonimsky quickly dashed off another song, this one for Utica sheets and pillowcases ("So soft, so smooth, so snowy white"). "You see, this idea of advertising jingles was one of my inventions—only, like my grandfather, I was too impractical to think of patenting it. This was 1924, just before the popularization of the radio, and nobody had yet thought of this notion of putting advertising to music, so it was a big innovation. The thing is that although the language of the words of these songs was new to me, the musical language was pure St. Petersburg Conservatory. That Castoria song could be ascribed to Mussorgsky—harmonically, melodically, contrapuntally. It would have received a perfect score from Glazunov.

"But I was changing. Maybe it was related to the fact that during those years I was having to move through so many new *spoken* languages, especially English. In any case, I began developing a longing to expand the boundaries of my *musical* language as well. So that just four years after this"—he repeated the "Children Cry for Castoria" theme—"I was composing this." Slonimsky proceeded to play an eerily modern-sounding piece, made all the more eerie by the way his hands moved across the keyboard, his left hand confining itself to black keys, his right to white ones. "You see," he explained, looking over at me as his hands continued playing, as if on automatic pilot (actually, as if on two *separate* automatic pilots), "the nineteen-twenties in music constituted an orgy of dissonance. To have merely joined in that orgy would not have satisfied my vanity. So instead I created this sequence, which I called 'Studies in Black and White,' in mutually exclusive consonant counterpoint—or, to be accurate, in 'consonant counterpoint in mutually exclusive diatonic and pentatonic systems,' as I phrased it at the time, for I was already addicted to polysyllabic self-expression." He slowed his playing down to half time, quarter time. "You see, it's a case of trompe-l'oreille: although it's in fact entirely made up of consonances, it sounds dissonant, because it's made up of the kind of so-called false relations which were forbidden back at the conservatory. Just as I loved puns in English, I loved them in music, too."

Over the years, Nicolas continued to compose—once in a while for full orchestra but more often for piano alone, or else for singer accompanied by piano. In 1928, the year of his "Studies in Black and White," he wrote the song "I Owe a Debt to a Monkey," inspired by the Scopes trial; in 1945, he composed a vocal suite based on epitaphs he'd found on the tombstones in an old New England cemetery, entitled "The Gravestones of Hancock, New

Hampshire." ("Stop, my friends, as you pass by. As you are now, so once was I. As I am now, so you will be. Prepare for death and follow me.") Most of the piano pieces are miniatures, composed from a somewhat cockeyed vantage point. In 1979, Schirmer's published Slonimsky's compilation *51 Minitudes*, a thin volume—just forty-two pages—that happened to be sitting on the piano easel that afternoon. Slonimsky opened the book and offered to display a few of them, beginning with the first, entitled "$\sqrt{B^5}$," or, as Slonimsky now demonstrated delightedly, the square root of Beethoven's Fifth, for what he'd done with this piece was simply to compress all the intervals between the famous notes of the clichéd opening of the Beethoven symphony, as it were, by their square roots. Ba-ba-ba-*bum* thus becomes Ba-ba-ba-*bee*, and so forth. "After a while," he suggested, "you might get to like this version better—it's more salty, more acrid. But what's fascinating is that it's still recognizably Beethoven." Some of the other Minitudes parody a variety of musical styles; for example, there's "Casanova in Casa Nueva, Hollywood, California," which Slonimsky describes as "a deliberately gooey tonal mucilage, imitative of movie music," and which includes such markings as "orgiastico" and concludes with a repeat sign marked "D.C. al orgasmo." Slonimsky played me several more examples, concluding with his "Fragment from an Unwritten Piano Concerto."

It wasn't half bad. I asked him why he hadn't written the full concerto—why, in fact, he hadn't taken his composing more seriously.

"What for?" he countered. "What am I going to do, eat the reviews?"

Didn't he have music welling up inside him, crying out for expression?

"No," he replied. "I don't believe in that sort of thing. Sometimes, admittedly, it can get bothersome—I'm composing away in my head. If I let myself go, it would get to be like a vision, an aural vision—I have to watch it. But I feel no need to write out these symphonies. I know too many geniuses who composed masterpieces and became mental basket cases worrying about how they weren't being recognized. I don't have this problem."

Rosing's American Opera Company in Rochester lasted just a few years; then Eastman withdrew funding for the venture as precipitately as he had originally extended it. But in the meantime Serge Koussevitzky had been appointed principal conductor of the Boston Symphony Orchestra, and, learning of the sudden availability of his surrogate orchestra, he invited

Slonimsky to Boston for a repeat engagement. Slonimsky accepted, moving there in 1925. Alongside his other, more official duties, and notwithstanding his minimal competence in spoken English, Slonimsky was soon delivering short introductory lectures on symphony concerts at the Boston Public Library. Paul Horgan, who was present at some of these, recalled for me one occasion when Slonimsky introduced a performance of the Dvořák Cello Concerto by praising the abilities of the evening's featured soloist, "that talented spaniel Pablo Casals."

In Boston, Slonimsky met Dorothy Adlow, a recent Radcliffe graduate. "Seven years younger than me," he says, "and an eternity wiser." She was the daughter of Russian Jewish immigrants who had begun as pushcart peddlers and then prospered. (Her father ran a furniture store and spoke English with the Irish lilt of most of his customers.) She herself had studied art history in college and, shortly after graduation, had become an art critic for the *Christian Science Monitor*. In that capacity, she would prove to be the only consistent breadwinner in the Slonimsky household for most of the ensuing years. By the late twenties, she and Nicolas were inseparable companions.

By the end of 1927, meanwhile, Slonimsky was spending less time with Koussevitzky. He had launched a small ensemble of his own, the Chamber Orchestra of Boston, announcing that he would be devoting his programs principally to baroque and ultramodern compositions, and that he himself would be the conductor. In Rochester, it seems, what little time Slonimsky had not spent studying English he had spent studying conducting—specifically, the conducting of Albert Coates and Eugene Goossens. Coates, in fact, had taken him on as a student. "I was a particularly inept student," Slonimsky recalled one afternoon. "For one thing, I seemed unable to give a decisive downbeat. That can be a problem for a conductor—and a calamity for the orchestra." But over time he improved. He found the downbeat, and by 1928 he seemed capable of conducting the most complex modernist compositions—indeed, the more complex the better. In particular, he became captivated by the growing achievement of American avant-garde composers (he took to them the way he seemed to take to all things American)—this at a time when virtually no one else was paying any attention to them. For example, he became a close friend of Henry Cowell, the master of dissonant counterpoint and startling tone clusters. Cowell allowed Slonimsky to conduct the premiere of his Sinfonietta with the Chamber Orchestra, and then

encouraged him to contribute a composition of his own to *New Music*, a quarterly, recently founded by Cowell, that was to become the fount of American modernism. Slonimsky contributed his "Studies in Black and White," which ran in the Fall 1928 issue, with some success. Cowell subsequently made Slonimsky an associate editor of the journal.

Slonimsky continued to identify himself with the fledgling American modernist movement and to champion its composers. The composers, in turn, championed him, for what that was worth. At one point, Cowell published an article in the magazine *Aesthete* titled "Four Little-Known Modern Composers: Carlos Chávez, Charles Ives, Nicolas Slonimsky, and Adolphe Weiss." The afternoon we were talking about this period, Slonimsky pulled a copy of the article out of his file and showed it to me. "Can you imagine?" he said. "Charles Ives, a 'little-known' composer. Extraordinary." Slonimsky went on to tell me about a day when Cowell took him along on a trip to New York to pay a call on Charles and Harmony Ives, at their brownstone, on East Seventy-fourth Street, where Ives, who was fifty-three, was still convalescing from a heart attack he'd suffered years earlier. Slonimsky described the chamber orchestra he'd recently founded and asked Ives if he would allow it to perform one of his works. Ives pulled out an old manuscript, which he had composed between 1903 and 1914 but which had never been performed, and asked whether something along its lines might do. This was the score of *Three Places in New England*.

In his autobiography, Slonimsky has recorded his impression of that moment:

> As I looked over the score, I experienced a strange but unmistakable feeling that I was looking at a work of genius. I can't tell precisely why this music produced such an impression on me. The score possessed elements that seemed to be mutually incompatible, and even incongruous: a freely flowing melody derived from American folk songs, set in harmonies that were dense and highly dissonant, but soon resolving into clearances of serene, cerulean beauty in triadic formations that created a spiritual catharsis. In contrast, there were rhythmic patterns of extreme complexity; some asymmetries in the score evoked in my mind by a strange association of ideas the elegant and yet irrational equations connecting the base of natural logarithms and the ratio of the circumference of a circle to its diameter with the so-called imaginary number, a square

root of negative quantity. The polytonalities and polyrhythms in the Ives score seemed incoherent when examined vertically, but simple and logical when viewed horizontally.

I often found myself wondering during the weeks I spent chatting with Slonimsky and reading his writings, to what extent he *loved* music. At first, paradoxical as this may seem, I even wondered whether he loved music at all. But, of course, he does. The proper questions are: How does he love it? What does he love in it? For it seems to me he doesn't love music as most people do. Slonimsky seems to me a very sensual man, in his way, and a man of deep emotions beneath his playful surface, yet his appreciation of music is hardly sensual or emotional. He doesn't get carried away by its so-called spiritual quality. Sometimes he almost ridicules—at any rate, he certainly downplays—the sensual aspect of musical experience. He is not someone who is ravished by the *sound* of music, the sensual experience of that sound, its emotional or spiritual referents. "Waves rising and falling, that sort of thing," he said to me one day. "The waves on the gulf of Finland just used to get me seasick. I don't see what value there would be in experiencing music in that way." Rather, his ear is so precise that he hears right through the sound to the structure, and it's the structure that quickens and vitalizes and transports him. I once discussed this with one of Slonimsky's best friends in California, the composer David Raksin. "It's true," Raksin said. "Nicolas doesn't appear to be ravished by music, he doesn't ecstasize. He's a cool guy—his flame burns a low blue." And that flame is intellect. Leibniz once wrote, in one of his famous letters to Goldbach, "Music is a hidden arithmetical activity of a mind that does not know it is counting." But Slonimsky *hears the counting*. For him, the love of music is a mathematical passion—it is calculation taking flight, a structural transport. For Slonimsky, I came to realize during the weeks of our conversations, structure *is* emotion. And in that sense, that afternoon in 1928 on East Seventy-fourth Street, he was indeed being ravished by the score of *Three Places in New England*.

Ravished or not, he would find it a damnably difficult piece to envision conducting. "There was, for example, the second movement," Slonimsky recalled, "in which two bands seem to be entering a village square from opposite sides, both playing in standard 4/4 time, but one playing at a third faster rate than the other. This section could get pretty tricky for the conductor, be-

cause if you addressed yourself to the side of the orchestra that was playing faster, you ran the risk of losing the slower side, and vice versa. I'd encountered a similar problem with a canon by Wallingford Riegger, in which he had half the orchestra playing in 5/8 time and the other half in 2/8. Those boys really liked to mix things up. But it happened that I had discovered in myself a curious capacity: I seemed to be able, on the spur of the moment, to divide my brain in half, so that with one arm I could keep one tempo while with the other I projected an entirely different one. It was really quite simple." Slonimsky proceeded to demonstrate this weird talent, whose exercise seemed to transform him into a berserk semaphore messenger. His movements were brisk, powerful, exact—hilarious. He slowed down to give me a chance to verify the separate tempi, but my mind boggled in the attempt. "One of the critics," he now declared, without abandoning the performance, "proclaimed that my conducting was evangelical, for my left hand knew not what my right was doing." His eyes were gleaming joyously—full of mischief.

This marvelous capacity and Slonimsky's overall rhythmic hypersophistication served him in good stead on the night of January 10, 1931, when he and his orchestra premiered *Three Places in New England* in New York City's Town Hall. "The program went off without incident," he recalls. "I wasn't even disturbed by the concertmaster's whispering 'So far so good' at the conclusion of each movement. The reviews the next morning were mixed, but Ives himself, who attended the concert—something unusual for him— seemed satisfied. Interestingly, a few weeks later I went down to Havana, Cuba, to conduct a similar concert—Ives, Ruggles, Cowell—and the musicians there had far less difficulty negotiating the rhythmic complications of those pieces." Within months of thus presenting the premiere of one of the most important pieces of twentieth-century American music, Slonimsky was granted his American citizenship.

In the meantime, Ives, who was independently rich from his days as an insurance executive, told Slonimsky that he would like to sponsor him on a return trip to Paris so that he could "rig up" concerts of American music there. This foray, in the spring and early summer of 1931, proved immensely successful. Slonimsky arranged to give two concerts in Paris and was able to engage one of the city's finest orchestras, which he had sufficient time to re-

hearse properly. The indefatigable Edgard Varèse, who was then in Paris, churned up a firestorm of publicity and anticipation. Announcements blanketed the kiosks. Slonimsky himself composed the program notes, encapsulating *Trois Coins de la Nouvelle-Angleterre* as *"géographie transcendentale par un Yankee d'un génie étrange et dense"* and Carl Ruggles's *Men and Mountains* as *"une vision brobdingnague par un inspiré de Blake."* Audiences packed both concerts, which also featured works by Cowell, Riegger, and Chávez, and the reviews were dazzling. "We have *sans blague*, just discovered America, thanks to a Christopher Columbus who left Russia for Boston," declared the weekly *Gringoire*. "This Christopher Columbus is called Slonimsky." Other reviews hailed Slonimsky for *"une oreille et bras excellents, une remarquable autorité, une souple intelligence."* Exercising some of that *souple intelligence*, Slonimsky now took time out from his triumph to accompany Dorothy Adlow, who had come along on the trip, on a brief visit to the Mairie, where the two of them were wed, Varèse serving as best man.

So successful had this trip proved that a second one was almost immediately arranged for the following winter, this time to include Budapest and Berlin in addition to Paris. The first of Slonimsky's second pair of Paris concerts, in February 1932, included works by Ives, Cowell, and Dane Rudhyar, and the Paris premiere of Béla Bartók's First Piano Concerto, with Bartók himself at the keyboard. The second concert featured the world premiere of Ruggles's *The Sun-Treader*, Varèse's formidable *Arcana*, and then, for balance, Brahms's Second Piano Concerto, with Arthur Rubinstein as soloist. Once again, Slonimsky was showered with rave reviews, but this time Paris was only a workup for Berlin, where he had been engaged to conduct the Philharmonic itself.

This proved to be one of the transforming moments of Slonimsky's life. "Never had I enjoyed such professional cooperation and competence," he recalls. "We went through four rehearsals with no complaints whatsoever. Indeed, what with all the newfangled percussion instruments I'd brought along, the Berlin Philharmonic players were like children in their enthusiasm. They particularly enjoyed the Lion's Roar, a bucket through which you pulled a rope. It had a wonderful name in German—the *Löwengebrüll*. During the concerts themselves, the sound that the orchestra achieved was close to perfection."

Slonimsky's glorious triumph in Berlin was to have a sadly constricted horizon, and as we sat talking about it that afternoon, and he pulled out a file to show me the yellowed clippings, he wasn't so much boastful as bewildered, still—dumbfounded that such promise could yield so little. The works—Ives, Cowell, Varèse, Ruggles, and so forth—evoked controversy, but the praise for Slonimsky's conducting was nearly unanimous. Surely the most impressive came from the redoubtable Alfred Einstein, of the *Berliner Tageblatt*, dean of the German critics, who hailed Slonimsky as "a talent of the first rank, of a quite elemental capacity to convince orchestra and audience alike." The words seem to have branded Slonimsky to the core. *"Ein Talent ersten Ranges"*—on several occasions, I heard him mutter them quietly, like a mantra, in persisting sad amazement.

Upon Slonimsky's return to America, his success continued for a few more seasons. He toured. In March 1933, he presided over yet another epochal premiere, this time of Varèse's *Ionisation*, scored for forty-one multifarious percussion instruments—a seemingly chaotic welter of sound deep under the surface of which lay a structure of shimmering precision. Varèse presently dedicated the piece to Slonimsky. Surprisingly, Columbia Records accepted *Ionisation* for a single disk, but it soon became evident that the complexities of the piece were beyond the capacities of the percussionists from the New York Philharmonic who had been commissioned to tackle them. Instead, Slonimsky assembled a remarkable impromptu pickup ensemble, including Cowell pounding tone clusters on the piano, the composer Paul Creston on the anvils, Wallingford Riegger rubbing the guiro, the composer Carlos Salzedo on the Chinese blocks, and a very young William Schuman, who was assigned the crucial task of pulling the Lion's Roar. Varèse himself manned the necessary pair of sirens, which he had managed to borrow from a retired city fireman.

From this final triumph, Slonimsky pitched headlong toward disaster. Several months earlier, he had had a successful outing to Los Angeles, where he conducted the L.A. Philharmonic to considerable acclaim. On the basis of that performance, he'd been engaged to preside over the Philharmonic's entire summer season at the Hollywood Bowl. Then, in July 1933, arriving to take up his assignment, he resolved to program a vigorous selection of contemporary work, starting with *Ionisation* itself. Such a bold undertaking,

however, while it might have worked for a single concert in a downtown auditorium, was bound to cause trouble at the staid and saccharine Bowl. Slonimsky stuck to his guns, insisting on the importance of exposing contemporary audiences to contemporary music and looking forward to the controversy. But those audiences proved instantaneously hostile, the orchestra mutinied, and the trustees quickly intervened. As Slonimsky puts it, "following the first concerts of the series, I was given the bum's rush out of Hollywood."

And suddenly his conducting career started to break up. The speed with which this happened is somewhat mysterious. Surely Slonimsky's adamant insistence on the necessity of programming vigorous, challenging, complex new music worked against him in the profoundly conservative context of mainstream American tastes. But now history, which had once made him sane, was also working against him. Ordinarily, he might have been able to return to Berlin, the scene of his greatest triumph, but this was already 1933, and Berlin was now cut off. (Even the year before, the Nazi critic Paul Zschorlich had excoriated the degenerate music that Slonimsky was trying to foist on the pure Aryan public. "The leader of this impudent exhibition was naturally a Jew," he pointed out in his review in *Germania*. "Slonimsky can call himself a hundred times an American, but one has only to watch his shoulder movements to recognize that he is a 100% Polish Jew.")

And then again, perhaps Slonimsky simply didn't have a talent for managing and exploiting his initial successes. This was not the sort of thing St. Petersburg intellectuals were well versed in doing; on the contrary, they were generally averse to any worldly exertions. At any rate, Slonimsky's conducting career was cut short. Nowadays, when, despite all his remarkable accomplishments, Slonimsky speaks of himself as a failure, this is what he really seems to have in mind—what he can't get out of his mind. As his former assistant Ana Daniel parsed it for me one afternoon, "the conducting clearly mattered to him enormously; in fact, in a way, Nicolas got everything he ever wanted except the one thing he ever really wanted, and that disappointment has surely remained a sorrow the rest of his life."

On the other hand, maybe he did get the one thing he ever really wanted—and, in fact, got it that very summer. For all the while he was battling with the orchestra and the trustees at the Hollywood Bowl, he was also monitoring

developments back East, where Dorothy was seven months pregnant. Re-
turning to Boston in defeat, he was presently consoled by the arrival of a
daughter, whom he immediately named Electra—after the Greek word for
"amber," or for some such reason. Within months, the debacle at the Hol-
lywood Bowl was receding into irrelevance. He was too busy teaching his
baby daughter Latin.

II.

"LIKE THE gaseous remnants of a shattered comet lost in an
erratic orbit"—or so Nicolas describes the situation in his autobiographical
manuscript—"occasional conducting assignments came my way." And oc-
casional compliments as well. At one point, for instance, Arnold Schönberg
compiled a list of good guys and bad guys among then-active conductors, and
there were only two good guys—Eugene Goossens and Nicolas Slonimsky.
But by the mid-thirties such assignments had virtually ceased. He would
now have to cobble together a livelihood in some other manner—a require-
ment rendered all the more urgent by Electra's birth. He managed to get var-
ious odd jobs. For a while, he had a radio program in Boston. He taught Rus-
sian sporadically at Harvard. He offered private lessons in piano and
composition. "I charged two dollars a lesson, but I invariably failed to look at
my watch—much to the distress, I imagine, of my captive students," Slo-
nimsky recalls. "Some of them, though, I must say, nearly drove *me* over the
precipice. I had one sixteen-year-old kid, for example, who protested vehe-
mently at my assigning him the slow movement of a Mozart sonata, because
he felt he wasn't getting his money's worth per number of notes played. And
then there was a society matron who came to consult with me one day about a
symphonic poem she claimed to have conceived. When I asked to see the
score, she said no, I didn't understand—that was precisely where she re-
quired my help: to arrange what she heard *in her imagination*. She proceeded
to describe a flat desert, horses galloping in the distance, a rising storm (vio-
lins, drums, whatever), the wind subsiding, a full moon rising (perhaps, she
suggested, to be represented by a lilting flute). . . ."

Increasingly, Slonimsky, now past forty, was turning to research and writing in his adopted language. As early as the mid-twenties, when he'd been consulting reference works in order to prepare for introductory talks prior to Boston Symphony concerts, he had begun to evince a certain compilation compulsion. "I was astonished by the tremendous discrepancies I encountered in dates for composition, publication, premieres, births, deaths," he recalls. "There were wholesale contradictions not only between but even within the various established sources. So I became something of a detective, burrowing for primary sources—contemporary reviews, correspondences, and so forth—writing letters to the principals involved whenever that was possible, trying to ferret out the truth and impose some order on the chaos."

Slonimsky started compiling his files—files on top of files—and was soon deploying his discoveries in ever more imaginative matrices. His continuing devotion to and fascination with modern music inspired the first of these efforts, the redoubtable *Music Since 1900*, which was initially published in 1937. In the years since, this book has gone through four editions, with updates in 1949, 1965, 1971 (that edition swelled to fifteen hundred and ninety-five pages), and this past year Slonimsky released a new three-hundred-and-ninety-page supplement. If the purpose of the work was disarmingly simple—to make a day-by-day chronological listing of every significant happening in the field of music since 1900—the execution was exhaustively thorough. In the preface to the 1971 edition, Slonimsky endeavored to explain his straightforward principle of inclusion: "I have established a simple criterion: when in doubt, do not delete. Better to have a hundred bits of musical flotsam and jetsam in circulation than to omit a single potentially important event. The fear of leaving out an interesting work has even invaded my dreams. One particularly vivid nightmare was that I had overlooked a really sensational item—the 'Red Army Symphony' by Brahms, written in 1938, and dedicated to Marshal Voroshilov." And, indeed, virtually everything makes it in. A British music critic once dismissed an unfortunate composer's sequence of new compositions by wryly observing that they would probably just "disappear into that impeccably kept graveyard of our century—*Music Since 1900*." Endurance records for "pianofortitude" and for harp playing underwater, the schedule for the inaugural run of the Chopin Express between Vienna and Warsaw, Scriabin's horoscope, and the arrest of

a Rumanian diva for spying during the First World War are all recorded. Under January 4, 1915, we learn of the American copyrighting of "'I Didn't Raise My Boy to Be a Soldier,' a sentimentally pacifistic tune by Al Piantadosi . . . challenging in quickstep time anyone to place a musket on his shoulder or make him shoot some other mother's darling boy . . . (650,000 copies were sold in the first three months of 1915)." In a note on that entry, we are invited to follow the changing course of American attitudes toward the war by way of the successive copyright dates for various sequels to Piantadosi's song, including: "I Didn't Raise My Dog to Be a Sausage" (April 21, 1915); "I Did Not Rear My Boy to Be a Coward" (October 18, 1915); "I Did Not Raise My Girl to Be a Soldier's Bride" (June 24, 1916); "America, Here's My Boy" (February 16, 1917); and "I'm Glad I Raised My Boy to Be a Soldier" (April 14, 1917). But Slonimsky's chronology is extraordinarily rich in serious revelation as well. Even a random browse through the year 1912, for example, elicits within just a few pages: May 29, the premiere of Debussy's *Prelude à L'après-midi d'un faune* by Diaghilev in Paris; June 26, the premiere of Mahler's Ninth Symphony ("a year, a month, and eight days" after the composer's death), with Bruno Walter at the podium, in Vienna; September 3, the premier of Schönberg's Fünf Orchesterstücke, Opus 16, in London; September 5, the birth of John Cage, in Los Angeles; October 16, "after forty rehearsals," the premiere of Schönberg's *Pierrot Lunaire*, in Berlin; and then, on November 17, "suffering from an excruciating toothache, exactly five months after his thirtieth birthday, Igor Stravinsky completes, in Clarens, Switzerland, *Le Sacre du Printemps.*"

Slonimsky was seldom satisfied with a mere date entry. Instead, for example, in the case of operas he'd include detailed and vividly wrought synopses of the plots; major symphonic works were granted crystalline, profoundly intelligent musical analyses, often complete with orchestration. Somewhere along the line, partly to rouse himself from the numbing stupor of his seemingly endless lexicographical task, Slonimsky hit upon the challenge of encapsulating every entry—no matter how long or exhaustive— within a single sentence. This artifice, he explains, also helped to ensure "the Aristotelian unity of place, time, and action within each item." The resulting sentences sometimes read as dazzling virtuoso performances in their own right (especially when one realizes that their author had only been exposed to English for the first time not much more than a decade earlier). Thus, for ex-

ample, consider the entry for April 27, 1905 (the sole utterly bogus entry in the entire volume); the name of the composer in question is a fairly transparent anagram:

> On his eleventh birthday Sol MYSNIK stages, in the recreation hall of High School No. 11 in St. Petersburg, in which he is a student, the world premiere of his politico-revolutionary opera in eleven scenes, *The X-Ray Vindicator*, scored for three countertenors, basso profundo, piano, balalaika, toy pistol and a static electricity generator, the action dealing with a young scientist confined in the dreaded Peter-and-Paul Fortress for advocating the extermination of the Tsar and the termination of the Russo-Japanese War, who escapes by directing a stream of Roentgen rays at himself from a hidden cathode ray tube as a Secret Police officer enters his cell, putting him to flight in superstitious horror by appearing as a skeleton, and then calmly walking through the open gate to resume his terroristic propaganda, with petty bourgeoisie characterized by insipid arpeggios on the balalaika and the playing of the waltz *On the Dunes of Manchuria* on the phonograph, revolutionary fervor by the songs "The Sun Goes Up, the Sun Goes Down, I Wish the Tsar Would Lose His Crown" and "We Fell as Martyrs to Our Cause Because We Scorned the Tsarist Laws," the X Rays by chromatically advancing sequences of diminished seventh chords, and Freedom through Terror by blazingly incandescent C major.

With each new edition of *Music Since 1900*, Slonimsky has wrestled with the question of an appropriate, worthy cutoff date. The 1971 edition achieved a transcendent culmination with its entry for July 20, 1969: "The Harmony of the Spheres of the Pythagorean doctrine that interprets the position and movement of celestial bodies in terms of musical concordance is mystically manifested as first men step on the silent surface of the moon." The 1986 supplement ended just slightly more prosaically with July 13, 1985: "'Live Aid,' the first global rock concert"—the telethon for African famine relief undertaken simultaneously in both London and Philadelphia—is "watched by something like 1,500,000,000 people . . . with the Philadelphia portion utilizing about 90,000 nails driven into the 23,744-square-foot plywood stage and 75 miles of cable connecting 16 tons of lighting equipment with 2 million watts of power, and involving 37 acts and 30 equipment changes, with hundreds of spectacular celebrities gracing the stage with their uninhibited crooning and howling presence, and hundreds of humble road-

ies donating their essential labor." (In a sense, perhaps, Slonimsky identifies with these last characters: he's now completing a distinguished career as a humble roadie with the ongoing road tour of the history of music.)

Every edition of *Music Since 1900* has included a fascinating—if wildly idiosyncratic—"Appendix of Letters and Documents." Included among the letters are many that Slonimsky elicited from some of the foremost composers and music critics of our time—Ives, Varèse, Schönberg, Webern, George Bernard Shaw—answering his questions about the actual chronology of such things as the invention of the twelve-tone system (the one from Schönberg in this regard is especially significant and is often quoted). The documents Slonimsky includes range from encyclicals on sacred music by Popes Pius X and Pius XII (with their "Blacklist of Disapproved Music") through the *Peking Review*'s pathbreaking treatise, "Has Absolute Music No Class Character?"—with stops along the way for, among other things, the "Ideological Platform of the Russian Association of Proletarian Musicians" (1929) and "The Musical Ideology of the National Socialist (Nazi) Party" (1934). But without a doubt the treasure of the 1986 *Supplement*'s "Documents" section is a strange, once highly classified U.S. Department of the Army report, from 1954, which Slonimsky managed to wrest from a grudging bureaucracy through a Freedom of Information Act suit; it explores "Communist Vulnerabilities to the Use of Music in Psychological Warfare." Slonimsky even reproduces the official stamp, "Regraded Unclassified Order Sec Army by Tag Per 7502444," on each page.

Slonimsky frequently appends notes (in a smaller typeface) to his chronological listings in *Music Since 1900*, in which he provides samplings from the contemporary critical response to premiered works. While his fascination with the acceptance or, more usually, nonacceptance of the unfamiliar, of course grew out of his own experiences as the premiere conductor for many avantgarde works, his curiosity about the subject presently became more general, extending back to the critical reception of now classical compositions. He began compiling files on the subject, and in 1953 he distilled those files into one of his most celebrated sourcebooks, the *Lexicon of Musical Invective*, a compendium, as its subtitle explains, of *Critical Assaults on Composers Since Beethoven's Time*. The bulk of that volume consists of a remarkable cavalcade of righteous indignation arranged alphabetically by victim (Bartók, Beethoven,

Berg through Varèse, Wagner, Webern), but what is perhaps Slonimsky's finest inspiration comes at the end, with a thirty-page "Invecticon," a cross-referenced alphabetical listing of individual terms of derision. A random trill from the Invecticon, for example, runs: "FRIGHTFUL (Berlioz); FROG LEGS, thrown into violent convulsions (Wagner); FROGLIKE SEXUALITY (Krenek); FRYING PANS (Wagner); FUNGI, hateful (Liszt); FUTILE (Berg, Debussy, Gershwin, and Schönberg)."

One afternoon, while discoursing on the nonacceptance of the unfamiliar, Slonimsky recited for me, by heart, two antimodernist poems he'd included in his *Lexicon*. The first one he'd managed to unearth in an American newspaper of the eighteen-eighties. Entitled "Directions for Composing a Wagner Overture" and signed "A Sufferer," it concluded:

> For harmonies, let wild
> discords pass;
> Let key be blent with key in
> hideous hash;
> Then (for last happy
> thought!) bring in your
> Brass!
> And clang, clash, clatter,
> clatter, clang and clash.

Slonimsky delivered the last line with zest and syncopation, and immediately launched into the second poem—this one, also anonymous, from a February 1924 issue of the Boston *Herald* and inspired by a recent Stravinsky performance. It began:

> Who wrote this fiendish
> "Rite of Spring,"
> What right had he to write
> the thing,
> Against our helpless ears to
> fling
> Its crash, clash, cling,
> clang, bing, bang, bing!

Instead of finishing his rendition of the second poem, he observed, " 'Clang, clash, clatter' and 'Crash, clash, cling.' The new not only sounds horrible to each new generation—it sounds horrible *in an identical way*."

I asked him why he had never brought the *Lexicon* up to date, including more recent examples in revised editions, as he did with most of his other lexicographical projects.

"Because it can't be done," he replied quickly and emphatically. "That's the sad point of it. Critics simply don't vesuviate the way they used to. That sort of vituperative inflammation has gone completely out of fashion. I mean, one critic once described the first movement of Bartók's Fourth String Quartet as conveying 'the singular alarmed noise of poultry being worried to death by a Scotch terrier'; the third movement, he said, reminded him of 'the mass snoring of a Naval dormitory around dawn.' Who ever says that sort of thing anymore? Or my personal favorite, a German review of my own 1932 performance of Wallingford Riegger's *Dichotomy*: 'It sounded as though a pack of rats were being slowly tortured to death, and meanwhile, from time to time, a dying cow groaned.'" Slonimsky paused for a moment, savoring the image—and the sound. "It's even better in German. Not just torturing them to death, but torturing them to death *slowly*. *Langsam*! There's a positive genius to such rhetoric. Nowadays, a critic may say that music he doesn't like is ugly, but he's unlikely to say that the composer is ugly, which is what one of the critics I cite said of Debussy. And no one goes in anymore for the kind of personal attack you get in that 1841 review of Chopin I included in the book: 'There is an excuse at present for Chopin's delinquencies; he is entrammeled in the enthralling bonds of that archenchantress, George Sand . . . We wonder how she can be content to wanton away her dreamlike existence with an artistic nonentity like Chopin.'" Slonimsky's eyes opened wide, his face displaying fresh astonishment, as if he had never before heard such words—even though he had memorized them. "The critics in those days had passion. But back then at least people got worked up about music—it occupied a central position in cultural life. New music took a passionate stand—and critics responded in kind." It occurred to me as Slonimsky spoke that this sort of language has not so much fled the world as shifted arenas: it is precisely the sort of language one now finds in film reviews. This in turn suggests that there was once a time when new music commanded the public presence, the urgency, the immediacy that new films do today.

Through the nineteen-forties and into the fifties, Slonimsky whiled away his energies in other ways as well. He followed up some earlier conducting visits

to Cuba with a tour of South America in 1941, which resulted, a few years later, in his widely heralded survey of the region's vigorous contemporary composing scene, "Music of Latin America." He published a series of essays about music on the Children's Page of the *Christian Science Monitor* and presently brought them together in a book entitled *The Road to Music*, which he dedicated "To Electra, Against Her Will." In 1948, he perpetrated *A Thing or Two About Music*, a scattershot recollection of anecdotes from music history, which was greeted with almost universal critical acclaim, except for one devastating pan, in *Music Library Notes*, which he wrote himself.

"He was round the house pretty much all the time," Electra recalls nowadays. "We lived in a two-bedroom apartment in a respectable working-class district, well situated, close by the Boston museum, the library, Symphony Hall. It was crowded—keep in mind that he was using it as an office and my mother was writing there as well—but it was all they could afford. There was never any money. My mother used to think of him as semiretired, and that made it okay. He'd participate in household chores. For instance, he'd wash the dishes, because he could make a pagoda out of them as they dried, but he'd invariably leave the pans, because they just weren't interesting. He'd breakfast in leisurely fashion, read the *Times*, expostulate about the day's events, putter around, and finally you might be able to get him to focus on work. Even in those days, there was a harem of successive secretaries—generally nubile young maidens who would become embroiled in all the household dramas, part of the collective superego trying to get Genius Boy to do whatever it was he was supposed to be doing."

Dorothy Slonimsky's family tried to persuade Nicolas to get a job as a bandleader in Miami Beach. (After all, he was a musician, wasn't he?) But he demurred. In general, he seemed to be backsliding into the habits of the St. Petersburg intelligentsia—know-it-all good-for-nothing.

In the mid-forties, Slonimsky's inspired puttering achieved its apotheosis in an astonishing work he compiled, whose title is *Thesaurus of Scales and Melodic Patterns*. The *Thesaurus* is a sort of musical index—a catalogue made up of rows of notes rather than words. Specifically, it is, Slonimsky explains, "an ordering of every possible succession of notes arranged by intervals as counted in semitones." In more than two thousand entries, Slonimsky has managed to generate every conceivable sequence of scales. Intellectually, the breakthrough that allowed him to accomplish this feat came when he dispensed

with the traditional division of the octave into two unequal parts—a perfect
fifth and a perfect fourth—and instead divided the octave exactly in half, to
form two tritones ("the dread *diabolus in musica* of the medieval theorists," as
he acknowledges, adding, "Bach himself had his knuckles rapped for flirting
with such a division in school—but those German teachers were all sadists").
From there, he ordered his melodic patterns by successively filling in the in-
tervals to form new scales. The afternoon Slonimsky went through the vol-
ume with me, delving deeper and deeper, across page after page of carefully
laid out scales, each scale differing just slightly from the one before, he
quickly lost me in his astral explications of the book's subtleties. Seeing that
he'd done so, he doubled back. "Never mind about the musical implica-
tions." he said. "It's *beautiful*—it's Mondrian."

Other musicians agreed. Arnold Schönberg labeled the *Thesaurus* "an ad-
mirable feat of mental gymnastics," averring, however, that "as a composer I
must believe in inspiration rather than mechanics"; Howard Hanson de-
scribed the work as "revolutionary" and "immensely valuable"; Arthur Ho-
negger labeled it *"absolument remarquable"*; and Leonard Bernstein, in time,
would praise it as "an astounding feat of invention and knowledge."

However, the various publishers whom Slonimsky initially approached,
though they were fascinated by the manuscript's premise and dazzled by its
execution, expressed virtually unanimous agreement that its chances of com-
mercial success were dismal. "Over and over," Slonimsky recalls, "I was told,
'It's great, but there's no chance of its selling among the hoi polloi.' That, by
the way, is a redundancy: 'hoi' is already 'the.' But finally, in 1947, a small
outfit brought it out, with virtually no promotion, and, mysteriously, the
book sold, sold some more, and then positively took off. None of us could fig-
ure it out. It turned out that what was happening was that *jazz players* had
heard about the book and were using it as a sort of rhyming dictionary, a kind
of melodic shake-and-bake. One of the sales guys told me, 'Yeah, it's a real
hot item up in Harlem.' Coltrane, for example, was assigning it to his whole
band." (Some have gone so far as to suggest that Coltrane's innovative "sheets
of sound" were actually sheets of Slonimsky.) "All sorts of people were com-
ing into stores who had no idea what a thesaurus was—they didn't know from
Slonimsky. They'd ask for the Resorious by Slumsky, or the Notorious by
Plumsky—but the book was selling. It's gone through six printings."

Even so, Slonimsky's cult notoriety remained circumscribed, and his fi-

nancial productivity downright marginal. A few years later, however, he was suddenly, though briefly, able to marshal his mammoth store of useless knowledge for practical profit. One day in 1956, he was invited to be a contestant on the nationally televised quiz show, "The Big Surprise." He competed in the category "Misinformation," and week after week he successfully batted down popular misconceptions and artful stumpers in all sorts of areas. By the sixth week, he had attained thirty thousand dollars, all of which he was now invited to risk in going after the hundred-thousand-dollar prize. He had never made anything like thirty thousand dollars before, nor had he ever attained such a level of public notoriety. Strangers were stopping him on the street to ask if he was going to go all the way; bookies were taking bets on his chances. Nowadays, he says wistfully, "There is no greater glory than making money in public." But in the end he decided to pocket the thirty thousand dollars. Mike Wallace, the show's host (yes, *the* Mike Wallace), asked whether he'd like to try answering the seven remaining questions, just for the fun of it. He agreed to and, effortlessly, he did. A Boston paper the next morning ran his picture on its front page, with the headline LOSES $70,000, HAS NO REGRETS.

Increasingly, during these years, Slonimsky was being drawn into the world of conventional musical lexicography. Editors, perhaps annoyed by his penchant for tripping them up in their errors but obviously impressed by his investigative zeal whenever he could be aroused to display it, invited him into their deliberations on a more official basis. He began contributing to Oscar Thompson's *International Cyclopedia of Music and Musicians* in 1939 and, upon Thompson's death, rose to its editorship in 1946; he remained at the helm there through 1958, supervising the fourth through the eighth editions. In 1949, he produced a supplement to the third edition (1940) of *Baker's Biographical Dictionary of Musicians* (which had been launched in 1900 by Theodore Baker, a pioneer American musicologist), and in 1958 he was appointed to preside over an entirely revised fifth edition. Slonimsky had reached the age of retirement—he was sixty-four—but in a profound sense his career was just beginning: he persisted at *Baker's* through a sixth edition, in 1978, and a seventh edition, in 1984. It proved an endless labor; as the critic Alan Rich recently commented, Slonimsky is condemned to work "in the manner of the painters of the Firth of Forth bridge, where the job, once completed, is ready

for recommencement." He had become the Keeper of the Files, Monitor of the Obituaries ("You can't get into musical heaven without St. Nicolas seeing you off at the gate," an admirer recently commented), Weigher of Worth, and Assigner of the Adjectives. (Aficionados study each new edition, trying to gauge the subtle realignments in Slonimsky's assignment of key adjectives—"brilliant," "celebrated," "famous," "eminent," "distinguished," "noted," and "remarkable" among them—at the head of his major entries. Most individuals in the *Dictionary* are initially identified only by vocation and nationality—"British pianist," say, or "Danish soprano"—but about 10 percent of them rate adjectives, and these adjectives have become the subject of Talmudic disputation among the *Dictionary*'s fans, who try to determine whether "brilliant," for example, is more or less laudatory than "remarkable." Slonimsky has recently introduced a new term, "seeded," which he appears to reserve for rock idols, but no one has any idea what *it* means. Some surmise it's a play on "seedy," but when Slonimsky is asked he merely smiles delphically and says, "Tennis.")

Baker's is widely considered the finest existing single-volume dictionary of musicians on the market (albeit a *huge* single volume, with 2,575 double-column pages, and weighing over seven pounds). Its coverage of a vast range of figures across the history of music is consistently thorough and authoritative. Abram Chasins, the composer-pianist and radio commentator, recently said, "When Slonimsky writes about musicians, the people themselves emerge, not just what they wrote but who they were. His writing is informed by a charm and warmth and individual personality you don't find in most other contemporary dictionaries, and yet it's objective. His analysis of musical forms is invariably exact, and his critical judgment absolutely pristine. And this is true of his treatment of all his subjects, whether they arrived on the scene four hundred years ago or just the day before yesterday." Thus, Slonimsky's entry on Handel contains crisp explications of the composer's entire musical output and also supplies a vivid character squeeze, including the facts that "Handel remained celibate, but he was not a recluse. Physically, he tended toward healthy corpulence; he enjoyed the company of friends but had a choleric temperament and could not brook adverse argument." Or, more recently, Luciano Pavarotti: "Idolized by the public as no tenor has been since the days of Caruso, he plays the part of being Pavarotti with succulent delectation. . . . Like most tenors, he likes himself immensely. Unlike most ten-

ors, he does not get involved in scandal." Slonimsky is always on the prowl for the bizarre detail, and he invariably frames the trophies from his indefatigable researches with liberal dollops of his own sly wit (as in the case of Gusto Tenducci, the "celebrated Italian castrato, b. Sienna 1736, d. Genoa 1790" who "was nicknamed 'triorchis' on account of the singular plurality of his reproductive organs that enabled him to marry"). Such details crop up throughout the volume, but they're especially liable to occur when Slonimsky is considering the achievements of the avant-garde. We discover, for example, that in addition to his other achievements the composer George Antheil contrived "a torpedo device in collaboration with the motion picture actress Hedy Lamarr," for which "they actually filed a patent, No. 2,292,387, dated June 10, 1941." Farther on in this entry, Slonimsky notes that "Antheil was the subject of a monograph by Ezra Pound entitled *Antheil and the Treatise on Harmony* . . . which, however, had little bearing on Antheil and even less on harmony." In the John Cage entry, we are informed that 4′33″ requires that its performer play nothing for the length of time stipulated by the title. We are also told, "It was followed by another 'silent' piece, 0′0″, an idempotent 'to be performed in any way by anyone,' presented for the first time in Tokyo, Oct. 24, 1962. Any sounds, noises, coughs, chuckles, groans, and growls produced by the captive listeners to silence are automatically regarded as an integral part of the piece itself, so that the wisecrack about the impossibility of arriving at a fair judgment of a silent piece since one cannot tell whose music is not being played is invalidated by the uniqueness of Cage's art."

In the last two editions of *Baker's*, Slonimsky has taken to including a substantial, though quirky, selection of contemporary popular performers. Sometimes these entries seem designed as much to puncture the self-seriousness of the lexicographical profession as to mock the vagaries of popular taste, as in a passage near the beginning of his entry on John Lennon: "He was educated by an aunt after his parents separated; played the mouth organ as a child; later learned the guitar and was encouraged to become a musician by the conductor of the Liverpool-Edinburgh bus." More often, however, they simply afford Slonimsky an opportunity to filter his genial contempt for those vagaries of taste through the medium of his own ebullient rhetoric. Thus, of Guy Lombardo: "The result is a velvety, creamy, but not necessarily oleaginous harmoniousness, which possesses an irresistible appeal to the obsoles-

cent members of the superannuated generation of the 1920's." Of Frank Sinatra: "In May 1976, the University of Nevada at Las Vegas conferred on him the honorary degree Literarum Humanitarum Doctor in appreciation of his many highly successful appearances in the hotels and gambling casinos of Las Vegas." And, finally, Slonimsky's description of the death of Elvis Presley, which "precipitated the most extraordinary outpouring of public grief over an entertainment figure since the death of Rudolph Valentino . . . Entrepreneurs avid for gain put out a mass of memorial literature, souvenirs, and gewgaws, sweatshirts emblazoned with Presley's image in color, Elvis dolls and even a lifesize effigy, as part of a multimillion dollar effort to provide solace to sorrowing humanity."

From the evidence of entries like these, one might easily assume that Slonimsky's belated musicological career has been one extended lark. No assumption, however, could be less well grounded. One afternoon, Slonimsky caught me looking at a rave British review of the latest edition of *Baker's* headlined SEVENTH HEAVEN. "Funny," he said. "It seemed more like Dante's *Inferno* to me." Indeed, on the question of a career in lexicography Slonimsky had had misgivings from the start. He recalled for me what it had been like reviewing the galleys of *Baker's Fourth* as he prepared his revisions for the fifth edition. "There were an incredible number of errors, but it took a tremendous amount of concentration to weed them out," he explained. "At one point, I came upon a little scribble in the margin left by one of the earlier editors. It said, 'I will go mad if I have to continue this for a long time.' I took this as an omen. And it's been known to happen. Consider poor John Callcott, whose case I included in the *Dictionary*." (Of John Wall Callcott, 1766–1821: "His mind gave way from overwork on a projected biographical dictionary of musicians, and he was institutionalized just before he reached the letter *Q*. He recovered; but not sufficiently to continue his work.")

Slonimsky loves to bewail the difficulties of the lexicographical profession; he can carry on for hours, retailing instances of absurd impasse and hopeless travail. He has written on the subject frequently, and the prefaces to the various editions of *Baker's* are rich with anecdotes of near-apoplectic exasperation. That particular afternoon, Slonimsky summoned up the case of Helen Traubel, a singer "who preferred to date her birth several years after the scission of her umbilical cord." (Luckily, Slonimsky explained, she was born in St. Louis, where a tradition of excellent record-keeping goes back to Napo-

leonic times, so it was not terribly difficult for him to upend her conceit.)
From Traubel, it was a natural progression—progressions in such conversa-
tions with Slonimsky are seldom so smooth—to the great conductor Leopold
Stokowski, who, Slonimsky said, "was born in London in 1882 but preferred
to have entered the world in Krakow five years later." He went on, "One day,
I got a letter from the folks over at Riemann's, the German dictionary, in-
forming me that I must have got it wrong in my account and that they were
henceforth going to cite Krakow, 1887, as the correct version, since they'd
just 'gotten it from the horse's mouth.' I wrote back informing them that they
must have gotten it from the other end of the horse, and enclosing a copy of
the birth certificate, which I'd managed to procure, to prove my case." Slo-
nimsky now free-associated from Stokowski to Stravinsky, with whom he
waged a drawn-out controversy regarding *his* birth date, and the date of his
departure from Russia as well. "Luckily, there I had a spy inside his household
and was hence able to examine the actual passport."

From dubious births, we proceeded to annoying deaths. "One of my main
problems is that composers decide to die out of alphabetical order," Slonim-
sky said.

I remarked that, come to think of it, he must greet each evening's newscast
with a certain foreboding, given the obituary havoc it could play with his
completed entries.

"Actually not," he said, doubling back. "No, deaths are perfectly okay."
He rummaged around among his papers and dug out a sheet headed "Stiffs,
October 1985," which consisted of a neatly typed list of musicians who had
died that month, along with the places and circumstances of their deaths.
"Now, of course, with all these I'll still have to double-check and get proper
documentation. But that's okay, that's just bookkeeping. No, what's really
terrible is when they *don't* die. The zombies. For example, I once had a per-
fectly unimportant Austrian ballet composer, one Alois Ludwig Minkus,
who was born in Vienna in 1826 and was then attached to the Imperial The-
atres in St. Petersburg until 1891, when he was pensioned off and immedi-
ately vanished. Obviously, he must have died sometime, but when? Where?
It took me years, literally decades, of sleuthing before I was finally able to de-
termine that he achieved his heavenly reward back in Vienna on December 7,
1917. But, I mean, you can't just leave a parenthesis dangling like that. And
that's only one case. There are dozens."

I asked him what other sorts of problems he ran into.

"Transsexuals!" he exclaimed. "Composers who've had sex-change operations. What pronoun do you use? That, I assure you, is not the sort of thing my predecessors in this line of work ever had to contend with."

The worst, though, the worst of everything, the horror of horrors and the bane of his existence, Slonimsky now informed me, were the inadvertent factual errors that, once born into print, refused to die and, indeed, spread exponentially from one sourcebook to another, eternally. They haunted his sleep like vengeful wraiths. They haunted his mailbox, too. For, over the years, Slonimsky has received thousands of letters from correspondents throughout the world. Some of them come from formal contacts—informants. He has one in Bulgaria, for instance, who keeps him apprised of compositional doings there and, whenever possible, in Albania, too. He has another in Peking, as well as people in Siberia and Egypt and Australia. Others are sent in by more casual contributors, whom he acknowledges in one of his prefaces when he thanks the "legion of anonymous (for their signatures are usually illegible) archivists." But over the years he has also attracted the attention of some true fanatics—people who scour each new supplement or edition and inundate him with their corrections and emendations and *his* omissions. "When I got one particularly vitriolic letter from one of these fellows," Slonimsky recalls, "one Stephen Ellis, from Glenview, Illinois, sideswiping my 1971 supplement to *Baker's* as 'grossly incomplete' and 'shockingly out of date,' with *pages* of examples, my first impulse was to dash off a note saying 'Sirrah!' and perhaps challenge him to a duel in the high Russian tradition. But I quickly thought better of it and instead struck up a correspondence, and he has proved an absolutely invaluable resource person. The thing about him and several of my other fellow-conspirators—Dennis McIntire, in Indianapolis; Michael Keyton, in Dallas; David Cummings, in Britain; Samuel Sprince, in Boston—is that they're usually nonmusicians and nonacademics, and often they can't even read music. They're obsessed amateurs, and they know more about music than the most erudite musicologists. Some of them, admittedly, have their idiosyncrasies. Sprince, for instance, is a fantastic energumen and a champion complainer. He sends me these thick dispatches typed out single-spaced, both sides, on sequences of disparate-sized little pages, always concluding with a complaint about the Boston weather—and he's *really* into zombies. They're his specialty. He keeps lists of musicians

born before 1900, arranged by birth year." Slonimsky rummaged among his papers and fished out a page headed "1894." "Look," he said. "He even has *me* on one of them. And then there's Keyton—he's a mathematician, who somehow became fascinated with the soloist who gave the world premiere of Tchaikovsky's Second Piano Concerto, in New York City, in 1881, an otherwise utterly insignificant pianist named Madeline Schiller. One day, he happened upon a picture of her in a newspaper of the period, he fell hopelessly in love with her, and since then he's managed to unearth over a hundred articles on the woman. I mean, these are the kinds of madmen I run with."

Only slightly less horrible than the outright mistakes—although in a way even more exasperating, because so easily avoidable—are misprints. And in the most recent edition of *Baker's*, the seventh, these have for some reason seemed exceptionally numerous. "My God, there's never been anything like it," Slonimsky said, cringing as he hefted a copy of the first printing of *Baker's* seventh edition onto my lap. "A complete disaster. I'm going to have to wear a hood the rest of my days. Monasteries won't even accept me. The shame, the derisive laughter will pursue me to my grave. Thank God they've already sold out the five thousand copies of the first printing so that we've been able to correct some of the grossest errors in the second printing. But this process of correcting the volume has produced a whole batch of new ones." He cited several examples—seemingly niggling matters that nevertheless left him mortified. He shuddered. We were silent for a moment, letting the terrors disperse, and then I asked him, "What does it matter? Why is it so important to you?"

"If you ask me what is the significance to the world that I have everything down precisely correct, the answer is zero. I have no huge Copernican ambitions, no need to transform the known universe. It's just that in doing my first book, *Music Since 1900*, I kept finding all these discrepancies, all these manifest impossibilities, and it became a game for me. I invented new research techniques—for instance, placing ads in Russian émigré papers in New York City to nail down a death in San Remo. Or, take nineteenth-century Latin-American composers: they're particularly troublesome . . ." With Slonimsky, any abstract question quickly dissolves into a miasma of particular instances, but I tried to steer him back. "I just don't give up, that's all. I can't stand it," he said. "It's like when I come upon misspellings in the morning paper, a paper that *no one but me is ever going to read*"—he waved a hand toward

a copy of the New York *Times* lying on the sofa—"I can't help it: I *have* to correct the errors before throwing the paper away." Sure enough, the front page was tattooed over with a pox of minuscule inked-in emendations. "I have to destroy them or they literally show up in my nightmares. I have a very rich dream life—no Freudian content, just pieces of paper that need to be picked up. And my mother, criticizing. Strange thing, though, about my dreaming—I never lose my chronological awareness, even while I sleep. My mother showed up in my dream the other night, nattering on about something or other, and I said, 'But, Mother, you must be a hundred and twenty-nine years old.'" Slonimsky smiled. "I don't know. Sometimes I ask myself, 'Why is it so important?' But I guess it's just that I write, I publish, and I have to know whether what I publish is true or not."

But why, I asked him, had he drifted into this lexicographical vocation at all? What did it do for him? How did it answer his needs and fit into his history?

"Ah," he said, "that's another question." He paused. "Perhaps it's genetic. You know, that uncle of mine who used to keep up that vast *cartothèque* on Pushkin and other Russian writers, and my grandfather who was famous for debunking all manner of Hebraic superstitions in the name of enlightened science. Perhaps—I don't know—it's a continuation of the exhibitionist tendencies of my childhood, the need, still, to show off my precocity and garner all that admiration."

Perhaps. But one evening a few weeks later I was talking with Steve Wasserman, a New York editor who treasures Slonimsky's enormous lexicographical achievement, and Wasserman said, "The strange thing about Slonimsky is that in a certain sense, for him, *Baker's* has been one gigantic, heroic feat of sustained procrastination." When I mentioned Wasserman's comment to Ana Daniel, Slonimsky's former secretary, she almost concurred. "Almost, but not exactly," she said. "It hasn't been so much a simple act of procrastination as a vast procrastinatory dirge—an extended act of mourning."

Nowadays, whenever Slonimsky imagines that someone is trying to pull a fast one on him he's likely to protest, "Look, you know, I wasn't born yesterday. I was born twenty-two years ago, when I first moved to California, but *not yesterday*."

He originally came to Los Angeles in flight from Boston, when that city

became intolerable to him following the sudden death, by heart attack, of his wife, Dorothy. He seldom talks about her these days, but when he does it's clear that she was an enormous presence in his life, and is an enormous absence. In the years he has been based in Los Angeles, he has traveled throughout America on lecture tours and throughout the world on research junkets, but he has never been back to Boston. "I warned her against marrying me," he said to me one day. "I suppose she saw me as a lost soul to be saved, but it's too terrible for words what she sacrificed for me."

I asked him if he imagined that he had ruined Dorothy's life.

"No," he replied instantly. "There was, after all, Electra."

Los Angeles, for Slonimsky in 1964, offered a sort of fresh beginning, a tabula rasa, and he was particularly charmed by how rasae the tabulae were with almost all the people he met. He taught music appreciation at UCLA until 1967, when, as he puts it, he was "irretrievably retired . . . owing to irreversible obsolescence and recessive infantiloquy." He was popular with the students—"He is a terrific piano player, who puts on quite a show almost every lecture," one evaluation read—and they, for their part, never ceased to astonish him. He has a whole routine he loves to fall into about the answers he used to get to his test questions—Monte Verdi; Shosty Kovick; "Beethoven's three symphonies, the First, the Fifth, and the Ninth"—and the *explanations* for those answers: "Schubert composed the Unfinished Symphony, also known as Finlandia." Why? "Because you talked about Finnish music, and I wasn't sure whether it was finished or unfinished, so I put them both in." He invariably concludes, "Socrates would have been no match for my students."

For Slonimsky, one of the big advantages of Los Angeles, and especially the Westwood area where he lives, is that it contained "a pullulation" of potential secretaries, the California "odalisques" without whom he couldn't function as a dictionary-maker. ("Odalisques!" he reports that one of them exclaimed to him one day. "I know what they are—there's one in Central Park.") Although he savors (and sometimes exaggerates) the intellectual innocence of his secretary-wards, they, for their part, have all been appalled by *his* innocence in the matter of managing his own business affairs. (This is an estimation they share with Electra.) To hear them tell it, publishers are always putting things over on Slonimsky. They point, for example, to his inability to demand a just royalty on *Baker's*, or to demand any royalty, or even to negotiate at all. He meekly accepts whatever is offered. For the sixth edition of

Baker's in 1978—which sold over twelve thousand copies at seventy-five dollars apiece—Slonimsky received a flat fee of thirty thousand dollars. For the six years of work on the 1984 edition, Schirmer Books (which had in the meantime become an imprint of Macmillan) paid him a flat fee of fifty-seven thousand dollars, of which more than two-thirds went to pay his secretarial and other office expenses. That edition has already sold over eight thousand copies at almost a hundred dollars apiece and sales are continuing handsomely, but Slonimsky will not be seeing another penny. He is not well off; indeed, his principal source of income these days is his occasional lectureships. "But it's partly his own fault," one of the former odalisques told me, in exasperation. "He's absolutely supine in the face of power—or imagined power. Maybe it comes from his background in the Russian intelligentsia, but for him outward success would blow everything. Intellectuals aren't supposed to work or to be seen working; they're supposed to putter, brilliantly, and they're certainly not supposed to haggle over something as insignificant as money. Anyway, it's easier for him to be self-deprecatory than to be visibly successful."

Notwithstanding his borderline economic existence—or, rather, precisely in standing with it—Slonimsky has over the years become a vital presence in the contemporary-music scene of his adopted hometown. We were talking a bit about that scene one afternoon as I drove Slonimsky over to a salon concert at the Beverly Hills home of the contemporary-music patron Betty Freeman—one of a regular series of such private concerts, but a special one, because it signaled the beginning of New Music America Festival, a week-long national celebration of contemporary music being staged throughout Los Angeles. At first, I didn't know *what* we were talking about.

"For some reason," Slonimsky said, "the ones they spawn out here are especially furfuraceous."

Which ones?

"The composers." Two beats, a smug smile spreading across his face. "From the Latin, *furfur*, dandruff. Hence furfuraceous: flaky." Of course. "In fact, I'm acquainted with several of the flakes out here. I even infiltrated their magazine, *Source*—they published two of my pieces, mistakenly imagining that I was one of their kind. One of these flakes, Philip Corner, once published an interesting composition in another issue of *Source*. It consisted of the simple injunction 'One antipersonnel type CBU bomb will be thrown into

the audience.' But it was never performed. Another of my flaky friends is Ken Friedman. When he told me that the finale of his Third Symphony was the Los Angeles earthquake of 1971, I naturally became curious about the orchestration. 'You don't understand,' he told me, with barely disguised contempt. 'The earthquake *was* the finale!'"

But perhaps Slonimsky's greatest triumph on the local scene, he now informed me, came one spring evening in 1981 when a gentleman calling on the phone introduced himself as Frank Zappa. "I couldn't believe it," Slonimsky said as we wove among the palm-lined drives into Beverly Hills. "He spoke to me about Varèse and that book I did about musical scales, all quite knowledgeably, and then asked if I'd mind coming up to his house in the Hollywood Hills for a visit. A few days later, as had been agreed, he sent a limo down to fetch me. We went up to the house, and it turned out he's a tremendously sophisticated musician. His studio includes an immense Bösendorfer piano, which even features nine additional keys in the bass. I mean, as my friend David Raksin says, you don't tune the thing with a tuning fork, you have to use a Richter scale! Anyway, far from what you might expect on the basis of his hoary reputation as the head matron of the Mothers of Invention, Zappa turns out to be an entirely regular family man, with a lovely wife of long standing and four children, one of whom, his teenage daughter Moon Unit, I met that evening and found especially fascinating. For, as you may know, she is a specialist in that strange lingo they speak in the school corridors and shopping malls of the San Fernando Valley. She can deliver whole paragraphs in the Valley language and you can't understand a word of it." Slonimsky spoke with the evident admiration of a fellow linguist. "She patiently explained to me the use of several of these Valley locutions, like 'gag me with a spoon' and 'totally grody to the max,' some of which she later incorporated into her famous record, and a few months later, when I got a new cat, I named him Grody-to-the-Max, in her honor. Anyway, Zappa asked me if I'd like to try out the Bösendorfer, and I played the coronation scene from *Boris Godunov*, which is rich in those deep bass sounds, and then he asked if I'd play some of my own compositions, and I played the last piece from that series of mine called 'Minitudes,' and then he asked if I'd be a featured soloist in his next concert. I laughed and said sure, but when? And he said, 'Tomorrow. We can rehearse the band in the afternoon.' Which we did, and which is how I came to perform as a soloist backed up by Zappa's band at their 1981 concert in the

Santa Monica Civic Auditorium. Zappa introduced me to the audience as 'our national treasure, Nicolas Slonimsky,' if you can imagine such a thing, and, to my astonishment, some of the fans shouted out 'All right!' Everything went well, and the applause at the end made me feel positively inebriated."

A few days later, I phoned Frank Zappa to hear his side of the story. He told me that he'd first heard of Slonimsky years ago, as a young teenager growing up in the California high desert community of Lancaster. At the time, he'd had a collection of R & B singles but only two albums, a Stravinsky *Rite of Spring* and his favorite, a Varèse. He'd read everything he could get his hands on about Varèse, and of course he'd repeatedly come upon the name Slonimsky. As the years passed, he'd followed Slonimsky's writings. "But I had no idea he was living here in L.A. Somehow, I figured a guy like that wouldn't want to live in a bleak place like L.A." The moment he learned that Slonimsky was a virtual neighbor, he called him up and invited him over. "He's incredible," Zappa told me. "He played my Bösendorfer, and nobody has ever played that piano as loud as that man—and not jumping up and down like a madman, just from the strength of his arms and his spirit. He's a human dynamo: he's got a fantastic brain, and a body made out of molybdenum. And another thing I really like about him is his clothes. That first evening, when he was standing there, his clothes didn't match, but they were obviously cool, and you just knew that this was one of the Real Guys. It was an honor to be able to play with him."

No sooner had Slonimsky and I arrived at Betty Freeman's than I lost him in the crowd. Actually, what happened was that someone near the entry as we were coming in was commenting that the trouble with most twentieth-century music, especially of the twelve-tone persuasion, was that there weren't any tunes you could whistle, to which Slonimsky immediately replied "Nonsense!" Whereupon he proceeded to whistle—or, at any rate, to hum breathily—the theme from Schönberg's *Klavierstück*, Opus 33a. This performance naturally attracted an audience, and he was off and running—being Slonimsky. That gave me a chance to talk with some of the other guests, and it became obvious that Slonimsky was well known and well loved in these circles.

"He's such a delightable man," someone commented, noticing how we were both gazing over at the same man. "He hasn't lost the ability to be delighted." The speaker, a shortish expansive man who seemed to be no slouch at enthusiasm himself, proved to be Alan Rich, the critic and writer on music

for *Newsweek*, who now lives in Los Angeles (just a few blocks from Slonimsky, it turned out) and is the cohost of these salons along with Betty Freeman. He began telling me about the day, some fifteen years ago, when he first met Slonimsky. "It was at Lake Placid, and we were going to be on a panel together, and as I saw him entering the room I became tongue-tied. I was terrified." Why? "I mean, if the Washington Monument were to walk into your living room, you'd regard it with a certain degree of awe, wouldn't you? And Slonimsky is a *monument* in the history of modern music. In my college days, LPs were becoming popularly available, and all you had to do was partake. I never had to go through the trial of being won over to new music—its triumph was already evident, the battle had been won. But with Nicolas, this is the man *who did it*, who wrote for *New Music*, who fought for and lobbied for and championed and suffered for new music. He's one of the heroes."

This estimation was echoed a few minutes later by Charles Amirkhanian, the composer and radio producer from Berkeley. "He was literally fifty years ahead of his time," Amirkhanian said. "I was talking to a friend the other day about the new-music scene in New York City in the early fifties. You know how many new-music concerts there were per year in New York City as late as, say, 1950–51? Maybe three or four, total. And twenty years before that Slonimsky was refusing to compromise: he was trying to perform new music virtually exclusively. It was heroic work, but he was undertaking it in an absolute cultural vacuum, and I guess he just recoiled: he retreated finally into lexicography. But for anyone under forty-five he's a living link to that era, to Ives and Cowell and, especially, Varèse." Amirkhanian said he had occasionally stayed overnight at Slonimsky's on his visits to Los Angeles. "He seems to enjoy having me around," he said. "He tells me, 'We're coconspirators in the distortion of music history.' I think he's profoundly lonely, at a certain level: all his contemporaries are gone. He has this strange pattern: he sleeps, he gets up, he sleeps some more, gets up again—all night long. At one point, around three in the morning, I woke up and came out of my room, and there he was, pacing in the living room, with a sheaf of papers in one hand and a pen in the other. 'I'm rewriting the Bach entry,' he told me. 'Rewriting it entirely.' And he did the same with Mozart and all the other major entries. I'm convinced that he conceived of this new edition of *Baker's* as his magnum opus, his testament, his ultimate statement."

A few minutes later, I circled back through the crowd to Slonimsky, who

was engaged in a jovial colloquy with John Adams, an accomplished young composer from San Francisco. Slonimsky was catching up on Adams's latest work—completion dates, premiere dates. I could see him filing away all the details in his memory for transcription onto his cards. It struck me that Adams, who is in his boyish late thirties, was about the same age as Henry Cowell had been—for that matter, as Slonimsky himself had been—when Slonimsky was first championing new American music as a conductor. And here Slonimsky still was, every bit as aware of the newest, most contemporary manifestation of music history, every bit as open and engaged, as he had been back then. A conversation between the generations, I said to myself, observing the scene. But later on, rethinking that formulation, I realized that Slonimsky and Adams were separated by more than a single generation, by more than two—indeed, by more like three.

A few days later, the generational spread had widened to almost four. Slonimsky was about to lecture to an undergraduate music-appreciation class. He was serving a three-week stint back at U.C.L.A., as a Regents' Lecturer, a position that involved his delivering a formal public lecture, which he'd do later that evening, and, in addition, making himself available to any regularly scheduled classes that might want to draw on his wisdom; this was to be one of those classes. There were about twenty students, ranged in rows in a wide, squat room, facing a piano, and the group looked to be about as much of a tabula rasa as any he'd confronted twenty years earlier: their teacher had presumably tried to impress upon them the world-historical significance of their visitor, but the students appeared to have escaped absolutely unscathed from the onslaught of this knowledge (Ives? Varèse? Cowell? Koussevitzky? *Baker's*?), and they just gazed up at their odd-looking guest with blank, amiable expressions. He was wearing shiny black shoes, black slacks, a black jacket, a striped shirt (open at the collar), a set of black suspenders, which framed his bulging belly quite elegantly, and, pinned to his lapel, a colorful NEW MUSIC AMERICA FESTIVAL button.

He gazed upon his audience for a moment and then shuffled over to the piano, upon the lid of which he set a narrow black satchel, which was similarly bulging. His tongue protruding just slightly from the corner of his mouth, he finger-poked out the melody of the trumpet call ordinarily used for signaling the start of a horse race: he delivered it with great brio but then

climaxed on a decidedly wrong note, at which point he winced and looked up in mock confusion. He stumbled across the keyboard for a few more moments with his pointer finger, as if trying to arrive at the proper send-off, but presently he gave up and instead turned to the class. "Rousseau," he began, "as you no doubt recall, says somewhere in *Émile* . . ." He paused for a moment, gazing at the class. "Jean-Jacques Rousseau, the philosopher," he enunciated carefully, "in his book *Émile* . . ." He shrugged and continued, "Anyway, he advises, 'The student must enjoy his lesson.'" At this point, he returned to the piano, sat down on the bench, and began playing a series of bass harmonies with his left hand. "Some of you may be familiar with Chopin's 'Black Key' Étude," he said. "When I was your age, or a bit younger, studying at the conservatory, I found it a terrifically tricky piece to play until one day I noticed that you could perform the right-hand part much more effectively"— he reached into his satchel and brought out a mysterious, brightly colored spherical object—"if you played it with an *orange*." Suddenly, he launched headlong into a spirited rendition of a now entirely recognizable melody, quickly and dexterously rolling the fruit up and down the black treble keys straight through to the climax, whereupon he grasped the orange tightly and hurled it down full force on precisely the right tone-cluster. The orange bounced off the keyboard and rolled over toward one of the students. "You can have it," he said. "Music should be nourishing as well." He was already playing a new progression of chords with his left hand, these quite dramatic and foreboding, and he continued, "Now, there's a particularly pesky violin passage in Wagner's *Tannhäuser* Overture which I've always found, when attempting to negotiate the piano transcription, works much better if you play it with"—his right hand darted back into his satchel—"a *brush*!" An old shoebrush, to be exact, with which he proceeded to slap the high keys with improbable precision and to hilarious effect. "Well," he said, calming down, "you get the idea." He had at any rate got their attention: the students all suddenly seemed genuinely interested in just who this man might be who had thus so abruptly hijacked their seminar.

One kid asked Slonimsky where he came from, and he replied, "I was born a long time ago in a town which has twice changed its name in a vain attempt to exorcise the stigma of its having been my birthplace. I'll let you figure it out." He then improvised a set of similar riddles regarding his exact age, generalizing from these to a consideration of the average ages of all sorts of cate-

gories of musicians. "As a lexicographer, you find yourself wondering about such things," he explained. "It helps keep you awake. Anyway, I have determined that, statistically speaking, for some reason organists live the longest. Scholars and pedagogues come next; then conductors, who tend to be pretty durable. Among instrumentalists, don't ask me why, but those handling the bigger instruments, like double-bassists and trombonists, tend to outlive your average violinist, who, in turn, outlasts the average flutist or oboist, who are apt to be of frail physique. Among singers, on average, tenors burn out faster than bass singers. And in all categories mediocrities outlive the great artists by a vast margin."

The kids were making wild guesses about his birthplace, so he decided to give them a nice, fat clue, saying that it was somewhere in Russia. This got him talking about serf orchestras. "Serf orchestras," he said. "That's s-e-r-f. Nothing to do with California—not the Beach Boys. These were the traditional folk orchestras formed by the Russian peasants during the czarist times, when they were living like slaves. Now, these serfs were generally illiterate and they certainly couldn't read music, so each player in the serf orchestra was assigned a different unique note, which he then had to play eternally—or, I mean, whenever he was performing in the orchestra. For example, you could be condemned to be E-flat or G-sharp forever—just that note, whenever it came up in the melody. Once, when I was researching something else in some stacks of old Russian journals, I came upon a note which read, 'Reward: F-sharp and A-flat, escaped from the orchestra. F-sharp is a tall fellow, bald, big blue eyes; A-flat is shorter, rounder, dark hair.' But this may be why Stravinsky was so fond of melodies with just four or five notes—that is what you always ended up with as the serf orchestras became depleted. In fact, if you want to compose a Russian folk song, the recipe is simple. Take any five notes in a scale and repeat them at random." He went over to the piano and, remaining standing, demonstrated the method, building out from his improvisation with limpid clarity. "Suppose," he continued, "you want to compose a spontaneous French impressionist *chanson*—say, some Debussy." He was suddenly crooning away, accompanying himself with a progression of swelling chords, "*Viens ici, je t'attends, je t'aime . . .* It's simple, you limit yourself to six notes from two mutually exclusive major triads. See?" He played the notes one at a time. "You can compose an entire opera like this." He was singing again, his back arched, baying at an imagi-

nary moon. "*Le soleil de minuit, sur la mer Méditerranée* . . . Admittedly, a geographically impossible opera. Or, if you try the reverse—two mutually exclusive *minor* triads—what you get is one of those dark, ponderous, lugubrious German arias: *Das Licht . . . die Nacht . . .*"

One of the kids asked him about South American music, and this set him to reminiscing about his travels through Latin America back in the forties. Presently, he was talking about the Brazilian master Heitor Villa-Lobos: "Now, there was a composer who was larger than life. Tall tales seemed to aggregate around his persona. There was one about a trip he took into the jungle—he was always venturing into the jungle to stalk authentic indigenous melodies—and about how he was captured by cannibals. Now, Villa-Lobos was quite portly and very interesting from the cannibal standpoint. But somehow he persuaded them to let him play his cello—in this story, he was traipsing around the jungle with a cello—and he did convince them, they let him, after which they all fell down before him, worshipping him as their new god. And that's *just the beginning* of the story. Well, subsequently I asked Villa-Lobos about that particular tale, and he denied it, but with Villa-Lobos you never could tell. He was a wonderful composer. I really should play you some Villa-Lobos. Let's see." He pulled up the piano bench and sat down. "This is his 'Alma Brasileira.' I hope I can remember it. I haven't played it in over twenty years." He could have fooled us: he tore into the piece with astonishing vigor, negotiating the intricate rhythmic patterns with absolute authority. When he finished the room was still.

He simply rushed to fill the stillness with more stories. From Villa-Lobos to Gershwin (how most pianists get "I Got Rhythm" all wrong: "It's not I-got-one-two-rhy-thm, it's supposed to be I-one-got-one-rhy-one-thm, completely even; I asked Gershwin about this one day and he agreed that it's always being misinterpreted") to Schönberg (his triskaidekaphobia) and on to Bach and then Rossini. "*You* are an endangered species," he informed the students, "because I could go on forever."

jOne of the kids asked him who was the greatest living composer.

"Hmm." He paused, momentarily stymied. "Hmm. I take the Fifth Amendment on that. They're all my friends."

At length, his talk did in fact conclude, after which he was surrounded by the departing students. ("What did you say your name was again?" "Was it Vladivostok?") But as we walked back toward the car I returned to Villa-Lo-

bos. "Were you serious?" I asked. "Have you really not played that piece in twenty years?"

"Well," he admitted sheepishly, "actually, I was cheating there a little bit. It just happens I was thinking about that piece this morning, and I rehearsed it in my head in the shower."

"In the shower?"

"Well, you know, the fingering."

Quite a vision. I asked him what it was he was remembering when he remembered a piece like that. Was it the sound of the music or the sight of the printed page?

"Neither," he replied. "I remember the structure."

The site of the public lecture that evening was a bit more formal—the main auditorium of UCLA's Schoenberg Hall. And Slonimsky appeared a bit more formal himself: he had donned a tie and a gray sweater-vest under his black jacket, and he had slicked his hair down. A nice crowd had turned out, and Slonimsky addressed it from a raised stage, all miked-up and bathed in bright arc lights.

He performed a medley of feats at the piano. Some I'd already witnessed, earlier in the day at the undergraduate class or else in the weeks before that at his home, but there were a remarkable number of fresh ones: his inventory seems limitless. For example, while talking about his ability to split his brain in half so that his right hand could conduct at one tempo and his left at another—an ability that proved terrifically useful in his conducting of modernist works—he averred that he could also do this when playing scales. He went over to the piano and announced that he would now play a continuous C-major scale with his left hand in 4/8 time, like this, while simultaneously playing an E-major scale in his right hand in 5/8 time, like this. He rattled off some quick mathematical calculations and told us that he'd start here, at these two low notes, and that if he was going to get it right we should expect his two hands to reach these two high notes, these ones here, simultaneously, and that then he'd take the scales down again. And that is precisely what he proceeded to do, effortlessly.

And he told wonderful stories—of lexicographical detection, of the vanity of geniuses, and of the wisdom of babes. But something strange was going on. The words were right, the ideas, but his timing was off—his *presence* was off. He looked haggard, mildly disoriented. He seemed to be merely

going through the motions and not to be connecting. For the first time since I'd started following him around, he suddenly struck me as an old man. "Well, what do you expect?" I found myself asking myself. "He's ninety-two years old." And I'd never thought a thing like that in his presence before.

At length, the evening ended, and I went backstage to join him. Magic: suddenly everything had changed back. He was surrounded by his fans, holding court, once again in the pink of good humor. After a while, he came over to me and said. "The lights! They were right in my eyes. It was terrible. I couldn't see anybody out there. I couldn't gauge anyone's reactions." And it occurred to me at that moment that it is precisely—and almost exclusively— Slonimsky's sense of fellow feeling, of being a living part of a live discourse, of offering himself *and getting a response*, all the inspired bluff and bluster, that accounts for his uncanny youthfulness. Pith him of that—put him out there on the stage alone—and the grace bleeds away: he's left with his haunting demons, his myriad senses of failure. He counts on people.

I drove Slonimsky home. "I just heard from Virgil Thomson, in New York," he told me. "Electra was having dinner with him, and he asked after my health, and she replied archly, 'Physically, he's all right.'" He laughed fondly. "Ah, well," he said, repeating his slogan, "I may not be endurable but I am durable." He paused. "I was thinking about it today. Do you realize that if Mozart had lived to be as old as me, he could have been Chopin's buddy and the mentor of the young Wagner?" It was a remarkable assertion: not many people capable of making such a statement are still capable of framing it. It was strange, too, to realize that the entire expanse of music history between Mozart and Wagner consisted of barely one century; and conversely, it was startling to be reminded that this man sitting next to me was almost a century old.

We pulled up to the curb by his house. "At least, I'm still ambulatory," he said. "And, for all its odd folds, Electra's estimation notwithstanding, my brain still does function. Every morning, when I wake up I lie there staring at the ceiling, and I give myself a little test. I ask myself, 'In what city was Miaskovsky's Thirteenth Symphony premiered?' *Because it's a trick question*! You'd think, of course, that it was Moscow. But it wasn't—it was Winterthur, Switzerland. And if I can get that right I know that I haven't gone senile during the night, that everything's okay, and so I get up and go feed Grody."

BOGGS'S BILLS

· · · · · · · · · · · · ·

I. A FOOL'S QUESTIONS

J. S. G. BOGGS is a young artist with a certain flair, a certain panache, a certain *je ne payes pas*. What he likes to do, for example, is to invite you out to dinner at some fancy restaurant, to run up a tab of, say, eighty-seven dollars, and then, while sipping coffee after dessert, to reach into his satchel and pull out a drawing he's already been working on for several hours before the meal. The drawing, on a small sheet of high-quality paper, might consist, in this instance, of a virtually perfect rendition of the face-side of a one-hundred-dollar bill. He then pulls out a couple of precision pens from his satchel—one green ink, the other black—and proceeds to apply the finishing touches to his drawing. This activity invariably causes a stir. Guests at neighboring tables crane their necks. Passing waiters stop to gawk. The maître d' eventually drifts over, stares for a while, and then praises the young man on the excellence of his art. "That's good," says Boggs, "I'm glad you like this drawing, because I intend to use it as payment for our meal."

At this point, a vertiginous chill descends upon the room—or, more precisely, upon the maître d'. He blanches. You can see his mind reeling ("Oh no,

not another nutcase") as he begins to plot strategy. (Should he call the police? How is he going to avoid a scene?) But Boggs almost immediately reestablishes a measure of equilibrium by reaching into his satchel, pulling out a real hundred-dollar bill—indeed, the model for the very drawing he's just completed—and saying, "Of course, if you want you can take this regular hundred-dollar bill instead." Color is already returning to the maître d's face. "But, as you can see," Boggs continues, "I'm an artist, and I drew this, it took me many hours to do it, and it's certainly worth something. I'm assigning it an arbitrary price that just happens to coincide with its face value—one hundred dollars. That means, if you do decide to accept it as full payment for our meal, you're going to have to give me thirteen dollars in change. So you have to make up your mind whether you think this piece of art is worth more or less than this regular one-hundred-dollar bill. It's entirely up to you." Boggs smiles, and once again, the maître d' blanches, because now he's into *serious* vertigo: the free-fall of worth and values.

Boggs has performed variations on this experiment at restaurants, hotels, airline ticket counters, hot dog stands, hardware stores, and countless other venues, in the United States, England, Germany, France, Ireland, Belgium, Switzerland, and Italy. (Although American, he has been based in London since 1980.) He has drawn larger and smaller denominations in each of the local currencies, and he has drawn more and less hostile reactions from each of the local citizenries. Often the maître d's and the cabdrivers and the shopkeepers have rejected his offer out of hand. But during the last two years, Boggs has managed to gain acceptance for his proposal on almost seven hundred separate occasions, in transactions totaling over $35,000 in value.

The entire game, of course, rests on the precision of Boggs's draftsmanship, which is remarkable, and yet Boggs always goes to great lengths to make sure that his victims—his beneficiaries, his patrons, his counterparts (one is not sure quite what to call them)—understand that he is not attempting to foist his drawings off as legal tender. For one thing, they're only drawn on one side of the paper—the other side is left blank, except for Boggs's signature and documentation. And in any case, good as they are, one couldn't actually mistake them for the real thing. Not, that is, unless one happened to be the Bank of England.

One evening in the fall of 1986, just before the opening of a London show that was to feature samples of Boggs's art, three constables raided the gallery,

confiscated the work, and hauled Boggs off to jail. He was eventually released into the custody of his solicitor, but dozens of his drawings remain in the custody of the British legal system—Boggs now refers to these as "the Scotland Yard Collection"—and on November twenty-third of this year, in the Central Criminal Court building in London, better known as the Old Bailey, Boggs would be going on trial, charged under Section 18, Subsection 1, of the 1981 Forgery and Counterfeiting Act, with four counts of reproducing British currency without the consent of the Bank of England.

Some saw the looming court battle as high comedy, some as low farce, some discerned a question of principle (indeed, nothing short of artistic freedom itself). Some were calling this case the art world's equivalent of the *Spycatcher* scandal. Boggs himself had at varying times seen his situation in all of these lights, but he also saw something else—his life on the line, for *each* of those four counts, he'd been told, carried a maximum penalty of a ten-thousand-pound fine and ten years in jail.

If the Bank of England intended to exercise some sort of chilling effect upon Boggs's enthusiasms, however, they clearly failed. Despite the trauma of his arrest and the spectre of his coming trial, Boggs continued to pursue his performance investigations with undiminished passion throughout the past year. Some of the results of this curious inquiry were on view this summer at the Jeffrey Neale Gallery on Lafayette Street in the Noho district of New York City. Viewers of this, the thirty-two-year-old artist's first one-man show in New York, were quickly given to understand that as far as Boggs is concerned, the actual drawings of his various bills should merely be considered small parts—the catalysts, as it were—of his true art, which actually consists of the series of transactions they provoke. Thus, in each instance, the framed drawing of the money was surrounded by several other framed objects, including a receipt, the change (each bill signed and dated by Boggs, each coin scratched in with Boggs's initials), and perhaps some other residue of the transaction (for example, evidence of the item purchased—the cardboard carton from a six-pack of beer, a ticket stub for airline travel—or else a photo of Boggs actually handing some swank waiter his drawing and getting back his change, the very change preserved behind glass in the adjoining frame).

One piece, entitled *The Shirts off My Back*, consisted of Boggs's drawing of

a one-hundred-Swiss-franc note, the four shirts he was able to purchase with it, and the receipts and change from the transaction. (All of them together were now being offered for sale at $2,000.) Another, entitled *Buying Money* consisted of four miniature coins (a miniquarter, two mininickels, and a minipenny) that Boggs was able to purchase from Florida artist Steve Holm with his own drawing of a one-dollar bill (also displayed), and the two real quarters, real dime, and four real pennies he'd received in change. (This piece was now being offered at $750.) A third piece, entitled *Printing Money / Money in the Bank*, consisted of a single aquatint print of a Boggs etching of a one-pound note (the etching itself went under the self-answering title, *How Much Does an Idea Weigh?* and this particular print was the forty-eighth out of a run of fifty), the deposit receipt Boggs had filled out in an attempt to deposit the etching *as* one pound into his account at the local Hampstead branch of the Midland Bank, and his monthly bank statement indicating that the deposit had indeed been accepted as such (his account had been credited one pound). That piece was going for $1,000.

Of course, the fact that all of these pieces had now been gathered together, some as loans from private collections and other as entities available for purchase, raised some interesting questions about the initial transactions themselves. If, for instance, Boggs did in fact manage to purchase a ticket for a flight from Zurich to London on British Airways, worth 290 Swiss francs, with a drawing of three one-hundred-Swiss-franc notes (a single drawing of three *overlapping* bills), it was easy to see how the ten Swiss francs in change and the actual ticket stub had made it into this show. But how had the initial drawing managed to rejoin them, so that the entire transaction could now be offered for sale at $1,500? Over and over again, the pieces at the Neale Gallery raised such questions, and as often as not last August, Boggs was right there in the gallery eager to entertain them. He seemed to feel that the show itself was merely a continuation of the series of transactions that had begun, in each case, with his taking pen to paper—and that there was still plenty of occasion for perplex, confoundment, and revelation.

He was there, at any rate, the day I happened to wander into the gallery. He was fairly easy to recognize, because his was the face on the oversize rendition of an imaginary hundred-Swiss-franc note that dominated one wall of the show. In that poster-size drawing he'd affected a sort of seventeenth-century countenance—long hair, steady, sober gaze. In that self-portrait, he

looked just like the sort of royal minister who might once have contrived the very currency of the realm, an achievement for which he'd been immortalized ever after by having his face included on its bills. And indeed, in person, there is something other-timely about Boggs. He's slight of build, with a wiry, taut body, a handsome face with sharp features, smooth complexion, high cheekbones. His somewhat narrow eyes tend to stay open just a bit longer and wider than normal (the whites occasionally visible just above the brown irises), so that he projects an intensity that is usually charming but can sometimes verge on the demonic. He likes to wear wide-collared white shirts, open at the neck, which together with his cascading long brown hair make him look like a refugee from some Renaissance Faire of the 1960s—or, for that matter, of the 1690s.

When he came up to talk to me, that first afternoon at the gallery, I asked him about the presence of those initial drawings in this show. "The thing is," he explained, "there are a lot of collectors, in Europe but also here, who want to buy my drawings of currency—but I refuse to sell them: that's the first of my rules. I simply will not sell an unspent drawing depicting an existing denomination in its exact size. Now, as you can see"—he gestured about the room—"I've occasionally painted larger canvases of actual bills, or else pastiches with aspects of several different bills all mixed together, and those I'll sell outright. But as for exact-size, existing-denomination drawings, I will only—and this is my rule number two—I will only *spend* them, that is, go out and find someone who will accept them at face value in a transaction that must include a receipt and change in real money. My third rule is that I will not tell anyone where I've spent that drawing for the next twenty-four hours: I want the person who got it to be able to have some time, unbothered, to think about what's just transpired. After that, however—and this is my rule number four—if there is a collector who I know has expressed interest in that sort of drawing, I will contact him and offer to sell him the receipt and the change for a given price. It varies, but for the change and the receipt from a one-hundred-dollar dinner transaction, for example, the collector might have to pay me about five hundred dollars. The receipt should provide enough clues for the collector to track down the owner of that one-hundred-dollar drawing, but if the collector desires further clues—the exact name of the waiter, for example, or his telephone number—I'm always prepared to provide those details as well at a further fee. After that, the collector is in a position to contact

the drawing's owner and try to negotiate some sort of deal on his own so as to complete the work."

Are there people who actually go along with all this—I asked Boggs—collectors who will actually pay him five hundred dollars for, say, an ordinary ten-dollar bill, three one-dollar bills, and a dog-eared receipt? He replied that he had a waiting list of eighteen such individuals right now. "I mean," he elaborated, "not all of them will accept just anything. Some are very finicky. I've got one guy who wants a fifty-dollar transaction involving clothing—painting supplies won't do, one hundred dollars won't do. I've got another guy who told me he wanted a five-dollar transaction involving drinks at a bar. Several months later I happened to perform such a transaction, but when I called him up to tell him, he asked me which side of the bill I'd depicted in my drawing. I told him the face side, and he said no, he was only interested in the *back*. So he'll just have to wait. I don't do commissions. I can't work to order."

Boggs went on to explain some further aspects of the mysteriously compounding value of his drawings. If a collector paid him, say, five hundred dollars for the change and the receipt to one of his transactions and then went on to pay, say, another five hundred dollars to procure the drawing itself, he'd then have a completed work that, at current market values in New York and London and Basel, could fetch as much as two or three thousand dollars. Boggs himself prefers to deal with the collectors directly—it is to his financial advantage to do so—but, not surprisingly, many of his collectors are professionals (lawyers and stockbrokers) who don't have the time or inclination to undertake the scavenger hunt themselves and instead choose to work through agents or dealers. Sometimes his own galleries will undertake the scavenger hunts, as it were, on spec. The various arrangements and subarrangements involving fees and cuts and so forth can get fairly complex, but this doesn't seem to bother Boggs; indeed, he usually seems to find such details as fascinating as the initial transactions.

I asked Boggs whether he might like to join me next door for a bite. He looked around—things were quiet in the gallery, not much action—and agreed. As we were walking over to the café, Boggs commented, "I hope you don't think I'm doing all this as some sort of insult to money, as if I were putting money down or something. I think money is beautiful stuff." I laughed as we entered the café. "I'm serious," he said, simultaneously pulling up a seat

and pulling out his wallet, rummaging around for a moment and then extracting a one-dollar bill. "I mean, look at this thing. No one ever stops to *look* at the bills in their pocket, just stops and admires the detailing, the conception, the technique. Part of my work is intended to get people to look at such things. Take this one here. This is an absolutely splendid intaglio print. It's actually the result of three separate printing processes—two on the face side, another on the back—all done on excellent, high-quality paper. Over the years, because of the danger of counterfeiting, they've had to make these bills more and more intricate, both in terms of imagery and technique. But as far as I'm concerned, money is easily more beautiful and developed and aesthetically satisfying than the print works of all but a few modern artists. And a dollar bill *is* a print: it's a unique, numbered edition. Few artists today understand the special nature of printmaking. They just try to translate their painting ideas into prints, and the results are usually mediocre. I mean, look at a Howard Hodgkin print. As a painter, he's the artist I admire perhaps more than any other in England. But in his prints, the color temperatures get lost. I'd rather have a dollar bill than just about any other modern print, even if I knew I could sell the print the very next day for several thousand dollars!

"And that's just talking about technique," Boggs continued. "Now look at the content, the iconography, the history. That crazy rococo profusion of leaves and scrollwork, symbolizing prosperity. The eagle with his thirteen arrows in one claw, one for each of the first thirteen states, and the olive branch in the other—and on the olive branch, the olives! And then the other half of the Great Seal, with that strange Masonic pyramid—an unfinished pyramid, one still in the process of being built. George Washington, on the facing side of the bill, was a Mason; the man who designed the seal was a Mason. There's so incredibly much of American cultural history wrapped up in this little chit of paper. And it's the same with other currencies. In England, I particularly love the fifty-pound note. On one side there's a phoenix, rising gloriously from the ashes. On the other, there's St. Paul's Cathedral. And anybody familiar with the history of England would realize that the imagery on that bill harkens back to the Great Fire of 1666—which destroyed the original cathedral along with much of the rest of London—and celebrates the long and glorious labor of reconstruction that followed."

Boggs paused for a moment, continuing to gaze at his dollar. "'In God we trust,'" he said. "Did you know that that phrase wasn't always part of our cur-

rency? They only started putting it on during the twenties and thirties as they withdrew the dollar's gold backing. It used to be you could redeem a ten-dollar bill for ten dollars in gold. In fact, originally dollars *were* coins, they were a particular kind of coin; the word derives from the word *taler*, which was short for *Joachimstaler*, which is to say the coins originally minted at the Joachimstal mine in Bohemia. Some of the early American paper bills included engravings on the back depicting the metal coins for which the paper bills could at any moment be redeemed. On the back of the five-dollar silver certificate, put out in 1886, there was a picture of five silver dollars. If you wanted to know what a five-dollar bill represented in those days, all you had to do was look at the picture on the back. But anyway, when they started withdrawing the dollar's metal backing—when you couldn't redeem your dollars for gold and in fact were no longer allowed even to possess gold on your own except as jewelry—that's when they started putting that phrase on the currency. When you could no longer trust in gold, they invited you to trust in God. It was like a Freudian slip."

The waiter came over and Boggs ordered some coffee and a sandwich. "It's all an act of faith," he continued. "Nobody knows what a dollar is, what the word means, what holds the thing up, what it stands in for. And that's also what my work is about. Look at these things, I try to say. They're beautiful. But what the hell *are* they? What do they do? How do they do it? Take this one here." He pulled a crisp five-dollar bill out of his wallet. " 'Five dollars.' But what's a dollar? By now, it's just an idea. For that matter, what's 'five'? It doesn't exist either. I mean, you can have the numeral"—Boggs traced a 5 on the tabletop with his finger—"the written word *f-i-v-e*, the sound *five* as I say it. But five itself doesn't exist, except as a concept. So you've got these two ideas joined together and they represent something else: they stand in for something you might eventually buy, for instance, but nothing in particular. And then I make a drawing of a five-dollar bill, and that's *another* order of representation: it's something that represents something that represents something but not anything in particular."

The waiter delivered his order, and Boggs took a few bites. "It's incredibly difficult to make something that's worth a dollar," he said. "As much as a dollar, only a dollar, exactly a dollar. The only thing that has that exact value *is* a dollar. With anything else, its value is constantly changing—including, of course, my drawing of a dollar."

Boggs gazed down at the two bills on the table, then picked them up and slid them back into his wallet. I noticed that they were all the money he had. "Before I got into these money pieces, I was doing a series of things about numbers. I like money, but I *really* like numbers. They're incredibly beautiful: perfection in terms of manipulated geometry. Over the years they've been honed and honed, as to form, so that today, for example, the muscles you use in your hand and arm in order to make a 5 combine into a gesture that just *feels* good. And numbers comprise a universal language. You can go virtually anywhere in the world, you might not be able to understand a word of the local dialect, but if you've got the right numbers on a sheet of paper, you've got the potential for a relationship with someone. Chinese, African, American bills all bear the same numerals. This just used to amaze me.

"I'm already a little bit crazy: lock me away in a studio with a notion like that and I can just about lose it. I was doing all kinds of things with numbers—passport numbers, Social Security numbers, credit card numbers, license numbers, phone numbers . . . images of people lost in whirlpools of numbers, or buoyed on seas of numbers, portraits of people in which the faces were entirely made of numbers. Eventually I found myself just doing portraits *of* numbers, wild expressionist renditions of twisted three-dimensional numerals that seemed to take on a sort of physical presence. I spent so much time with them that they started taking on *personalities* of their own. Some were quiet and sad, others stoical. I knew a 5 that was definitely spoiled and rowdy, there's no other way I could describe him. I almost started relating to them as if they were alive." Boggs sipped his coffee. "It got strange . . . real strange."

He was silent for a few moments, staring out vacantly. I asked him about his background. For one thing, what did the J.S.G. stand for? "James Stephen George," he replied noncommittally. "My parents and my childhood friends call me Stephen, but now I prefer to go by Boggs. Actually Boggs isn't the name I was born with. My biological father and my mother divorced when I was very young; Boggs is my stepfather's name, the man I consider my father. My mother married him when I was about five, and he subsequently adopted me. I was born in New Jersey in 1955; we moved around a lot when I was a kid, but we eventually settled in Florida. My father used to be a citrus grower, now he's an investor. He's a lot more conservative than I am, he's more into the se-

curity money can provide. My mother thinks this whole money series stems from a wish on my part to please him, to make contact with him. I don't know that that's true, but it does seem like these are the first of my works he's gotten into at all. I did a large pastiche painting of an English pound note a while back, and up in the corner where an actual pound note says 'Bank of England: I promise to pay the bearer on demand the sum of 1 pound,' mine says, 'I promise to promise to promise to promise.' When my dad saw that, he told my mother, 'That's a brilliant work of art. People don't realize how true that is.' In fact, he'd been the one who'd explained it to me in the first place."

I asked Boggs about his educational background. "I never graduated from high school," he said. "I was kicked out of the eleventh grade." Over what? "Oh, it was nothing—just bullshit. I was accused of starting a riot in the auditorium, but it was somebody else who threw the book at the principal. Still, it was no great loss. I was bored senseless at school. I got a job working in a printing company, and in my spare time I wrote a play, and then I started working the night shift so I could earn the extra money I needed to rent a theater and mount a production of my play. Ever since then I've been working sixty hours a week at least. For a while I managed a rock group. Then I went up to Ohio where a friend of mine had moved. I got a position in a management training program with Holiday Inn, and they sent me to Miami University there in Oxford for a semester or two. I was trying desperately not to be an artist. I was in a business program, majoring in accountancy, I was even tutoring accounting. But it wasn't working. I've tried several times to quit— Lord knows, I'd have an easier life if I could—but every time I stop making art for any length of time I go crazy, literally. I've been on intimate terms with suicidal depression."

He sighed. "Anyway, I came back to Florida, spent a year at Hillsborough Community College in Tampa majoring in art, and then, during my summer vacation in 1978, I went to London for what I thought would be a month— only, for the first time in my life I really felt *at home*. I called my parents and told them I wouldn't be coming back. I stayed on in London, though as a foreigner I couldn't afford art school and that became frustrating. That Christmas I came back here to New York, and a lawyer friend of mine said he was going to take me over to Columbia and see if he couldn't get me admitted to the arts program there. The dean of admissions was dubious (he threw out my application—after all, I hadn't even graduated from high school), but one of

his assistants interceded on my behalf, and they decided to admit me on a special basis as of January 1979. And that's how I come to have a degree from Columbia."

He paused for a moment and then smiled, both crafty-sly and utterly transparent (a combination I often noticed in the days ahead). "I mean," he said, "I have the piece of paper—a blank one. They gave it to me a year later on condition I'd leave. I kept signing up for classes for which I didn't have the prerequisites—studio art, economics, Russian—and they said, okay, we'll let you take these advanced courses but you have to take these other required courses, too. I said, 'Look, I'm working full-time, I'm painting full-time, I'm going to school full-time, and you want me to take all these classes I have no interest in?' They said, 'Take it or leave it.' So, I left it. I visited my sponsor at the admissions office, and he said, 'You're right, there's nothing more we can offer you, you don't need it, you're already a master.' He laughed, opened his drawer, and handed me a blank diploma. I was on the next flight back to London. I didn't even clean out my locker."

Boggs described how he got various odd jobs in London, and how he occasionally tried to kick his art habit, only invariably to fail. In August 1983 he started painting full-time once again and he's been doing so—frequently in perilous financial circumstances—ever since. He'd paint portraits, or, as he puts it, 'exchange one sort of a portrait on paper for a handful of other sorts of portraits on paper.' For a while, he was painting objects—the objects themselves. He did a painting of a suitcase—or rather, onto a suitcase—that he called *Home*. He did a series of more conceptual works, including one that consisted of a blank canvas scrawled over with hundreds of signatures—his own signatures—one of which, he explained, wasn't a signature but rather the autograph with which he signed the piece. And, increasingly, he got into numbers.

I asked him about the more immediate origin of his current money series. He explained that while based in London, he'd often traveled to countries where he didn't speak a word of the native language, and so he'd sometimes pull out his sketchpad and draw a picture to convey the things he wanted, and that sometimes he'd trade the drawing for the object. But actually, he said, the money pieces had their real origin in the United States.

"I was in Chicago one day in May 1984," Boggs recalled. "I'd gone there for the Art Expo, and I was sitting in this diner, having a doughnut and coffee

and doodling on this napkin, as I'm given to doing. I started out by sketching a numeral, a *1*, and gradually began embellishing it. The waitress kept refilling my cup and I kept right on drawing and the thing grew into a very abstracted one-dollar bill. The waitress came up to ask me if I wanted *another* refill—I was already caffeined right out of my face—and she noticed the napkin, and she said, 'Wow, that's great. What are you going to do with it?' I said I didn't know. She said, 'Can I buy it?' Here was this greasy napkin, covered with coffee stains and an hour's worth of hand perspiration—and here was this woman wanting to buy it. So my immediate reaction was, 'No, you can't buy it.' I could see the disappointment in her face. She offered me twenty dollars. No, I told her, it's not for sale. Then she offered fifty. I just shook my head and asked her how much I owed her. She said ninety cents. I said, 'Tell you what: I'll pay you for my doughnut and coffee with this drawing.' And she was over the moon. This set me to thinking: what was it that she valued so much? Was it the way the drawing mimicked a regular dollar bill? or the fact that she'd sat and watched me do all the work? or that it somehow succeeded as a drawing in communicating something? I got up to leave, and she called out, 'Wait a minute. You're forgetting your change.' And she gave me a dime. We smiled, and I walked out.

"For a long time, I carried that dime around in my pocket. I'd rub it like Aladdin's lamp, and the genie of memory would appear. I still have it: I keep it in my London studio along with my other valuables."

Our waiter brought over a refill, as if on cue, and Boggs continued. "Several months later, back in London, I was telling an artist friend about all this, and he said, 'Ah well, that's America for you. That could never happen in England.' I said that I bet it could. So I began a drawing of a five-pound note. I spent four days doing it, and then we set out to try and spend it. Well, you have to be persistent. We started out at 11:00 A.M., we went to place after place, all different kinds, restaurants, magazine stands, clothing stores—wealthy neighborhoods, poor neighborhoods, trendy ones. And everywhere the answer was no. We eventually wound up, exhausted and depleted, at this Covent Garden pub. We ordered drinks and I pulled out the drawing and the guy behind the counter said, 'Yeah, sure, I'll take it.' Just like that. And he gave me change. My friend Warren was amazed.

"Anyway, that was in November 1984, and I figured I'd proved my point. In January 1985, I started work on a major painting, four by eight, which

gradually turned into a sort of pound note. It said *one pound* in one corner, *five pounds* in another, *twenty pounds* in a third, and in the middle it said *six pounds*. This was the painting where I wrote 'I promise to promise to promise. . . .' I called it *Pined Newt*, after the way snobby upper-class Brits pronounced the words, you know, almost as if holding them at a distance. Anyway, I worked on that painting for almost a year, maybe twenty hours a week. And toward the end of working on it, I started to become aware, what with my mounting debts, how very much it was *costing* me to make art.

"In May 1986, at the International Contemporary Art Fair in London, I exhibited *Pined Newt* at the booth of an unconventional local gallery called Fort Apache. At that point I was $20,000 in debt and I was just about to declare bankruptcy, but the *Pined Newt* sold. I got fifteen hundred pounds, thereby temporarily saving my ass. But then I looked and saw—what?— easily a thousand hours of work, years of study, all my expenses for supplies, all my natural talent—and although I was grateful for the fifteen hundred pounds, I became pretty depressed. Around that point I decided to try to start subsidizing myself through my drawings of money."

Things didn't go very well at first. The enterprise was hardly more profitable on a per hour basis than the *Pined Newt* had been. The drawings took hours, sometimes days, to complete and further hours to spend: often merchants who had things Boggs wanted to buy wouldn't accept his bills, whereas those who didn't have a thing he needed seemed to take a fancy to the drawings. The British in general weren't all that open to such playful artistic license. At one level, Boggs values this sort of indifference. As he'd told an interviewer for a marginal London art journal around this time, "You don't paint to sell in London. And you can do anything you want. You are free. Chances are no one is going to buy it anyway, and the galleries are probably not going to want to talk to you no matter what you paint. So you can paint whatever your imagination, talents, and abilities can stretch to." Which was all well and good. But it didn't pay the rent. In fact, one day it got to the point where Boggs could only pay his rent with a money drawing; luckily his landlord was willing to entertain such curious recompense at least this once. Still, Boggs's prospects did not appear particularly sanguine.

It happened, however, that a Swiss dealer had seen *Pined Newt* at the London art fair and had wanted to buy it, even though it had already been sold. Hansruedi Demenga, who runs two galleries in Basel, did manage to meet

Boggs, however, and invited him to Switzerland the following month for the annual Basel Art Fair.

"My first night in Basel," Boggs now recalled for me, "Rudy took a group of eight of us to a cheap artists' restaurant, and while we were there, I took out a Bic pen and started drawing a one-hundred-Swiss-franc note on a napkin. A hundred Swiss francs is about the equivalent of fifty-five dollars. Anyway, when the waitress came with the bill, I offered her my drawing and she took it without so much as a question. I proceeded to draw two more notes and took them along to the evening's next stop, a disco named Totentanz, the Dance of Death, where I immediately succeeded in spending them, too. My first night in Switzerland, and I'd already spent three drawings!

"The following day I just kept at it. Every time I offered one of my drawings, it seemed, I'd obtain what I wanted, and people were giving me real money in change—even though I couldn't speak a word of the language. I was spending money like a drunken sailor, buying rounds of drinks, taking taxis, buying clothes. The first few nights I stayed at Rudy's home as his guest, but after a while I arranged to move into a five-star hotel, and they agreed to accept drawings in lieu of payment for my entire account. It was incredible."

I asked Boggs why he thought the Swiss proved so open to his offers. "The Swiss get a bum rap," he suggested. "People think of them as stodgy and conservative and uncreative. I found the average people I met to be quite open, with a very high level of general education and interest in art. And beyond that, they tend to understand value, and to understand risk. They'll look at a drawing and understand that it's an object of worth, and of such-and-such a worth. They're a nation of bankers, and they're used to assessing value on an everyday basis. They look at your offer and then they move on it, right there, decisively. They seem comfortable with their own evaluations. They don't need somebody else to hold their hand."

Boggs resumed his saga: "Back at the artists' café, Rudy had offered me one hundred Swiss francs in real money for that first one-hundred-Swiss-franc drawing. But I explained to him how a few weeks earlier, a dealer in London had made a similar offer: he'd said he'd be willing to buy as many drawings as I could generate at face value, and we'd gotten into a fight, me insisting that as art objects they were certainly worth more than face value, and him refusing to pay more. Things got a little heated, and finally I swore, 'On my word,

I will never sell these drawings. If you want one, you'll have to go track it down and then see how much you'll have to pay for it.' So I told Rudy I couldn't sell it to him either. I'd already fallen into my first rule. After a couple of days, though, Rudy had told several friends about me, and he had several collectors eager to buy any of my drawings. I told him he'd have to track them down, I couldn't remember where I'd spent them. I reached into my pockets and extracted a handful of receipts. (I never throw anything out; you should see my London studio.) Meanwhile, Rudy suggested that I henceforth write on the back of my drawings 'Galerie Demenga will redeem at face value'—supposedly this was to protect me legally. And I did do that for a few days. But after a while I stopped, because it began to feel like a con."

I asked Boggs whether anyone took the Galerie Demenga up on its offer. "The funny thing was," Boggs replied, "people would go to the gallery to show their drawings and ask if it was really true that the gallery would redeem them at face value. Rudy or his assistants would say, 'Absolutely,' but then the people would say that they weren't interested in selling them, they'd just been curious. Finally, in exasperation, Rudy went on the local radio station and announced, 'There's an artist here in town named Boggs who's spending drawings of Swiss franc notes. He won't sell any of them to me. I hereby announce that if it's a real Boggs, the Galerie Demenga will pay *ten times* face value.' After that, I *really* got popular. Cabbies were almost colliding in their haste to pick me up whenever I stuck my hand out."

I asked what Demenga had meant by "if it's a real Boggs." "That was the other crazy thing," Boggs explained. "Because people started coming into Demenga's gallery with counterfeit drawings and claiming they were by me. I quickly developed a series of consistent idiosyncrasies in my own renditions—I now have seven of them, such as the fact that I always mismatch the two serial numbers on the face of any of my bills (only one of them is correct, I usually leave a digit out of the other)—so that Demenga would be able to identify the real Boggs bills. One time I happened to be in the gallery and a guy came in with a drawing of a one-hundred-Swiss-franc note that he wanted to redeem and they told him it was obviously a fake, but that it was a *good* fake, so that though they wouldn't honor it at ten times face value, they would offer him face value itself. 'Are you kidding?' the guy exclaimed. 'Do you know how long it took me to make this thing?' Whereupon he stomped out in a rage. Which, of course, was my point precisely."

Boggs went on to explain that it was in Switzerland that he began to discern the wider possibilities of his medium. Faced with so many successful transactions, and such interesting ones, he began to sense how the transactions themselves, beyond the simple drawings, were the true aesthetic objects. "I'd been saving the receipts and after a while I started saving the change, too, and presently I was even saving the actual bills I'd used as models for my drawings. And I was trying to figure out what to do with all this stuff. One evening, after I'd spent my biggest denomination yet—a five-hundred-Swiss-franc note at the Hotel Euler—I called Dr. Robert Kahn in London, who's become a sort of patron of mine. I quickly explained the situation, and I concluded by saying, 'So I've got this receipt and one-hundred-and-ninety Swiss francs in change and what I want you to do is to buy them from me for . . . oh, I'll give them to you for three hundred Swiss francs.' He hesitated for a moment, but then he took them. And then he went back to bed. Because I'd called him at about two in the morning."

After that, all the principal ingredients of Boggs's new art form were in place. For the next several months he would just go on going on. "I used to get so tired," Boggs concluded, "of people asking me how much money I'd made as an artist over the past year. Now, however, on any given day, I can tell them exactly."

It was getting late, and I asked Boggs if he had any drawings he might like to try and spend here at the café in payment for our meal. But he said, no, he was fresh out of art. "As I say," he explained, "it takes me a long time to draw them. But I'm planning to draw a few more bills in the next few evenings and then I'm going to go out and try to spend them." I asked if I could join him on his spree, and he said sure. We agreed to meet back at the gallery three days hence.

In the meantime, I picked up the tab.

Boggs had almost accidentally stumbled upon the terrain but then decided quite deliberately to pitch his tent there along the faultline where art and money abut and overlap—and his current work has definite ramifications in both directions. The questions it raises start out as small perturbations: How is this drawing different from its model (this bill)? Would you accept it in lieu of this bill? If so, why? If not, why not? But they quickly expand (as you think about them, as you savor them) into true temblors: What is art? What is

money? What is the one worth, and what the other? What is *worth* worth? How does value itself arise, and live, and gutter out?

During the next few days I spent a lot of time at the library. I began with Georg Simmel, the great German-Jewish philosopher and sociologist whose *The Philosophy of Money* was published in 1900. In its final pages, Simmel concludes that "there is no more striking symbol of the completely dynamic character of the world than money. The meaning of money lies in the fact that it will be given away. When money stands still, it is no longer money according to its specific value and significance. The effect that it occasionally exerts in a state of repose arises out of an anticipation of its further motion. Money is nothing but the vehicle for a movement in which everything else that is not in motion is completely extinguished." But if in one of its aspects Simmel saw pure motion in money, in another he located an absolute stillness. "As a tangible item, money is the most ephemeral thing in the external-practical world; yet its content is the most stable, since it stands at the point of indifference and balance between all other phenomena in the world"

It occurred to me that Boggs's work operates in the space between those two absolute characterizations. He momentarily slows the mindless frenzy of exchange, forcing us to mind it; and in so doing, he briefly forces the age-old monolithic stasis to budge and shudder. It's a sort of magic. But then, all art is magic (we *knew* that), and so is all money.

"Although it is an ancient fact of life, or rather an ancient technique," Fernand Braudel writes in *The Structures of Everyday Life* (the first volume of his magisterial history of the progress of civilization and capitalism from the fifteenth through the eighteenth centuries), "money has never ceased to surprise humanity. It seems mysterious and disturbing . . . [and] complicated in itself." While chronicling the resurgence of money and exchange in late medieval and then Renaissance Europe, Braudel quotes one contemporary characterization of this new presence, money, as "difficult cabala to understand."

That primordial sense of the mystery initially surrounding money in turn dovetails nicely with a famous passage from Norman O. Brown's visionary *Life Against Death*, the 1959 book in which Brown attempted to fashion a reconciliation of Marx and Freud. Brown had earlier pointed out that "it is essential to the nature of money for the objects into which wealth or value is condensed to be practically useless. . . . This theorem is equally true for

modern money (gold) and for archaic money (dog's teeth)." Brown goes on to suggest that money therefore consists in the transubstantiation of the worthless into the priceless (of the "filthy" into "lucre"): "The sublimation of base matter into gold is the folly of alchemy and the folly of alchemy's pseudosecular heir, modern capitalism. The profoundest things in *Capital* are Marx's shadowy poetic presentiments of the alchemical mystery of money and of the 'mystical,' 'fetishistic' character of commodities. . . . Commodities are 'thrown into the alchemical retort of circulation' to 'come out again in the shape of money.' 'Circulation sweats money from every pore.' " This, for Brown, is where Freud comes in, because "Freud's critique of sublimation foreshadows the end of this flight of fancy, the end of the alchemical delusion, the discovery of what things really are worth, and the return of the priceless to the worthless. In a letter to Fliess, Freud writes, 'I can hardly tell you how many things I (a new Midas) turn into—excrement.' "

One can hesitate before the grandeur of Brown's prophecies regarding any imminent recovery of true worth (I mean, maybe, but we're certainly not there yet) and still admire the suggestiveness with which its formulation frames the issue: money as an alchemical delusion. How did money arise— and more specifically in the current context, where did *paper* money come from?

Anthropologists have all sorts of theories about the origins of money itself. One of the more intriguing was posited, about a decade ago, in an art exhibition catalogue of all places—the catalogue to the Düsseldorf Städtische Kunsthalle's extraordinary *Museum des Geldes* ("Museum of Money") show in 1978. That show, jointly curated by the Kunsthalle's director, Jürgen Harten, and his anthropologist friend Horst Kurnitzky, surveyed the recent history of artists' works on the theme of money, but it began with and was grounded in a theoretical framework established by Kurnitzky. Kurnitzky suggested that money had its origins in ancient rituals of sacrifice and expiation. These ceremonies originally involved human sacrifice, but as time passed, priests became empowered to substitute, through various arcane and sacred rituals, other beings—for example, pigs—for the human victims. Kurnitzky suggests that this exchange of one entity for another formed a sort of ur-model for all later substitutions, exchanges, and trades—served, that is, as a sort of precursor to the very notion of money. One doesn't have to buy that entire thesis or any of its corollaries (Kurnitzky and Harten's suggestion,

for example, that the ancient pig-sacrifice rituals live on into the present day in the form of piggy banks, or their suggestion that the Surrealist movement tapped into a deep intuitive understanding of the links among dreams, sacrifices, and money) to acknowledge that in its earliest incarnations, the creation and control of money was almost invariably a priestly function. The earliest vaults were temples. The very word "money" harkens back to the Latin epithet for Jupiter's wife—Juno Moneta—in whose temple the mint was located.

The earliest, most primitive economies consisted of self-sufficiency in most things and barter for the rest. You had wool, I had corn—we traded. This sort of economy was predicated, however, on what the economist W.S. Jevon has called "the double coincidence of wants." Otherwise things quickly became complicated: You had wool, which I wanted; I had corn, which you didn't; but he had a blade and she had a basket, and you wanted his blade, she wanted my corn, he was willing to trade his knife for her basket . . . and so forth. As these exchanges became ever more convoluted, certain commodities kept recurring and gradually became mediums of exchange, standards by which the other potential items of trade could be measured. These "commodity moneys" had to fulfill certain requirements—they needed to be convenient to transport and store and subdivide, for example, and they needed to be somewhat durable—but beyond that, they could consist and have consisted in any of a remarkably varied and arbitrary range of items. At one time, cows were the medium of exchange in Italy, and the Latin word for cattle, *pecus*, was the root of another Latin word for money, *pecunia*, which, of course, survives in our own "pecuniary." On the Fiji Islands, whale teeth were used, tea bricks were used in many inner areas of Asia, camels in Arabia; American Indians traded wampum (strings of shells), early Canadian colonists used playing cards, and colonial Virginians made tobacco leaves their legal tender in 1642. I've read of woodpecker scalps being used as money, though I don't know where and can't imagine how. In Romania today, the underground economy for some reason runs on unopened packs of Kent cigarettes (ten pounds of lean beef going for one carton). And then, of course, there were the precious metals—especially silver, to a somewhat lesser extent gold, and for more modest transactions, bronze and, later, copper. Coins minted from these materials were common throughout the Mediterranean region during antiquity, but tended to subside (as did trade) dur-

ing the early Middle Ages, only to resurface in the later Middle Ages, the period at which Braudel's account begins.

Money must have seemed "complicated in itself," Braudel writes, for not even in France was the monetary economy fully developed, even as late as the eighteenth century: it made its way into certain sectors and certain regions and left others utterly undisturbed. Wherever it did penetrate, however, it provoked profound transformations. "What did it actually bring?" asks Braudel. "Sharp variations in the prices of essential foodstuffs; incomprehensible relationships in which man no longer recognized either himself, his customs, or his ancient values. His work became a commodity, himself a 'thing.' " By way of illustration, Braudel reports the testimony of sixteenth-century Breton peasants, who expressed confusion and astonishment at how much less abundance they now had in their homes because "chickens and goslings are hardly allowed to come to perfection before they are taken to sell for money to be given either to the lawyer or the doctor (people formerly almost unknown), to the one in return for dealing harshly with his neighbor, disinheriting him, having him put in prison; to the other for curing him of a fever, ordering him to be bled, . . . or for a clyster; all of which our late Tiphaine La Boye of fond memory [a bone setter] cured, without so much mumbling, fumblings and antidotes, and almost for a Paternoster."

"History," Braudel concludes, "shows us an endless procession of these condemned men—men destined not to escape their fate. Naïve and astonishingly patient, they suffered the blows of life without really knowing where they were coming from." Braudel himself, however, does not long tarry in this elegiac melancholy. Explaining that money was a symptom rather than the cause of the burgeoning monetary economy ("Its flexibility and complexity are functions of the flexibility and complexity of the economy it brings into being"), Braudel soon moves on to the sort of dazzling inventory of particular details that he so clearly relishes. Some that I particularly relished involved early European impressions of travel in China where, according to contemporary accounts, everyone, "however wretched he may be," carried around large scissors and precision scales (so as to be able to cut from loaves of silver and weigh the slices), and little wax-filled bells with which to scoop up any random splinters (when they'd accumulated enough splinters, all they had to do was melt the wax).

The precious-metal based trade economies, however, had many internal

problems. For one thing, while a chest of coins was considerably more con-
venient to lug around than a herd of cattle or a brace of woodpecker scalps, it
still wasn't *all that* convenient (or safe) to cart around. Furthermore, over the
years, there tended to be a flight of metal out of Europe toward Asia, which
was fine at one level—Europe got silks and spices and so forth in return—but,
when compounded with the problem of hoarding, it meant that at times, in
certain places, the currency of exchange would dry up almost completely, at
which point trade would become, in the words of one contemporary witness,
"an occupation of much perplexity."

I took a break from such reading, one afternoon, to lunch with Robert
Krulwich, the economics correspondent for National Public Radio and CBS
television, who, I happened to know, was also a Boggs enthusiast. (Indeed,
he was planning to air a short piece on Boggs himself.) Krulwich's reports are
prized as much for their crystalline clarity as for their droll perspective, and
when I asked him to help me understand the transition from metal to paper
money, he didn't disappoint me. "Well," he said, "I suppose you know all
about the camels and the cows and the woodpecker scalps and all that, so I
won't bore you with them. But anyway, eventually people are using gold
coins and baubles in their transactions, and they occasionally have to break up
these pieces or the jewelry or whatever as they go about their business. Every
so often they then take the remaining pieces and whatever new scraps they've
picked up along the way to their neighborhood goldsmith, for him to refash-
ion all the scraps into something more presentable, or maybe just into a bar.
The goldsmith weighs it all, and then he hands his customer—let's say the
customer's you—a marker, an IOU, a little chit of paper saying how many
grams you've left with me and can expect to get back. I'll be the goldsmith.
Now, you can take that marker and exchange it for goods, say, with the wine
merchant, who would then be entitled to redeem it with me for the gold or
else just to keep it circulating (which might be more convenient for him,
what does he need with the gold?). Okay, so I'm the goldsmith and one day
I'm sitting there and I say, hmmm, I've got all this gold and I know all these
markers are circulating, but you know what? They're not going to all be re-
deemed at once. I can issue a few extra markers and get some goodies for my-
self (I hear the wine merchant has some good stuff this week) and nobody's
going to be the wiser. It's risky but it's not that risky. Well, that's the line of
reasoning that makes me the grandfather of the first bankers.

"I'm oversimplifying, but that's how paper money really gets going. Bankers a few generations down the line are issuing IOU's on their own, backed only by their say-so that they have enough on reserve to cover them—and in some places in the world you still see traces of this. You can go to a powerful place like Hong Kong and you think something like the Queen or the government is backing up the money—but when you turn over the little srap of paper all you see is a picture of the bank—the building itself!

"Now," he continued, "one of the things that's interesting is that paper money circulates but that doesn't drive out the gold, just as the gold didn't completely drive out the barter. Everything exists side by side. Then in the 1830s you begin to get checking, which is a method whereby I sign a piece of paper instructing my bank to give you some of their other kind of paper. As usual, this innovation first gets accepted by the elites, but it gradually spreads throughout the society, and meanwhile, paper bills and gold and barter continue right on alongside.* Little by little the various backings of the coins get withdrawn—you can no longer redeem your check for a paper bill that you can redeem for gold and silver. Now, all you can exchange your old bill for is a new bill. But by the 1960s, people (again starting with the elites) are using fewer paper bills and checks anyway: they've started using credit cards, which are just sequences of numbers splayed onto carbon paper. And now, in the eighties, we're even getting rid of carbons, it's all becoming electronic—my number telling my bank's number to transfer such-and-such an amount to this supplier's bank's number. It's becoming more and more invisible. Nowadays, half a trillion dollars exchanges hands every day—although no hands are involved, and in a sense no dollars either, and not even numbers really. It's just binary sequences of pulses racing between computers.

"In the midst of all that," Krulwich concluded, "this fellow Boggs has found a way to illustrate, to act out, the essential nature of exchanges and

* There are, of course, still places in the world into which the institution of checking has not yet penetrated. Until just recently, the entire Soviet Union constituted one such zone. However, according to a recent report over National Public Radio, the Soviet Union has begun to introduce personal checking as part of the *perestroika* in financial services. That introduction, however, is slow—shopkeepers have to be trained to accept checks—and irksomely cumbersome: if a bank customer should happen to lose his checkbook, his entire account is frozen and he can't get at any of his own money until the checks themselves become invalid, which can be as long as two years. One Soviet official was quoted as saying that this was still a lot better than losing the money itself, in which case the customer would *never* get any of it back.

money. He forces us to see, among other things, how it's all a fiction, there's nothing backing it, it's all an act of faith. In a way, though, he's in a bit of a retro position. He's still back with the goldsmith and his grandson, the banker—drawing money. The challenge for the next Boggs—or else, maybe the *next* challenge for *this* Boggs—will be to find some way of commenting on all the invisible traffic."

Back at the library I continued reading Braudel and others on the origins and development of paper money: "This type of money that was not money at all," Braudel writes, "and this juggling of money and bookkeeping to a point where the two became confused, seemed not only complicated but diabolical. . . . The Italian merchant who settled in Lyons in about 1555 with a table and an inkstand and made a fortune represented an absolute scandal." (This Italian, in a sense, sounded like one of *Boggs's* grandfathers.) In 1682 William Petty published a question-and-answer manual entitled *Quantulumcumque Concerning Money* (roughly translated "The Least That Can Be Said Concerning Money"), and his answer to Question 26, "What remedy is there if we have too little money?" was simple: "We must erect a Bank." By the early seventeen hundreds, the Scottish banker John Law exulted over "the business potentialities of the discovery that money—and hence capital in the monetary sense of the term—can be manufactured or created." As Braudel writes, "This was . . . a sensational discovery (a lot better than the alchemists!)." And again, alchemy seems the appropriate analog: not long before, serious scholars had been laboring over vats and retorts, trying to distill gold out of manure. Those who got distracted along the way became the early chemists; those who kept their attention on the main goal became the early bankers. For in fact paper money *did* seem to create wealth out of nothing.

(In this context, it occurred to me—as it no doubt has to Boggs as well—that the odd thing about art is that it recapitulates the confusion about paper money: why, and how, is it worth *anything?*)

Miles DeCoster, in a curious but extremely lively monograph entitled "Iconomics: Money," notes that the solidity of that newly created wealth could be illusory: "Experience showed that in expansive times a reserve of coins equal to less than ten percent of the value of the notes issued would suffice. Experience also showed that in times of contraction the value of such notes could disappear as quickly as it appeared. So, too, could a bank." The

fact is that, though unlikely, a day could indeed come when everyone at the same time would try to redeem his markers with the goldsmith or his grandson—and the result would be a magic collapse: wealth turned right back into manure. John Law himself found this out when the national bank he founded in Paris, soon after the death of Louis XIV, went from phenomenal growth to cataclysmic rupture in just a few years, with the bursting of the Mississippi Bubble in 1720. Earlier, much of the "Tulipmania" that possessed Holland in 1636–37 had been paper-driven, as Simon Schama has masterfully shown in his recent *The Embarrassment of Riches*. People weren't so much trading the tulips themselves as paper futures on next season's tulips. Speculation ran rampant, causing great disquiet among the more sober-minded burghers who saw the process, according to Schama, as "a kind of economic alchemy whereby fools imagined they might turn mere onions (the bulbs) into gold." (In one passage, which has uncanny resonances with the situation of the art market today, Schama notes that tulips had been around in Holland for several decades before the mania. They'd originally been imported from Turkey, and their cultivation was initially prized by a relatively small band of gentleman horticulturists. Things began to change in the mid 1630s, however, and "it was this transformation [of the tulip] from a connoisseur's specimen to a generally accessible commodity that made the mania possible.") At any rate, of course, there, too, the bubble burst, and tremendous (paper—and real) fortunes were lost almost overnight.

Paper money was particularly favored in England's American colonies, where a perennial shortage of coins throughout this period tended to famish trade. According to Miles DeCoster, some issues were private (he cites one paper certificate with the inscription, "I promise to pay the bearer three pence on demand, Azariah Hunt, Trenton"), but others were put out by the colonial governments themselves. Usually they were backed by the promise of payment in coin at some future specified date, but "in 1713, Virginia established public tobacco warehouses and issued paper certificates in various denominations for tobacco deposited by the public." The overlords back in London tended to frown on the widespread reliance on paper throughout the colonies, and their attempts to dissuade the practice (and thereby, from the colonists' point of view, to strangle development) were an ongoing source of friction.

The Revolutionary War, when it finally came, was largely financed through a series of paper issues in various denominations that were simply de-

clared "legal tender," with the promise of redemption in coin at some (sig-
nificantly) unspecified later date and with no backing whatsoever at the time
of issuance (future tax revenues, it was hoped, would eventually subsidize the
scheme). These certificates, which were known as Continentals, may have
been necessary for the success of the Revolution, but almost immediately
thereafter they spiraled into near-worthlessness (hence the contemporary say-
ing that "a wagonload of money would scarcely purchase a wagonload of pro-
visions"), thereby wreaking havoc on the young country's economy. One of
the side effects was serious exploitation and dispossession of farmers, many of
whom had borne the actual brunt of the fighting as Revolutionary troops (for
which they'd been paid in paper), by urban merchants and landlords who
started foreclosing on their farms. The resultant series of farmers' uprisings,
such as Shay's Rebellion (1786), in turn spooked the merchants and the more
secure landed gentry into convening the Constitutional Convention in 1787.
The document they in turn produced restricted the right of coinage to the
federal government, and forbade both state and federal governments from is-
suing paper money.

The Constitution did not, however, prohibit private issues, and banks (in-
stitutions that, incidentally, had been pretty much illegal under British
administration) now rose to the challenge and opportunity and began issuing
paper. The situation in the United States during its first four score and seven
years sounds pretty chaotic. Legal money took the form of gold and silver
coins, but the actual day-to-day circulation consisted in the paper issue of the
various independent state and local banks. These paper bills were denomi-
nated in dollars, with the promise of redemption in coin, and yet not all
banks, not all promises, were considered equally reliable. Thus, in much the
same way that exchange rates today regulate trade between various national
currencies (dollars into lire into francs into yen and so forth, in constantly
changing configurations), in those days exchange rates were established
among the various banks' issues, so that one bank's dollar might only be
worth eighty-five cents in another bank's currency. According to DeCoster,
"In principle the exchange or discount rate was based on the assets and relia-
bility of the issuing bank, but rates were in effect often determined by the dis-
tance of the issuing bank from New York." Robert Krulwich had told me a
story about the considerable complications the Illinois rube Abraham Lin-
coln faced in trying to find some way of paying for his son's schooling back in

Exeter, New Hampshire, as no East Coast–based bank would honor any of the checks drawn on his Illinois bank's account. (Come to think of it, that almost sounds as bad as the situation at some New York banks today.)

Hundreds of state and local banks were issuing their own scrip, but they were not the only source of money. There were in addition thousands of counterfeiters faking all these various sorts of scrip and, in more enterprising cases, simply creating entirely fictitious issues out of whole cloth. "When guides for detecting bogus bills were published," writes DeCoster, "the counterfeiters faked the guides to the advantage of the spurious issues."

The Civil War changed everything. In order to finance the fighting, the governments of both sides began issuing paper money. The Confederacy simply did it, but the Union had to finesse its way around its Constitutional prohibitions by invoking the emergency situation. The bills the U.S. federal government began issuing in 1861, technically known as Demand Notes, were more popularly known, owing to their appearance, as "greenbacks." The first issue, of sixty million dollars, was mass-produced through engraving; serial numbers were then individually stamped on the certificates, and then they were all *hand-signed!* As Robert Friedberg notes in the standard reference book *Paper Money of the United States*: "The first plates made for the various denominations had blank spaces for two signatures, and below these spaces were engraved 'Register of the Treasury' and 'Treasurer of the United States.' These two busy and important Treasury officials obviously could not sit down and personally autograph several million notes. Therefore a large staff of clerks from the Treasury Department was employed to sign their own names for the two officials. The way the plates were worded made it necessary for these clerks to write also the words 'for the' in addition to their own names."

The National Bank Act of 1864 hastened the demise of state banks and the standardization of circulating currency. Banks were allowed to obtain national charters (the first one to do so in each locality became The First National Bank of, say, Wichita, the second one The Second National Bank, and so forth). These privately owned banks were allowed to issue paper, but the notes themselves were printed by the government and were uniform in design, except for the prominently engraved name of each separate bank. Meanwhile, the battles before the Supreme Court following the Civil War regarding the constitutionality of the federal paper, the greenbacks (Lincoln's

Treasury Secretary Salmon Chase who'd issued them in the first place, now, in 1870, as Chief Justice of the Supreme Court, spoke for the majority in declaring them unconstitutional and then dissented vigorously the next year when a new majority declared them constitutional after all), prefigured three decades of extreme social and political conflict regarding the proper character of the nation's currencies. Some insisted on exclusive gold backing (and no printing of paper without such backing); others favored silver backing as well (so-called bimetallism). Many of the same issues first broached in Shay's Rebellion now resurfaced with the Populist movement, which pitted farmers and laborers against bankers and the large trusts.

Throughout this period, polemicists continually wrestled with the notion of paper money as phantasm, as fantasy—indeed, as a specifically *artistic* fallacy. During the 1870s, for example, David Wells composed an anti-greenback tract entitled *Robinson Crusoe's Money*, in which, as a sort of satirical cautionary tale, he traced the natural history of money on an imaginary island. Soon after the introduction of paper currency to the island, Wells reported that the inhabitants took to employing "a competent artist, with a full supply of paints and brushes, and when any destitute person applied for clothing, they painted upon his person every thing he desired in way of clothing of the finest and most fashionable patterns, from top boots to collars, and from blue sallow-tailed coats to embroidered neckties, with jewelry and fancy buttons to match." Twenty years later, when Wells's tract was reprinted as part of the anti-silver campaign, it featured an accompanying illustration by the great cartoonist Thomas Nast. Nast's drawing consisted of a rag doll propped against a wall, though a message scrawled on the wall asserted that "This is not a Rag Doll but a Real Baby by Act of Congress." A hand from off to the side extended into the picture offering the doll a chit of paper upon which was printed "This is Milk by Act of Congress." Onto the wall behind the doll was tacked a drawing of a cow with the heading "This is a Cow by the Act of the Artist."

Silver coinage became the main issue of the 1896 election, culminating in Democratic candidate William Jennings Bryan's ringing challenge, "We will answer this demand for a gold standard by saying to them, 'You shall not press down upon the brow of labor this crown of thorns, you shall not crucify mankind upon a cross of gold.'" Bryan lost, but with time, so did the gold standard.

In 1913, Congress established the Federal Reserve System, which, though retaining a regional emphasis, gradually evolved into a central bank and unified the currency of the nation. Ironically, Lincoln's old Treasury Secretary Salmon Chase now found himself being posthumously honored for his repudiation of the greenbacks he'd launched by having his visage affixed to their largest single denomination, the $10,000 bill. The separate local bank issues were standardized, by 1928, into bills that began to look like the ones we use today (the ones Boggs has mastered). In 1933 all forms of currency—gold certificates, silver certificates, bank notes, federal notes, and so forth—were declared interchangeable. Just before the Second World War, the possibility of redemption in gold was canceled, and silver redemption (the possibility of exchanging bills for progressively less pure silver dollars) was likewise suspended after 1968. In 1972, the United States suspended gold payments against international accounts, thereby severing the last connection between paper and metal. We trusted in God.

And all of this history, in a sense, was resonant from the moment Boggs took his pen to paper.

Jackson Pollock is said to have settled his drink bills with paintings (the lucky bartender!), and Kurt Schwitters merrily included everyday receipts in his collages (*Merzbilder*, he called them, those framed jumbles, a word he derived from *Commerz*, the German word for commerce). Boggs is by no means the first artist to have stumbled upon these precincts. Picasso, the story is told, used to go out shopping: he'd sign his checks and then dash off smart little doodles on the backs—the checks were seldom cashed. (So that, Picasso truly *was* the modern Midas.) Years later, the Swedish artist Carl Fredrik Reuterswärd made a three-dimensional bronze of Picasso's signature, stood it on a tottering pedestal, and titled it *The Great Fetish*. He also printed stretched-out versions of Salvador Dalí's signature and sold them by the centimeter. Marcel Duchamp went to his dentist one day, couldn't pay or didn't want to, and instead drew an ornate check, filled it in and signed it, and the dentist accepted. (Years later, when Jurgen Harten was trying to procure the check for inclusion in his "Money" show, the Italian dealer who then owned it demanded $3,000 just for the loan.)

The mad artist-brut Adolf Wölfi, holed up in a Bern asylum for schizophrenics for the last thirty-five years of his life (he died in 1930), did a series

of large, wild drawings of bill-like entities, covered over with elaborate calculations and tabulations: endlessly he kept his delusional accounts. Years later, the Swiss artist Daniel Spoerri (born in 1930) opened his checkbook and wrote out a series of checks, payable to cash at ten Deutsche marks each, and sold them as art for twenty Deutsche marks apiece. ("In exchanging art for money," he explained, "we exchange one abstraction for another.") Timm Ulrichs, a young German artist, went to court and had his name declared a trademark. On March 1, 1971, Pieter Engels went on life-long strike as a visual artist and proposed that the Dutch government pay him 25,000,000 florins for a stone marker ("a visualization") commemorating the ongoing event.

In 1923, during Germany's terrifying bout with hyperinflation, a Munich cabaret artist named Karl Valentin papered over a park bench with worthless 100,000-Deutsche-mark notes. The German word for bench is "bank" and he called his piece *Deutsche Bank*. (My grandmother, who lived through those days, used to tell amazing stories. She described, for instance, how café waiters would take your order on improvised pads of stapled-together 100,000-Deutsche-mark notes: the bills literally weren't worth the paper they were printed on; it would have cost the establishment more to buy fresh pads than to bundle the used notes.) Yves Klein used gold leaf in some of his monochrome series, which in turn gave him the idea for his *Immaterielles*. Accompanied by a collector, he'd take a small glass box filled with gold flakes to the bank of the Seine, open the box, and toss the flakes to the wind. The collector would gain "possession" of the piece by purchasing the receipt for the gold at face value, plus a minor profit for the artist.

Larry Rivers created a famous sequence of paintings based on slapdash renditions of French money, which in turn features engraved versions of Jacques-Louis David's portrait of the dashing young Napoleon (this around the time that Jasper Johns was painting his American flag—both artists bringing expressionist energy to bear on the flattest of surfaces and imagery). Andy Warhol, early on, created a silk screen that consisted of a sheet of two-dollar bills, as if fresh off the presses. The French artist Arman filled a transparent polyester mannequin torso with suspended dollar bills and called her *Venus*.

In 1969, the artist Les Levine purchased five hundred common shares of Cassette Cartridge corporation at 4 3/4 dollars per share. As he declared in the

press release that accompanied (and, in a sense, *was*) his piece, "After a period of one year, or at any time which it is deemed profitable prior to that, the Cassette Cartridge shares will be resold. The profit or loss of the transaction will become the work of art." Robert Morris, as his contribution to that year's "Anti-Illusion" show at The Whitney Museum, undertook a more convoluted but less risky transaction, which he titled *Money*. He arranged for the Whitney to solicit a $100,000 loan, at 5 percent interest for the duration of the show, from a stockbroker-collector; that money was in turn invested in the Whitney's name and at a 5 percent return, with the Morgan Guarantee Trust. At the conclusion of the show, the Whitney withdrew the money and interest from the bank and returned all of it to the collector, who then made a tax-deductible contribution to the museum in the amount of the 5 percent interest, which the museum then paid to Morris for having come up with the whole brilliant scheme. All of this was documented on the walls of the museum during the show in the form of the three-way exchange of letters in which it had all been agreed to in advance. Rafael Ferrer, as his contribution to the same show, spread out fifteen large cakes of melting ice strewn with autumn leaves and declared, Klein-like, "If anyone complains that it's not collectible art, I'll sell them the bill for the ice as a drawing." The art critic Jean Lipman chronicled these and other similar efforts in an article in the January-February 1970 issue of *Art in America* entitled "Money for Money's Sake." She celebrated the ingenuity of such artists in addressing "the old problem of support for the artist," but concluded with the wan hope that such "frank, pure money transaction works will allow artists to retire while still young and inventive, perhaps to take up a hobby in their creative middle years, something fresh like painting or sculpture."

Ed Kienholz took up watercolors. Soon after he'd achieved fame and notoriety through his remarkable assemblage tableaux, in the late sixties, he undertook a series in which he'd spread two strokes of washed-out color horizontally across a piece of quality paper; then he'd smudge in a thumbprint and sign his name; and then he'd get out an old-fashioned stencil kit and stencil between the bands of color the name of some object or other that he desired: "For A TAP AND DIE SET"; "For TWO GOOD MOUNTAIN HORSES"; "For A NEW OVEN AND RANGE"; "For ONNASH'S MERCEDES." To his astonishment, people would happily trade him such things for the opportunity to own an original Kienholz. Indeed, that's how he came to furnish much of

his then-new home in Hope, Idaho. But he soon realized that objects by themselves didn't answer all his needs. He still needed some pocket cash, so he started a new series: *For $1.00*; *For $2.00*; *For $3.00*; and so forth, on up through *For $10,000.00*—which he proceeded to sell in sequence, after having distributed the first several pieces to his family. As he observed at the time with evident delight, he'd transformed himself into a mint. (Each collector who bought into the series could assume that he or she was pretty much guaranteed at least a ninety-nine cent profit from the outset: once you bought *For $425.00*, all of the pieces in the series bought up to that point immediately became worth at least $425.99, since the next cheapest watercolor on sale from Kienholz directly was *For $426.00*.) Presently Kienholz prepared a brash comparative panel: under the heading "Their Brand X" he mounted samples of each of the denominations of regular U.S. currency; under the heading "Better Brand Y" he mounted some of his own offerings.

Barton Benes, a Manhattan artist, has for some time been deploying old, used paper bills, fresh from the Fed's shredding machines (sometimes procuring millions of former dollars' worth at a time), as the principal medium in his collages and sculptures. "Money is cheaper than art supplies," he once told the *Wall Street Journal's* Meg Cox. "Paint can cost ten or twenty dollars a tube, but you can tear just a few dollars and make a piece."

As his contribution to Project '74, a major exhibition celebrating the 150th anniversary of the Wallraf-Richartz Museum in Cologne under the banner "Art Remains Art," the American artist Hans Haacke presented an elegantly framed color-photo reproduction of Edouard Manet's *Bunch of Asparagus*, flanked by a procession of ten densely researched panels laying out the social and economic positions of each of the successive owners of the painting over the years, and the prices they had paid for it. The penultimate panel credited the painting's recent acquisition by the Wallraf-Richartz Museum to the work of the chairman of its Friends of the Museum committee, the noted financier and collector Hermann J. Abs, who, Haacke revealed, had had a decidedly checkered past under the Third Reich (he'd headed the foreign division of the Deutsche Bank and served the Nazis on various industrial councils). Perhaps not surprisingly, the trustees of the museum rejected Haacke's offering, provoking a scandal which could well have gone under the banner slogan "Art Remains Politics."

As early as the 1960s, Elaine Sturtevant, the elder stateswoman of the so-

called "image appropriation" movement, began unabashedly lifting imagery from the work of such contemporary masters as Duchamp, Warhol, Stella, Lichtenstein, and Oldenburg—making virtually identical copies of their paintings and serenely signing them with her own name. Some of her models, such as Oldenburg, did not take kindly to the gesture; Warhol, on the other hand, not only welcomed it but even lent her his silkscreens to copy. Paradoxically, in recent years the prices on Sturtevant works have been going up in tandem with those of the original works they ape. Meanwhile, a new generation of younger artists has taken to aping Sturtevant herself, after a fashion. Sherrie Levine's recent show at Mary Boone included a series of pieces entitled *Untitled (after Alexander Rodchenko)* which consisted of elegantly framed photographs of photographs by Rodchenko, the great early twentieth-century Soviet avant-gardist. Levine's pieces were selling for a handsome sum, although Mary Boone herself declined to divulge specifics. "I frankly don't see what price has to do with it," she insisted, when pressed. "I just don't come at art that way."

So that, yes, Boggs was by no means the first to stumble upon these precincts. Although he'd known relatively little about most of these other sorts of work before he got started with his own drawings, he'd been hearing of them with some regularity ever since. Far from feeling threatened, he seems positively to celebrate each new instance. At least, he did every time I brought some new precursor, uncovered in my researches at the library, to his attention. This was partly because he needed all the precedents he could muster as he prepared for his coming trial at the Old Bailey. But it was largely because he was authentically fascinated by the issues such works raised—fascinated and still at something of a loss himself as to the ultimate significance and meaning of his own work.

Furthermore, for all the similarities, there were profound differences. Most of these other kinds of work had focussed principally on internal issues of art and money: how money skews the workings of the art world, how fame skews money, what people value in art and how they express that value, and so forth. Bogg's work, by contrast, was chiefly about the world outside galleries and museums: his work takes place at a three-way intersection, that of art, money, *and* the everyday world. If anything, a more apt sort of precursor to Boggs's vocation might be found in that of the young Charles Simonds, back in the early seventies, when that artist set up shop, as it were, on the side-

walks of dilapidated neighborhoods and fashioned his miniature-brick ar-
cheofantastical ruins in the hollowed-out flanks of crumbling tenements. Si-
monds would invariably draw a crowd of onlookers, but he'd leave the
question hanging as to just what sort of activity was going on—art? play?
madness?—and indeed that confusion was part of what the work was about.
In a similar sort of way, Boggs is engaged in philosophical disruptions, in
provoking brief, momentary tears in the ordinarily seamless fabric of taken-
for-granted mundanity. The people he addresses (at least those he involves in
the early stages of his enactments) are cruising along on automatic pilot—
hey, he confronts them, wake up, wake up, look down there, what's holding
this thing up, there are no visible means of support, how is it that we fly at all?

Anyway, most of those days before the spree I spent at the library, reading up
on art and money. Occasionally I'd head back to my office and place a few calls.
I reached Boggs's landlord, Ted Gardiner, at his manor in Compton-Dando,
outside Bristol, England. "Ah, yes," Gardiner admitted jovially, "I once ac-
cepted Stephen's drawing in lieu of rent." I asked him why. "Well," he said,
"for two reasons. First, he had no money, and second, because I figured, who
knows, perhaps some day in the future it will be worth something, maybe
even more than the rent. I mean, Stephen is a tremendous character and we're
all quite fond of him. He has an old head on his shoulders: he's packed a lot
into his young years. He's a bit frustrating to have as a tenant, though. I've
never been able to get a rent increase out of him. His rent is two-hundred and
fifty pounds a month, in Hampstead, and it's been that way for five years. He
simply ignores my letters." I asked him whether he intended to make a cus-
tom of accepting drawings. "Well," he said, "that's the thing, isn't it? I
mean, landlords are landlords and tenants are tenants, and landlords can't get
fat and ugly unless tenants pay their rents, so . . ." His voice trailed off. "As
time goes along, I suppose, to collect the odd one or two pieces wouldn't
hurt." I asked Gardiner what he'd done with his drawing. "I've got it resting
quiet right here in the safe in my study." Not on the wall? "Oh, you see, the
trouble is, when you live in a house that dates back to the sixteen-hundreds,
it's rather difficult to hang modern art."

I called Boggs's mother in Tampa. She was most open and forthcoming,
told me stories of his youth—about his Alice Cooper phase, for instance,
when no makeup was safe in the house, and about other early intimations of

his artistic calling. "One week the walls of his bedroom were a pristine white, and the next week every inch of the walls was covered with designs and patterns and shapes—all in Day-Glo paint. Including the ceiling. The first time he went away, his dad and I put four coats of white paint on the walls and ceiling. The Day-Glo bled through every coat. In desperation we paneled the walls. But the ceiling art still shows through." She was quiet for a moment. "Perhaps we shouldn't have painted over the walls."

She spoke with great fondness of her son, with high regard and mild concern over his future. She told me that when it came to recollections, she preferred writing to talking, and she promised she would write if any further anecdotes occurred to her. The next day, an eleven-page letter arrived, express mail, brimming with stories. My favorite concerned an early incident: "We two were living just south of Tampa when he was five. Some forbidden fruit had been denied and, Boggs being Boggs even then, he decided to run away. I watched as he packed a little suitcase and went up the dirt road toward the highway. I jumped in my car. I found him on the dual highway, on the median strip, thumb stuck out, heading north. I pulled over and shouted, 'Where ya going, buddy? I'm just going up the road a piece, but hop in.' He crawled in. I drove about a mile to the local supermarket and told him this was as far as I was going. He didn't get out. I said, 'Look, buddy, this is really as far as I'm going, so you'll just have to get another ride, whatever your name is.' 'Ahh,' he said in a whisper, 'you know me. I'm your son.'"

And I called Rudy Demenga in Basel, who proved a true enthusiast. I asked him how he'd met Boggs. "I discovered Boggs at the Hippodrome discotheque in London, and immediately I *knew*." Knew what? "Genius." How? "I smelled. I can smell genius." How? "Moved. How he moved. He was just like an Indian when he is going to catch a wild animal." What was he doing? "He was looking for a girl to dance with. I was touched by him. I asked the lady at my table, who he is? She said he's an artist. The next day I went by the booth of his gallery at the art fair. I saw his big painting of the pound note, and the way he had packed so many things into it, I could see that I was right about him. I invited him to come to the Basel art fair. I told him I wanted him to draw Swiss bank notes. Through currency you can criticize the whole government and culture of a country. It's good for artists to change the world."

I asked Demenga how he would describe Boggs. "He looks like an American Indian, but with a white face. He is like a sports athlete, he weighs not

one gram too much. Each time there are young girls, they fall in love to him. He is always busy. He is a brilliant mathematician. He knows what is one and one—that is, at the higher level."

Demenga's account of Boggs's Basel stay elaborated on Boggs's own. "One day he went to a local department store and bought an Indian tent with a drawing of an Indian tent. The next day Boggs went to the Venice Biennale. Since all the hotels were occupied, he took that tent along with him. He tried to buy a rail ticket at the station with his money drawing, but they wouldn't take it. Then he drew a drawing of the ticket itself, and they wouldn't take that either. This was virtually his first serious rejection here in Basel and he came back to the gallery dejected. He asked to borrow the money. One does end up borrowing him a lot of money. In Venice he slept in his tent, but from what I understand, for him Italy was no Switzerland."

Demenga related how Boggs then went back to England and resumed work there. "On the first of November, I went to England to see his new show," Demenga recalled. "I remember the day because that was when we had that catastrophe here in Basel with the fire and the chemical spill into the Rhine. Anyway, at the tax-free shop at the airport I bought a gift for Boggs, sort of a briefcase with inside lots of chocolates in the shape and wrapping of one-thousand-Swiss-franc bills—it looked like a million francs in chocolate. I arrived in London and went to the gallery and it was amazing, all the Boggses had been removed and there were little notices 'Confiscated by Scotland Yard.' Boggs came up, and when he saw my present he shouted, 'Oh Rudy, you brought the bail money!'"

New York was no Basel either, or so I discovered on the day of our spree. We were heading West on Houston, toward I Tre Merli, the Soho restaurant, with Boggs carrying his bulging satchel. "A weird thing happened to me yesterday," he commmented. "I was being interviewed by a critic for one of the minor journals around town and he intimated that if I'd give him a drawing he'd give me a good write-up. It was like he was asking for a drawing of a bribe. When I said no, he said that was okay, he was just testing me. Which was also weird, that I'd proved my integrity by *not* drawing a bribe."

Once at the restaurant, we ordered some salads, and I mentioned how the place's Italian fare reminded me of Boggs's Italian junket. "Yeah," Boggs said. "Italy was about the worst place I've been so far. Hardly anyone would

take my drawings. In Milan, once, I offered this waiter a drawing and he said no, I'd used the wrong kind of paper and mine didn't have this special kind of thread running through it like the regular Italian lire do. But then he told me confidentially that I could get the right sort of paper at such-and-such a place and that I could fake the thread in such-and-such a way, and that if I did all that, he would be happy to take my bills, because he thought the drawing was pretty good. In other words, he wouldn't take the drawing as a drawing, but he would have taken it as a counterfeit."

Boggs was silent for a moment and then said, "So, listen, do you have a twenty-dollar bill I can borrow a second?" As I checked my wallet, he reached into his satchel, pulled out his pad, and extracted a superb rendition of a twenty-dollar bill. "Thanks," he said, grabbing the one I'd come up with. "I need it as the model." Reaching back into his satchel, he pulled out a precision green pen. "This is a Koh-I-Noor pen with an incredibly fine tip—point thirteen millimeters. Thing's so delicate it can only stand a few hours of Boggs treatment. In fact, I've got to get another one today. I go through dozens of these, both green and black, at nine dollars apiece. And the paper costs three dollars a large sheet, and what with all the mistakes and the rejects, I end up extracting maybe two or three finished drawings per sheet. It costs me a goddamn fortune to draw these bills."

He looked over at my twenty-dollar bill and then carefully transposed its serial number onto the appropriate spot on the lower left-hand side of his drawing: B22613726F. He repeated the process on the upper right-hand side, dropping a digit. Then he asked me if I had a five and a ten—I did. He borrowed those and used them as the models for the two more drawings that he now pulled out of his pad. He then took a black pen and carefully squeezed in, along the narrow blank border at the top of each of my bills, the printed annotation: "The Model. NYC. NY. 20.8.87. J.S.G. Boggs." He then signed his name and returned the money to me, saying, "There. You can't spend them anymore though, because they've become part of the art, they're part of the transaction." Whereupon he smiled. There was a sense, whenever one hung around Boggs, of being continually subject to imminent contamination with aesthetic perplex. Grudgingly, I folded the bills and slid them into a special, separate compartment of my wallet.

He now continued with the final touches on his drawings. On one of them, in place of the minuscule letter and number code in the lower right-hand

quadrant of the bill, which, he explained, normally indicated the serial number of the precise plate from which the particular bill had been drawn (B431, for instance, or R72), he wrote $E = MC^2$. On another, he wrote LSD. To the other side of one of the bills he carefully printed the proviso "This note is legal tender for artists." On one of the others he wrote, "This note is legal and tender for all." I noticed that in place of the phrase "Federal Reserve Note" at the top of his bills, he'd written "Federal Reserve Not." And down at the bottom, where one might normally find the signature of the Secretary of the Treasury, he'd substituted his own above the label, "Secretary of Conception." Indeed, although on first glance his drawings appeared identical to their models, closer inspection revealed that virtually every detail had been slightly skewed.

The waiter brought over our salads and admired the drawings. Boggs turned the drawings over on their blank backs, scribbled *"Lucrum Cessans,"* signed his name, and set them aside. *"Lucrum Cessans?"* I asked. "Yeah," he said, "it's a Latin phrase meaning, roughly, 'loss of profit.' In the early days of banking, there were religious prohibitions against interest on loans. But gradually people came to realize that in giving over money, you're also giving up the use of that money for a period. In those days they'd offer the example of a cow. If I lend you my cow and you give it back to me a year later, you're giving me back the same cow, but I've lost a year's worth of milk and now I'm getting a year-older cow. For that reason, it was argued, by analogy, that I ought to have the right to charge interest. Otherwise, *lucrum cessans*, I'm foregoing my profit. When I write '*lucrum cessans*' on the back of my drawings, it's because anyone who accepts them is in fact profiting from my loss."

Boggs ate a bite of salad and continued. "It's one of the important aspects of my work. I never spend a drawing unless I'm convinced it's actually worth at least three or four times the face value at which I spend it. There was one guy who wanted to enter into this big transaction—it's a long story, but basically he wanted me to draw four one-thousand-dollar bills for something I really wanted. But he wanted the drawings almost immediately, he wouldn't give me time to do them adequately. So I just said no."

Boggs took a few more bites. "The thing about the cows and interest reminds me of this true story I once heard about some agronomist estate manager in Africa somewhere who reproached some of the tribesmen on his estate for wasting their time and resources feeding and sheltering some old sick

cows. 'Look, Master,' one of the tribesmen replied, pulling two paper bills from his pouch. Paper money was new in this area at the time. 'Here's two pound notes, right? One of them is old and crumpled, and the other's new. But they're both worth a pound. It's the same with cows.' "

That in turn reminded me of an anthropological story Krulwich had told me about an old tribesman who tried to explain to his son about how last year's cow had been magically transformed at the town market into the coin rattling about in his safebox.

The waiter brought over our bill. Boggs offered the twenty-dollar drawing. The waiter clearly loved it, but he explained that he was only a waiter and as such had no authority to make such a judgment. He suggested we speak with the manager and went to fetch her. She, too, came over, was also clearly taken with it, but likewise explained that she had no authority, this sort of judgment was the owner's exclusive domain, and he wasn't around. This sort of response—the claim, as it were, of lack of standing, the claim that one didn't even have the right to an opinion—came up repeatedly in different forms as we proceeded through our day. Indeed, in the little Museum of the Natural History of Reactions that I was forging in my mind, I ended up giving it a whole wing.

I picked up the tab and we headed out. Boggs dived into a photo store and tried to buy some film with his five-dollar drawing. The Hispanic woman at the register smiled and excused herself, "We're just a chain here." Down the street, Boggs tried to buy a can of Coke at a tiny deli. "No," came the curt reply, "I don't *need* that."

We wandered over to Utrecht's art supply store: Boggs needed to get another pen. "Last year when I was in town," Boggs said, "I pulled off a nifty transaction in there. I bought a ninety-nine-cent pad of green paper with a drawing of a green one-dollar bill." We walked into the store, and at first the signs were auspicious: on the wall behind the cash register was a doublesize blowup of a ten-dollar bill, taped, for no apparent reason, to the wall. Boggs found his pen, approached the young man at the register, handed him the pen, pulled out his ten-dollar drawing, and politely launched into his spiel (Boggs is always extremely courteous when he's delivering his spiel): "Hello, I'm an artist and I draw money. This is a drawing. I did it with my own hand. It's not an etching, I drew this. It took me a long time to do. And now I've used up my pen, and I'd like to buy this one. I was wondering whether you'd

honor my drawing at face value. It's not legal tender, but it's obviously worth
something, and I've arbitrarily assigned it the price of its face value." The guy
behind the counter literally blushed scarlet. "Part of my art," Boggs contin-
ued, evenly and congenially, "is that I have to spend my drawings." The guy
blew up: "You're pushing your luck there, buddy," he almost shouted. "I
don't think the federal government would be too happy with this." Boggs was
unfazed: "Don't you think it's worth something?" "Look," came the reply,
"we're not in the business of appraising worth here. I'm sure it's worth some-
thing but—I'm an artist myself, and let me tell you, if I could get away with
paying for my supplies with drawings of money, believe me, I'd draw hun-
dreds of them." "You think so?" Now Boggs began to lose his cool. "You
know how long it took me to draw this thing? I bet you couldn't get through
two." Whereupon he left the pen at the register and marched out with his
drawing.

It was remarkable how electric the room had become the moment Boggs
pulled out his drawing. Not just the clerk—his colleagues, the other people
in the store, everybody seemed to become hypercharged. This almost always
happens, although sometimes the tension gets defused in nervous humor and
usually Boggs remains serenely detached amidst the crackle. I was reminded
of sociologist Erving Goffman's famous observation: "To walk, to cross a
road, to utter a complete sentence, to wear long pants, to tie one's shoes, to
add a column of figures—all the routines that allow the individual unthink-
ing competent performances were attained through an acquisition process
whose early stages were negotiated in a cold sweat." Boggs throws us back on
first things.

We wandered over to the Strand Bookstore. Boggs had to leave his satchel
with a guard at the entry but he pulled out his pad and took it along. "Got
your bill with you?" I asked. "Sure," he said, nodding toward his pad. "I al-
ways carry my wallet." He browsed for a few moments, selected a book, took
it up to the counter, made his way toward the front of the line, and went into
his rap. A smile began to break over the cashier's face, but otherwise he didn't
say a word. "Don't you think it's *worth* ten dollars?" Boggs pressed. "Next!"
announced the cashier.

We moved on and drifted into Washington Square Park. "Maybe I should
try to buy some drugs with a drawing," Boggs said. "You know, purely as a
transaction." He thought about it for a moment. "Nah," he said, "I'm in
enough trouble."

We made our way toward the arch. "It's funny though," he continued, "how these transactions are themselves a lot like drug deals. The same sorts of questions come up: Is it real? Is it a con? Is it good stuff? Is it worth it? Is it legal?"

Boggs pulled another pad out of his satchel and showed me a recent drawing of an eight ball on a pool table. "Do you like that drawing?" he asked. It's okay, I said. "Do you think it's worth anything?" Yeah, I said, to the person who wants it. "Finding that person is tremendously difficult."

We started up Fifth and came upon one of those pushcart hot-dog stands. "Want a hot dog?" Boggs asked, as we approached the stout, middle-aged vendor-lady. He did his rap. The lady gazed on, only gradually comprehending. "I from Romania," she finally said, haltingly. "My boss, he want . . . he expects . . . look." She reached into a side panel and pulled out a price list; she then counted out five soda cans on her cart top, pointed to the soda price, and tapped it five times, gesturing toward her cash box. She smiled, "But it good . . . you talented." She patted Boggs's arm in encouragement. "Too bad we didn't have any cartons of Kents," Boggs commented as we walked on.

We walked past a vitrine that featured sign-making materials and signs ("No Trespassing," "Sorry, We're Closed," "Have a nice day," and so forth). "Wait a second," Boggs said. "I want to check this out." Inside there were signs of every sort, and numbers. Boggs considered a panel displaying three-dimensional wooden numbers. The sales clerk came over, a friendly kid with a hearty Brooklyn accent. "How much are these numbers?" Boggs asked. "Dollar seventy-nine each." "Tell you what," Boggs explained. "I want to get a 2 and a 3, and I want to buy them with this *drawing* of a five." He then proceeded into his rap. The sign vendor seemed impressed. He took the drawing in hand, gave it a good long look. "Very nice," he said. "Very nice. From far away you couldn't even tell. Beautiful. I could never do that. I praise you on your artistic work. But I'm not the manager. I could never take it." Boggs suggested he could buy it himself and reimburse the cash register. "But what would I do with it?" the clerk asked. "What would I do with it? If it were bigger, I'd frame it. But that size, my friends would just think I had a five-dollar bill on my wall. They'd think it was strange. And anyway, if I were going to frame something, I'd frame a real five-dollar bill." Couldn't argue with that logic, and Boggs didn't even try. "*That* was interesting," he said, as we walked down the street and into Barnes and Noble.

Boggs browsed in the financial section. "See," he said, "in a transaction

like this, I'm not looking for a book to read but rather for one that will look good as part of an eventual framed set. Like this one here"—he reached for a volume entitled *Economics in One Lesson*—"but I don't like the colors on its cover. Or this one here"—a book called *Beyond Our Means* with a burning hundred-dollar bill on its cover—"but it's too expensive. No, I guess I'll try this one." He reached for the paperback of *Indecent Exposure*, with a handwritten check as the illustration on the cover and a price tag of $3.95, and headed for the checkout lines. Only, rather quickly he was faced with a conundrum, for the sign above one register read CASH ONLY, while the others were labeled CASH OR CHARGE. By no means sure which applied, he eventually settled on one of the charge lanes because it had the shortest line. Once at the front of it, he performed his set speech. The young lady behind the register stiffened mildly and then said, "Probably not. Not here anyway, although you can try one of the other registers." He went to the next register, produced his five-dollar drawing, and repeated his speech. This cashier looked dubious. "Do you at least like the drawing?" he asked. "No," she replied. "Oh," he said, "I must be in the wrong line." He moved to the next lane and tried once more. By this time business had more or less come to a standstill and the five cashiers were convening as a committee. He went through his spiel once again, and this time the cashier was silent. "Do you think it's worth five dollars?" he asked. "No," she said, "I think it's worth more than five dollars." "Will you take it then?" he asked hopefully. "No," she replied. "We take real money here." At that point Boggs gave up and went to return the book to the stacks. "Hey, artist!" the remaining cashier shouted after him. "You forgot me!" So he returned to her (she was the one behind the CASH ONLY line) and he did his rap one more time, and this lady just started laughing. "Remember that girl that used to work here who came from that college upstate where they give them too much fresh air?" she asked her colleagues. "She'd have taken it. Girl was real smart about books but she had *no common sense*." Boggs gave up, returned the book, and then cheerfully bid the girls a good afternoon, leaving in his wake a veritable symposium.

Back on the street, we figured maybe the problem was the neighborhood, so we decided to try uptown a ways. We hailed a taxi to the Algonquin (the cab-driver spoke not a word of English and even Boggs couldn't bridge the linguistic gulf—I wonder what the poor guy told his wife that night about the weird offer somebody made him that day). The man behind the Algonquin

bar explained he had no authority and suggested we talk to the manager. The manager in turn considered the offer, pocketed the five-dollar drawing, and summarily ordered the bartender to fix the man a drink. Simple as that. Boggs explained how he'd need the change and a receipt, and now the manager balked. "I'm offering you a drink in exchange for your drawing," the manager insisted. "What's the problem?" Boggs explained the problem and the deal fell through. "That often happens," Boggs told me as we walked. "People often defer because they lack authority. But those in middle authority often jump at the opportunity, particularly when they have some sort of carte blanche open tab and aren't paying themselves. But they just can't deal with the business of the change and the receipt, so the deal falls through."

We headed thirstily on. We crossed Sixth Avenue diagonally and headed toward Forty-seventh Street Photo (located paradoxically on Forty-fifth Street), a place known around the neighborhood as Yeshivah Stereo, owing to the full-line electronic store's exclusively Orthodox Jewish staff. Boggs spotted a worthy potential purchase, a four-dollar bottle labeled SOLUTION (photographic solution). "A bottle of the solution would look good as part of one of the transactions, don't you think?" Boggs commented, as he went over to the cashiers. There, two bearded gentlemen considered him sagely as he delivered his spiel. They carefully looked the five-dollar bill over and another couple of younger fellows came by. They all entered into a disputation, partly in English, partly in highly spirited Yiddish. The problem, it appeared, was that of the prohibition against graven images. "You see," explained one of the bearded cashiers, "Abraham Lincoln as money—it's borderline, but we can take that. The question is whether or not it would be *treyf* to hang a *picture* of Abraham Lincoln." "You hang pictures of the rebbe," one of the younger scholars pointed out. "Yeah, precisely," replied the other, "but Lincoln's no rebbe. No, this is definitely *treyf*." At that point, an old middle-manager type drifted over, looked in on the quorum, saw the drawing, and his eyes almost bulged. He snatched the drawing out of the cashier's hands and went racing with it to the back of the store. Boggs looked over at me incredulously, but I didn't have a clue. For a while I thought the old guy had gone to call the cops or something. He was gone for five, ten minutes, and showed no sign of coming back. "Does this mean you're accepting the drawing?" Boggs asked one of the bearded cashiers, who simply shrugged. I noticed that one by one all of the salespeople seemed to be drifting to the back of the store: there was a regular party going on back there. Finally the middle manager re-emerged—

the very picture of decorum—returned the drawing, and pronounced very solemnly that no, they definitely could not take this.

From there we drifted over toward the real Forty-seventh Street, where we wandered among the booths in the gold and jewelry bazaars. "That," Boggs suddenly exclaimed, thunderstruck, "*that* I've got to have." He was gazing into a low showcase at a small, flat, rectangular gold pendant stamped with the face of a one-hundred-dollar bill, on sale for thirty-seven dollars. Boggs asked the booth manager whether he'd take thirty-four, and he pulled out his three drawings. "I suppose so," said the salesman before Boggs even had a chance to go into his routine. As Boggs now proceeded with it, the fellow gave the drawings a more careful inspection. "Now I can see it," he said. "A second look and I can see that they're not genuine. A talented fellow like you should be doing something more positive." Boggs explained how he had to have that pendant, it was important to his art. "Well then," the salesman proposed, "go out on the street, sell your drawings, and bring me back the money. We only take money here. See the problem with these is, I take them and then when I want to give them to a lady over there to buy something, she won't accept them. Maybe you should try an antique shop."

Boggs tried a few more stalls before dejectedly abandoning his pendant fixation. "I've got to get a drink," he said, as we hit the street. "There's one bar we could go to uptown a ways where I know I could spend one of these drawings," Boggs said. "The bartender up there loves them. He has told me he'll accept as many as I care to offer. But that's not what this work's about, to do it over and over just to be doing it. His mind's not being challenged anymore, he's not learning anything." A few blocks uptown we entered a bar. The young waitress took our order. Boggs requested separate checks. "So," he said, "you're beginning to see. It's not as easy as it sounds. It takes me ten hours to draw one of these things, and then another ten to spend it. And then the thing I buy I usually can't use because I have to save it for the final piece, and I can't use the change either." Why do you do it, I asked. "Because there's a lot I still don't understand about these transactions. Whenever I get the feeling I've understood, I know that just means I'm not pushing hard enough, I have to push harder, to find new ways. I know my work reflects something, resonates with something in society, but I'm not clear what. I often view my work as the symptom, but I don't know the disease."

I asked him why he thought he'd become an artist. "Oh that," he said.

"I've come to believe that sort of thing is eighty-twenty. Eighty percent you're born with it and stuck with it and you have no choice. That leaves you just a 20 percent chance of escaping your fate as a child—and I guess I just didn't make it." What in his childhood had prevented him from escaping? "I don't know," he said, but the question set him to talking about his early days. "When I was two my mother ran away to join a traveling carnival and she took me along with her. From two to five we traveled up and down the Eastern seaboard with the carnival. My best friends were the giant and the bearded lady and the spider man. The guy she was with ran several concessions. We had the Deep Sea Adventure trailer, which was just a bunch of aquariums on the inside with the best stuff in the tank outside to draw the people in. I was making change by the age of three. Hell, I knew how to shortchange by the age of four. That last is a joke. Don't write that down. Seriously, just a joke."

Boggs began to relax again, telling tales of his carny youth. The day's dejection fell away. "There was this Wild Man of Borneo show. What they'd do, they'd dig a wide rectangular trench about six feet deep, surround it with four feet of chain-link fence, pitch a tent up over the whole thing, and then put all these exotic posters up outside the tent. They'd toss snakes and chickens and lizards and frogs and tarantulas into the trench, all of which they'd cart from place to place in boxes. They had normal snakes, and they'd take a box of rattlesnake rattles and sew them on their tails. Then they'd take real old defanged rattlers and they'd throw them in, too. They'd scatter bones all over the bottom. Then they'd get this guy and dress him all up. He was supposed to be from Borneo, so he should have been black, but this was the late fifties and that sort of thing was pretty sensitive, so instead they got this pathetic old white drunkard and they stained him with berry juice and they put him in the pit and charged folks fifteen cents to get into the tent and watch him go wild, snarling and yelling and throwing the snakes all around. Between shows, he was just a drunk. One day the Wild Man of Borneo went into town and got so drunk he forgot where he was, and he started to perform his act in a bar. They threw him in jail, and suddenly there was no Wild Man of Borneo for the evening show. So instead they had the Wild Boy of Borneo—they stained me with the berry juice and dressed me up and put me into the pit . . . My mother happened to be away that evening, and when she came back and found out, she was really furious. But actually, I loved it.

"I loved all of those things. I loved the Gorilla Man, which was a show

where this man would turn into a gorilla right before the audience's eyes—
every quarter hour on the quarter hour. The way they did it was with a pane of
glass running through the cage at a forty-five-degree angle between the man
in the gorilla suit and the audience in the bleachers. As the show began, it was
completely dark on the gorilla-man's side and a bright spotlight shone down
on this other guy in regular street clothes just off stage. His image was re-
flected in the glass and you couldn't see the gorilla man at all. Little by little
the light on the regular guy went down as the spotlight rose on the man in the
gorilla suit behind the pane of glass. So that before the audience's eyes the reg-
ular man seemed to be turning into a gorilla. And then silently, invisibly, the
glass pane was retracted, and now the gorilla man pounced toward the front
of the cage, tore it away, and went bounding into the audience, utterly clear-
ing the tent in thirty seconds. The guy who thought up that act was a carnival
genius. Because the problem with carnival acts was always the milling-about
afterwards: people took too long in clearing the tent, it slowed things up for
the next show. But with this act, not only did you clear the tent instanta-
neously, but you created such an impression outside that people immediately
started lining up to see what all the commotion had been about.

"You know the strongman with the barbells?" Boggs asked. "That was an-
other nice act. The audience would drift in and there on this metal platform
would be resting the barbell with these huge black iron spheres prominently
labelled 1000 LBS each. The strongman would come out and challenge any-
one from the audience to try and lift the barbell. Invariably some macho stud
would rise to the challenge and fail miserably, whereupon he'd confidently
announce that the feat was impossible. He was no plant—you could always
count on somebody from every audience to play that role. But anyway, then
our strongman would stroll over and with a huge heave and gargantuan ex-
ertions, he'd somehow manage to lift the sucker. Worked every time. The
people backstage just had to remember to turn off the electromagnets under
the platform."

Boggs was quiet for a moment, savoring the memories. "One time I'd de-
cided I was going to get a tattoo. I was about four. The tattoo guy told me
sure, he'd do it, and then he went into this real shtick, telling me all about the
needles and the blood and the pain and so forth, all in wonderfully gory detail,
and I squirmed off the chair and said, 'Actually, maybe tomorrow.' That same
evening I took a walk outside the carnival grounds, and I came upon an aban-
doned campfire. I thought it was out. It was so unspeakably beautiful, so del-

icate, those dainty little cakes of white ash leaning one against the other. They were so lovely I just wanted to take one home to show my mom, and I reached over to pick it up. Turned out they were white-hot coals. I screamed in agony and went running back to the carnival. I was okay, but I learned something. I learned that outside the carnival, just as in it, things weren't necessarily what they seemed.

"But anyway," he continued, "the thing is that traveling with the carnival, the towns we'd visit always seemed utterly vapid by comparison with the life inside the carnival. And when we left the carnival, after I was five, and settled in Tampa, school was just incredibly boring. If I'd had a 20 percent chance of escaping my artistic fate, I'd lost it by then."

The waitress came over with the bill and she and Boggs got into a nice and easy bantering conversation. Boggs pulled out his five-dollar drawing and offered it to her, and she said she really liked it but that the bar wouldn't take it and she couldn't possibly afford to. "Oh come on," Boggs said, "just five dollars?" She explained that she was a struggling actress herself and that sometimes she didn't even clear nine dollars a night in tips. "Oh well," he said. "Thanks anyway." And I picked up the tab.

Outside on the street again, Boggs commented, "Too bad. It's a shame: if she'd just taken it, somebody would probably have come along in a few days and offered her five *hundred* dollars for it. And she could obviously have used the money." It occurred to me that Boggs was operating a sort of floating aesthetical-ethical crap game. Or else a sort of fairy tale virtue test, in which the worthy agreed to sacrifice and were subsequently rewarded a hundredfold.

It was past four-thirty now, and Boggs said he had an idea. We walked up to the Museum of Modern Art and got into the admission line. Adult tickets were five dollars apiece, and on reaching the front of the line, Boggs pulled out his drawing and gave his rap. The girl seemed flustered. "I can't take that," she said. "But it's art, and this is an art museum," Boggs replied commonsensically. "I know," she said, "but for me to be able to accept that, they'd have to convene a full meeting of the board of directors. Those are the people who make all the decisions on acquisitions." Boggs gave her his meltingest hangdog expression. "Listen," she proposed confidentially, "it's four-forty-five right now and this is Thursday. Come back in fifteen minutes and you're allowed to pay whatever you wish."

That sounded promising, but to pass the time, we crossed the street over to the Crafts Museum, where Boggs again tried to use his five-dollar drawing

for an admission ticket. The fellow there wasn't nearly so friendly as Boggs was laying out his spiel. "Look," he finally said gruffly. "I'm a painter, so you're talking to the wrong guy about the value of art."

We meandered around for a few minutes and then returned to the Modern; it was now just past five. Boggs approached the same cashier and once again presented his drawing. "I don't *want* your drawing," she said in exasperation. "You can give me anything you want, give me a penny, and then I can let you in." "I know," said Boggs, "that's why I'm giving you this." She looked at him for a moment, looked to her sides, and then quickly punched 0.01 into her register and gave him the receipt, returning the drawing. "There," she said, "now get going."

Boggs just shrugged his shoulders. "Can't give it away," he said. We pretty much decided to give up for the day. We made our way back outside and then on toward Sixth Avenue. Along the way we passed a young Haitian street vendor who was selling exuberant paintings of Caribbean street scenes—black women strutting down the street balancing baskets on their heads, young men hoeing bountiful vegetable gardens or dancing their hearts out, jungle beasts peering lasciviously from behind the foliage. INVEST IN THE FUTURE read a little sign the vender had propped up along the wall. FRANCIS PARAISON. ORIGINAL PAINTINGS. Almost as an afterthought, Boggs inquired if he had any paintings for sale at twenty dollars. "Sure," Paraison said, "those over there." Boggs picked one of them up, a colorful village scene. Boggs asked if he would take nineteen dollars. "Suppose so," Paraison replied. Boggs reached into his satchel and extracted his twenty-dollar drawing.

"Would you take this?" Boggs asked.

Paraison looked at it for a few moments, a wide smile breaking over his face. "Absolutely," he said. "Absolutely, I'll take that."

The actual transaction took a surprisingly long time to complete. For the next fifteen minutes Boggs was engaged in an almost frenzied ritual of documentation. He got the one-dollar change from Paraison and then had him draw up a receipt on a sheet of scrap paper. Meanwhile, he took the dollar bill, squeezed into its upper border the printed words "The Change" and an abbreviated summary of the transaction, and then he dated and signed it and set it aside in a special envelope. He borrowed his own drawing back for a moment and on its blank backside he likewise annotated details of the transac-

tion—date, location, Paraison's name and address, and the serial number of the bill that he was giving in change. He then took Paraison's receipt and similarly annotated that, including the serial number of his own drawing, and then he slid that into his envelope as well. Paraison seemed bemused but tolerant. "It's a good drawing," he said. Boggs now went on to annotate the back of the painting. He then double-checked all the annotations and, satisfied, he returned his twenty-dollar drawing to its new owner and bid him a friendly good evening.

As we walked away, I commented how the obsession with documentation among conceptual artists—those most immaterial, seemingly least bureaucratic creators—had always amused me. I cited the way Lucy Lippard a while back had been able to put together a several-hundred page chronological sourcebook entitled *Six Years: The Dematerialization of the Art Object, 1966–1972* as if the art object's simple disappearance could not be allowed to remain standing as simple mute testimony to itself. Boggs responded that the documentation in his own case didn't really arise out of that sort of impulse. "No," he said, "what my documentation is about is the fact that the transaction itself is the art object. This particular one, incidentally, was a rather pretty one, didn't you think? An exchange of artworks on the curb outside the Museum of Modern Art. But now its components, for the time being at least, are becoming scattered. He has the drawing and I have the change, and these are both very specific objects. If the piece is ever to be reassembled, only those two specific entities, with their specific serial numbers, and then the various other components—all of them cross-annotated with each other—will be able to do the trick. The transaction itself thus becomes a unique object."

Boggs explained that he would now keep mum about the transaction for the next day but that thereafter he would begin contacting dealers and collectors about its existence. It had been a full day, and following the momentary excitement of the successful transaction, we both realized how exhausted we'd become. So we decided to pack it in.

During the next several days I kept up regular telephone contact with Boggs. He related how he was eventually able to spend the five-dollar drawing on a six-pack of beer in Greenpoint and the ten-dollar drawing on lunch at a small sandwich shop in Soho. He'd also accomplished a fifty-dollar transaction with a downtown video store. He was currently negotiating "a major, really major" transaction that he'd tell me more about when next we met.

Meanwhile, I received a call one evening from a young woman with an En-

glish accent who introduced herself as Helen Traversi, an independent art dealer. She explained that she was here from London working on behalf of certain collector clients and trying to track down, among other things, money drawings by Boggs. She was just confirming that I still had the models for the three drawings from my spree with him, which I did. She told me she might be getting back to me about them but that for the time being she was particularly interested in tracking down the drawings proper. As far as she'd been able to determine from her investigations, including conversations with Boggs himself, he had spent at least fourteen drawings during his current stay in New York, and she'd already been able to buy several of them back. She told me she'd gone over to the curbside outside the Modern earlier that day and located Paraison, but that the Haitian artist had refused each of her increasingly ample offers: he simply didn't want to part with his Boggs.

The next day I went over to the Modern to talk with Paraison, and sure enough, there he was, hawking his paintings. He broke into a broad smile as I approached. "You again," he said, reaching for my hand. "Yeah, everybody want to know about that drawing. Yesterday a lady come by, offer me a lot of money. But what for should I sell it? I like it. Several hundred, a thousand dollars, what can I buy with that? Some food that then it's gone?" He reached into his back pocket and pulled out his wallet: he kept the drawing neatly folded among the other bills, right there in his wallet! "Here I have the idea. And I *like* this idea. It's a good idea." Paraison paused. "I almost lost it the other day, though," he said. "My little boy reached in and took it for ice cream money, and I only just noticed as he was heading out the door."

A few days later, at another midtown bar, while recounting a recent hundred-dollar transaction with the artist Christo, Boggs reached into his satchel and extracted an envelope containing the eighty dollars he'd received in change, all neatly annotated. It turned out that Boggs was carrying all sorts of recent transactions in that satchel. Presently, he pulled out a candy box covered with money wrapping. As he opened it, I was expecting to see Demenga's chocolate bail, but instead there were dozens, scores, of actual ten-dollar bills inside. "This is an ongoing piece I'm working on," Boggs said. "It's almost finished. I started with a hundred new, consecutively numbered actual one-dollar bills. I signed them all, and have been offering them for sale at ten dollars apiece. Each time somebody buys one, I annotate the date and the place

and the name of the purchaser on the ten-dollar bill I receive in payment—I stipulate that payment be in the form of a ten-dollar bill—and when I finish I'm going to frame the hundred ten-dollar bills as one half of a diptych, the other half of which will obviously be scattered all over the world." So that box contained almost a thousand dollars.

Then, after rummaging around, Boggs pulled out an actual thousand-dollar bill and an actual five-hundred-dollar bill (Presidents Cleveland and McKinley respectively), both antiques encased in separate Lucite frames, along with two exquisite drawings that he'd made using the two framed bills as models. He explained that the big transaction he'd been working up and was about to pull off involved trading these two drawings for a three-dimensional holographic portrait of himself holding up a British pound note. "I want to be able to show the British court what an *actual* reproduction of a pound note looks like," he explained. Actually, he had talked the portraitist down from her standard fee of fifteen hundred dollars to $1,499, so that he could get a dollar in change. He'd rented the Lucite-encased models from a local coin store for a week at the standard rate of fifty dollars. (He'd had to rent antiques, for, as he explained, the Treasury no longer issued such bills. Partly in an effort to foil drug pushers, the highest denomination that currently circulates is the hundred-dollar bill.) He now pulled out a fifty-dollar drawing with which he was hoping to pay the rental fee. "This is going to be a really beautiful transaction when it's finished," he said. "Wheels within wheels!"

I asked Boggs whether he wasn't concerned to be traipsing around with so much money. "Nah," he said. "I don't look like the sort of person who would be carrying anything worth stealing. In fact, if anything, I look like the mugger, not the muggee." That was true, as far as it went. But it also occurred to me that in a strange sort of way, all of that cash was no longer really money for Boggs. He no longer thought of it in those terms. Once he'd signed and annotated a bill, he'd taken it out of circulation, rendering it a mere component in an arcane artistic project that nobody except for him and a few collectors could possibly find of any interest.

He recounted how he'd been working very hard to develop a technique for *erasing* dollar bills. "It takes a lot of time—*a lot of time*—and it's been a trial-and-error process, but I've just about perfected a method whereby I can efface the inks on a bill and get it down to blank paper. I've got a variety of ideas as

to what I might do with that. For instance, take an uncut sheet of thirty-two virgin one-dollar bills, erase one of them, and then draw it back in. Or else, entirely erase both sides of a one-hundred-dollar bill and then try to sell the blank paper for one hundred dollars—which would be an interesting transaction in itself, but might also make a nice homage to Rauschenberg who once erased a de Kooning drawing and claimed the blank sheet of paper as his own work of art.

"I'd also like to create my own unit of currency, the Bogg, print up a series, and then study its price fluctuations." Boggs went on to point out that one company in England called De la Rue's actually designs and engraves currency for over one hundred of the world's countries. "You know how I feel about the technical quality of the printing work on most currency as opposed to that on most art," Boggs said. "What I'd really like to do is to print an edition of my own money with De la Rue's. But for the time being I'm enjoined from doing so. In the wake of my arrest, there's literally an injunction forbidding anyone at De la Rue's from so much as talking to me."

At this point I asked Boggs about that arrest. We'd mentioned it so often in passing, but, seriously, what on earth had happened there? And what was this upcoming trial going to be all about?"

"Back in August 1986," Boggs began with a sigh, "after I'd come back from Switzerland, the *Daily Telegraph* ran a piece on my success there, and as a sort of postscript their legal correspondent was asked for his opinion, and he suggested that in England anyway I might be in violation of Section 18 of the 1981 Forgery and Counterfeiting Act, which makes it an offense for anyone, without written permission from the Bank of England, to—I believe I've memorized the phrase now—'reproduce, on any substance whatsoever, and whether or not to the correct scale, any British currency note,' or some such.

"Anyway, after that article came out, I wrote a letter to Mr. Robin Leigh-Pemberton, the Governor of the Bank of England—this was in early September—asking him for permission to go on drawing my likenesses of British currency. He passed my letter on to his deputy, a Mr. Gorden Edridge, who, late in September, wrote back denying permission, telling me what I was doing was illegal and that I was risking confiscation and arrest. *He hadn't even seen the work*! I wrote back once more, enclosing slides, acknowledging that this was an unusual case but insisting that mine was a serious artistic endeavor

deserving of serious attention. He wrote back, denying permission once again. I called him and tried to explain things, but he was adamant and in fact very intimidating. He told me I was risking the full might of the Bank of England.

"At that point I decided I'd better engage a solicitor. I went to a young fellow who specializes in art law—his father was an artist, and he represents the Picasso and Matisse estates and all sorts of others. His name is Mark Stephens, his partner's name is Roslyn Innocent (of all things), and their firm is called Stephens-Innocent. Anyway I engaged him, and as a retainer I offered him as much as I could afford at the time, which was a check on my account at Midland Bank made out to the sum of one millionth of a pound. He was a good sport: he accepted. And he told me that he really doubted the Bank of England would actually do anything.

"On Friday, October thirty-first, of last year—Halloween—I was in a small independent gallery called the Young Unknowns where I was helping set up my contributions to a group show on the theme of money. Other artists were involved, too, but mine was the work where the image of the pound note was most directly quoted. Actually I was going to be having two shows—that one and another in the lobby of my own branch office of the Midland Bank in Hampstead, which was going to be opening the following Monday. I was figuring, hell, I'll do the shows and somebody from the Bank of England will drop by and see that I'm not threatening anyone and they'll let the issue pass.

"Instead, that afternoon, I was there at the gallery, being interviewed by a television crew from BBC-1, when suddenly three big guys, two in suits and one dressed more casually, barged in and immediately started throwing orders around. The regularly dressed guy—his name was Reg, he identified himself as a detective from New Scotland Yard—shouted in a voice like thunder rolling down a mountain: 'Turn that camera off now!' They expelled the film crew—of course, there were protests all around. Then the three guys started taking things off the wall, my things and other people's things, although, interestingly, they decided to leave some of the more overtly political works. 'Let's not get involved in that,' they said to each other. They stuffed all this stuff into a big black bag. I was speechless. Peter Sylveire, the gallery director, was going crazy: 'You can't do this! freedom of speech! freedom of expression! a private establishment!' and so forth. All this took about half an hour. Then they came over to me and said, 'Are you Stephen Boggs?' I said yes.

'You're under arrest.' Part of me wanted to laugh, but it was also pretty scary, what with the firmness in their voices: they were taking this whole thing very seriously. 'We're taking you to the station.' They led me outside and stuffed me in the car, Peter in hot pursuit, yelling, 'You can't do this, don't be crazy!'

"So there we were, cruising along in this unmarked Ford Sierra, with them engaged in nonstop interrogation all the way to the station: 'So, you thought you could get away with it? How many have you made? When did you make them? Where did you make them? Who were your accomplices? Why don't you tell us now and save us a lot of trouble?' I was starting to panic. 'Look, I just want to talk to my counsel. Please, sir, may I, please, sir?' 'So your counsel told you to keep quiet. Why don't you just . . .' and so forth."

They delivered Boggs to the station, read him his rights, frisked him, and removed his belt and comb ("So you won't try to commit suicide by hanging yourself or slitting your wrist"). They continued to question him and he continued to ask them to please call his solicitors. "Reg said, 'Okay, who's your solicitor?' and I said, 'Stephens-Innocent.' Reg became furious: 'Lock him up if he's going to be a smartass.' They threw me in a little cement cube with a thick steel door with a little grated slot in the middle. No windows, a plank of wood for a mattress. Some time passed and then the slot opened and Reg was there asking, 'So, did you decide to cooperate?' 'Please,' I said, 'call my solicitors, the firm's name is Stephens-Innocent, I'm not trying to be a smartass.' But Reg just slammed the slot shut. He wouldn't believe me, and things were really getting scary. Nobody knew where I was."

Finally, the second time they opened the grate, Boggs was able to convince them to look up the firm's name in the phone book, and they were eventually able to track down Mark Stephens, who promised he'd be right over. In the meantime, the police were examining the evidence. "At one point Reg came back, opened the door, and said, 'Hey, need a blanket or a cigarette? Listen, me and the boys have been looking at your work. It's actually pretty good. How much do you sell it for?' I couldn't tell if that was a trick question, although Reg definitely seemed to have softened. 'I'm really sorry,' I said, 'but I want to talk to my solicitor.' "

Stephens showed up around nine and told his client he didn't have to talk to these people. They told him they were going to go search his apartment, with or without his permission. He told them to go ahead, he hadn't done anything wrong. The interrogation now resumed, with Stephens as a sort of

referee. "They were talking crime," Boggs recalls, "and I was talking art. It was kind of a hilarious conversation. 'Look,' I said, 'If I drew you a picture of a horse, would you try to put a real saddle on it?' "* Little by little, the Scotland Yard boys began to lose their enthusiasm for the case. Their leader— "Chief Inspector Davies: this wasn't just some bobbie, they'd sent some chief inspector, top-of-the-line brass to supervise in my apprehension"—looked over at his colleagues and wondered out loud, "What should we do with him?" Gradually they came to the conclusion that as far as New Scotland Yard was concerned, they were set to drop charges. They called the Bank of England and informed them so, and then released Boggs to the custody of his solicitor, with a warning that he not try to flee the country. It was around midnight.

Boggs went home to his ransacked studio apartment and collapsed into the arms of his girlfriend. He spent Saturday utterly depleted. Sunday morning arrived and out of habit he went and got the morning papers. To his astonishment, his own name was in the headlines. The *Daily Telegraph* trumpeted ARTIST DEFIES BANK OF ENGLAND AGAIN! and went on to report that his Midland Bank show was set to open the next day. "Too bad that show's never going to happen," Boggs sighed to his girlfriend. All of its pieces had been there in his studio, he had been planning to mount the show late Friday afternoon, and he assumed the police had confiscated them during their search. His girlfriend now informed him that late Friday, at a point when she'd had no idea where he was, she'd just assumed he was being forgetful and she'd gone and mounted the show herself—things had been so hectic since that she'd forgotten to tell him. Now he freaked out all over again. He called Stephens and they agreed to meet the next morning at the bank.

The first thing Monday morning, Boggs called the local bank manager to

*Back in the 1870s, in the anti-Greenback tract *Robinson Crusoe's Money* discussed earlier, David Wells argued that to imagine that paper money might supplement or replace precious metals was to succumb "to a mere fiction of speech and a bad use of language," for paper could only represent money; it could no more be money than "a shadow could be the substance, *or the picture of a horse a horse*, or the smell of a good dinner the same as the dinner itself" (italics added). Boggs often drifts into metaphors which turn out to have a rich history in the tradition of American populist and anti-populist rhetoric, though he has no academic grounding in that history (perhaps the spirit of the debate still swirled around the carny encampments of his youth).

The spirit and tenor of that debate were recently reinvoked by Walter Benn Michaels in his fascinating study, *The Gold Standard and the Logic of Naturalism: American Literature at the Turn of the Century*.

offer his profuse apologies for all the trouble he'd no doubt caused. "I prom-
ised him I'd be right over to take the show down," Boggs recalls. "And then
the bank manager said, 'You don't need to do that. The Bank of England has
already been in touch, and we've talked with our solicitors, and they tell us
there's no reason why we shouldn't proceed with the show, which is precisely
what we intend to do.' That completely blew me away. I couldn't believe it. I
just sank to my knees and started bawling."

Later that morning Stephens met Boggs at the branch bank in an exultant
mood. It appeared the Bank of England had been in touch with officials in all
of the other countries whose currencies Boggs had been drawing—the Amer-
icans, the Swiss, the Italians, the Germans, the Belgians, and the French—
trying to put together a coordinated prosecution, and all of the other coun-
tries had declined to go along. Notwithstanding which, the Bank of England
was remaining firm. Later that afternoon, a somber-faced official arrived, en-
tered the bank, confiscated the one drawing that depicted a denomination of
British currency (a twenty-pound note), and left. When Stephens called the
Bank of England to find out what was going on, he was informed that "In due
course we're going to arrest your client." (In Britain, the Bank of England re-
tains the right to launch a private prosecution, even when other law enforce-
ment agencies have decided against proceeding with a case.) Stephens asked
what they meant by "in due course." "As soon as the press dies down," came
the reply.

Meanwhile a public furor was developing. Boggs was suddenly a popular
hero—people were recognizing him on the street and bidding him good
luck. And ad hoc petition campaign was launched, and such luminaries as
David Hockney and Gilbert and George signed the statement defending ar-
tistic freedom. Another petition was signed by sixty members of parliament,
and one of them, Tony Banks (Labour MP for Newham Northeast), orga-
nized a show of artworks on money-related themes in the House of Commons
itself, under protection of parliamentary privilege.

Undeterred, the Bank of England proceeded with its case, which received
its first hearing on April eighth of this year, in the chambers of Stipendiary
Magistrate Eric Crowther at the Horseferry Road Court. Boggs was repre-
sented by Stephens, and the Bank of England by Robert Harman, Q.C. (the
Q.C. stands for Queen's Counsel and connotes a very important personage in
the British legal caste system).

"The whole case turned on whether or not I had been engaged in making 'reproductions' of British currency," Boggs recalls. "Now, in art world parlance, the word 'reproduction' has a very specific meaning. It suggests a debased form of image production—one achieved in multiples of some sort. In ordinary usage one says, 'Oh, that's not an original, that's a reproduction.' So, I mean, there's no way that what I was doing was a reproduction. Regular British pound notes are reproductions. I was making original drawings. Seemed obvious to me." Boggs paused for a moment. "Anyway, by the end of the day, the judge announced that he didn't feel competent to rule on the issues raised in the case, and that it should therefore be remanded for consideration by a jury of my peers—'a jury of twelve good men and women and true,' as he put it—and that's what we now have coming up on November twenty-third at the Old Bailey."

During the next few days I found myself conversing with all sorts of lawyers. First off I tried to reach Robert Harman, Q.C., to get the Bank of England's side of the case. I did get through but found him extremely reticent. "I'm afraid I can't speak to you," he apologized. "My lips are sealed. My branch of the profession is very strong about this business of not ventilating the case before trial. I can't help it if the defendant has waived his own right to that silence, but in my own case it might be seen as very unfair for me to get a bite at the cherry, as it were, before the hearing." I was able, however, to ascertain the lineaments of Harman's position in an article in the English journal *The Law Magazine*, in which Jolyon Jenkins summarized the proceedings at the April prehearing. According to Jenkins, Harman submitted that the term "reproduction," as used in the 1981 act, meant "a copy which is substantially the same as a currency note or any part of it." The Bank of England retained unfettered discretion to grant or refuse permission in cases of such reproduction, so that the only question was whether or not these drawings of Boggs's were reproductions. For Harman, the word "reproduction" needed to be considered consistently with the definition of the term in the copyright law, which is to say an object exhibiting a degree of similarity "sufficient to come so near to the original as to suggest that original to the mind of every person seeing it." Which Boggs's drawings obviously did. So that Boggs was obviously guilty and hence liable for the appropriate penalties.

Mark Stephens was considerably less reticent when I called him. From the

outset he agreed with certain aspects of Harman's position. "Look," he said, "everything revolves around the definition of reproduction. 'Reproducing' is what we lawyers call an absolute offense, which is to say, if you've done the act, you've committed the crime. What we're arguing about here is whether Boggs has done the act, whether what he's done is to reproduce. Well, there are ten meanings for the word "to reproduce" listed in the *Oxford English Dictionary*, and not one of them applies to the facts in this case the way the Bank of England would like it to. We intend to call an editor from the *O.E.D.* as one of our witnesses. The word 'reproduce' implies not merely a visual similarity but a functional one as well. Look, if for example I had you over to my house and you were admiring my beautiful Chippendale desk and I offered to make you an exact reproduction of that desk for a thousand pounds, and you accepted that offer and gave me the money, and then a week later I delivered to you a *drawing* of that desk, you'd be quite cross with me. And you'd have a right to be. What Boggs has made, in the same sense, is not money, it is not redeemable in silver or gold or even a nice new note—nor does it claim to be. A bank note represents value, and a Boggs does not, though it *has* value. Boggs does nothing to resolve the category confusion, as it is the very process of his art to mystify, to obscure the distinction itself. But surely it is the function of law to recognize and proclaim such obvious category distinctions."

Out of curiosity I called some American lawyers as well. I tried to get through to the Secret Service's General Counsel, John Kelleher, but his secretary informed me that the Secret Service does not provide advisory opinions, and neither would he. It does, however, provide a form letter on the subject of the legal parameters for reproduction of American currency, and she was happy to send that along to me. According to that memo, the Boggs situation vis-à-vis U.S. law is a decidedly iffy one. The operative sections of the U.S. Code (Sections 474 and 475 of Title 18) mandate prison terms and heavy fines for any person who "makes or executes, in whole or part, after the *similitude*" of any U.S. currency, or who makes "*likenesses*" of such currency. One could easily imagine a Harman-Stephens type debate on the precise applicability of such words as "make" and "similitude" and "likeness" in the Boggs context.

One of Boggs's New York lawyer friends, Herbert Nass, however doubted there'd ever be occasion for such debate:

"The Treasury Department has bigger fish to fry, so I'd be surprised if it

ever came to a prosecution here. But then again, I'm flabbergasted things have gotten as far as they have in England. And I know Boggs is very concerned about it. I mean, we can sit here and philosophize and satirize all we want, but the last thing Boggs wants to have to do is to spend the next several years making license plates." Nass paused for a moment. "Not in jail anyway," he added, as an afterthought.

Boggs dropped by. He was getting set to return to London to continue preparations for his case. He brought along the hologram. In the end the holograph-portraitist had dissuaded Boggs from holding up the pound note. Instead, she had portrayed him holding up and looking through an ornate, empty picture frame. The artist framed, perhaps? The way he was holding the frame, at any rate, by its long vertical sides, his hands brought all the way around, made it look eerily like Boggs behind prison bars.

Apropos of nothing in particular, Boggs said, "A lot of people who call themselves artists *are* counterfeits. The Bank of England just got the wrong man." He sighed. "I really don't understand why all this is happening to me," he said. "I don't understand why they feel so threatened, although I must say I like Demenga's comment: 'One fool can ask more questions than a hundred wise men can answer.' So now they're going to send me to my room for forty years."

He smiled wanly, headed out the door and toward the airport, and that was the last I saw of Boggs for several weeks.

II. "MORONS IN A HURRY"

*T*HAT WAS in mid-September. Soon after Boggs left, I realized I'd gotten pretty much hooked on the story and would now have to go over to London to cover the trial. I took to calling Boggs for updates at regular intervals. One afternoon I asked him how he was passing his time in anticipation of the trial. "Stephens has me boning up by researching all the earlier instances of artists' taking currencies as their subject matter," he replied. "Actually, as you know, I've been doing some of that all year—that's how I stumbled upon that case of William Harnett."

· · · · · · · ·

William Harnett?

"Didn't I tell you about Harnett?" Boggs asked. "It's an incredible coincidence. It turns out that there was this nineteenth-century American artist named Harnett who specialized in trompe-l'œil canvases and was arrested by the Secret Service in 1886 on charges of counterfeiting, because he'd made four paintings depicting various denominations of dollar bills. There are all kinds of eerie parallels. He was charged with four counts, I was charged with four counts. He was arrested in 1886, I was arrested in 1986. In 1880, he'd gone to live in London; I went to live there in 1980. The date of his arrest was November 23rd—a hundred and one years to the day before the date of my trial. Pretty weird, huh?" Boggs hummed the theme from *The Twilight Zone*, and then continued, "I heard about him from Edward Nygren, the curator of collections at the Corcoran Gallery, in Washington, to whom I'd been referred in the course of my researches. It turns out there was a whole spate of these trompe-l'œil paintings of dollar bills starting in the eighteen-eighties, and Nygren is one of the world authorities. He, in turn, referred me to Alfred Frankenstein's book *After the Hunt*, which is about Harnett and his contemporaries, and which includes several illustrations. I did a little article about all this for the October issue of *Art & Antiques*. But, really, you should take a look at Frankenstein's book."

I did. During the next few days, I tracked the book down, and I also called Nygren. He sent me a copy of his unpublished monograph called "The Almighty Dollar: Money as a Theme in American Painting." It was true: Boggs had stumbled upon a strange byway in the history of art and money.

The late eighteen-hundreds, I now learned, witnessed the highest triumph of the trompe-l'œil style of painting which had so absorbed commonsensical American artists and their audiences since Colonial times. Common images included fireplaces whose warmth almost radiated off the canvas, and after-hunt scenes before which one almost felt compelled to reach out and stroke the wet fur on the felled rabbit hanging from the painted hook on the painted wall. In this context, money, a three-dimensional object existing in a shallow space, seemed ideally suited for portrayal. But artists evidently weren't drawn to money—and certainly not so obsessively—for purely formal reasons. Nygren reminds us that money was an obsessional topic throughout the Gilded Age in both political and cultural circles. It was in this period, as we have seen, that the Populists and the robber barons were battling it out

over greenbacks, bimetallism, the gold standard, and so forth. This was also the period, as Nygren points out, when William Dean Howells had one of his characters in *The Rise of Silas Lapham* remark to another, "There's no doubt but money is to the fore now. It is the romance, the poetry of your age. It's the thing that chiefly strikes the imagination." And this was also the period when Theodore Dreiser offered his popular definition of money in *Sister Carrie*: "Something everybody else has and I must get." It was the era of Horatio Alger and the era of Mark Twain.

This was the context in which American artists—William Harnett the first among them—began executing their money paintings. Usually, the image consisted of a single bill, or several bills, tacked to a blank wall like a trophy—though, as Nygren points out, an illusory one. That was the whole idea: you were seduced into reaching for it, and it wasn't there.

Alfred Frankenstein characterized the counterfeiting story as "the van Gogh's ear of the Harnett saga." It was famous in its time and even long after. It seemed to capture the essence of the master—a painter whose technique was so exquisite that he was arrested by the Secret Service for counterfeiting. Under interrogation, it appears, Harnett was asked how many images of money he'd perpetrated, and he confessed to four. He was let off with a warning: he was to cease and desist forthwith and was never to attempt any such images again. And, as far as is known, he never did.

But Harnett's brush with the law appears only to have inflamed the imagination of some of his colleagues: they bridled at the prohibition. Perhaps the most remarkable of Harnett's successors was John Haberle. In 1888, he exhibited at the Art Institute of Chicago a painting entitled *Reproduction* (caveat Boggs!), which consisted of a ten-dollar silver certificate flanked by scraps of newspaper in which one could make out fragments of text: "John Haberle the Counter . . . ceives the eye into the belief that . . ." and "would humbug Barnum." The following year, Haberle exhibited a painting entitled "U.S.A.," which featured a frayed one-dollar bill portrayed face down in a veritable ecstasy, a delirium of chutzpah, so that the viewer could read the complete text of the prohibition against imitation of federal currency which at the time was included on the backs of all United States bills. There were countless other instances of the sub-genre—works with such provocative titles as "A Perfect Counterfeit" and "A Bad Counterfeit" and "Time Is Money," by such middling masters as N. A. Brooks, J. D. Chalfant, F. Danton, Jr., and—my own favorite—Victor Dubreuil. Sometime after 1896,

Dubreuil created a painting entitled "Safe Money," which Nygren was re-
cently able to secure for the Corcoran's collection; indeed, it was the acquisi-
tion of this astonishing piece which launched Nygren on his own art-and-
money passion. "Safe Money" portrays an open safe teeming with the palpa-
bly obscene profits of the North South East and West RailRoad monopoly,
whose abbreviated name graces the top of the safe; the edge of the painting is
the notched, bevelled edge of the open safe itself. That bevelled edge has the
effect of a picture frame, so that here, near the beginning of the twentieth
century, Dubreuil seems to have made and proclaimed a discovery about the
quintessential nature of the art that was to come. Renaissance artists had pos-
ited the thesis that the picture plane ought to function as a window slotted
into the wall. Dubreuil for his part anticipated the status of art in the wake of
the robber barons' apotheosis, how the picture plane would thereafter func-
tion as a *vault* cut into the wall—an occasion for the ostentatious display of
wealth.

Alfred Frankenstein, after much research, was able to establish that the Se-
cret Service had not simply gone off half-cocked in its philistine suppression
of Harnett. It appears that, unbeknownst to any of these artists, the Secret
Service had been trying since 1879 to track a fiendishly accomplished coun-
terfeiter whom it had dubbed Jim the Penman. According to Frankenstein,
Jim the Penman did not print his bills but, rather, *drew and painted* them,
"with artists' materials, and with a professional artist's imitative skill." In
those days, a hundred dollars was worth so much that the effort must have
seemed worth it. The Secret Service apparently hauled Harnett in on the as-
sumption that he might be their man. As it happens, Jim the Penman wasn't
caught until a decade later: in 1896, he was revealed to be a German immi-
grant named Emanuel Ninger, who operated out of Flagtown, New Jersey.*
Frankenstein quotes Laurence Dwight Smith's book *Counterfeiting: Crime
Against the People* to the effect that Ninger's notes were considered so remark-

*The Secret Service probably derived their "Penman" pen name for Ninger from the example
of the famous Victorian forger James Townsend Savard, who also went by the name Jim the
Penman. Savard's British exploits inspired a novel and a play. They also appear to have inspired
James Joyce, whose *Finnegans Wake* features an authorial alter ego named Shem the Penman—
himself the author of a work entitled *The Haunted Inkbottle*.

The Argentine writer Julio Cortázar was also inspired by cases of forgery encountered in his
work as a translator for the United Nations, some of which he describes in his *Around the Day
in Eighty Worlds*; one case is particularly noteworthy: "My strange (to say the least) visits to In-
terpol have introduced me to almost alchemical labors, vocations bordering on martyrdom or
poetry, beginning with a man who falsified bills of the maximum denomination (because any-

able at the time that "there was public protest after his arrest, subsequent to his passing a hundred-dollar bill in New York," and "collectors paid high rates for specimens of his work." Boggs, for his part, comes down pretty hard on Emanuel Ninger, who in one sense was the closest to him in technique of all these predecessors. In a section of his *Art & Antiques* manuscript which that magazine did not use, Boggs writes, "Jim the Penman stole from people, using his talents deceitfully and stupidly. Remember, even if his works were worth more than face value, which he himself did not recognize, he did not give people the opportunity to appreciate his workmanship. Instead he would leave them to present the piece to the bank, whereupon it would be confiscated, leaving the party both uncompensated and without even the novel object to keep as a souvenir."

It's not surprising, perhaps, that these late-nineteenth-century money pieces are enjoying a fresh vogue in this, our own gilded age. Ironically, collectors have to wade through a thicket of false attributions—there are, for instance, countless counterfeit Harnetts—to find the real thing (or, anyway, the reputedly real thing), but, once found, it fetches a good price. In 1899, Haberle's *Imitation*, which portrays a dollar bill and some seventy cents in change, sold for a hundred and seventy dollars. As Lot 81 at Sotheby's May 1987 auction—near the height of the recent run-up in art-world-auction prices—it was estimated that it would continue the symmetry by bringing a maximum in the neighborhood of $170,000. It actually went for $470,000.

In my own brief foray at research into these nineteenth-century figures, incidentally, I came upon one other antecedent for Boggs's situation: the melancholy case of the great American landscape artist Ralph Albert Blakelock. Crushed by the meagerness of his earnings as an artist, he took to manufacturing his own money, million-dollar bills with miniature landscapes and his own portrait in the middle. When he tried to cash one of these bills at a New York bank, he was apprehended and remanded to a mental asylum, where he lived out the remainder of his days.

During those weeks before Boggs's trial, while I was studying the relations of money and art and value in the late nineteenth century, something quite re-

thing less wouldn't be worth the trouble) by a procedure that consisted of cutting vertical slices of half a millimeter from two hundred legitimate bills so that their reduction in size would be so slight as to pass unnoticed, later to make from the two hundred bills the two hundred and first that represented his profit."

markable, of course, occurred in the world of contemporary values: the stock market collapsed, with the Dow Jones industrial average losing over five hundred points in a single October afternoon, and similar calamities occurring on financial exchanges throughout the world. This catastrophe caused a great deal of anxiety about money and an even greater amount of mystification. (It was just around this time that a homeless New York City woman, who, as it happened, went by the street name of Billie Boggs, was forcibly removed to a mental hospital for, among other things, indulging in the manifestly insane behavior of burning dollar bills in public; this Boggs, too, went on to become the subject of a celebrated test case.) Experts calculated that almost half a *trillion* dollars in value had disappeared from the American economy overnight—but what had happened to it, one wondered. Where had it gone? One answer was that it hadn't *gone* anywhere; it wasn't now in some new place, where we would eventually be able to locate it if we just set our minds to it. Rather, it had in a sense never existed in the first place. There is always something dreamlike about the great speculative frenzies, and, inevitably, at some point the dreamers awake. It was simply, as many commentators now took to noting, morning again in America.

Those whose lives and livelihoods were tied up in the art market observed these developments with considerable alarm. Prices in the art world during the previous half decade had been surging alongside those in the financial markets, and, in many cases, among the same clientele. The new class of young stockbrokers and investment bankers and corporate lawyers and freelance speculators constituted a large proportion of the new players in the art scene, particularly in the contemporary art scene, and dealers and artists and auctioneers cringed at the spectacle of their sudden difficulties. Not only might many of the players now have to absent themselves from the market, at least for the short term, but many of them might well simultaneously have to dump substantial portions of their own collections onto the market as a way of raising quick cash and covering their other losses. The market thus threatened to glut at the very moment that many of its best players were abandoning the field. Or so, anyway, were many interested observers beginning to fear. These trepidations began to congeal around the prospect of the big upcoming contemporary art auctions at Christies and Sotheby's, scheduled for the first week in November in New York.

I decided to attend one of these galas—the opening night of the Sotheby's

sale on November 4th—as a way of gauging the status of the current scene and in turn preparing for that other upcoming spectacle of values-in-contest, the Boggs trial scheduled for later that month in London. The place was thronged with rich folk in formal attire: a friend of mine commented that he'd never seen so many white people in black clothes. It is strange the way people dress up to spend money—or, more precisely, to be *seen* spending money. The wardrobes *were* spectacular—but they could easily have predated the crash. The looks on people's faces, however, were decidedly post-crash. There was a certain forced gaiety in the air, but it barely veiled the air of distractedness, the anxious looking-about, the tightness around lips and eyes, the dry catch in people's voices. A great deal was clearly at stake. No one knew what was going to happen: if a series of lots near the beginning of the auction (de Koonings and Mitchells and Lichtensteins and Heizers and Morleys from the estate of the late dealer Xavier Fourcade) were to fail to meet their reserve (the secret minimum stipulated by the seller), who knew what effect this might have on the subsequent pieces in the sale? The room seemed primed for a chain reaction. (Every failure of confidence, just as every sustaining of confidence, can be said to result from a chain reaction.) Many of the people in the room had big money tied up in their private collections back home, and whether or not they themselves had works up for auction, they seemed edgily aware that at any moment now they might suddenly have wee money tied up in those collections.

But as it happened, that evening, the market held. From the start prices seemed to steady: some a bit higher, some a bit lower than expected, a few shockingly higher, another few disconcertingly lower. It was as if everyone in the room had momentarily agreed to consecrate this space as immune to the laws of gravity wreaking such havoc just beyond its portals. There was a great unspoken agreement: people would continue to bid incredible sums of money for various works on offer (sums equivalent in many cases to several decades' pay for most workers), in part to sustain the value of other similar works they themselves already owned.* That was part of what was going on, part of

*During the ensuing months this issue of art and money continued to bedevil professionals in the field. In February 1988 the New York City Department of Consumer Affairs ordered all galleries to "conspicuously display" the prices of art works along with the works themselves. This led to howls of protest from dealers. One of them, Gerald Stiebel, explained to Douglas McGill of the New York *Times*, "We don't like the price getting in the way of the enjoyment of the exhibition. Some of the figures that we ask for things are difficult to comprehend, for us as well as for the public."

why faces loosened tangibly as the evening progressed, sparkle returning to those previously veiled gazes. There were, however, other factors also at work. Prices quoted high in dollars were in fact considerable bargains in Japanese yen or German marks, since one aspect of Wall Street's crash had been a headlong plummeting in the dollar's exchange rate. There were a lot of phone bids from overseas, and translated into many of these currencies, prices for de Kooning and so forth might actually have been said to have slid considerably. Beyond that, these particular auctions were highlighting works by the great, established masters—de Kooning, Pollock, Dubuffet, Johns, Christo, Hockney, Stella, and so forth. Investors who'd managed to bail out of the market in time, before the crash, had plenty of cash that they now needed to park somewhere, and these sorts of triple-A rated (as it were) works on paper and canvas could well have seemed decidedly more secure than some of the other paper securities on offer these days—stocks, bonds, regular green bills. (John Russell subsequently wrote in the New York *Times* of his "depression at the thought of the loud applause [at these auctions] that greets what is, in effect, a definitive loss of faith in money.") This effect was even more evident in the transstratospheric prices registered in the ensuing weeks by such quadruple-A rated lots as the van Gogh *Irises*, which fetched a record fifty-three million dollars. Many of those who were reassured by the steady performance of the market for established masters still looked with real foreboding toward any upcoming auction which would feature the until-recently highly prized works of the young phenoms of the seventies and early eighties. De Kooning and Pollock were one thing, but might the next Schnabel, say, to come up for bid prove the first tear in the bubble?

Boggs's work, of course, addressed precisely these sorts of confusions and anxieties. Why do people place any value whatsoever on certain sorts of configurations on paper, and why do they then suddenly lose their faith in that value? Questions like these were suddenly making people crazy, and one couldn't help wondering what sort of impact that general mood of edginess would have on the upcoming trial.

I next met Boggs a few weeks later at his London gallery, the Young Unknowns, on the south side. On the very eve of his trial, he was defiantly displaying his wares as part of a group show. There were old works, including a piece called "The Banker's Dozen," that consisted of nine drawings of non-

British denominations and signs boldly attesting to the earlier confiscation by Scotland Yard of the four others—pound notes. There was the holographic piece, with its two money drawings, receipt, and Boggs himself, all framed. And there were some new works as well, including a framed drawing of a ten-pound note—only, when you looked closely, you realized that you were looking at a frame surrounding a stretch of wall onto which Boggs had directly drawn the bill, as if to taunt Scotland Yard: "Confiscate *that!*" There was, in addition, a medium-sized black wooden box projecting from the wall and labelled "Safe" (Boggs's homage to Dubreuil?). The box had a glass panel at about eye level through which one could see an actual one-pound note—or, rather, the *reflection* of a one-pound note, for the piece consisted of an internal sequence of angled mirrors which conveyed the image of an actual note buried in the depths of the box. "Now, *that*," Boggs suggested, "might actually constitute a reproduction of a pound note. So go ahead and arrest me."

I asked Boggs how things were going.

He said he was feeling tense. As it turned out, the prosecution was not going to be seeking a jail sentence after all, only a fine. But the point was moot, because Boggs had resolved—he'd *had* to resolve, to hear him tell it; he had no choice if he was going to safeguard the principle of artistic freedom—that he wasn't going to pay any fine under any circumstances. "I mean, if they fine me I'll draw them the fine," he said. "Then they'll probably fine me for that, and I'll draw that fine, too. But eventually they'll probably rule me in contempt, and that *will* lead to a jail sentence." The prospect seemed both to quicken and to terrify him.

He was, at any rate, quite notorious. The coming trial was receiving a good deal of press coverage, and he was being recognized when he appeared in public. "The other day, I was at the British Museum," he told me. "They currently have up an exhibition of British banknote design through the ages, of all things, and it's got some terrific items, including the actual old portraits that the Bank of England used as models for the etched portraits on the current bills. So just who's copying whom? Anyway, they also have several glass cases filled with wonderful examples of classic, long-abandoned banknotes. I took out my sketching pad and started to draw some of them. Really beautiful things. Suddenly, a woman came over to me and told me I was to cease and desist—it was against the law to draw British currency. I said, 'Oh, yeah?' And anyway these bills were two hundred years old, for God's sake. I

ignored her and went back to work. About half an hour later, a big bouncer type came over and said, "Hello, Mr. Boggs. We're not supposed to be here, are we?' And he proceeded to throw me out. It was as if they'd been expecting me."

As he was being led out, Boggs had managed to pick up a copy of the show's catalogue, and he now pulled it from his satchel. "Here," he said. "Look at this." He turned to a page on which was reproduced George Cruikshank's 1819 cartoon version of a contemporary British currency note—virtually exact, except that the central image in Cruikshank's rendition consisted of a ghastly line of bodies dangling from an extended gallows, and the "£" had been fashioned out of a noose. The catalogue text explained that in those days counterfeiting was rampant, as was the death penalty as its punishment, and it went on to say, "The system was hard, for it is quite apparent that not only those who actually perpetrated the forgeries risked dire punishment; anyone who handled the counterfeit notes, knowingly or not, stood to suffer just as much." (The text also pointed out how along the left side of his bill Cruikshank had conspicuously printed "Specimen of a Bank Note—not to be imitated.") Boggs acknowledged that, all things considered, he was probably lucky to be testing the limits of the British currency laws at the end of the twentieth century rather than near the beginning of the nineteenth.

The next morning, however, it became clear that, jail sentence or no, the Bank of England was still taking this case very seriously. Not only had the case been assigned to the Central Criminal Court, the Old Bailey, but it had been assigned to Courtroom No. 1, perhaps the most historic such chamber in England. As journalists and lawyers milling around the antechamber beforehand recalled, this was the room in which Dr. Crippen, the infamous wife-murderer, had been tried in 1910; this was the room in which most of the spy cases, the Official Secrets cases, the I.R.A. terrorist cases, the S & M brothel cases, the cases of the Yorkshire Ripper and the Bath Murderer had all been heard. And Boggs was going to be sitting in the very spot that all those vile miscreants had once occupied—news that wasn't doing much to calm his fidgets.

Courtroom No. 1, which is on the second floor of the Old Bailey, opens out on an august hall (green serpentine columns, dark wood panelling and benches, marble parquet floors, elaborate, somewhat kitschy murals above

the entryway to each courtroom). That hall, in turn, opens out on a high central vault, the interior of the cupola whose exterior distinguishes the building on the skyline of the City of London. (The City, of course, is London's financial district: the Bank of England's headquarters are on nearby Threadneedle Street, and the stock-brokerage houses are scattered all around.) The exterior of the Old Bailey's dome was under scaffolding the week I was there: I was told that the gold-plated statue of blindfolded Justice atop the cupola was too heavy and was threatening to come crashing down through the building. Were it to do so, some of the milling journalists and lawyers and prospective jurors now remarked, it would probably take out the four-panelled mural at the top of the interior vaulting, whose panels depicted, in compass-point rotation, Truth, Learning, Art, and Labour. "As usual," Boggs noted, "Art is portrayed as opposed to Truth."

The murals above the courtroom doors portrayed various allegorical scenes, the import of which was driven home by weighty mottoes inscribed in elegant lettering underneath: "The Law of the Wise is a Fountain of Life," for instance, and "Right Lives by Law, and Law Subsists by Power." The motto above the entry to Courtroom No. 1 proclaimed, "Poise the Cause in Justice Equal Scales" (just like that, with no punctuation), and the mural showed an imperial scene with a panoply of dignitaries and common folk bowing down before dour Justice, her scales suspended at the end of an outstretched arm. It occurred to me that in this standard icon Justice is portrayed as having recourse to a money changer's scales as the device for metaphorically judging the worthiness of competing claims and values. How would Boggs's bills balance off against the real thing in the days ahead?

Presently, the judge in the case preceding Boggs's completed his summation, dispatched his jury, and vacated the room; and the bailiff now came out to look for Boggs. It appeared that Boggs would have to be placed under formal arrest, booked and frisked downstairs, and prepared for a dramatic entry up an interior stairwell that led directly to the dock.

Boggs left with the bailiff, and the rest of us drifted into Courtroom No. 1, which proved to be a large, distinguished wood-panelled space laid out in classic British-courtroom style, which in itself bespeaks a whole philosophy not only of justice but also of social roles. The judge's bench and table were on a raised platform beneath a Damoclean sword and a coat of arms; facing that throne, on the other side of the room and at the same level, was the

dock—the defendant's chair and desk, which were enclosed by a low, square wooden balustrade. Directly behind the defendant's chair, and within the enclosure, was the flight of stairs leading to the holding cells below. Over to the judge's right and one and two levels below his platform were the jurors' benches; the next level below theirs held the press seats; and then, at the lowest level, in the basin between the judge's and the defendant's plateaus and facing the jurors' escarpment, were the tables for the various defense and prosecution lawyers, the solicitors and barristers.

The solicitors were the ones in street clothes, with the piles of documents on the tables before them; they had handled the earlier phases of the case. The barristers and their assistants wore black robes, little white double bibs (in the style of Cotton Mather), and elegantly coiffed gray wigs; it was they, and they alone, who would argue the case, from their positions at little podiums by their sides. Robert Harman, Q.C., was serving as the prosecuting barrister. Boggs's solicitor, Stephens, had managed to procure for him the services as barrister of Geoffrey Robertson, a famous advocate of civil liberties and press rights—a sort of British combination of Floyd Abrams (although there is no formal equivalent of our First Amendment in Britain, Robertson has championed such First Amendment-type clients as the *Observer* and the *New Statesman*) and the Harvard lawyer Arthur Miller (as Miller does on PBS, Robertson conducts a popular legal roundtable program on Granada Television). Robertson has also been a frequent advocate before the European Court of Human Rights in Strasbourg (his clients elsewhere have included members of the beleaguered Czech Jazz Section), and, to judge from his comments to the press, he seemed to see the current Boggs proceedings as a necessary, if probably futile, exercise—merely a preliminary to his heart's true desire: an appeal of the Boggs case before the Strasbourg court.

The spectators, who were seated on rows of benches behind the defendant's enclosure and also in a steep gallery, something like a surgeon's amphitheatre, in the upper part of the wall opposite the jury, were taking advantage of the lull before the trial to size up the two barristers. Harman was a spry-looking elderly gentleman with sharp features, narrow lips, a wide smile, a clear gaze, large ears, and a tiny face. His wig fitted him perfectly: it might well have been fashioned out of his own hair. Moreover, it looked not the least bit anachronistic on him; on the contrary, he had a confident eighteenth-century presence that made everybody else in the room seem vaguely out of date. Robertson, by contrast, was clearly a modern man, a

good deal younger than Harman, taller and fleshier, and with thick, almost bouffant hair, which would have stood any American Presidential candidate in good stead, and atop which perched an absurdly cocked wisp of a wig. ("Geoffrey," Boggs asked him during one of the recesses, "how often do you have to take that thing to the vet?")

The den mother, or mother hen, of the court now rose and stamped her staff, instructing all present to rise for the judge's entrance. A side door near the back opened, two dark-robed ushers entered and surveyed the scene, and then, presumably finding everything in order, bade their lord the judge, the Honorable Sir David McNeill, to enter. He did, and proved to be a kindly-looking, middle-aged, bespectacled gentleman, with dark bushy eyebrows. He was all decked out in a comfortable bright-red robe with white ermine sleeves, and, on his head, a distinctive white wig. In one hand he carried the traditional black cap, which he'd be required to don should he find it necessary, at any point in the coming proceedings, to sentence anyone to death for high treason. He walked to his bench, then turned to bow to the ushers, to the clerks, to the barristers, to us—I lost track of the bows. Courtroom novices, like me, tended to return all of them; the pros knew which single bow to respond to.

The judge now sat, and everyone else sat, and the judge called for the defendant Boggs to be brought up, and nothing happened. "Bring up the defendant," the judge repeated, and still nothing happened. The bailiff, flustered, went off to see what could have gone wrong and returned a few moments later to report that the officers downstairs had somehow misplaced their charge, the defendant Boggs, but were looking for him and would no doubt be delivering him shortly. All of us just sat around, politely nodding to each other. Finally, after about ten minutes, the hatch opened and Boggs was delivered to his fate. (Boggs subsequently told me he'd been frisked three separate times down there, in three successively deeper interior chambers, and had finally been remanded into a solitary cell. "That cell would have made a great studio," he reported. "A bright white cube. The walls were covered with scratched-in initials and insignias and slogans. I took out my pen and had just enough time to draw the beginnings of a pound note before they came to fetch me.")

The judge announced that Boggs would no longer have to go through the ritual of pretrial incarceration, and then he summoned a panel of prospective ju-

rors. He told them that this was going to be a case involving the currency of the realm and asked if any of them had any ties to the Bank of England. One of them said that, actually, she was married to a man who worked for a company that did business with the Bank. What sort of business? Printing. The judge looked over at Robertson; Robertson smiled and shrugged—it didn't matter to him—and the woman was permitted to stay. Robertson made peremptory challenges of two other jurors, Harman accepted the whole lot, and, as quickly as that, we had our jury: eight women and four men, ranging in age from their early twenties into their sixties. They were a uniformly ordinary, middle-class-looking group, with the possible exception of one somewhat scruffy and dishevelled gentleman in his mid-thirties.

The judge invited the prosecution to open its case. Harman informed the jury that this case was being brought under Section 18 of the 1981 Forgery and Counterfeiting Act, but the prosecution would be alleging neither counterfeiting nor forgery—only the act of reproduction, for which, he declared, there ought to be two simple possible tests: Does the copy suggest the original to a person looking at it, and was it obviously copied? If the copy met those tests, it would clearly be a reproduction, and therefore its creator would be in violation of Section 18—unless, that is, he had procured advance permission from the Bank of England, which, as part of its assigned protective role on behalf of the integrity of the national currency, had been granted unfettered discretion in granting or withholding such permission. The question was going to be a straightforward one: Had the defendant, Mr. Boggs, reproduced British notes or had he not?

The prosecution's first witness was a mid-level official with the Bank of England, Geoffrey Russell, to whom Harman successively presented the four Boggs drawings—of a ten-pound note, a five-pound note, and two one-pound notes—that formed the basis for the four counts with which the Bank was charging Boggs. Harman invited Mr. Russell to detail all the similarities between Boggs's drawings and standard pound notes of the same denominations. A strange tar-baby effect developed here: each time Mr. Russell pulled an actual five- or ten-pound note out of his billfold to use in comparison, he had to surrender it as evidence. As a witness, he was being cleaned out.

Robertson, for his part, during the cross-examination, trotted Mr. Russell through all the obvious differences. At one point, when Mr. Russell commented that it had been some time since he'd studied the Boggs drawings, the last time he'd seen them having been before Christmas, Robertson said,

"You mean last Christmas, the Christmas of 1986, when the Bank itself included reproductions of pound notes on its own Christmas cards?"

The judge scowled. "You're not suggesting, Mr. Robertson, that those reproductions were unauthorized?" he said.

"Oh, no," Robertson quickly assured His Lordship. "No doubt those reproductions were *easily* authorized." In subsequent asides, Robertson let it be known that the Bank of England had even granted permission to a chain of sex shops to reproduce a decidedly risqué version of a British pound note.

At this point, the judge received word that the jury in the previous case had now reached its verdict, and he recessed our trial for lunch, so that the other trial could occupy the premises. Everyone got up and bowed, and most of our group left—all except me. I decided to stay on and witness the outcome of the other case. The trap door opened, and its defendant emerged to take Boggs's place. Barristers, solicitors, judge, and jury all trooped in, and there were bows all around. The jury announced its verdict on three counts of rape—not guilty—and was gratefully dismissed. The prosecutor then pointed out to the judge that there remained the matter of a fourth count, which had been held over for separate consideration. It appeared that at the moment of his arrest the defendant had been in possession of five counterfeit fifty-pound notes. The defense lawyer got up and explained that the defendant had been given the five notes earlier that evening *as a joke*, and had kept them to show them around as such; he'd never intended to pass them. (This struck me as a novel defense, and I resolved to relay it to Boggs as a possible backup position.) The judge, however, was not amused. "A joke?" he said grimly. The defense lawyer immediately fell back on an alternative strategy, arguing that the seven months the defendant had already spent in jail, unable to post bail on the three counts on which he'd now been found not guilty, ought to be sufficient penance for this other offense. (Again this game of scales, I thought, of values weighed one against the other.) The judge considered that line of argument for a few moments, and, following a stern lecture to the defendant on the evils of counterfeiture, decided to accept it. End of that case, bows all around, and, a bit later, bows all around, resumption of ours.

Harman's next witness was a somewhat more senior official of the Bank of England than Mr. Russell, Graham Kentfield, who turned out to be the boss of Gordon Edridge, the recalcitrant bureaucrat with whom Boggs had engaged

in that unsatisfactory correspondence the year before, just prior to his arrest. (Edridge had meanwhile retired and was not being called as a witness; Mr. Kentfield explained that, in any case, the man had been acting under his direct orders the entire time.) Harman and Kentfield rehearsed the entire correspondence between Boggs and the Bank: Boggs's two letters asking permission, the Bank's two letters refusing it. Kentfield presented the aspect of a self-assured and unflappable bureaucrat: the validity of his position was self-evident, to him anyway, and its obvious validity to anyone else was equally self-evident. He explained that reproductions of currency notes made with even the most benign of motives—he cited the case of eye-catching advertisements in newspapers—could be used by a second party to diddle naïve and trusting third parties (he told of instances in which reproductions of pound notes had been cut out of newspapers, hand-colored, and palmed off on unsuspecting little old ladies in Suffolk). This was what the Bank had to protect against; this was why the Bank had a strict set of guidelines, which it sent to all prospective applicants, and which it had sent to Boggs. Boggs had been asking for "blanket permission" to contravene both the law and those guidelines—a request that, self-evidently, could only be met with a "blanket refusal."

In his cross-examination, Robertson tried to determine how this law and those guidelines could ever be made to apply to fine artists, as opposed to commercial artists. "Let me see if I have this right," he said to Kentfield. "If Mr. da Vinci was proposing to include some pound notes in his upcoming painting of *Christ Driving the Moneylenders from the Temple*, you're suggesting that, in keeping with the guidelines, he'd have to send the Bank a detailed sketch, in duplicate, taking care to leave the space intended for the bills blank pending your approval of the whole scheme? And, in keeping with your guidelines, were you to grant permission, he'd still be required upon completion of his project to destroy all materials associated with the image's manufacture? What does that mean? The brushes? The palette? The easel? The painting itself?"

Mr. Kentfield declared Robertson's example preposterous—for one thing, moneylenders in Christ's time would never have been lending British pound notes—and smugly asserted the self-evidence of common sense. Robertson tried to get Kentfield to admit that Section 18 clearly applied to mechanical, and not manual, reproduction; to commercial, and not fine, art; but

Mr. Kentfield serenely stuck to his position. What Boggs had been doing was obviously reproduction; as such, it had required the Bank's permission, which Kentfield had not once but twice refused to grant: case closed, as far as he was concerned. Robertson got Kentfield to admit—and Kentfield saw no problem in this, either—that it was he alone who had decided not only how to reply to Boggs's initial request but how to reply to Boggs's appeal of that decision as well. Subsequently, in his summation, Robertson would describe Kentfield as a witness "whose brow doubt had never furrowed," and Kentfield, seated in the back of the courtroom at the time, seemed in no way bothered by that characterization.

Harman now called Inspector James Davies, the arresting officer from Scotland Yard, and reviewed with him the circumstances of Boggs's arrest and subsequent interrogation. Indeed, in a particularly surreal exchange, Harman had Davies assist him in reading the transcript of Boggs's entire post-arrest interrogation into the record, with Davies playing himself and Harman taking on the role of Boggs. ("Q: Did you draw or paint that article? A: It is my job to allow my thoughts and feelings to be expressed and communicated through visual work of my hands. For art to be true and just and honest, I must allow my inner self out. Q: Did you draw or paint it? I accept what you appear to be trying to indicate, but the question I am asking is not about why you might have done it, but if you did it. A: Can I claim total responsibility for all things which make me a human being, being that I consider this to be a part of or reflection of my self? I've gone into my mind to the place where art originates—and it is a very expansive place: I have yet to dent the territory, I am only beginning to explore it. Q: Did you with your hand with a pen, pencil or paintbrush—irrespective of the reasons, whatever they may have been, which caused you to do it—paint, draw or color this item? A: If you are asleep and you have a dream, are you responsible for the creation of that dream? I have bled onto this piece of work." And so forth.) Robertson, in his cross-examination, solicited from Inspector Davies the fact that Boggs had never been in trouble with the law before, and also Davies's own certain opinion that Boggs had never tried to pass off any of his drawings under false pretenses.

The judge adjourned the hearing for the day. Boggs, coming out of his enclosure, waved to Davies (who nodded nervously back) and then remarked to me that he'd become good friends with the inspector in the months since his

arrest. On each occasion he'd encountered Davies during the various pretrial procedures, Boggs said he had regaled the inspector with details of his most recent exploits and shown him his most recent drawings. "Don't do that," Davies had pleaded. "Don't tell me that. Don't show me that. I don't even want to know about any of this."

Now, however, Boggs seemed somewhat rattled by his day. "It's strange to be sitting up there listening to all these people talking about you and your work, and not be able to say a word," he observed. He was too restless to go home, so I suggested he might like to take in a play. We looked through the paper and naturally settled on Caryl Churchill's *Serious Money*. Churchill had described her play as "a City Comedy," and, dealing with the world of speculative high finance in the wake of London's "Big Bang" deregulation of financial markets (and before the Bust), it presented a class of people who were in the regular habit of producing wealth out of nothing in a manner considerably grander than anything Boggs had ever envisioned.

Back at the Old Bailey the next morning, the bailiff came up to Boggs in the anteroom and inquired about some sketching he'd seen him doing in his notebook during the previous day's testimony. "You weren't sketching the judge or any of the witnesses, were you?" he asked.

Boggs said no, he'd been sketching the sword and the coat of arms on the wall above the judge.

"Well, that's strictly forbidden," the bailiff informed him sternly. "It's forbidden for anyone to sketch any of the persons or things inside the courtroom during a trial, and I will not have such behavior in my courtroom." (That prohibition, by the way, accounted for another curious spectacle I'd come upon while walking around the Old Bailey during breaks: courtroom sketch artists who kept barrelling out of their courtrooms into the hallway and frantically sketching from memory as much as they could recover before diving back for another visual draught.) Boggs promised to desist from such insolence, and reported to his seat.

Once the proceedings had resumed, Harman rather quickly wrapped up his presentation of the prosecution's case. He, too, seemed to feel that the evidence of reproduction was self-evident. Robertson now asked the judge if he could make certain technical submissions on why the case should be dropped

without further ado, and the judge, though he looked dubious, excused the jury until after lunch.

Robertson's submissions had to do with the misapplication of the legal term "reproduction" in this case, and they were technically dazzling—at times too clever by half (as when, to buttress his claim that "reproduction" had to be total and exact and without any variation whatsoever, he cited phrases in parliamentary acts which asserted that a given section should be understood to "reproduce" such-and-such a section from another act, by which was obviously meant "taken in toto verbatim," and not "sketched out to an approximate likeness"). Finally, however, they proved futile.

The judge seemed to feel he was dealing with a common-sense application of a word in common usage, and he really couldn't see what all the fuss was about. "So I reject your submission, Mr. Robertson," he concluded at length, "though I thank you for making it. It was most interesting."

Robertson didn't seem deeply disappointed: perhaps he'd simply been rehearsing for Strasbourg. Boggs, for his part, had spent his morning in the dock sketching merrily away.

After lunch, the jury came back, and Robertson launched his case with a flamboyant opening statement. In contrast to Harman's cool, crisp, efficiently friendly style, Robertson's was rhetorically expansive. "The *Mona Lisa* is not a reproduction of an Italian woman," he told the jurors, "and van Gogh did not reproduce sunflowers. To be sure, Boggs is not an artist of that calibre—and being an artist would in any case be no defense in itself—but if you just look at his drawings you will see that they are not reproductions but, rather, artists' impressions, objects of contemplation." He went on to claim that not only had these drawings never been passed off as real currency but they couldn't possibly be. He had repeated recourse to what was apparently a quasi-legal standard, that of the "moron in a hurry," as in "Not even a moron in a hurry would mistake these drawings for the real thing—they are obviously drawings." (There was in subsequent examinations and cross-examinations much discussion of the relative capacities of Boggs's drawings and hurried morons to fool and be fooled. What about, for instance, a moron in a hurry *in a dimly lit room*?) "No," Robertson concluded, theatrically, "Boggs's drawings and real money are as different as chalk and cheese, or rather as chalk and cheese that's been carved out to resemble chalk. Boggs is

no mere reproducer, he's an artist. You may or may not like what he does; you may find what he does of value, or you may feel a Boggs isn't worth the paper it's drawn on. The invitation to come up and see my Boggs sometime may hold no fascination whatsoever for you. But that's not the point. The point is that these are original works of art and not reproductions at all."

With that, Robertson called his first witness, Boggs himself. Under friendly questioning, Boggs reviewed his background for the jury, describing how he'd come to his current preoccupations, how he drew his drawings and "spent" them, what became of them after they were spent, how his true fascination was with the very act of transaction itself, how he'd first heard about his potential legal problems with the Bank and had immediately taken steps to address them, the stone wall he'd encountered there, and so forth. He was at his most charming.

During the cross-examination, however, Harman clearly rattled him. Following a come-on-you're-an-intelligent-young-man sort of prologue, he showed that Boggs himself had developed doubts about the legality of his production (he returned again and again to the evidence of the two letters), and that when he failed to get the reassurance he'd desired, he had simply resolved to ignore the prohibition and break the law.

Boggs insisted that the law couldn't possibly apply to his work.

Harman interrupted him abruptly: "Are you suggesting that because your drawings are works of art, they are incapable of being reproductions?"

"I suppose so," came Boggs's carefully measured reply, "because once you crossed over the line into reproduction, it would no longer be a work of art."

Harman was clearly trying to leave the jurors with the impression that Boggs considered himself, as an artist, to exist in a universe beyond the reach of laws that applied to mere mortals like them. But the jurors, uniformly poker-faced throughout the proceedings, were giving no indication of whether they accepted that characterization. (In one surprising development, the slovenly juror of the previous day appeared to have cleaned up his act considerably: he was dressed in a casual suit, and had brought along, as leisure reading, a history of merchant banking.)

The third day of the trial began with Boggs still on the witness stand (he had by now attracted a bevy of beautiful young women who gazed down upon his ongoing martyrdom in attitudes of dreamy concern from perches in the spec-

tator gallery), but he was soon replaced by three expert witnesses. Robertson had planned to call that editor of the Oxford English Dictionary to testify concerning the meaning of "reproduce," but he had now decided not to (in fact, now that the defense team reexamined the book, it turned out that one of the O.E.D.'s ten definitions of the word came uncomfortably close to describing precisely the sort of activity Boggs was engaged in). Instead, Robertson called René Gimpel, a prominent art dealer; Michael Compton, a distinguished senior curator of the Tate Gallery, recently retired; and Sandy Nairne, the director of visual arts at the Arts Council of Great Britain. All three testified that to call Boggs's drawings "reproductions" was to utterly confound the word's universally accepted art-world meaning. They rehearsed all the differences between Boggs's drawings and real bills, including, in one interesting line of questioning, that of value itself: they confirmed that Boggs's drawings regularly fetched prices in excess of one hundred times the face value of their models. To which Robertson extrapolated: "Has anyone here ever heard of a reproduction being worth *more* than its original? How, then, can Boggs's drawings be considered reproductions?" He went on to note, in passing, that it would be preposterous for someone to pass off a Boggs drawing to some unsuspecting third party at merely its face value—and that anyway this had never happened in the more than seven hundred instances when his drawings had changed hands—so that that concern of the Bank's was likewise unfounded.

Compton spoke of the different traditions that the two sorts of objects addressed: the banknotes merely addressed the tradition of earlier banknotes, whereas Boggs's drawings manifestly alluded to such earlier-established art-world traditions as trompe-l'oeil, barter art, Pop art, and conceptual/performance art. "Excuse me," interrupted the judge, who seemed to relish playing the role of the jovially dense common man. "How's that? *Con*ceptual-slash-performance art? Do I have that right? Oh dear." (At moments like this, the judge's dark eyebrows would dance behind his thick-rimmed glasses in a virtuoso performance of their own, reminiscent of the highest traditions as practiced by such masters as Senator Sam Ervin.) "The banknote is intended to exude anonymity and authority," Compton resumed. "Boggs's drawings instantly and overwhelmingly exude individuality."

With each of these witnesses, Harman seemed content to get the man to admit on cross-examination that, darn it, for all their supposed differences,

there were still plenty of similarities between the Boggs drawings and the actual bills, and, in fact, the Boggses were obviously drawings *of* standard bills. It was like pulling teeth.

With that, the presentation of evidence was over. Harman completed his summary to the jury, and Robertson started his before lunch and concluded soon after. At that stage of the proceedings, it seemed to some of us in the press box that it was going to come down to a question of whom the jury resented being condescended to by more—distant, arbitrary bureaucrats who saw their authority as beyond appeal, or eccentric, self-assured art types who imagined their precious categories to exist outside the law. Such, at any rate, were the caricatures that Robertson and Harman chose to emphasize in their closing statements.

The judge now gathered his papers together and began his summation of the case and his directions to the jury. For three hours, in a presentation that carried over to the next morning, he expertly analyzed the relevant laws and reviewed the various lines of argument and presentations of evidence. His tone was friendly, congenial, but finally no-nonsense. He was particularly succinct in his summary of the case for the defense, enumerating each defense argument in turn and affably declaring each, in turn, to be utterly without merit. After reviewing the basic provisions of Section 18, he said, for example, "The fact that a drawing might not resemble a currency note in every particular cannot provide a defense against this charge. The fact that the maker did not intend it to be passed, or that it might not even be capable of being passed, would not provide a defense, either. Nor would it be a defense to claim that the copy was made by hand rather than by machine: the parliamentary act makes no reference to mechanical means, and you can't go putting into an act of Parliament words which Parliament itself did not put into the act. Nor would the assertion that the copy in question were a work of art constitute any sort of defense whatsoever." He paused to smile warmly at the jury, and resumed, "This case is not about artistic freedom or freedom of expression or anything of the sort. You may have heard it described as a test case; nothing could be further from the truth: this is a very narrow and specific case. Please don't be deluded into imagining that you're trying the contemporary art establishment." Even veteran British trial reporters, who had seen a lot of biased summations by judges in their time, were taken aback by the tenor of

this presentation. "This is the world's most friendly hanging judge," one reporter scrawled in a note he passed to another.

"It provides no defense whatsoever that the drawings in question may be worth more than the originals," the judge continued, "or, for that matter, that they may in some manner provide the defendant with a principal source of his livelihood. Whether or not the defendant understood the law is immaterial. The comparative quality of the material upon which the copy was executed can be of no relevance. Evidence of the defendant's good character is likewise beside the point: that he were a man of evidently good prior character could in no way help us to determine whether he had in fact committed this specific crime, just as the reverse would be true. You would be untrue to your oath if you took mitigating circumstances into account in finding the defendant not guilty. I will of course take those circumstances into account in determining sentencing." The judge now paused significantly. "Or lack thereof"—he smiled—"should that prove necessary."

The first reporter's note now came back to him, overscrawled, "Or the world's most fiendish tweaking one?"

The judge seemed to be directing his jury the way Captain Hook directed his prisoners down the plank. It was pretty clear what he was expecting from all the parties involved. The jury would be a good jury and return a guilty verdict, he would be a good judge and impose a suspended sentence, and we could all get out of here and have a good weekend.

"Really, ladies and gentlemen of the jury," the judge went on, "we have a pretty straightforward question here. The word 'reproduction' is a perfectly common one used in everyday discourse, we all know what it means. And we can all also recognize that Section 18 forbids not just the reproduction of entire bills but even any 'reproduction in part.' If there is no more than just the reproduction of an actual serial number, you may find it difficult not to find that 'reproduction in part' has taken place."

A chill went through the press ranks: we flipped back through our notebooks and recognized in horror all the times we ourselves had transcribed the various serial numbers as they were being entered in evidence. Again, the judge smiled cordially. "But that will be for you to decide, not me."

By the end of the judge's summation, it was beginning to seem that the jury's decision might turn not just on the question of its respective antipathies toward art types and bank bureaucrats but also on the extent to which its

members might, on the one hand, have grown to resent the rigidities of this utterly charming and avuncular judge and developed a willingness to rebel or, on the other, might have been rendered irredeemably crazy by precisely those congenial rigidities and hence without wills of their own.

Shortly after eleven-thirty on the morning of the fourth day—Thanksgiving Day back in America, as it happened—the judge concluded his summation and direction, the jury headed for its chamber, and Boggs and the defense team repaired upstairs to the court cafeteria to wait out the jury's deliberations.

Robertson and Stephens were pretty grim: the judge's instructions had been devastating. Robertson was already sketching out his strategy for Strasbourg. Stephens asked Compton, the Tate's man, whether, in the event of a guilty verdict, the defense might at least move to wrest Boggs's confiscated works from the presumably destructive hands of the Bank, so that they could be preserved under the aegis of the Tate's Archive. Compton said that while such an arrangement would probably be acceptable it was important to understand that there was a distinct bifurcation between the Tate's Archive and the Tate's Collection—that just because works might be accepted into the Archive did not mean that they had been deemed worthy of being included in the Collection. "Now," he went on, musingly, "that does not mean that at some future date a work in the Archive might not be raised up into the Collection." He paused for a moment, his face darkening. "Or, I suppose, things might just as well go the other way around."

Word suddenly arrived that everyone was to return to the courtroom immediately: the jury had reached its verdict. It had been out only ten minutes. Stephens and other members of the defense team walked close to Boggs on the way downstairs, urging him to keep his cool, acknowledging that though the sudden verdict looked very bad, they would immediately launch their appeals on any guilty verdict, even one with a suspended sentence, and that the important thing was that he stay calm and collected, and not complicate matters by shooting his mouth off and incurring a contempt citation. Boggs, taking it all in as he descended the stairs, seemed pale and short of breath.

We all poured into the courtroom (there seemed to be a lot more press people about than at any time earlier), the judge's entry was announced, we all rose, he entered, we all bowed, we all sat, the jury was summoned and filed in, they all sat. The clerk asked the jurors whether they had selected a fore-

man. Indeed they had: the formerly scruffy gentleman now rose as their spokesman, decked out in the immaculate three-piece suit of an established banker. The judge inquired whether the jurors had arrived at a verdict. Yes, they had. Was it unanimous? Yes, it was. And what was it?

Not guilty on all four counts.

The judge rolled his eyes momentarily skyward and then smiled. Harman did likewise. Now, the judge and Harman smiled bemusedly *at each other*. Robertson initially seemed almost taken aback (the man had virtually reserved his suite at the Strasbourg Hilton), but then broke into a wide grin. Stephens was beaming. Boggs threw his arms up in the air in unmitigated exultation.

The jury had turned the judge's plank into a springboard from which it had propelled itself clear out of the law's strictures.

"Well," the judge said. "We've certainly all learned something here today." He thanked the jurors and dismissed them, declared Boggs a free man, ordered his confiscated drawings returned to him, and adjourned the proceedings.

The first person to shake Boggs's hand as he emerged from the defendant's dock was Inspector Davies. Boggs went over to the evidence table, pulled out his once-confiscated drawing of a five-pound note, and handed it to Stephens as a bonus.

A few minutes later, on the sidewalk outside the Old Bailey, as Boggs was being interviewed by London Weekend Television, he was spotted by the jurors filing out from their separate exit. They all rushed over to hug and congratulate him.

"It was the correct verdict," one of the jurors solemnly told the television reporter.

"We *loved* the work," the man in the three-piece suit assured Boggs confidentially.

Boggs now turned to the camera and announced that in celebration of the verdict he would embark immediately on a new project. From that moment on, he said, for the next year, he would spend no real money whatsoever. "I will live off what I can procure with my art," he declared. "My needs are limited. If I can't get something with a drawing, I'll just make do without it. It's going to take an awful lot of work and an awful lot of scrambling, but I want to see if it can be done.

"Anyway," he said, "I've got a head start." He reached into his satchel,

pulled out his sketch pad, and displayed a drawing of a fifty-pound note, which, he explained, he'd been laboring over up there in the dock, the entire last half of the trial.

POSTSCRIPT, 1988

Within a few days of the Old Bailey verdict, two curious events occurred in Boggs's life: the Bank of England swears it had nothing to do with the first, and, just as adamantly, I swear I had nothing to do with the second.

About three days after the verdict, Boggs returned to his flat late one evening to discover it ransacked and all his currency drawings stolen. In all likelihood, the vandals had been reading about "the defendant, of 15 Denning Road, Hampstead," in the British tabloids throughout the previous week, and about his strange drawings, "in many cases worth well over one hundred times their face value on the current art market." Boggs nevertheless had some difficulty convincing the neighborhood constables, who arrived to take his report of the incident, that these simple drawings were in fact worth considerably more than the mere, say, five pounds that they appeared to represent.

A few days later, in an unrelated development, Boggs got a call from a stranger who just happened to be passing through town that week and who'd likewise been reading all about his trial in the papers. The caller sensed a kindred spirit, he said, and asked if he might come by to meet him. He gave his name as Akumal Ramachandar. (Akumal subsequently told me that he happened to be in London between stints in Warsaw and New York and various other places, where he'd principally been promoting his Polish artist discovery, and that in fact he, of all people, had recently enjoyed a sojourn in the Strasbourg Hilton, as some sort of guest of the European Parliament—another long story, this one in some way involving another new friend and karma-colleague, the noted graphic artist Tomi Ungerer.) Akumal did go to meet Boggs, loved the work, and on the spot invited Boggs to fly out to Bengalore as his guest so they together might test his luck at passing drawings of rupees. Last I heard, Boggs had accepted the invitation.

Designed by David Bullen
Typeset in Mergenthaler Garamond 3
by Wilsted & Taylor
Printed by Haddon Craftsmen
on acid-free paper